HOW TO
DRAW

A complete step-by-step guide for beginners
covering still life, landscapes, figure drawing,
the female nude and human anatomy

■

IAN SIDAWAY, ANGELA GAIR, JAMES HORTON,
PATRICIA MONAHAN AND ALBANY WISEMAN

NEW HOLLAND

First published in 2005 by
New Holland Publishers (UK) Ltd
London • Cape Town • Sydney • Auckland
www.newhollandpublishers.com

Garfield House, 86-88 Edgware Road
London W2 2EA
United Kingdom

80 McKenzie Street
Cape Town 8001
South Africa

14 Aquatic Drive
Frenchs Forest, NSW 2086
Australia

218 Lake Road
Northcote, Auckland
New Zealand

ISBN 1 84537 088 0

10 9 8 7 6 5 4 3 2 1

Printed by Craft Print International,
Singapore

Contents

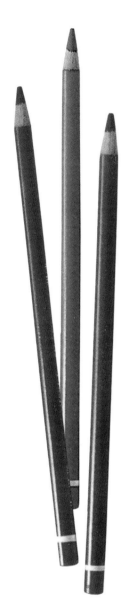

MATERIALS AND EQUIPMENT

There is an almost overwhelming variety of drawing materials available to the artist today, and new ones are being developed all the time. In this section the main categories of drawing media are described and illustrated.

PENCILS

Graphite pencils are graded by the H and B systems, according to the relative hardness or softness of the graphite core. Hard pencils range from 9H (the hardest) to H. Soft pencils

Pencils can be used both to produce a quick study or to create a finely detailed drawing. Several pencils, in a range of soft and hard leads, were used to achieve the subtle tones in this still-life drawing.

range from 8B (the softest) to B. HB is midway between hard and soft and is good for everyday use. A very soft lead enables you to make broad, soft lines, while hard leads are suited to fine lines and precise details. A medium grade such as 2B or 3B is probably the most popular for drawing.

Extremely soft pencils, known as graphite sticks, are also available. These are quite thick and produce strong, dark marks that are especially effective on rough-textured paper.

CHARCOAL

Stick charcoal is made from vine or willow twigs charred in special kilns and is available in various thicknesses. Thin sticks are suitable for sketches and delicate, detailed work.

Thicker ones are better for bold work and for covering large areas quickly. Soft charcoal is powdery and smudges easily, so use it with care and protect the finished drawing with spray fixative (see page 11).

PASTELS

Pastels are made from finely ground pigments bound together with gum to form a stiff paste, which is then shaped into sticks and allowed to harden. Four main types are available:

Soft pastels are the most widely used of the various types because they produce the wonderful velvety bloom which is one of the main attractions of pastel art. They contain more pigment and less binder, so the colours are vibrant. The

smooth, thick quality of soft pastels produces rich, painterly effects. They are easy to apply, requiring little pressure to make a mark, and can be blended and smudged with a finger, a rag, or a paper stump (torchon).

Hard pastels contain less pigment and more binder than the soft type. Although they have a firmer consistency, the colours are less brilliant. Hard pastels can be sharpened to a point with a blade and used for crisp lines and details. Unlike soft pastels, they do not crumble and break easily, nor do they clog the tooth of the paper, so they are often used in the preliminary stages of a drawing to outline the composition, or for adding details and accents at the end.

Pastel pencils are thin pastel sticks encased in wood, like ordinary pencils. They are clean to use, do not break or crumble as traditional pastels do, and give greater control of handling. Pastel pencils are perfect for line sketches and detailed small-scale work, and can be used in conjunction with hard and soft pastels.

Oil pastels are different in character from traditional pastels. The pigment and chalk are combined with an oil binder instead of gum, making the sticks stronger and harder. Oil pastels make thick, buttery strokes and their colours are clear and brilliant. Though not as easy to control as the other pastels, they have a robust quality which makes them ideal for direct, spontaneous working. Oil pastels require little or no spray fixative as they do not smudge easily.

COLOURED PENCILS

An increasingly popular drawing medium, coloured pencils offer the same lively linear quality as graphite pencils, but with the added bonus of colour. In use, coloured pencils can be overlaid to create visual blending of colours, but they cannot be mixed like paints. For this reason, they are produced in many different colours, shades and tints.

WATER-SOLUBLE PENCILS

These are similar in appearance to ordinary coloured pencils, but the lead contains a water-sensitive binder. You can apply the colour dry, as you would with an ordinary coloured pencil, and you can also use a soft watercolour brush dipped in water to blend colours together on the paper to create a wash-like effect.

CONTÉ CRAYONS

These are oblong sticks of very high-grade compressed chalk, slightly harder and oilier than pastels. Traditionally used for tonal drawings, conté crayons were in the past limited to black, white, grey and three earth colours – sanguine, sepia and bistre. Recently a wide range of bright and subtle colours has been introduced, available individually or in boxed sets.

Water-soluble pencils can be used as both a painting and a drawing medium.

You can use the flat side of the crayon for shading and creating broad, flat areas of colour, or you can break off small pieces and use a corner or edge to make crisp outlines. Conté crayons combine well with soft pastels and with charcoal, and are shown to their best advantage when used on tinted paper with a fairly rough texture.

DRAWING INKS

There are two types of drawing ink: water-soluble and water-proof. Both types come in a wide range of colours as well as the traditional black. With water-soluble inks the drawn lines can be dissolved with water and the colours blended. With waterproof inks the lines remain intact and will not dissolve once dry, so that a wash or tint on top of the drawing may be added without spoiling the linework. Water-soluble ink should be used with all pens except dip pens to ensure that they do not clog.

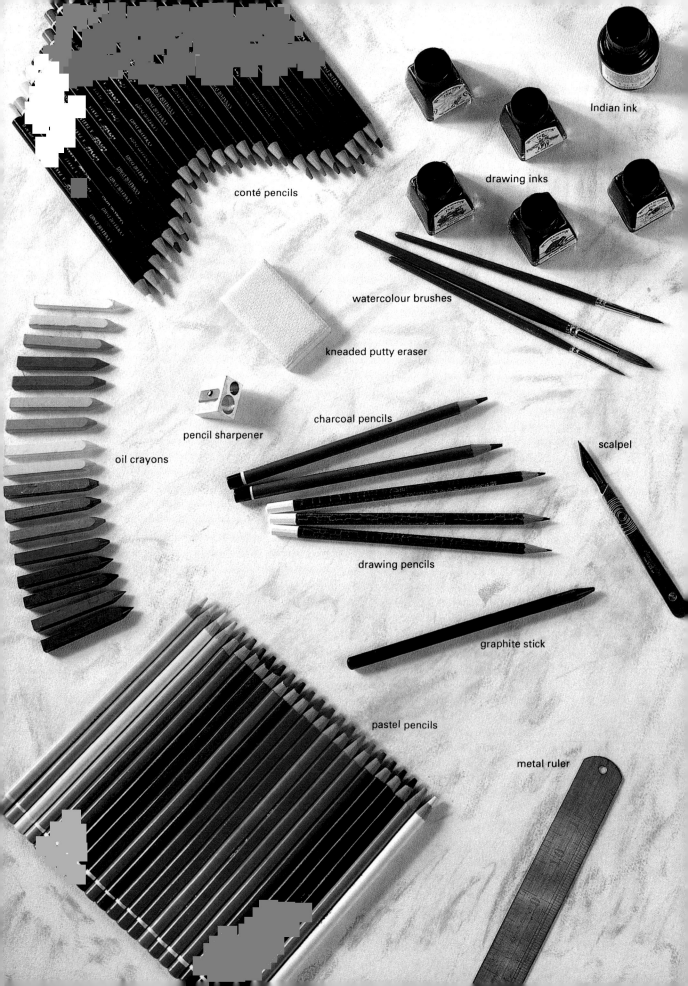

conté pencils

Indian ink

drawing inks

watercolour brushes

kneaded putty eraser

pencil sharpener

charcoal pencils

scalpel

oil crayons

drawing pencils

graphite stick

pastel pencils

metal ruler

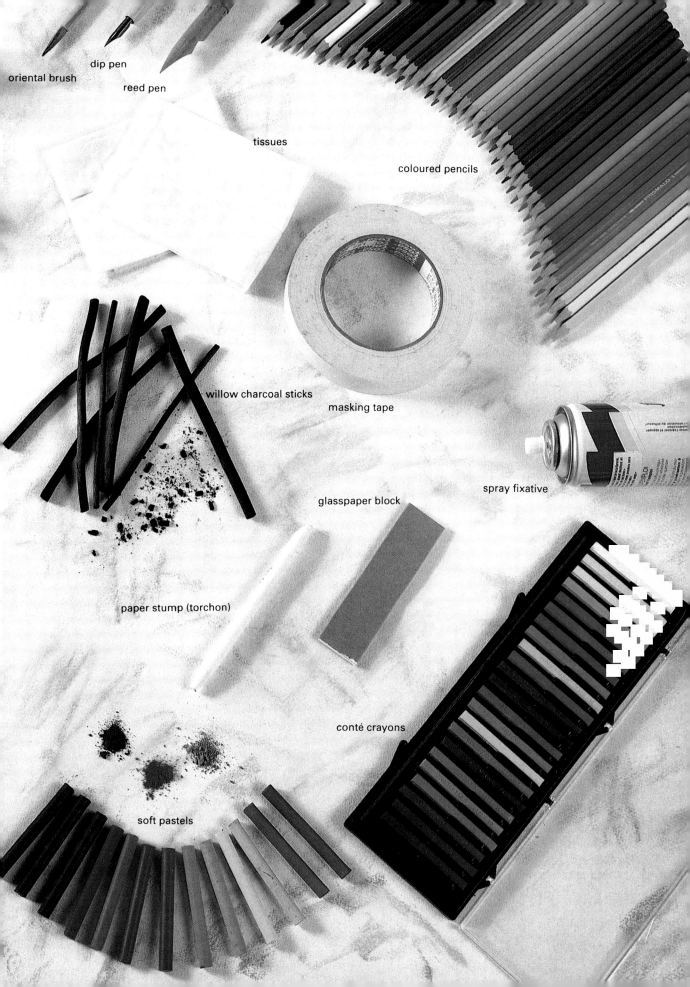

oriental brush

dip pen

reed pen

tissues

coloured pencils

willow charcoal sticks

masking tape

spray fixative

glasspaper block

paper stump (torchon)

conté crayons

soft pastels

PENS AND BRUSHES

Many types of drawing pen are available today. Simple dip pens consist of a holder which can be used with a selection of nibs. They produce flowing lines that can be made to swell and thin. The more traditional reed pens produce soft, slightly irregular strokes, making them ideal for bold line drawings. They are available from art supply stores, but many people prefer to make their own pens from bamboo cane.

Fountain pens with their built-in supply of ink are useful for impromptu sketching because they don't need to be dipped into ink frequently. They are smoother to draw with than dip pens, but the nib range is more limited and most fountain pens need water-soluble ink to prevent them from clogging. Fibre-tipped pens and marker pens are available in a wide range of colours. Technical pens produce a controlled, even line and are more suited to detailed line work.

Watercolour brushes have a pleasing, springy quality that is well suited to brush drawing with ink. Bamboo-handled oriental brushes are inexpensive

A small selection from the wide range of drawing papers available includes: 1 sugar (craft) paper; 2 and 6 cartridge (drawing) paper; 3 flour paper; 4 spiral-bound sketch book; 5 tinted watercolour paper; 7 vellum; and 8 Ingres pastel paper. An art folder (9) is useful for transporting drawings.

and their soft, pointed bristles produce flowing, natural lines.

PAPERS

Drawing paper is available in a wide range of weights, textures and colours, and can be purchased as single sheets, pads, sketchbooks or as boards which provide a firm support.

The texture of the paper – how rough or smooth it is – will affect the way you draw. Machine-made papers are available in different finishes: "hot-pressed" (HP); "Not", meaning not hot-pressed (cold pressed); or "rough". Hot-pressed papers are smooth; Not papers have a medium texture, or "tooth"; and rough papers, as the name suggests, have a coarse texture.

The "weight" of a paper refers to its thickness. Lightweight papers will buckle when wet washes of ink or paint are applied, so choose a good-quality heavy, paper.

Choosing a Paper

The character of the paper can influence a drawing quite dramatically, so it is important to choose carefully. It is worth exploring the effects of a single medium on different papers; they can vary enormously.

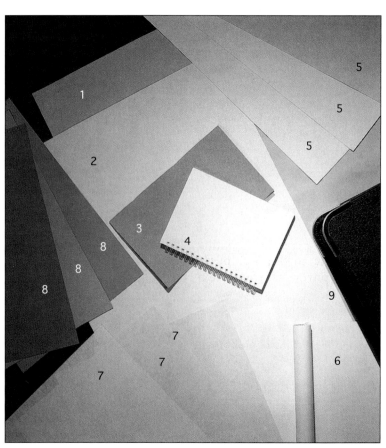

Pencil Almost any type of surface can be used for pencil work. Generally, a smooth paper is most suitable for finely detailed drawing, and rougher surfaces for bold drawing.

Coloured pencil A smooth or medium-textured paper is best for coloured pencils. The water-soluble variety requires a heavy, watercolour-type paper to withstand wetting.

Pastel and charcoal Powdery materials such as pastel and charcoal need a support with enough surface texture to hold the particles of pigment. Smooth or shiny papers are unsuitable because the pastel or charcoal stick slides around and the marks are easily smudged. Waxy materials such as conté, oil pastel and wax crayon also work best on a textured surface. Canson, Ingres (charcoal), Fabriano and the inexpensive sugar (craft) papers are all good for charcoal and chalks.

When working with any of the above materials, choose a tinted paper, against which both lights and darks show up well. Pastel papers come in a range of surfaces: soft velour for blending colours smoothly and evenly; medium grain for general purposes; rough textured for lively, vigorous work; and very fine grade flour paper which can hold dense layers of pastel and produce a strong, brilliant effect.

Pen and ink Bristol board has a very smooth, brilliant white surface and is ideal for pen and ink. It comes in different thicknesses, the lighter weights being more like a sturdy paper than a board. Smooth cartridge (drawing) paper is also suited to pen drawing, but brush and ink works well on a Not (cold-pressed) or rough surface, which breaks up the strokes and adds sparkle and vigour to the drawing.

DRAWING ACCESSORIES

Erasers For erasing, plastic or kneaded putty erasers are best, as the familiar India rubber (pink pearl) tends to smudge and can damage the paper surface. Putty erasers are very malleable; small pieces can be broken off and rolled to a point to reach fine details. A putty eraser can also be pressed onto the paper, and unwanted marks lifted off simply by pulling it away. Use it on soft graphite, charcoal or pastel drawings, both to erase and to create highlights.

Paper stumps Paper stumps, also called torchons, are used for blending or shading charcoal, pastel or soft graphite drawings. Made of tightly rolled paper, they have tapered ends for working on large areas and a sharp point for small, delicate details.

Knives and sharpeners A sharp craft knife or scalpel for sharpening pencils and cutting paper is also needed. Knives are very useful too for scratching lines into an oil pastel drawing to create interesting textures – a technique known as sgraffito.

A pencil sharpener is convenient, though a knife is preferable as it gives a longer point and is less prone to breaking the lead. Sandpaper blocks, consisting of small, tear-off sheets of sandpaper stapled together, are useful for getting fine points on graphite sticks, pastels, crayons and charcoal sticks.

Drawing board If you draw on sheets of loose paper you will need a firm support. You can buy a commercial drawing board at an art supply store, but it is far cheaper to get a good piece of smooth board from a timber merchant (lumberyard). If the drawing board feels too hard, place a few extra sheets of paper under the top one to make a more yielding surface.

Fixative If you are using pastel, chalk, charcoal or soft graphite pencil, the best way to preserve your drawings is to spray them with fixative. This varnish-like fluid binds the particles of pigment to the surface of the paper so they will not smudge, smear or shake off. Fixative is available in aerosol spray form or mouth-type atomizers.

Drawings executed in soft media such as pastel, charcoal or soft pencil should be sprayed with fixative to prevent smudging.

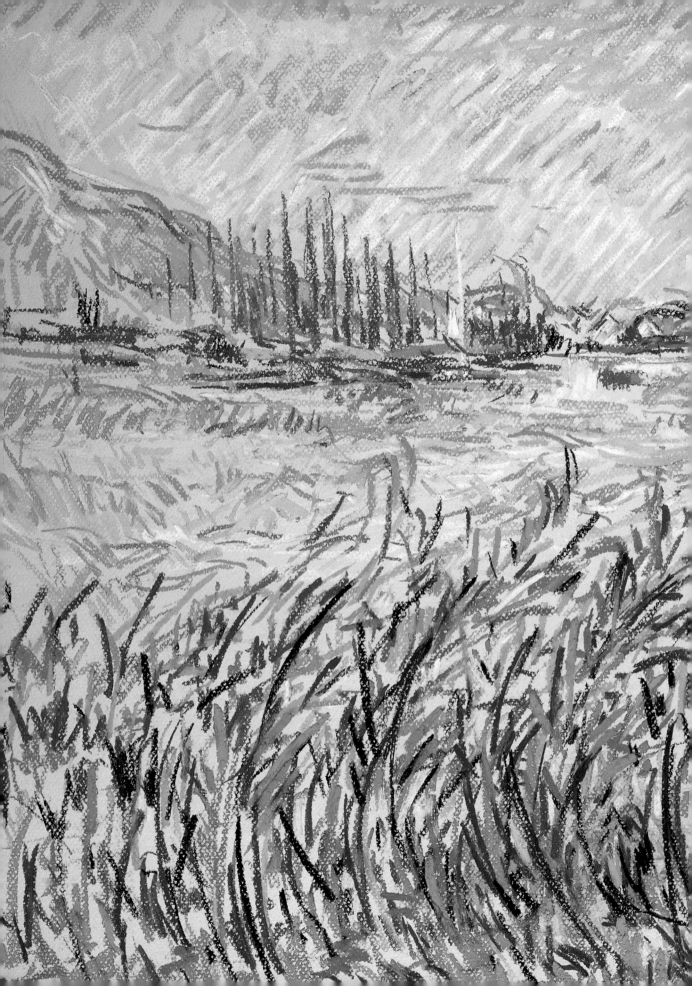

Drawing

ANGELA GAIR

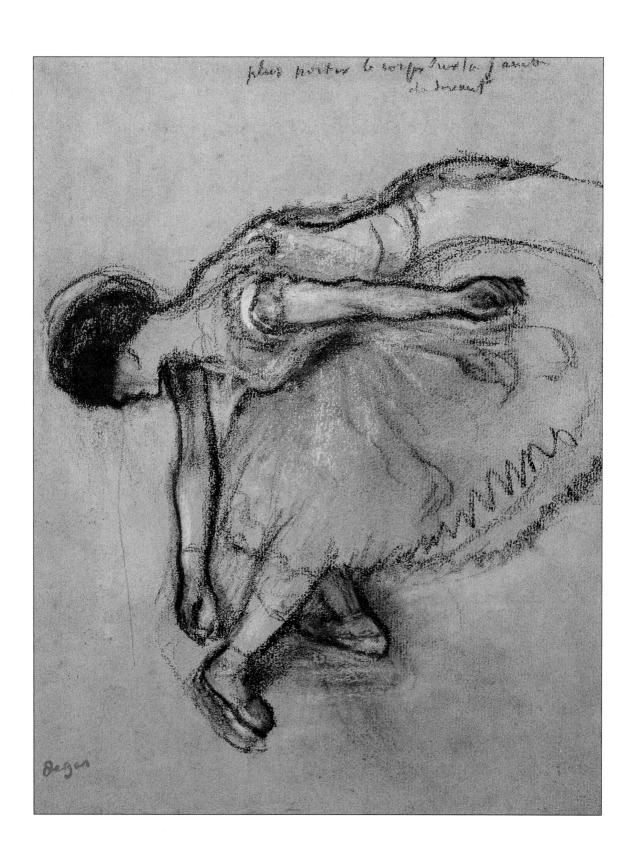

INTRODUCTION

Drawing is one of the most elementary of human activities. Its origins go back to the beginning of recorded history, when man began to depict hunting scenes on the walls of caves with charcoal outlines coloured with earth pigments. The ancient Egyptians used pens made of sharpened reeds and ink made of powdered earth to draw hieroglyphics – pictures representing words – on sheets of papyrus. But these early drawings were stylized and served a purely symbolic purpose.

It was not until the Greek classical period, in the fifth century BC, that artists began to make realistic representations of nature and to devise the classical concepts of proportion, space and

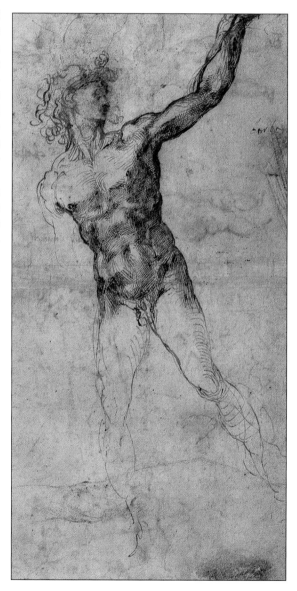

Dancer *Edgar Degas*

This pastel and charcoal study of a ballet dancer has an immediacy which captures the essence of a fleeting pose. The vigorous, sweeping strokes and the various visible alterations describe not only the grace and beauty of the dancer's stance but the general feeling of movement in her body. Charcoal and pastel are sympathetic drawing media, responding immediately to the artist's impulse.

Sketch of a Nude Man *Michelangelo Buonarotti*

A sculptor, painter and architect, Michelangelo was one of the greatest artists of the Renaissance. Although incomplete, this drawing in pen and bistre ink shows his mastery of human anatomy. The muscles of the male torso are accurately represented and drawn with force and vigour using the technique of hatching and crosshatching to give a powerful statement of form and volume.

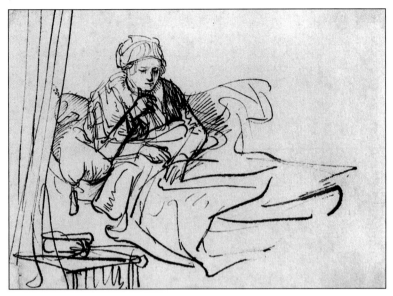

Saskia in Bed
Rembrandt van Rijn

This is one of a number of drawings which Rembrandt made of his wife Saskia in bed during the long illness that led to her death. Even in a rapid sketch like this one, Rembrandt's mastery of the pen-and-ink line is evident; with a few whiplash strokes he manages not only to convey a wealth of detail but, on a deeper level, to suggest his own emotional response to his subject.

volume that still have a strong influence on art in the present day.

During the Middle Ages, artists worked in the service of the Christian church which decreed that there should be no graven images, so realistic representation was once more replaced by stylized and symbolic images. However, all this changed with the flowering of the Renaissance between the fourteenth and sixteenth centuries. The term Renaissance means "rebirth", and the new era saw the narrow, superstitious beliefs of the Middle Ages give way to a resurgence of interest in the classical ideals of Greek and Roman art. Drawing became established as the foundation of training in the arts. Anatomy, proportion and the science of perspective (the technique of giving an illusion of three-dimensional space on a flat, two-dimensional surface) were studied, and apprentices were encouraged to draw directly from nature as well as copying from the drawings of their masters.

This explosion of artistic activity was matched by an increasing variety of drawing media. Charcoal and chalk were used for making large studies and cartoons for larger, commissioned paintings. Silverpoint – the precursor of the graphite pencil – was used to make smaller, carefully executed drawings used as prepara-

tory studies for paintings and sculptures. The silverpoint stylus was a silver wire set into a wooden handle, which made delicate silver-grey lines on paper coated with gesso or chalk. Pen and ink drawings were executed on beautifully tinted papers, often highlighted with white chalk. From this period there emerged some of the world's greatest artists, among them Leonardo da Vinci (1452–1519), Michelangelo (1475–1564), Raphael (1483–1520), Albrecht Dürer (1471–1528) and Hans Holbein (1497–1543).

During the early Renaissance (the early fifteenth century) drawings were precise and linear in style, with the emphasis on the exact character of surface detail. But by the time of the High Renaissance (late fifteenth and early sixteenth centuries) drawing had become looser in style and surface detail was suggested rather than rendered with precision. The edges of forms became softened and broken and a feeling for light, space and air was more evident.

By the seventeenth century drawing had at last become valued as a form of artistic expression in its own right rather than a mere adjunct to painting. The methodical use of hatched and crosshatched lines to build up dark tones, used by the Renaissance artists, gave way to a new freedom and vigour of execution and a greater

use of dramatic chiaroscuro (contrasts of light and dark). Holland produced several artists of genius, most notably Rembrandt (1606–1669) and Claude Lorrain (1600–1682), both of whom produced superb drawings in pen and ink or brush and wash.

During the eighteenth century, France became the chief centre of artistic innovation. The invention of the graphite pencil helped to make drawing even more popular by enabling fine lines and shading to be achieved without the inconvenience of using ink. Antoine Watteau (1684–1721) drew with a light, delicate touch that expressed the rococo ideals of grace, charm and courtly sophistication. Pastel also became a popular medium at this time, its greatest exponents being Rosalba Carriera (1674–1757), Jean-Baptiste Chardin (1699–1779) and Quentin de la Tour (1704–1788).

The classical revival dominated the first part of the nineteenth century in France. Jean Auguste Dominique Ingres (1780–1867), arguably the greatest draftsman of his age, produced many portrait and figure studies in pencil. His technical virtuosity was astounding and his beautifully wrought figure and portrait studies were the result of years of painstaking study and disciplined observation. Ingres told his pupils that the technique of painting could be mastered in a week, but the study of drawing demanded a lifetime.

By the middle of the century, however, some French artists began to break away from the strict confines of Classicism. Eugène Delacroix (1798–1863) was the leader of the Romantic movement; his pen and ink drawings are charged with energy, the writhing, turbulent lines moving freely to describe his emotional reaction to his subject. Honoré Daumier (1808–1879) belonged to the Realist group of painters who rejected grandiose historical themes and portrayed ordinary life around them. Daumier drew people with humour, satire and sympathy, using charcoal and pen and ink with an economy and fluidity of line that accentuates the sharpness of his observation.

The most striking characteristic of twentieth-century drawing is its diversity of style and expression. Just some of the artists worth studying are Pablo Picasso (1881–1973), whose prodigious output encompassed many styles, subjects and techniques; Henri Matisse (1869–1954), whose use of eloquent calligraphic lines is breathtaking beautiful; Giorgio Morandi (1890–1964), who achieved incredible subtleties of light and shade with patiently hatched and crosshatched lines; and David Hockney (born 1937), whose influence has raised the status of the coloured pencil from child's drawing tool to a major drawing medium.

Coloured Drawing, Paris '73 *David Hockney*

The quiet restraint of this interior scene stems from the subdued colours and static composition. Hockney has used coloured pencils to create layers of hatched and crosshatched marks woven into mixed hues and tones. Much of the current popularity of coloured pencil is due to Hockney's work in the medium.

BASIC TECHNIQUES

MAKING MARKS

The first step in drawing is to discover the potential expressive range of your chosen medium by experimenting with the marks it can make. Start by making random marks on scrap paper – scribbling, hatching and rubbing until the drawing instrument seems to be an extension of your hand.

Pencil

The immediacy and sensitivity of pencils make them the most popular tool for drawing. The character of a pencil line is influenced by the grade of pencil used, the pressure applied, the speed with which the line is drawn, and the type of paper used. Soft pencils are good for rapid sketching and encourage a bold, gestural style of drawing. Hard pencils make fine, incisive lines and are better suited to detailed representational drawing. Tonal effects are achieved by means of hatched and crosshatched lines; by varying the density of the lines, fine gradations in tone from light to dark can be created.

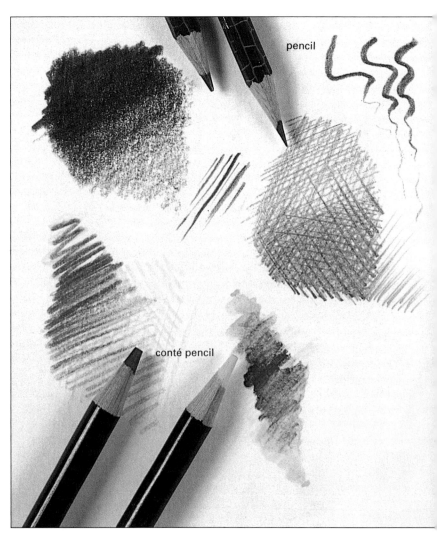

pencil

conté pencil

Charcoal

Charcoal is a uniquely expressive medium with a delightful "feel" to it as it glides across the paper. With only a slight variation in pressure on the stick a wide range of effects is possible, from delicate hatching to strong and vigorous marks. Because charcoal smudges so easily it can also be rubbed and blended for rich tonal effects, and highlights can be picked out with a kneaded putty eraser. Charcoal is messy to handle, and it is advisable to use spray fixative to prevent unwanted smudging.

Pastel and Crayon

Pastels, chalks and crayons are extremely versatile in that they can be both a drawing and a painting medium. By twisting and turning the stick, using the tip and the side, it is possible to obtain both expressive lines and broad "washes" of colour.

Soft pastels and chalks, being powdery, can be blended easily to create a delicate veil of colour, but a more lively effect is gained by combining blended areas with open linear work. The density of colour is controlled by the amount of pressure applied; with strong pressure you can achieve the density of oil paint, and this effect can be contrasted with strokes that pass lightly over the surface.

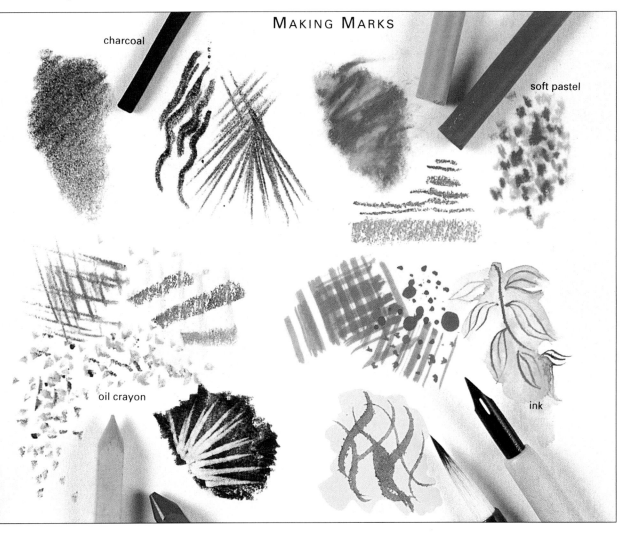

MAKING MARKS

charcoal

soft pastel

oil crayon

ink

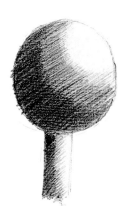

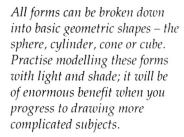

All forms can be broken down into basic geometric shapes – the sphere, cylinder, cone or cube. Practise modelling these forms with light and shade; it will be of enormous benefit when you progress to drawing more complicated subjects.

Ink

Whether it is bold and dynamic or delicate and lacy, ink drawing has a striking impact. Pen and ink is a linear medium and pen marks cannot be varied tonally by altering the pressure on the nib as easily as pencil marks can. Tones must be rendered with lines or marks, overlapping or varying the spacing to create degrees of light and dark. Ink can also be applied with a soft brush to create a completely different range of marks, and washes can be laid down using diluted ink.

FORM AND VOLUME

The way light and shadow fall on objects helps to describe their solid, three-dimensional

form. In drawing and painting, solidity and the illusion of a third dimension is suggested by using tonal values – degrees of light and dark. Natural forms such as clouds and trees often have complex and irregular shapes which make it difficult to represent the subtle areas of light and shadow.

The best approach is to ignore distracting detail and simplify what you see, breaking the subject down into basic areas of light and shade. These simplified areas are called "planes". The lightest planes are those areas that receive direct light; the darkest are those furthest from the light source. In between are the mid-tones – varying degrees of light and dark. Once you have established the basic form and structure of your subject by simplifying it into planes of light and shade, you will find it easier to develop detail and refine the drawing by breaking up these simplified major planes into smaller, more complex and subtle ones.

PROPORTIONS OF THE FIGURE

Most artists gauge the proportions of the figure by taking the head as their unit of measurement. Generally speaking, the head of a standing adult fits into the total height of the figure about seven times. This is a useful guide, but remember that no two people are built exactly alike or carry themselves in the same way, and there is no substitute for sensitive observation of the actual subject.

A common mistake in drawing figures is to make the arms too short and the hands too small. When the arms are relaxed, the tips of the fingers hang a considerable way down the thighs, and the hands measure almost one head unit.

Seated Figures

When drawing a seated figure, use the proportions of the chair as a guide. Within this frame, mark off the position of various points of the body – shoulders, hips, thighs, knees – in relation to the back, seat and legs of the chair. Foreshortening of the legs, particularly if they are crossed, can be difficult to represent convincingly. The tendency is to draw what we know, not what we see; it is vital to look repeatedly at your model, to check that angles and proportions are correct, and, most of all, to trust what your eyes tell you.

A useful tip is to regard the figure as a two-dimensional shape and draw its outline as accurately as you can.

In the average adult human, the length of the head from crown to chin represents one-seventh of the total height of the figure.

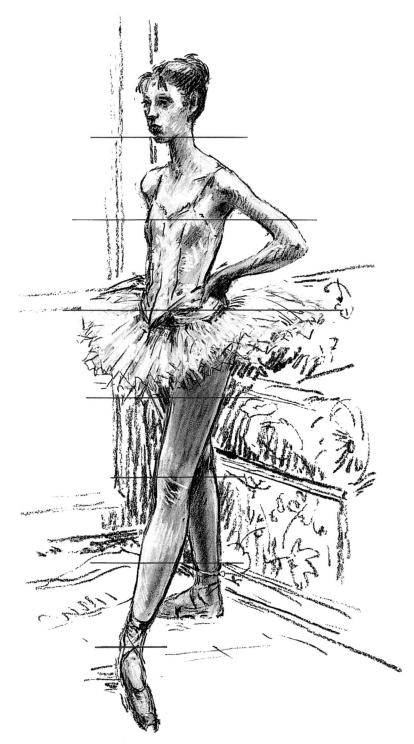

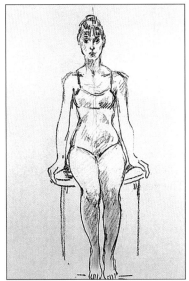

In a seated figure, the thighs appear foreshortened. Observe the model closely and draw what you see, not what you know.

LINEAR PERSPECTIVE

HL VP

ONE-POINT PERSPECTIVE
When you stand in the middle of a road, hallway or room, all parallel horizontal lines appear to converge at a single point on the horizon (HL), known as the vanishing point (VP).

TWO-POINT PERSPECTIVE
When you view a building from one corner, the horizontal lines of each wall again appear to converge at the horizon, and each set of lines has its own vanishing point (VP).

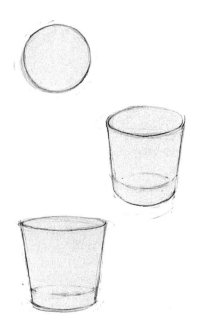

LINEAR PERSPECTIVE

Perspective is a useful set of principles which help the artist to create a convincing illusion of three-dimensional depth and space on a flat, two-dimensional piece of paper.

The principle of linear perspective is that all parallel lines on the same plane (for example the edges of a long, straight road) appear to get closer together as they recede into the distance. The point at which they appear to meet is called the "vanishing point". The vanishing point is always on the horizon line, and the horizon line always corresponds to

your eye level. The vanishing point gives you an exact method for determining the angle of every receding line in your picture, thus ensuring that your drawings are accurate and true. This is the simplest form of perspective, known as one-point perspective.

If two sides of an object are visible – as when you are facing the corner of a building –

Hold a glass in your hand so that you are looking directly onto it. Slowly tip the glass away from you and observe how the circular rim flattens out into an ellipse. The further you tip the glass, the narrower the ellipse.

two vanishing points are necessary. The lines forming the top and bottom edges of both sides appear to converge and meet on the horizon, each with its own vanishing point.

SPHERES AND ELLIPSES

When drawing a still-life subject, you will inevitably be faced with the problem of depicting bottles, glasses, jugs, cups and other cylindrical or spherical shapes in perspective. This task may seem daunting at first, but it becomes much easier if you understand how perspective works.

A circular shape such as the rim of a glass, when viewed from an oblique angle, flattens out and becomes an ellipse. To demonstrate this, hold a glass in front of you and look straight down on it. You will see that the rim forms a perfect circle and the sides of the glass are not visible. Now slowly tip the glass away from you: observe how the further you tip the glass, the narrower the circle becomes and the sides of the glass come into view.

When drawing rounded objects, draw them as if they were transparent in order to get a sense of their three-dimensional shape. You can then erase the parts that are not actually visible. Use light pressure, feeling out the form with flowing, continuous strokes. Lines drawn with too much pressure often look awkward and uneven, and unwanted lines are difficult to erase.

SQUARING UP

You may wish to base a drawing on a sketch or a photographic image; but it is often difficult to maintain the accuracy of a drawing when enlarging or reducing a reference source to the size of your working paper. A simple method of transferring an image in a different scale is by squaring up (sometimes called scaling up).

Using a pencil and ruler, draw a grid of equal-sized squares over the sketch or photograph. The more complex the image, the more squares you should draw. If you wish to avoid marking the original, make a photocopy of it and draw the grid onto this. Alternatively, draw the grid onto a sheet of clear acetate placed over the original, using a felt-tip pen.

Then construct an enlarged version of the grid on the working sheet, using light pencil lines. This grid must have the same number of squares as the smaller one. The size of the squares will depend on the degree of enlargement required: for example, if you are doubling the size of your reference material, make the squares twice the size of the squares on the original reference.

When the grid is complete, transfer the image that appears in each square of the original to its equivalent square on the working sheet. The larger squares on the working sheet serve to enlarge the image. You are, in effect, breaking down a large-scale problem into smaller, manageable areas.

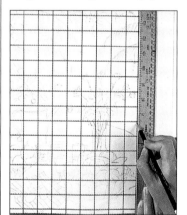

1 Draw a grid of squares onto a sheet of tracing paper laid over the reference sketch.

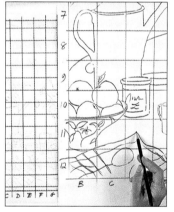

2 Lightly draw a grid of larger squares onto the drawing paper and transfer the detail from the reference sketch, square by square.

GALLERY

A vast range of drawing materials, supports and equipment is now available to the artist, and the opportunities for personal expression are without limit. The drawings shown on the following pages demonstrate a broad cross-section of techniques and media, and reveal how each of these can be used in different ways and for a variety of subjects.

Some of the artists featured have employed traditional methods that go back to the Renaissance, such as line and wash, hatching and crosshatching. Other artists have used experimental techniques and materials – drawing with inks and bleach, for example – to create particular effects. Their drawings should serve to inspire you to experiment with media and techniques and open up new horizons.

~

African Village

Annie Wood

51 x 36cm (20 x 14in)

This drawing is a fine example of the intricate textural and colour effects that can be achieved using sgraffito. In this technique, the broad colour areas of the design are first blocked in with wax crayons; the entire area is then covered with a layer of black wax crayon and this is scratched into with a sharp instrument, revealing the colours beneath.

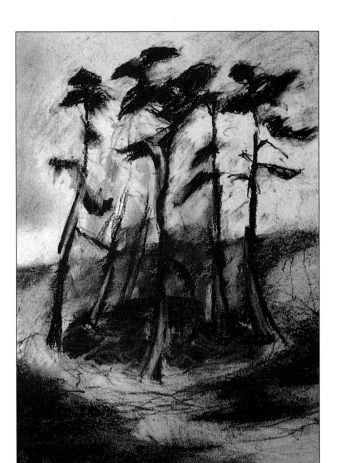

Foxhall Heath

Sheila Bryan

28 x 18cm (11 x 7in)

This ancient Roman burial ground has fascinated the artist since childhood. Working from imagination and memory, she has exploited the dense tonal qualities of black conté crayon to convey both the starkness of the scene and its haunting atmosphere. The sky and landscape were laid in with the side of the crayon and the lighter tones lifted out using tissue paper and an eraser, while the dramatic shapes of the Scots pines were drawn directly with the point of the crayon.

Mr Bill

Kay Gallwey

41 x 46cm (16 x 18in)

Pastel, charcoal and watercolour are combined in this lively and sympathetic study of a cat. The support is a sheet of beige Ingres (charcoal) paper, its colour providing a useful mid-tone which shows through the drawn marks, holding them together. The cat's ginger fur was washed in with watercolour paint, applied with a rag. Over this, scribbled strokes of charcoal and white pastel were used to outline the form and express the texture of the soft fur.

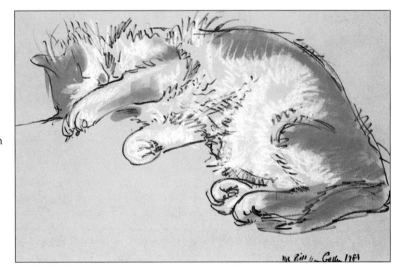

GALLERY

Life Study

Rosemary Young

40 x 44cm (15½ x 17½in)

As a sculptress, Young is naturally interested in the play of light and shade on forms. Here the contours of the figure were modelled with vigorous hatched strokes using an 8B pencil. Then a hard eraser was used to smudge some of the tones, and a soft putty eraser to lift out the highlights, almost as if carving out the forms. It is hard to believe that such a finely wrought drawing was executed while standing well back from an easel, the pencil tied to the end of a stick!

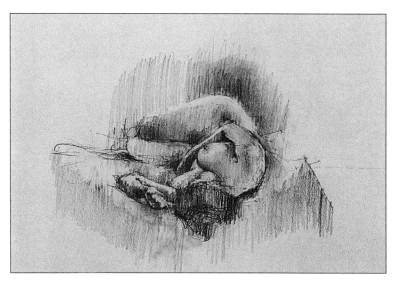

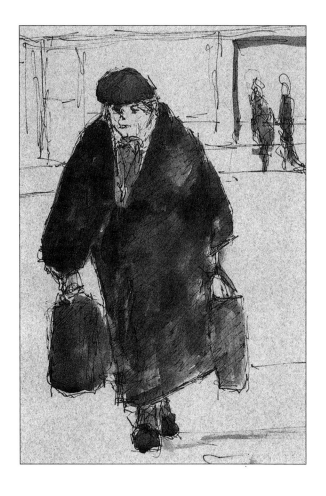

The Shopper

John Denahy

19 x 13cm (7½ x 5in)

This line-and-wash drawing is a touching and humourous study of an old woman returning from the market weighed down with her shopping. Denahy first sketched in the form of the figure with rapid, scribbled lines using a technical pen. Then he used sepia ink – less harsh than dense black – and a brush to wash in the dark tones that convey the bulk of the figure. The sketchily drawn background lends a sense of scale to the drawing and acts as a counterpoint to the main figure.

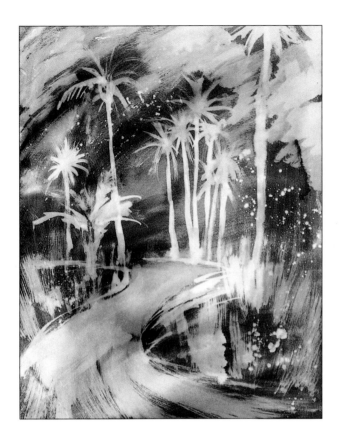

Night in the Rainforest

Annie Wood

71 x 51cm (28 x 20in)

This is an example of a bleach drawing. The technique involves covering the paper with writing ink and then drawing into it with a brush or drawing implement dipped into diluted household bleach. The bleached areas turn a pale golden brown, so the finished drawing has the mellow beauty of an old sepia-tinted photograph. This image was drawn with an old, splayed brush, and in places the bleach is spattered onto the paper by flicking the brush.

Corsican Landscape

Joan Elliott Bates

51 x 41cm (20 x 16in)

A strong sense of space and of the massive bulk of the mountains is expressed in this mixed-media drawing. Working on a watercolour block, the artist drew the linear framework with compressed charcoal (which does not smudge and requires no fixing) and then washed in the tones with watercolour. In places she worked into the washes with water-soluble crayons to add definition and help knit the colour in with the black lines.

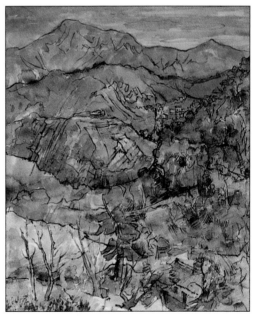

Smooth Talker

Oliver Canti

74 x 104cm (29 x 41in)

The visual humour in Canti's drawings is a delight, and reflects his interest in animals and their behaviour. He works with huge oil pastels, 2.5cm (1in) in diameter, which he favours for their broad, painterly effects. The first layer of colour is worked over with a brush and turpentine in places, to dissolve and blend the pigment. Then he fixes the drawing and works over it with further layers, using the point and the side of the stick to create a rich patina of colour and texture that conveys the luminescence of the light.

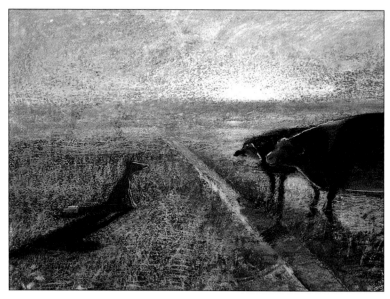

Four O'Clock

Annie Wood

58 x 42cm (23 x 16½in)

This drawing illustrates how an eraser can be used, not just for correcting mistakes, but also as a mark-maker in its own right. Using a graphite stick, which is very soft, Wood laid down tones of grey and black, softly blended with her finger. She then worked back into this with an eraser, lifting out the lightest tones with bold strokes. For the small, sharp lights she used a hard pencil rubber, cut to a point.

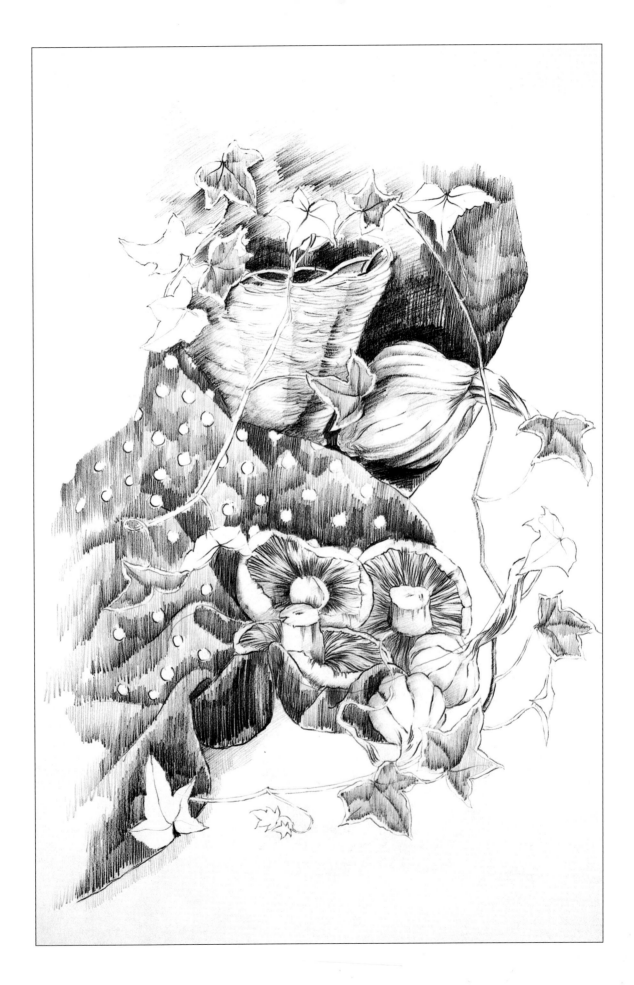

Technique

1

HATCHING AND CROSSHATCHING

Artists today have an enormous variety of drawing materials and techniques at their disposal. Yet somehow a simple, finely wrought pencil drawing has a timeless appeal which has never been surpassed.

This still-life study employs the classical techniques associated with monochrome media such as pencil and pen and ink. Using a system of hatching and crosshatching, the artist has built up a carefully modulated network of fine lines to establish the dark, medium and light tones and suggest the contours of the objects. Variety is achieved by altering the direction of the strokes and by using a combination of hard, medium and soft-grade pencils.

As in watercolour painting, the white of the paper plays an essential part in a pencil drawing. Here small areas of untouched paper indicate the lightest highlights, and the artist has deliberately faded out the tones at the edges of the drawing to create a softly "vignetted" effect.

Annie Wood
Still Life with Ivy
58 x 41cm (23 x 16in)

HATCHING AND CROSSHATCHING TECHNIQUE

Hatching and crosshatching have been used for centuries as a means of creating form and texture in a monochrome drawing. In hatching, the lines run parallel to one another; in crosshatching, they cross each other at an angle to create a fine mesh of tone. Simply by varying the number of lines and the distance between the lines, it is possible to obtain a tremendous range of tones, varying from very light to extremely dark. But because the white of the paper is not completely obliterated, the tone retains a luminosity that is one of the assets of this technique. The lines themselves can also convey energy and movement, particularly when they run in different directions, following the contours of the subject and describing its form and volume.

The effect achieved will be determined by the type of pencil used (hard or soft) and its point, by the type of paper, by the degree of pressure applied and by the character of the lines, whether tightly controlled or free and sketchy. In this project drawing, for example, the artist has worked on a hot-pressed cartridge (drawing) paper, its smooth surface making the fine pencil lines appear crisp and clean.

This technique is time-consuming and requires a patient, methodical approach, but it is very satisfying. It is important to build up the lines gradually until you achieve the depth of tone you require. Too much deepening of tone too early can make the finished drawing overly dark and heavy, so be patient when building up the shadows. It is essential with this type of shaded drawing to refer constantly to the subject, looking carefully at the shadows and judging each tone in relation to its neighbour. Try to develop the drawing as a whole, gradually bringing the tones in various parts of the composition into line with each other as you work.

Before attempting the following project, practise drawing series of lines close together to create a range of darks, lights and mid-tones. Use a sharp pencil and smooth paper. When you have mastered this, practise varying the pressure, angle and direction of the strokes.

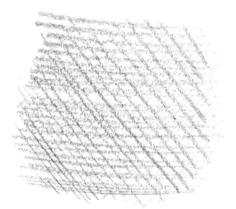

In crosshatching, subtle and intricate colour harmonies can be obtained by interweaving strokes of different colours.

STILL LIFE WITH IVY

Right: The objects in this still life were chosen for their interesting contrasts of texture, tone and pattern. The wicker basket was raised up on a pile of books, hidden by a cloth, so as to emphasize the graceful lines of the trailing ivy.

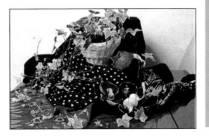

Materials and Equipment

• SHEET OF SMOOTH-SURFACED CARTRIDGE (DRAWING) PAPER •
GRAPHITE PENCILS: GRADES HB, 3H, 2H, B AND 2B • SOFT KNEADED PUTTY ERASER • CRAFT KNIFE • SANDPAPER BLOCK

1

Start by making sure all your pencils are sharpened to a fine point. Working on a sheet of cartridge (drawing) paper, lightly sketch the main outlines of the objects using an HB pencil.

2

Once you are satisfied with the composition, use a 3H pencil to tighten up and darken the outlines. Begin shading the dark patterning on the ivy leaves with parallel hatched strokes.

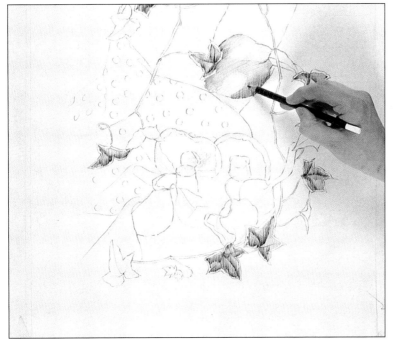

3

Continue building up the mid-tones with diagonal hatched strokes, using a 2H pencil for the lightest areas and a B pencil for the darker ones. Work on the onion with lightly hatched strokes of a 2H pencil. Strengthen the shadow at the base of the onion with crosshatched strokes of a B pencil.

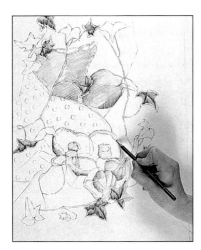

4

Lightly shade in the basket containing the pot of ivy with a 2H pencil. Then work on the lightest parts of the mushrooms and the garlic bulbs. Continue working all around the drawing so that you can judge the relative tones of neighbouring objects. Gradually you will see the contours emerge from the complex pattern of lights and darks.

5

Use a kneaded putty eraser, formed into a point, to lift out soft highlights such as those on the onion.

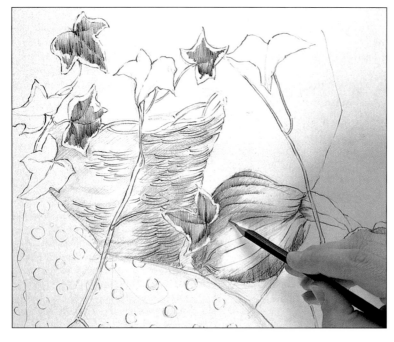

6

With a 2H pencil, suggest the texture of the wicker basket with dark, curved strokes, working on top of the lighter hatching. Draw the lines on the papery onion skin and begin working up the darker tones with further hatched strokes.

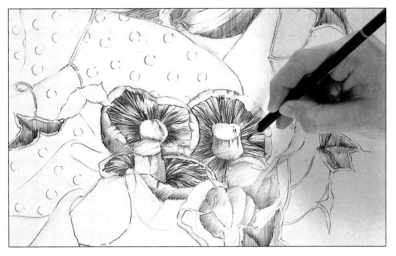

7

Draw the dark gills of the mushrooms with strong lines using a 2H pencil.

8

Indicate the form of the foreground drapery with vertical hatched strokes, using a B pencil for the lighter tones and a 2B for the darker ones. Vary the density of the lines and leave areas of paper untouched for the highlights and the white polka dots.

Fill in the dark backcloth with a 2B pencil. Lay down closely spaced parallel lines, working first in one direction and then going over them in another, until the required density of tone is achieved.

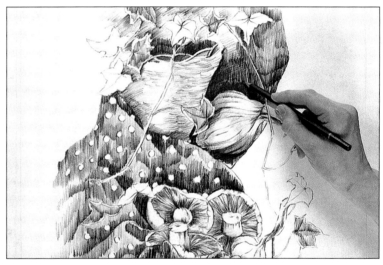

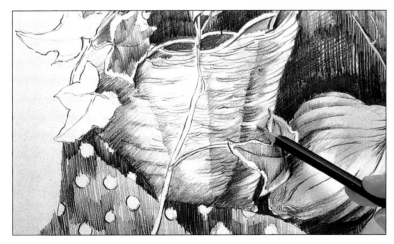

9

Finally, add further texture to the wicker basket with curved strokes using a 2B pencil.

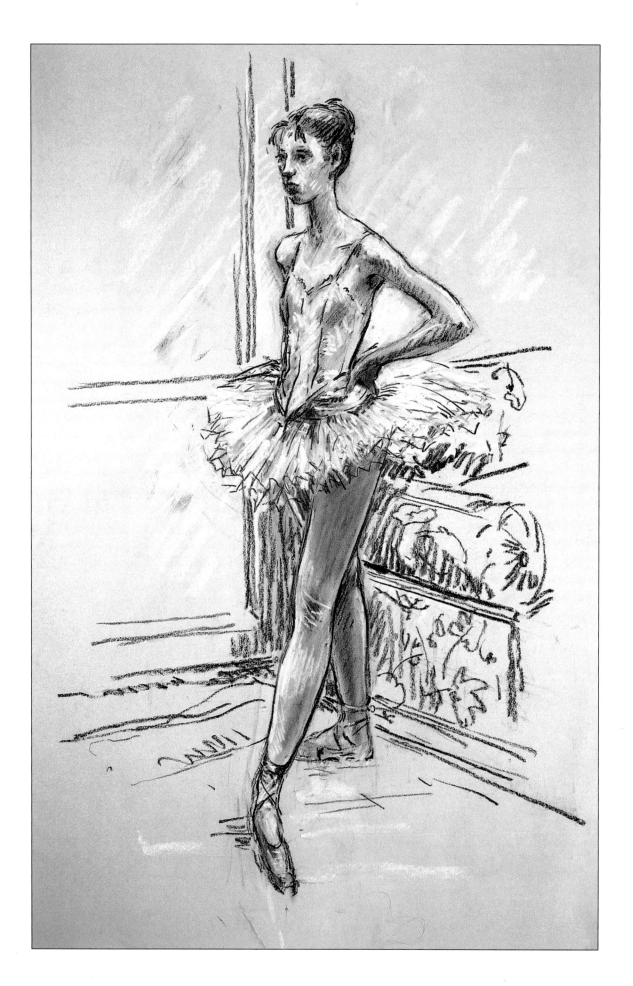

BLENDING WITH CHARCOAL AND CHALK

Charcoal and chalk are so immediate and responsive in use, they are almost an extension of the artist's fingers. Used together they give a full tonal range, from pale silver-grey to rich velvety black, and also a sensitive line. By varying the pressure on the charcoal stick it is possible to produce a wide range of effects, combining strong and vigorous linear work with delicate smudges.

In this lovely drawing of a dancer, the gesture of the pose is conveyed through the varying quality of the charcoal lines. A combination of smoothly blended tones and fine hatching describes the contours of the figure. The "lost and found" quality of the drawing retains a pleasing spontaneity.

Kay Gallwey
Ballet Dancer
79 x 53cm (31 x 21in)

BLENDING TECHNIQUE

One of the attractions of powdery media such as pastel, charcoal, chalks and crayons is that they are easily blended to create soft, velvety tones and subtle gradations from dark to light. The blending technique has many uses – in softening fine lines and details, suggesting smooth textures, modelling form with degrees of light and shade, lightening tones, and tying shapes together.

To create an area of blended tone, either apply lightly scribbled strokes with the point of the stick, or use the side of the stick to make a broad mark. Do not press too hard on the stick – if the mark is too ingrained it will be difficult to blend. Lightly rub the surface with a fingertip to blend and create an even tone. Repeat the process if a darker tone is required.

Colours or tones can be fused together softly by blending with a fingertip, or with rags, tissue, brushes or paper stumps (torchons). Depending on the subject, you can use purely blended tones or mix blended and linear tone techniques to add variety and texture. Another approach is to create an area of soft blending and then overlay it with linear strokes. Here, the blended tones act something like an underpainting, adding extra depth and subtlety to the drawing, while the strokes have the effect of tying the drawing together.

As a general rule, the smoother the surface of the paper, the easier it is to blend tones. On the other hand, a textured paper can actually enhance the blending effect, creating a more random, broken texture. The colour of the paper also plays an important part in the drawing. A light grey paper is a good choice for drawings in charcoal and chalk, making it easier to judge the light and dark tones against the mid-tone of the paper.

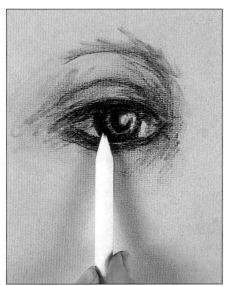

A paper stump (torchon) is useful for blending and darkening small areas and intricate shapes.

BALLET DANCER

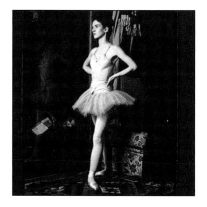

Left: The model is posed beside a window so that the light creates strong patterns of light and shade on the body. Because she is a dancer, she instinctively strikes a pose that is at once graceful and relaxed.

Materials and Equipment
• SHEET OF PALE GREY INGRES (CHARCOAL) PAPER • STICK OF CHARCOAL, MEDIUM THICKNESS • STICK OF WHITE CHALK OR CONTÉ CRAYON • SPRAY FIXATIVE

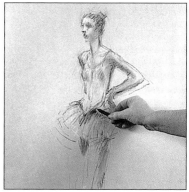

1

Use a craft knife to sharpen the charcoal stick to a point. Sketch out the figure with light, feathery lines, checking that the proportions are correct (see pages 20-21).

2

When you are satisfied with the proportions and the gesture of the figure, begin strengthening the charcoal lines, still working lightly. Block in the shadows on the thighs with light strokes smudged and softened with the finger. Suggest the tulle skirt of the dancer's tutu with light strokes of white chalk, and pick out the highlights on the legs.

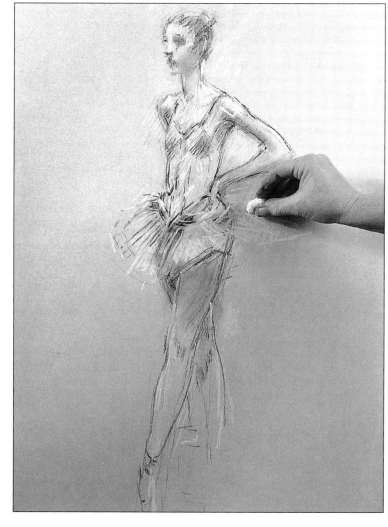

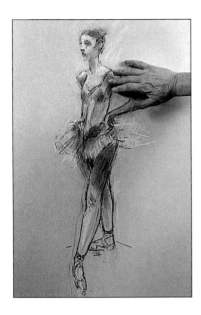

3

Define the forms of the arms and upper torso with more softly blended charcoal strokes. Strengthen the contours of the legs to convey the feeling of the model's weight resting on them. Lightly draw the model's ballet shoes.

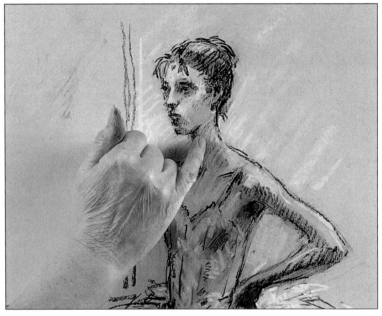

4

Sharpen the charcoal stick to a fine point and draw the model's hair and facial features. Indicate the shadow on the throat with charcoal, and the highlight running along the shoulder and the back of the neck with white chalk or conté crayon, blending the two tones together with feather-light strokes of a fingertip.

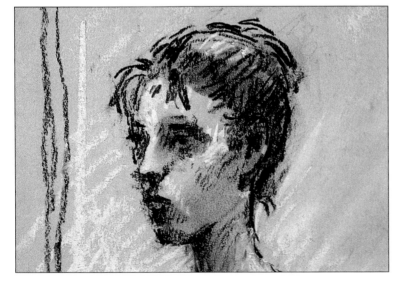

Left: The sheer poetry of the drawn line is demonstrated in this close-up detail of the head. The combination of softly blended tones overlaid with broken lines of charcoal and chalk suggests without overstating, and the marks themselves are beautiful in their own right.

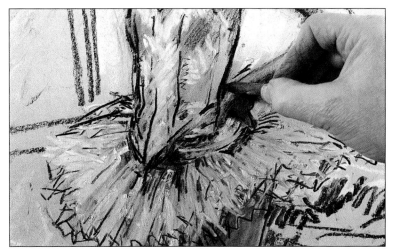

5

Continue to bring the drawing "into focus" by adding more linear details with both the charcoal and the chalk. Refine the texture of the tulle skirt of the tutu with semi-blended strokes of chalk and charcoal.

6

Complete the modelling of the legs with blended strokes of charcoal, overlaid with strokes of white to suggest the sheen of the dancer's tights. Finish off the ballet pumps, keeping the outlines soft and broken so that the feet appear to rest on the floor; tight outlines make the feet appear "cut out" from the background. Finally, sketch in just enough background detail to place the figure in context, without overwhelming the main subject. Spray the drawing with fixative to prevent accidental smudging.

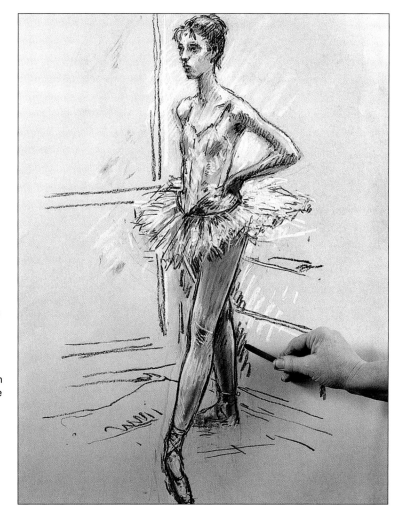

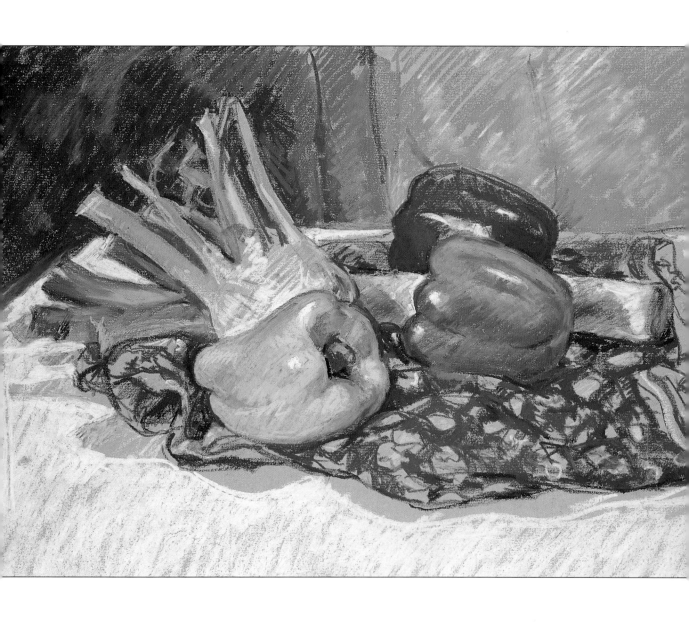

Technique

3

BUILDING UP

The vibrant colours and thick, buttery texture of oil pastels have been exploited to the full in this colourful group of vegetables arranged on a kitchen table.

Working with oil pastels is an exciting challenge. Because of their waxy texture, only a minimal amount of blending is possible so colour and form have to be built up in layers of hatched and crosshatched strokes to obtain solid areas of colour. To introduce textural variety and to prevent the drawing from appearing dense and overworked, the artist has left some areas in a fairly loose linear state, in contrast with the more solid areas of colour used, for example, on the peppers. Allowing the paper to show through helps to breathe air into the drawing, and in addition the cool, neutral tone of the paper becomes integrated into the composition, enhancing the bright colours of the subject.

~

Elizabeth Moore
Still Life with Peppers
33 x 43cm (13 x 17in)

~

THE BUILDING-UP TECHNIQUE

Most drawings – apart from quick sketches – have to be built up in stages, working from "the general to the particular". This applies particularly to pastels, oil pastels, charcoal and chalks, where the nature of the medium necessitates areas of colour being built up in several layers, one on top of the other. This is because powdery or waxy pigment tends to clog the surface "tooth" of the paper if applied too heavily in the early stages of a drawing, so that the surface becomes slippery and difficult to work on. To avoid this, it is best to start by working lightly and sketchily, feeling out the shapes and forms, and to work up gradually to thicker layers of colour. In the case of soft pastel and charcoal, it is helpful to fix the drawing at various stages with spray fixative so that further layers of colour can be built up without muddying those underneath (in the case of oil pastels, however, fixing is generally not necessary).

After sketching the outlines of the subject, block in the main colour areas lightly, either by scribbling with the point of the pastel stick or using it on its side to apply broad strokes. Continue adding further layers of colour, building up the density of pigment and intensity of colour required. To prevent the drawing from becoming too dense and overworked, it is advisable to allow the tone of the paper to break through the strokes in some areas.

Oil pastels are a bold, exciting medium, with an immediacy that makes them ideal for the inexperienced artist. Lack of confidence often makes beginners draw too tightly and meticulously and overwork their drawings. Working with a robust medium like oil pastels encourages a freer approach that will be of enormous benefit in developing greater confidence.

In fact, oil pastels are not suited to small-scale detailed work; the sticks are too chunky and fine blending is not possible. Far better to exploit the tactile qualities of the medium and work on a large scale using vigorous, textural strokes and building up a rich patina of waxy colour.

Break off a small piece of the pastel stick and use the side to build up thick, solid layers of colour.

STILL LIFE WITH PEPPERS

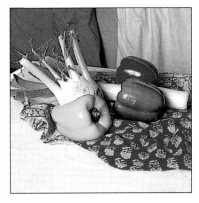

Left: A group of vegetables makes an excellent subject for a still-life study. This combination of a leek, a bulb of fennel and three peppers was chosen for the exciting contrasts of shape, colour and texture it contains.

Materials and Equipment

- SHEET OF NEUTRAL GREY CANSON PASTEL PAPER • OIL PASTELS: CADMIUM RED, OLIVE GREEN, WINSOR BLUE, COBALT BLUE, ALIZARIN CRIMSON, WHITE, LEAF GREEN, RAW UMBER, LEMON YELLOW, CADMIUM YELLOW, YELLOW OCHRE AND CERULEAN

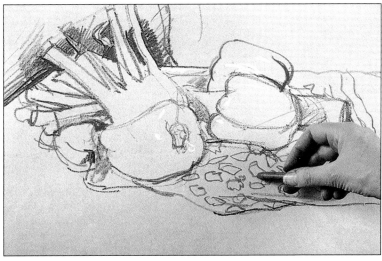

1

With the point of the pastel stick, draw in the outlines of the vegetables using cadmium red for the red pepper and olive green for the remaining vegetables. Sketch the folds and pattern of the red cloth with cadmium red and suggest the dark blue background cloth with Winsor blue. Draw the lines lightly, feeling around the objects, correcting a shape by re-drawing it. Any unwanted lines will be obliterated later by thick strokes of oil pastel.

2

Sketch in the light blue background cloth with loose strokes of cobalt blue. Begin to build up the colour of each vegetable with fairly dense strokes. For the red pepper use cadmium red, darkening the shadow areas with alizarin crimson. Merge the two tones of red together by overlapping the strokes and smudging them with a fingertip. Apply thick strokes of white for the shiny highlights.

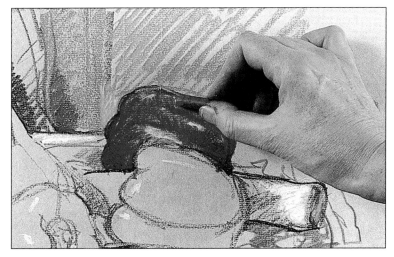

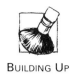
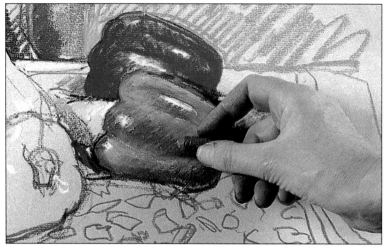

3

Build up the green pepper using leaf green for the light parts and olive green for the darks. Add white for the highlights, and again smudge some of the tones together with a fingertip to suggest the bulbous form of the pepper.

4

Use semi-blended strokes of white, leaf green and raw umber for the stalk of the leek. Begin to build up the form of the yellow pepper with dense strokes of lemon yellow, allowing areas of the paper to show through between the patches of colour.

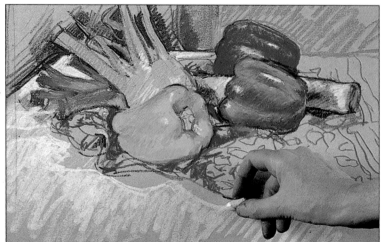

5

Complete the yellow pepper, building up layers of hatched lines and smudged colour. Use lemon yellow for the light tones, overlaid with cadmium yellow for the mid-tones and yellow ochre for the deepest shadows. Begin blocking in the foliage on the leek and fennel with mixtures of olive green and leaf green. With a white crayon, roughly hatch in the white table cloth, leaving patches of untouched paper to convey the shadow cast by the red patterned cloth.

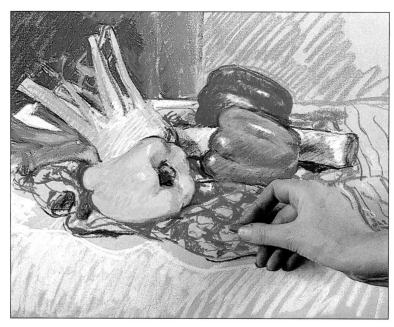

6

Draw the stalk of the yellow pepper with olive green and raw umber. Continue to relate the still life to its background by deepening the tones on the dark blue backcloth with further strokes of Winsor blue and cobalt blue. Fill in the pattern on the red cloth with cadmium red, alizarin crimson and cadmium yellow.

7

Continue to refine the drawing, observing the play of light on the forms, altering the tones and intensities of the colours where necessary. Finish off the light blue backcloth with strokes of cerulean blue partially blended with white.

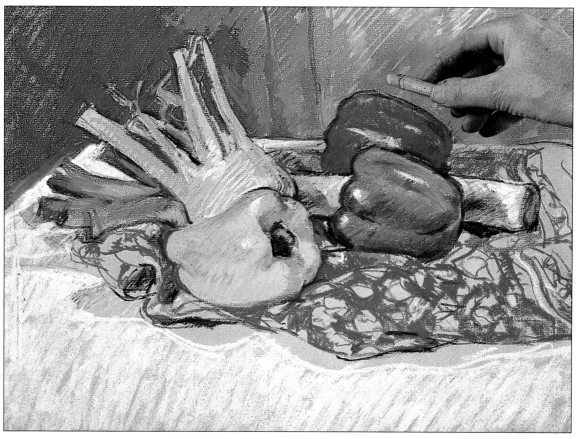

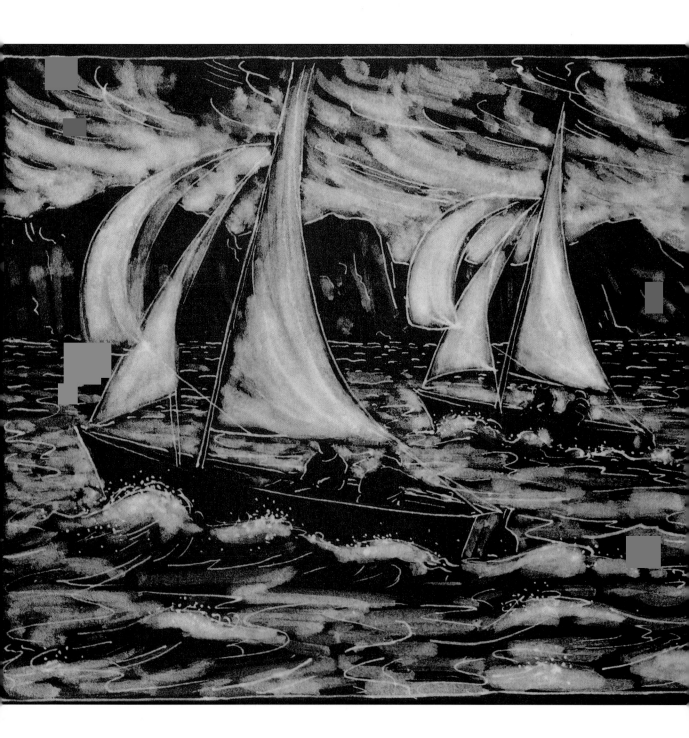

Technique

4

THE BLEACH-OUT TECHNIQUE

In the unusual and exciting technique known as bleach out the image is "drawn" onto a background of black ink using ordinary household bleach. This produces an effect closely resembling a sepia print, and bleach-out drawings are full of mood and atmosphere.

The bleach-out technique is suitable for almost any subject, but an image with strong tonal and textural contrasts gives the most effective results. In this drawing of two racing yachts, the strong light-and-dark contrasts and the sweeping shapes of the sails, waves and clouds convey the exhilarating nature of the scene.

Ted Gould
Yachts
20 x 23cm (8 x 9in)

USING THE BLEACH-OUT TECHNIQUE

Bleach out is a "negative" method of drawing in that a light image is drawn onto a dark background, as opposed to the more conventional "positive" drawing methods in which dark lines are drawn on a light background. It is a simple technique, requiring the minimum of materials, yet it produces striking effects unobtainable with any other medium.

All you need is a sheet of fairly heavy cartridge (drawing) paper or Bristol board, some black fountain pen ink and almost any type of improvised tool with which to draw the image in bleach on the ink. Cotton buds (swabs) are excellent for making a range of dabs and strokes, and dip pens for lines and fine details. Sable brushes should not, however, be used as the bleach would perish or dissolve the hairs.

Start by applying a coat of black fountain pen ink over the entire picture area (two coats provide greater density and contrast). It is important to use fountain pen ink – the technique will not work successfully with water-soluble ink, or with waterproof Indian ink. When the ink is completely dry, use a white conté crayon to sketch the main outlines of the image.

Pour a little household bleach into a small glass jar, then dip your chosen drawing implement into it and lightly "draw" the areas that are to be the lightest tones in the image. You may find it useful to lay a sheet of paper beneath the area you are working on, to prevent smudging the conté drawing and also to catch any accidental drips of bleach.

Where the bleach is applied, it dissolves the ink, but the light areas do not appear white as you might expect; they are a very attractive warm sepia colour. By applying the bleach lightly at first, then more heavily, a range of subtle tones can be built up. If you do unintentionally obliterate an area with bleach, you can re-touch it with ink.

Before embarking on your first bleach-out drawing, spend some time considering the end result. Make a pencil sketch, indicating the placing of tones and masses. This will help you to decide where the darks, mid-tones and lights are to be.

Note: *When using bleach, take care not to get any on your skin or in your eyes, and work in a well-ventilated room.*

Drawings of great tonal and textural beauty can be achieved with the bleach-out technique. This drawing is based on Monet's painting, Grain Stacks, End of Summer, Morning Effect, *(1891).*

YACHTS

Right: A photograph from an old sailing book provided the reference for this drawing.

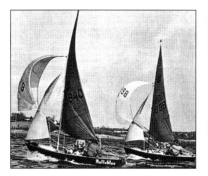

Materials and Equipment

• SHEET OF CARTRIDGE (DRAWING) PAPER OR BRISTOL BOARD • LARGE FLAT WATERCOLOUR BRUSH • BLACK FOUNTAIN PEN INK • WHITE CONTÉ CRAYON • HOUSEHOLD BLEACH • SMALL GLASS JAR • COTTON BUDS (SWABS) • DIP PEN WITH FINE NIB

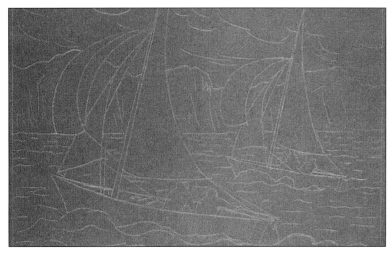

1

With a large flat watercolour brush, lay an even wash of black fountain pen ink all over the picture area. Leave to dry. Then apply a second coat and leave to dry thoroughly. Applying light pressure, draw the outlines of the image directly onto the black ink with white conté crayon. If you make a mistake, the lines can be erased by rubbing with a fingertip or a soft eraser.

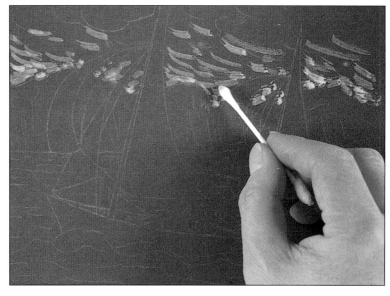

2

Pour a little household bleach into a small glass jar. Dip a cotton bud (swab) into it and begin "drawing" the clouds with small, curved strokes. Be careful not to use too much bleach at this stage.

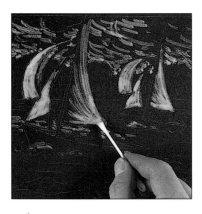

3

Still using bleach applied with a cotton bud, begin blocking in the sails of the two yachts. Apply the bleach gradually with light strokes to build nuances of light and shade.

4

Now indicate the waves with small, undulating strokes. Use a fresh cotton bud if you find the first one is beginning to disintegrate.

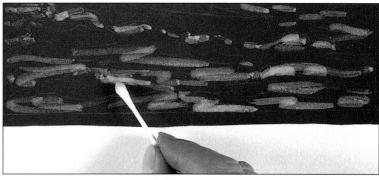

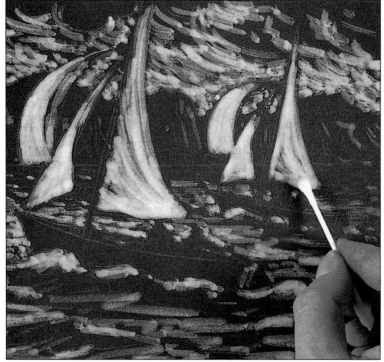

5

Work into the drawing to strengthen the shapes and lighten the tones of the clouds and the sails. Use bolder strokes now, but develop the whole image gradually rather than completing one area and then moving on to the next; this way, there is less danger of any one element "jumping out" because you have applied too much bleach.

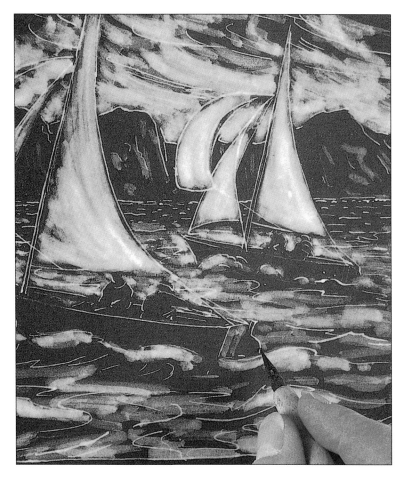

6

Dip the pen nib into the bleach and begin to strengthen the image with linear details. Suggest the craggy outlines of the cliffs in the background, then add linear detail to the yachts and the figures. Then add some sweeping, curving strokes to the sky and water to accentuate the movement of the clouds and waves. These lines provide an effective contrast with the broadly tonal areas.

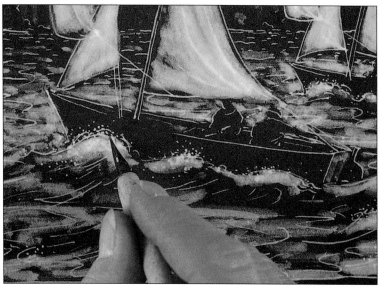

7

Finally, use the point of the pen nib dipped in bleach to add tiny stippled dots around the waves lapping along the hulls of the yachts. This suggests flecks of foam and enhances the impression of movement.

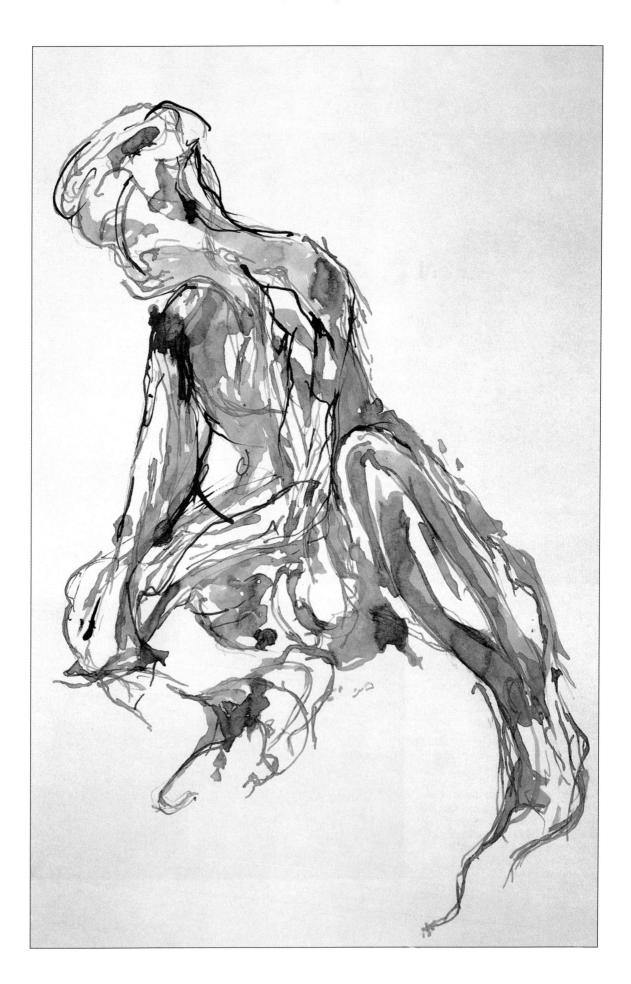

LINE AND WASH

Leonardo da Vinci wrote of drawing as the equivalent of a rough draft of a poem, all the more fertile for being incomplete. Certainly an image which suggests, rather than overstates, lives on in the memory for the simple reason that the viewer actively participates in it, supplying the "missing" elements from his or her own imagination.

In this vigorous line-and-wash study of a male nude, the artist has combined lively brushwork and fluid ink washes with crisp linear marks drawn with a reed pen. Line-and-wash drawings are highly expressive, suggesting more than is actually revealed. The secret is to work rapidly and intuitively, allowing the washes to flow over the "boundaries" of the drawn lines and not be constricted by them.

Hil Scott
Male Nude
51 x 38cm (20 x 15in)

USING LINE AND WASH

Drawing with pen, brush and ink is an exciting fusion of drawing and painting. The combination of crisp, finely drawn lines and fluid washes has great visual appeal, capturing the essence of the subject with economy and restraint.

The traditional method is to start with a pen drawing, leave it to dry and then lay in light, fluid washes of ink or watercolour on top. Alternatively, washes can be applied first to establish the main tones and the ink lines drawn on top when the washes have dried. The most successful method, however, is to develop both line and tone together so that they emerge as an organic whole.

It is worth experimenting with a range of pens and brushes to discover which ones are best suited to your style of drawing. Dip pens, quill pens and reed pens produce very expressive lines which swell and taper according to the amount of pressure applied to the pen. In contrast, modern technical pens produce thin, spidery lines of even thickness which are suited to a more controlled, graphic style of drawing.

Watercolour brushes can be used both for drawing lines and for laying washes. Avoid using small brushes – large brushes discourage tight, hesitant lines. Bamboo-handled oriental brushes can be bought in most art supply stores. They are very soft and flexible and their long bristles hold a lot of ink and produce expressive, flowing strokes.

It is important to choose the right type of ink for drawing the lines. If you want to overlay washes without dissolving the drawn lines, choose Indian ink, which is waterproof. If you want greater flexibility to be able to dissolve and blend some of the lines, choose a soluble ink such as Chinese (drawing) ink, which is also more delicate than Indian ink.

MALE NUDE

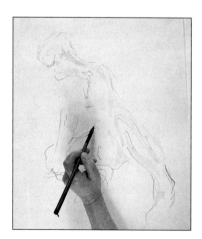

1

In a mixing palette or four small jars, mix four tones of black Chinese (drawing) ink, ranging from extremely diluted to full strength.

Working directly on the paper, suggest the overall pose of the model with gestural lines using the reed pen and the medium-light tone of ink. Work quickly and use a very light touch, referring constantly to the model. Load the oriental brush with the lightest tone of ink and begin suggesting the shadowed parts of the body.

2

Build up on the original framework
of the drawing by using the brush
and pen together to reinforce the
lines and tones using the medium-
light tone of ink. Still referring
constantly back and forth to the
model, concentrate on the major
shadows, leaving areas of
untouched paper to serve for the
highlights.

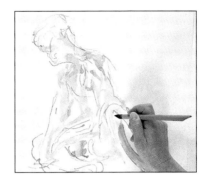

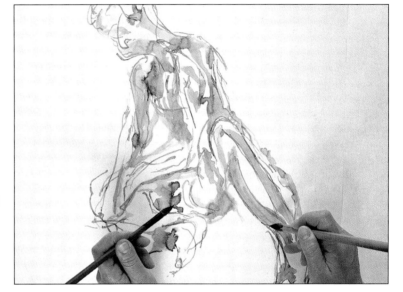

3

Continuing to work very fast,
strengthen the darker shadows on
the body with the medium-dark tone
of ink, again bringing the lines and
tones along at the same time. Here
you can see the artist, who is
ambidextrous, working with the
brush in one hand and the pen in
the other.

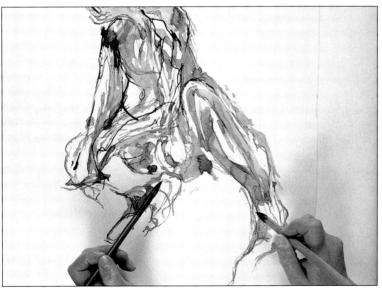

4

Add further washes of medium-dark
tone with the brush to enhance the
muscular forms of the body further.
Dip the pen in the darkest tone of ink
and reinforce the gesture and feel of
the pose with further lines. Here, for
example, dark lines emphasize the
tension of the muscles of the
shoulders and the back of the neck,
and the weight of the arms pressing
down on the knees.

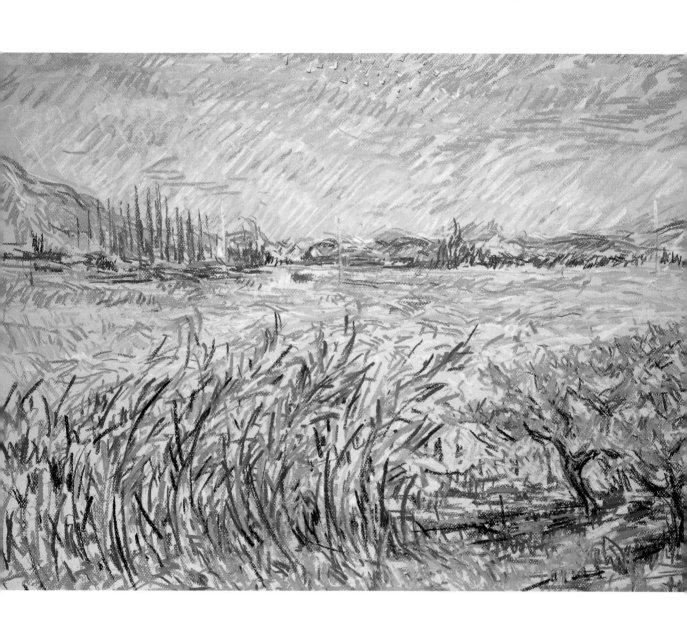

Technique
6

BROKEN COLOUR

In 1888 Vincent van Gogh settled in Arles in southern France, where he drew and painted many landscapes. Since then generations of artists have followed in his footsteps, inspired by the clear light and vibrant colours to be found in this particular region.

In this pastel drawing, the artist's use of pure, unmixed hues and exuberant line work is vividly descriptive of the Provençal countryside under the fierce southern sun. The artist has used a pale, cream-coloured paper, its luminosity playing a crucial role in creating the illusion of intense light. The warm, creamy ground and the cool blues in the sky, for example, enhance each other optically, to give an ethereal, airy quality which aptly evokes the subject.

Kay Gallwey
Provençal Landscape
53 x 74cm (21 x 29in)

USING BROKEN COLOUR

The term "broken colour" refers to a method of building up areas of tone or colour with small strokes and dabs of pure colour which are not joined, but leave some of the toned paper showing through. When seen from a normal viewing distance, these strokes appear to merge into one mass of colour, but the effect is different from that created by a solid area of smoothly blended colour. What happens is that the incomplete fusion of the strokes produces a flickering optical effect on the eye; the colours scintillate and appear more luminous than a flat area of colour.

This technique is usually associated with the French Impressionist painters, who were the first to exploit its full potential. The Impressionists were fascinated by the effects of light and found that using small, separate strokes of colour was an ideal way to capture the shimmering quality of the bright sunlight of southern France.

Pastels are particularly suited to the broken colour technique because of their pure, vibrant hues and ease of manipulation. However, it is advisable to keep to a fairly limited palette of colours so as to achieve an overall harmony rather than a discordant hotch-potch of colours. In addition, the colours must be close in tone, otherwise the shimmering effect of light is lost.

In the project drawing, for example, most of the colours are light and bright, and even the darkest areas are relatively light in tone. The colour of the paper also contributes to the finished effect, appearing between the broken strokes of pastel and providing a harmonizing element.

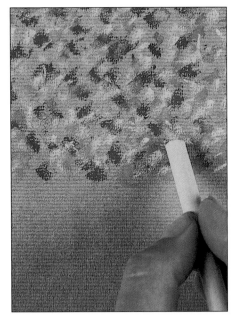

Pointillism is another broken colour technique, often used in pastel and coloured pencil drawings. Separate colours are applied as small, closely spaced dots which blend optically and create a sparkling web of colour.

BROKEN COLOUR

PROVENÇAL LANDSCAPE

1

It is best to avoid drawing a pencil outline of the composition as this could have an inhibiting effect. Simply plot the main elements with a few sketchy marks using the appropriate colours for each area of the landscape.

Materials and Equipment

• SHEET OF CREAM-COLOURED CANSON PAPER • SOFT PASTELS: BLUE, GREEN, RED, ORANGE, PINK, BROWN, YELLOW AND PURPLE, EACH IN A RANGE OF DARK AND LIGHT, COOL AND WARM HUES • SPRAY FIXATIVE

2

Begin building up the tones and colours with separate strokes. Work all over the picture with light strokes so that you can build up further layers later without clogging the surface of the paper.

Indicate the sky with loosely hatched strokes of pale blue, the background hills with cool blues and greens and the rice fields with reds and oranges. Use stronger, darker colours in the foreground: blues, pinks and greens for the foreground weeds, and even darker greens and blues for the olive bushes on the right of the picture.

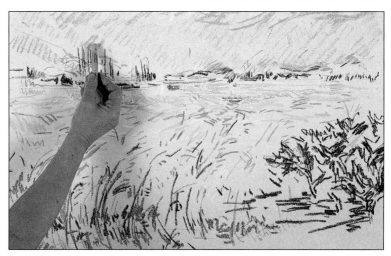

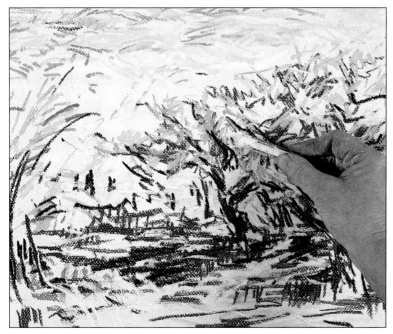

3

Continue laying down strokes of colour, blending them slightly in places but leaving most of them separate. Develop the olive bushes, using dark browns and blues for the trunks and branches. Suggest the foliage with small, scribbled strokes of dark, medium and light green. For the shadows cast by the bushes, use broken, horizontal strokes of dark blues intermixed with pale yellow to indicate reflected light.

61

4

Develop the foreground weeds with curving, sinuous strokes of green, blue, pink and purple, still leaving plenty of the paper's colour showing through. Here you can see how the pastel marks are broken up by the paper's texture, adding to the overall sense of movement.

5

Returning to the sky area, build up a web of loosely hatched strokes, again letting the cool tone of the paper show through. To suggest the shimmering light of the sky, use overlaid strokes of two blues that are similarly pale in tone; here the artist is using phthalocyanine blue, which is cool, and ultramarine, which is warm.

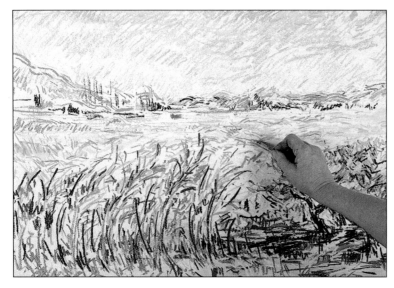

6

Continue working all over the picture with separate strokes of colour that curve to follow the forms. Here the rice fields in the middle distance are being developed with strokes of reds, yellows and oranges. Indicate the tractor in the distance with a tiny stroke of bright red.

7

Work on the hills and trees in the distance with cool blues and greens. Cool colours tend to recede, whereas warm colours come forward, so by using cool colours in the background and warm colours in the foreground, it is possible to create a sense of distance in the landscape. This principle is known as atmospheric perspective.

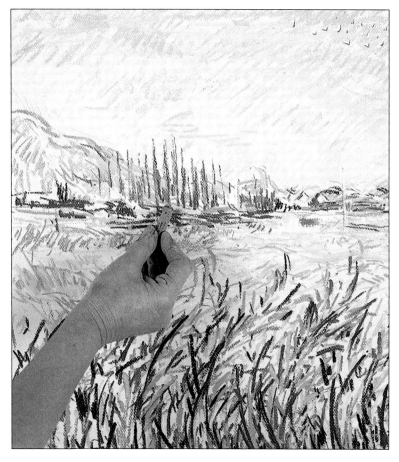

8

Finally, add a few strokes of dark blue-grey in the foreground weeds to give them definition and bring them forward in the picture plane. Because pastel is a powdery medium, the completed drawing should be sprayed with fixative.

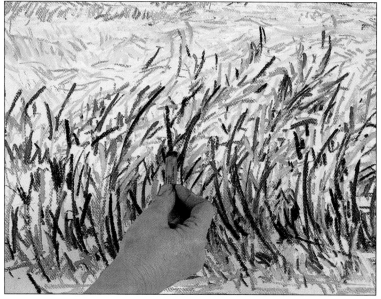

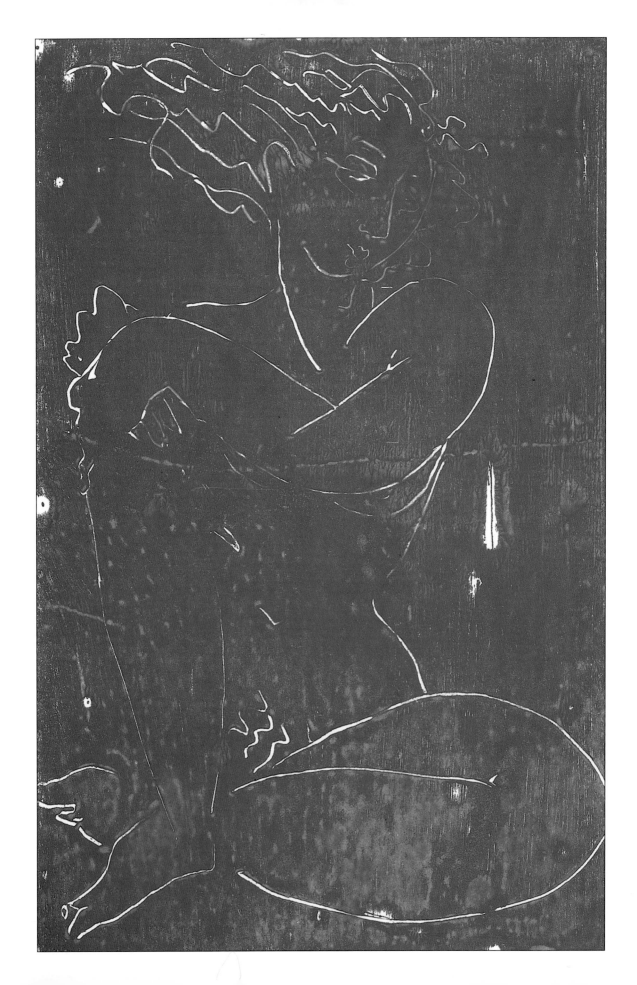

Technique

7

MAKING A MONOTYPE

Monotyping is a fascinating technique which crosses the boundaries between drawing, painting and print-making. It was widely used by the Impressionist painter Edgar Degas as a basis for his pastel paintings. Monotyping is very effective when used as a direct drawing technique; because it is so immediate, it encourages you to lose your inhibitions and draw with a loose, fluid action.

This figure study recalls the drawings of Henri Matisse with its decorative, elegant lines. The artist drew into the paint with a fingernail, making long, sweeping lines that follow each subtle change in the contour of the figure.

Kay Gallwey
Female Figure
58 x 41cm (23 x 16in)

MONOTYPE TECHNIQUES

Whereas other printing methods can produce a "run" of several identical prints, a monotype is a one-off print, so in fact it is more of a drawing than a printing technique. You can create a single monotype quickly and simply, using the minimum of equipment.

There are three basic methods of monotyping. For the first you need a smooth, non-absorbent surface such as a thick piece of glass or a metal plate, at least as large as the intended print. Draw directly onto this surface using oil paint or printing ink (thicker and more like a paste than drawing ink). Then place a sheet of paper on top of the drawing and press with a hand roller, the palm of your hand or a rag dampened with turpentine. Remove the paper carefully to reveal a reverse impression of the drawing on the chosen surface.

The second method is similar to the first, except that the chosen surface is completely covered with a smooth layer of ink or paint and drawn into to create a "negative" image. Any tool that comes to hand can be used for this – a brush, a clean rag, a piece of cardboard, even a fingernail. This is the method chosen for the project described on these pages.

The third method works rather like a carbon copy. Place a sheet of paper over the inked surface and make a line drawing on the top surface of the paper using a sharp implement such as a ballpoint pen or a hard pencil. When you lift the paper, the inked image is "printed" on the reverse side.

This technique works best with a subject which has strong, organic shapes. A figure study is an ideal choice, as are flowers, trees, animals, skies and water. When you draw into the ink, make the lines bold and clear-cut to compensate for the fact that some of the ink closes over the lines when the paper is being rubbed to transfer the image. Try to work on a fairly large scale, because the movement of the hand must not be restricted – draw with strong, sweeping movements from the elbow or shoulder.

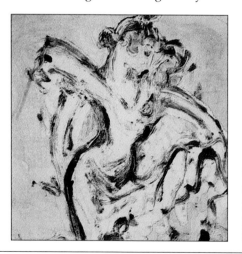

This is an example of a "positive" monotype, in which the image is painted on a glass slab with printing ink or oil paint. A print is taken by laying a sheet of paper over the slab and by gently rubbing the back of the paper with the hand.

FEMALE FIGURE

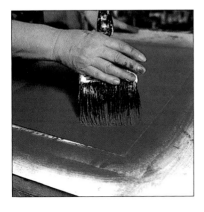

Squeeze out about 2.5cm (1in) of cobalt blue printing ink onto the printing surface, mixing it with a little turpentine to make it more malleable. Use a lino-cutting roller or a large decorator's brush to spread the ink over the printing surface. The ink dries quite quickly, so complete this initial stage as fast as you can.



Materials and Equipment

• SHEET OF GLASS OR SMOOTH METAL AT LEAST AS LARGE AS THE INTENDED PRINT • COBALT BLUE PRINTING INK OR OIL PAINT • LINO-CUTTING ROLLER OR LARGE DECORATOR'S BRUSH • SCRAP PAPER • SHEET OF THIN CARTRIDGE (DRAWING) PAPER • COTTON RAG • TURPENTINE OR WHITE SPIRIT (PAINT THINNERS) • MASKING TAPE



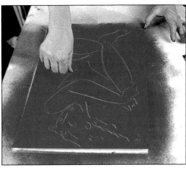

Blot off any excess ink by laying a piece of scrap paper on the surface and rubbing the back of it. Select a pointed instrument to draw with – you can even use a fingernail – and make your drawing directly on the inked surface.

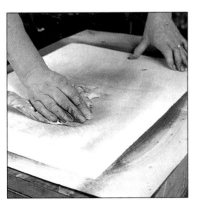

To print the image, carefully lay a thin sheet of cartridge (drawing) paper over the inked surface, avoiding any movement once the paper has touched the surface. Force the ink into the paper by rubbing the back of it with a rag dampened with turpentine.

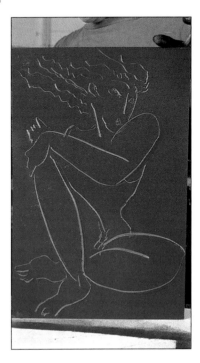

Carefully peel the print away from the surface by lifting it slowly from one corner. Attach it to a board with masking tape and leave to dry. The finished monotype has the vigour and spontaneity of a direct sketch, yet it also contains graphic qualities found only in a print.

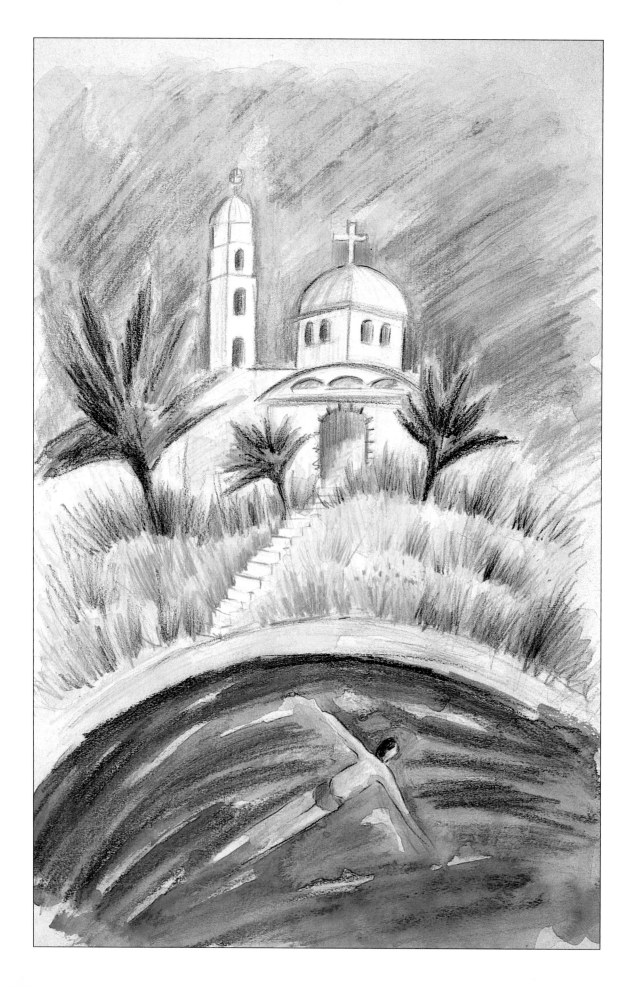

USING WATER-SOLUBLE PENCILS

There is a wide range of coloured pencils and crayons on the market, and in recent years this medium has become increasingly popular with fine artists as well as graphic designers. Water-soluble pencils, which can be used as both a drawing and a painting medium, are clean, quick and portable, and ideal for outdoor sketching.

In keeping with the Mediterranean subject, this water-soluble pencil drawing of a garden in Greece plays sunshine yellows against clear blues to produce a vibrant effect. Multi-layered washes and strokes are used to develop form and texture.

Annie Wood
The Pool
48 x 33cm (19 x 13in)

How To Use Water-Soluble Pencils

Water-soluble pencils are a cross between coloured pencils and water-colour paints. You can apply the colour dry, as you would with an ordinary coloured pencil, and you can also use a soft watercolour brush dipped in water to loosen the pigment particles and create a subtle water-colour effect. When the washes dry, you can then add further colour and linear detail using the pencils dry again. This facility for producing tightly controlled work and loose washes makes water-soluble pencils very flexible.

After lightly applying the required colours with hatched strokes, work over the colours with a soft brush and a little clean water to blend some of the strokes and produce a smoother texture. (This takes a little practice; if you use too much water the paint surface will become flooded and blotchy; too little will not allow for sufficient blending of the colours.) The water will completely dissolve light pencil strokes, blending the colour until it looks similar to a watercolour wash. Heavy pencil strokes will persist and show through the wash.

Apply the water gently – do not scrub at the paper with the brush as you want to keep the colours fresh and bright. Rinse the brush every now and then to make sure you are working with clean water, otherwise the colours may become tainted.

Interesting textures can be created by building up the picture with multiple layers of dry pigment and water-dissolved colour. When adding dry colour over a dissolved base, however, the paper must first be completely dry; if it is still damp, it will moisten the pencil point and produce a blurred line, and it may even tear.

Suitable surfaces for water-soluble pencil work are either a smooth illustration board, or a good-quality watercolour paper or medium-grain drawing paper, which should be stretched and taped to a board first.

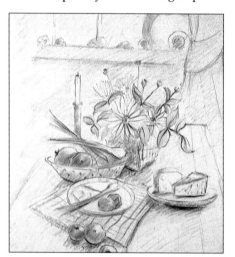

Water-soluble pencils have a freshness and delicacy that is ideally suited to a subject such as this still life, softly lit by the morning sun.

THE POOL

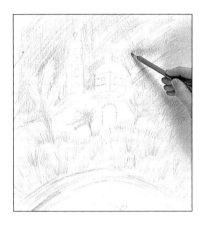

1

Lightly indicate the main elements of the composition with a soft pencil. Fill in the sky area with loosely hatched diagonal strokes of pale blue pencil, leaving some of the white paper showing through. Work lightly to avoid making any hard line. Use a warm yellow pencil for the palm trees and grasses, using upward flicking strokes.

Materials and Equipment

• SHEET OF 300GSM (140LB) NOT (COLD-PRESSED) SURFACE WATERCOLOUR PAPER, STRETCHED • SOFT PENCIL • WATER-SOLUBLE COLOURED PENCILS: PALE BLUE, WARM YELLOW, DARK BLUE, LIGHT GREEN, DARK GREEN, PINK, PURPLE, ORANGE, LIGHT OCHRE, VIOLET, BLUE-GREEN AND DARK BROWN • MEDIUM-SIZED ROUND WATERCOLOUR BRUSH

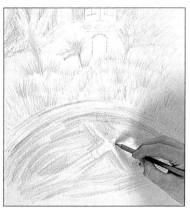

2

Suggest the water in the pool with light strokes of pale blue, again leaving plenty of white paper showing through. Vary the direction of the strokes to suggest the movement on the water's surface created by the swimming figure.

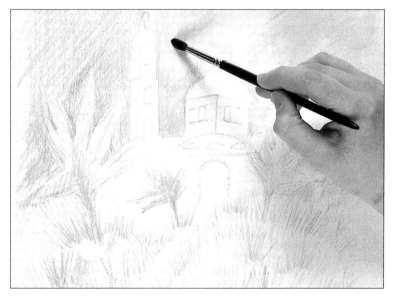

3

Load a medium-sized round brush with water and work it lightly over the sky area to soften and partially blend the pencil lines. Use sweeping, diagonal strokes to give a sense of movement to the sky.

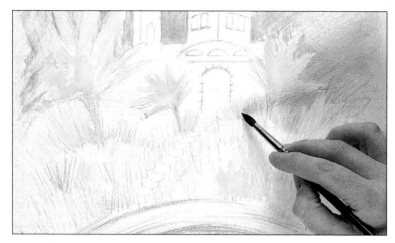

4

Rinse your brush, then apply water to the trees and grasses to blend some of the pencil strokes and create a smoother texture. Don't worry if some of the yellow wash runs into the sky area – it will mix with the blue and form green, giving a suggestion of more foliage in the background. Leave to dry.

5

When applying the water, work lightly across the drawn lines without rubbing too hard. This releases just enough colour to produce a light wash which does not completely obliterate the linear pencil strokes.

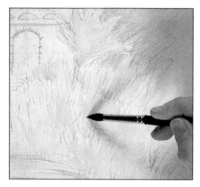

6

Work back into the sky with further diagonal hatched strokes of both pale and dark blue, leaving some areas of wash untouched. With the dark blue pencil, firm up the water with vigorous directional strokes that follow the curved form of the pool. Leave some patches of pale blue to indicate the highlights on the water's surface.

7

Work into the trees and grasses with short, upward flicking strokes of light and dark green. Also add touches of pink, purple and orange to add colour interest and give a suggestion of heat and bright sunlight. Block in the figure's skin tone with a light ochre pencil, and his swimming trunks with pink. Add further washes of water to pick up and dissolve some of the colour in the pool.

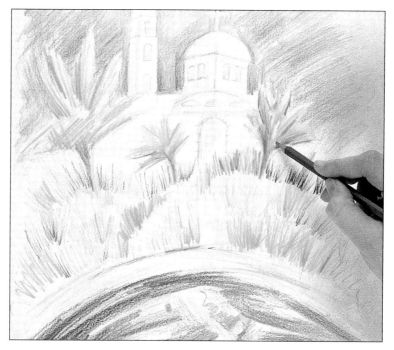

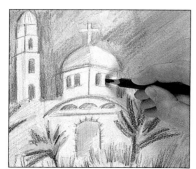

8

Add strokes of dark green to the palm trees and grass. Strengthen the detail on the church, blocking in the door, the windows and the shadows on the walls with strokes of pink and yellow. Then darken the door and windows with overlaid strokes of dark blue and violet.

9

Darken the water with broad strokes of blue-green, wetting some of the strokes to create a sense of movement on the water's surface. Leave to dry, then block in the swimmer's hair with dark brown. Finally, strengthen the outline of the figure with a dark blue pencil.

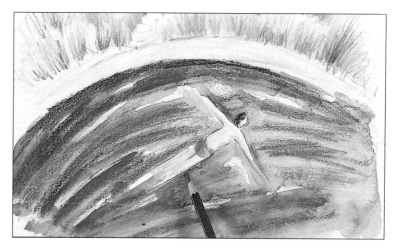

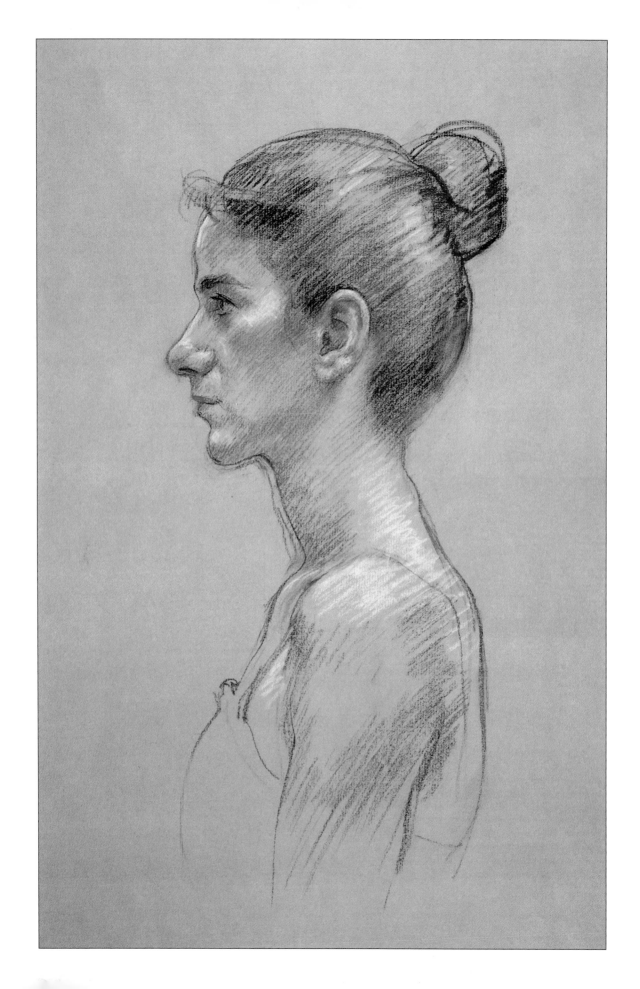

Technique

9

DRAWING ON TINTED PAPER

A drawing done in pastel or conté crayon on tinted paper is very much a marriage of medium and paper. Because areas of the tinted paper show through the drawn marks they play a key role in the overall colour scheme; thus the paper and the drawn lines work in tandem, creating an exciting fusion of texture and colour.

This study of a head in profile was drawn in conté crayon on a warm buff-coloured paper. The paper creates the mid-tones, while the form of the head and shoulders is modelled with hatched strokes, using earth colours for the darks and white for the highlights. Because the paper itself acts as the mid-tone for the skin and hair, the artist needs only a few colours to build up a fully developed portrait.

Elizabeth Moore
Head Study
51 x 33cm (20 x 13in)

USING TINTED PAPERS

There are two ways in which a tinted paper surface can function in a drawing. The first is as a mid-tone, from which the artist can assess extremes of light and shade. The second is as a unifying element, its colour linking the various areas of the composition to form a unified image.

Drawing papers come in such a wide range of colours that it can be difficult to choose the best one for your needs. Start by deciding whether you want the paper's colour to harmonize with the subject or to provide a contrast. Then decide whether the colour should be cool, warm or neutral. For example, artists often favour a paper with a warm earth colour to accentuate the cool greens of a landscape, or a neutral grey paper to enhance the bright colours of a floral still life. Finally, decide whether you want a light, medium or dark-toned paper. In general, mid-toned papers give the best results. They allow you to judge both the light and dark tones in your drawing accurately, and they provide a quiet, harmonious backdrop to most colours. It is generally best to avoid strongly coloured papers since they will fight with the colours in the drawing. If you are in any doubt, choose muted colours such as greys, greens and browns.

Conté crayons are similar in effect to charcoal but they are harder and therefore can be used for rendering fine lines as well as broad tonal areas. Although conté crayons are now available in a wide range of colours, many artists still favour the restrained harmony of the traditional combination of black, white and the three earth colours – sepia, sanguine and bistre. These colours, with their warm, tender and soft tones, are especially suited to portrait and figure drawings. Expressive lines can be drawn with the crayon point while varied tones are possible using the side of the crayon, thus providing an exceptional way of suggesting form, light, colour and volume. The traditional colours also give an antique look reminiscent of the chalk drawings of Leonardo da Vinci, Michelangelo, Rubens and Claude.

This cloud study is worked in chalk on tinted paper. The paper forms a useful mid-tone from which to work up to the lights and down to the darks.

HEAD STUDY

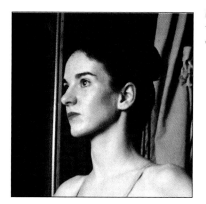

Left: Strong directional light coming from the left of the model helps to describe the volumes of the head.

Materials and Equipment

• SHEET OF BEIGE CANSON PAPER • CONTÉ CRAYONS: SEPIA, INDIAN RED, WHITE, RAW UMBER AND BLACK • SPRAY FIXATIVE

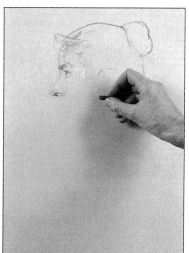

1

Using the sepia crayon, start by sketching the main outlines of the head and positioning the features. Use light, feathery strokes so that you can build up the darker tones later without clogging the surface of the paper.

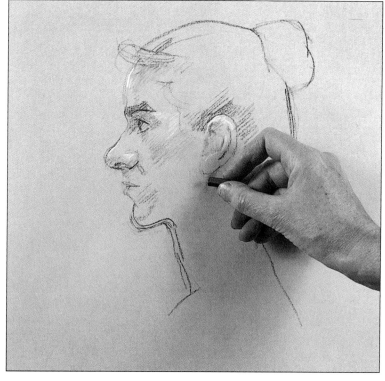

2

Continue to define the head and features and the line of the neck and shoulders. To establish the main planes of the face, begin shading in the darkest tones with light hatching, using the sepia crayon. Indicate the mouth and cheeks with Indian red.

3

Continue defining the tones and colours on the face with sepia and Indian red. Indicate the highlights on the forehead, upper cheek and chin with white. Use stronger tones of sepia and Indian red to model the inner ear. Build up the shadowed areas of the hair with overlapping strokes of sepia, allowing the buff paper to show through. This shading helps to define the underlying form of the head. Hatch in the shadow on the neck.

4

Strengthen the modelling on the face and neck with fine hatching to produce carefully graded tones. Use sepia, raw umber and Indian red for the shadows and white for the highlights. As you draw, constantly relate shapes and volumes to one another rather than drawing one part in detail and then moving on to the next. Use stronger tones of sepia and Indian red to model the inner ear, and solid strokes of white for the highlights. Darken the hair with strokes of black.

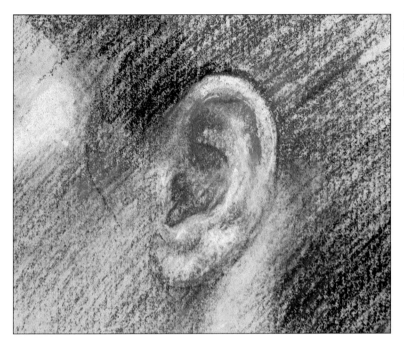

Left: The whorls and curves of the ear are quite complex, but the trick is to render them as simply as possible, paying close attention to the shapes of the shadows and highlights.

5

Briefly sketch in the shadows and highlights on the neck and shoulders with sepia and white. The head is more fully modelled as this is the focal point of the picture.

Observe how the tinted paper shows through the drawing in places, suggesting the mid-tone between dark and light. These patches of bare paper also help to breathe air into the drawing, enhancing the delicacy of the drawn lines. Because conté smudges easily, the finished picture should be sprayed lightly with fixative.

Technique

10

INK AND GOUACHE "WASH-OFF"

Ink and gouache "wash-off" is an unusual technique that exploits the properties of waterproof Indian ink and water-soluble gouache paint to produce a negative image in black and white. The results are unpredictable, which is part of the fun, and the finished result is very striking, with textural effects that resemble those of a woodcut or lino print.

Wash-off is most successful with a subject that is essentially linear and decorative, as in this stylized image of a vase of poppies.

Ted Gould
Poppies
41 x 36cm (16 x 14in)

"WASH-OFF" TECHNIQUE

Ink "wash-off" is a simple technique, but it requires careful planning and should not be hurried. In particular, it is vital to ensure that each stage is completely dry before you move on to the next. You will need a sheet of watercolour board or good-quality, heavy watercolour paper, which must be stretched and taped to a board as it will be saturated with water during the wash-off process.

First paint your chosen image or design with thick, white gouache paint – it is essential to use white because a colour would stain the paper and spoil the finished effect. If you find it difficult to see the white gouache against the white paper, you can stain the paper first with a pale watercolour wash. Apply the paint quite thickly; if it is too thin the ink applied subsequently may mix with the paint.

When the gouache is bone dry, use a large brush to cover the whole paper with an even coat of black waterproof Indian ink. When applying the ink, make sure your brush is well loaded because if you try to go over an area again the gouache will begin to mix with the ink and the final effect will be spoiled. Use a large, soft brush and work quickly, "floating" the ink on – too much pressure will cause the gouache beneath to dissolve and mix with the ink.

When the ink is completely dry, hold the painting under cold, running water. This causes the soluble gouache paint to dissolve and it is washed off; the areas of dried ink covering the gouache disintegrate and are washed off at the same time, but the ink in the unpainted areas remains. The result is a white, "negative" image on a black background.

POPPIES

1

Make a careful outline drawing of the subject in pencil.

Materials and Equipment
- SHEET OF NOT (COLD-PRESSED) SURFACE WATERCOLOUR BOARD OR HEAVY STRETCHED WATERCOLOUR PAPER • HB PENCIL • MEDIUM-SIZED ROUND SOFT BRUSH • PERMANENT WHITE GOUACHE PAINT • LARGE SOFT BRUSH • BLACK WATERPROOF INDIAN INK • SMALL SOFT SPONGE (OPTIONAL)

2

With a medium-sized round soft brush and permanent white gouache, carefully paint in those areas which are to remain white in the final image. Of the various whites available, permanent white is the best as it has the thickness and body required for this technique. Paint the lines on the table and on the screen in the background with drier, thinner paint so as to create broken brush strokes. Leave to dry completely.

3

Using a large soft brush, paint Indian ink over the entire picture surface, starting at the top and applying the ink in broad, horizontal bands. Leave to dry.

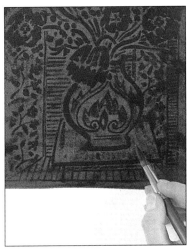

4

When the ink is bone dry, hold the board under running water. The gouache will start to dissolve and come away from the board, lifting the ink covering it. Any stubborn areas can be coaxed off gently with a soft brush or sponge. The black ink that was not painted over gouache remains intact. Leave to dry flat.

Right: This close-up detail of the finished image shows the subtle nuances of line and tone that can be obtained by varying the thickness of the gouache applied initially. Here, a smooth, thick layer of gouache was applied on the flowers, while thinner, drier paint was used for the pattern on the vase.

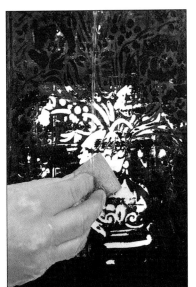

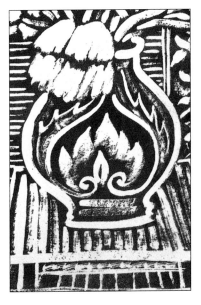

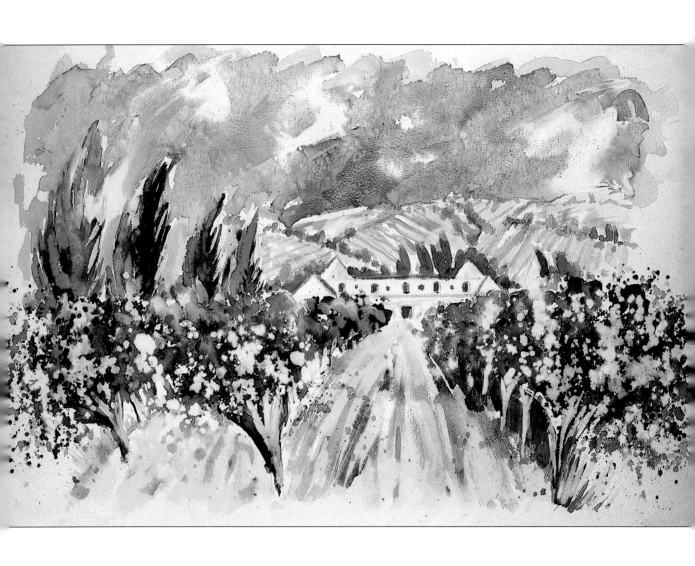

11

INKS, BLEACH, SALT AND SUGAR

Coloured inks, like watercolour paints, are a fluid medium capable of producing exciting, spontaneous effects. Exploiting the medium to the full, the artist has employed several innovative techniques in this bold interpretation of a landscape in Tuscany.

In order to recreate the energy inherent in this dramatic landscape, the artist worked linear strokes of diluted household bleach into the brightly coloured inks, spattered ink and bleach onto the trees to give them a sense of movement, and sprinkled a generous amount of salt and sugar into the washes in the sky area to create intriguing textures.

Annie Wood
Tuscan Landscape
48 x 64cm (19 x 25in)

USING INKS WITH OTHER MATERIALS

Salt or sugar sprinkled into a wet wash of ink produces exciting textures and effects. The granules soak up the pigment and, when the ink is dry, they can be brushed off, leaving a delicate pattern of pale, crystalline shapes where the salt or sugar granules have absorbed the ink around them. These shapes can be used to suggest all manner of natural textures, such as falling snow or weathered rocks and stones.

A variation on this technique is to apply both salt and sugar more heavily to the wet ink wash. Instead of brushing the granules away when the ink has dried, they are left in place on the paper. As the ink dries the granules of salt and sugar cake together and create an attractive, grainy surface texture.

In the project starting on page 49, a dry layer of fountain pen ink was drawn into with a cotton bud (swab) dipped in household bleach to produce "negative" shapes and outlines. A similar technique is used in this project, this time using diluted bleach brushed and spattered onto the ink to create interesting textures. Always use fountain pen ink as neither water-

proof nor soluble drawing ink will bleach out successfully.

When you are mixing up the bleach solution, add water a little at a time and test it on a dry wash of ink on scrap paper to check that it is of the right strength. Some brands of household bleach are stronger than others, and only those that contain chlorine are suitable for this technique.

When using a bleach solution it is advisable to choose an old paintbrush which must have synthetic hairs, as the bleach would destroy natural ones. **Note:** *Always work in a well-ventilated room and avoid getting the solution in your eyes or on your skin.*

The final technique used in this project is spattering. This is another excellent method of simulating rough and pitted textures, and it also lends movement and spontaneity to the drawing. In this project spattering has been employed to suggest the blossom on the trees in the foreground. To create spatter, load a round watercolour brush with ink and hold it horizontally above the paper. Tap the brush handle with your outstretched forefinger to release a shower of small drops onto the paper.

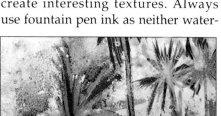

Here a combination of brightly coloured inks, worked into with bleach and sprinkled with sugar and salt, succeeds in evoking the steamy atmosphere of a Brazilian rain forest.

TUSCAN LANDSCAPE

Materials and Equipment

- SHEET OF SMOOTH CARTRIDGE (DRAWING) PAPER OR WATER-COLOUR PAPER, STRETCHED •
SOFT PENCIL • SMALL ROUND WATERCOLOUR BRUSH •
FOUNTAIN PEN INK: BLACK AND TURQUOISE • WATER-SOLUBLE DRAWING INKS: BLACK, TURQUOISE, CARMINE, SUNSHINE YELLOW, EMERALD GREEN AND BRILLIANT GREEN • MEDIUM-SIZED FLAT WATERCOLOUR BRUSH •
HOUSEHOLD BLEACH • AN OLD, SYNTHETIC-HAIR WATERCOLOUR BRUSH (SMALL ROUND) FOR APPLYING BLEACH • TABLE SALT • GRANULATED SUGAR

1

With the paper stretched and taped to a board, lightly sketch in the main elements of the composition with a soft pencil.

2

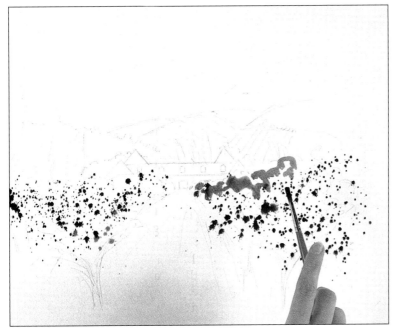

Now apply some random spattered dots to the foreground trees. Load a small round watercolour brush with black fountain pen ink. Lay the board flat on the work surface. Hold the brush as shown, about 5cm (2in) above the paper, and tap it gently with a forefinger to release a shower of dots onto the upper parts of the trees. If you wish, mask off the rest of the drawing area with paper to catch any stray dots of ink.

3

Working quickly before the ink spatter dries, rinse the brush in water and shake off the excess. Then work back into the spatter with the damp brush, blending together some of the spattered dots to create an impression of foliage. Draw the tree trunks, then draw the cypress trees on the left of the picture with slightly diluted ink.

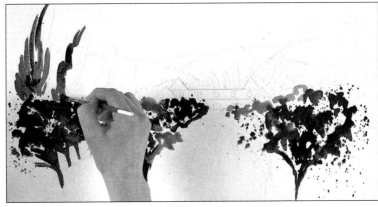

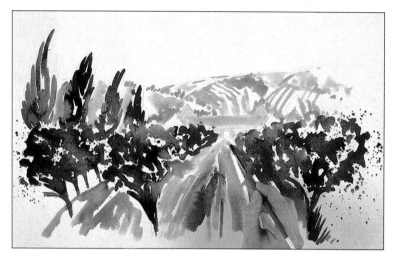

4

Mix one part black drawing ink to two parts water and use this to draw in the receding lines of the foreground field and the farmhouse. Use much smaller marks to suggest the fields and trees in the background. Notice how the tones in the foreground are darker than those in the background, conveying an impression of recession and distance.

5

Paint the sky using turquoise fountain pen ink and a medium-sized flat brush. Sweep the ink on quite randomly, varying the tones of blue and leaving patches of white paper showing through.

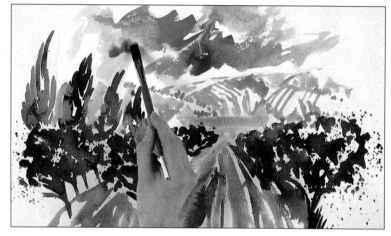

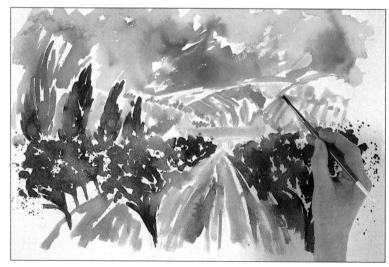

6

Switching back to the round brush, apply touches of thinly diluted turquoise ink to the distant fields and trees.

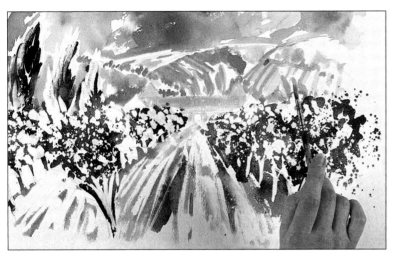

7

In a small glass jar mix one part household bleach to two parts water. With a small round synthetic-hair watercolour brush, spatter the bleach solution onto the foliage of the foreground trees as you did with the ink in step 2. Use the brush to blend together some of the dots and draw the tree trunks. Apply a few streaks of bleach to the foreground field and the cypress trees.

8

Loosely work into the sky area with the bleach solution to create an impression of scudding clouds. Bleach out most of the farmhouse, leaving the windows and some linear details. Leave to dry.

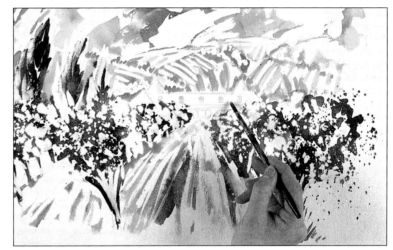

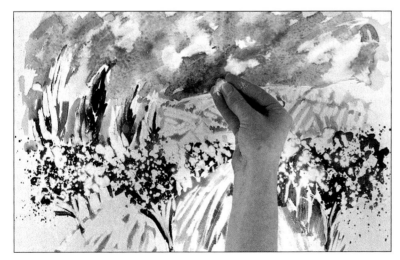

9

Still using the old paintbrush, because of the bleach on the paper, work into the sky area again with loose brush strokes of fairly diluted turquoise ink. While the ink is still wet, sprinkle it first with salt, then with sugar. The salt soaks up some of the pigment, and the salt and sugar cake together on the surface. The result is an interesting, mottled texture.

Above: In this close-up detail of the sky you can see the granular effect created by the salt and sugar.

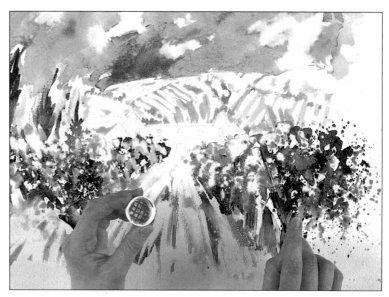

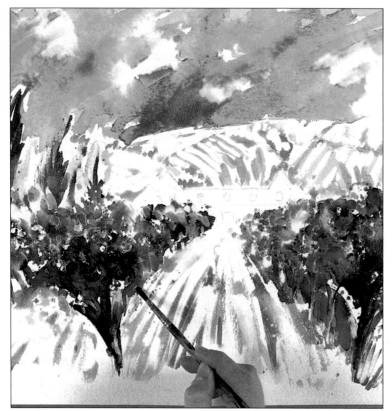

10

With carmine drawing ink and the old paintbrush, work into the trees once more with the spatter-and-blend technique.

11

While the carmine ink is still wet, repeat step 10 with turquoise ink and reinforce the tree trunks. The bleach applied earlier merges with the pigments and creates pools of luminous colour. Leave the drawing to dry.

12

Apply a loose wash of sunshine yellow drawing ink over the fields, slightly diluting the colour in the distance. Leave to dry, then paint the cypress trees with a mixture of emerald green and brilliant green drawing inks. Use the same colour, diluted to a pale tint, for the hedges and trees in the distance.

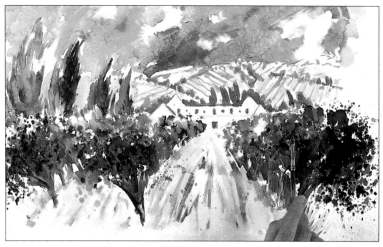

13

Strengthen the details on the farmhouse with diluted black drawing ink. Darken the three trees in the immediate foreground with further spatters of black and turquoise ink, diluting the ink with water in places to obtain tonal variation. Leave to dry.

14

Finally, spatter the foreground trees once more with the bleach solution and work a few lines into the cypress trees. Leave to dry flat.

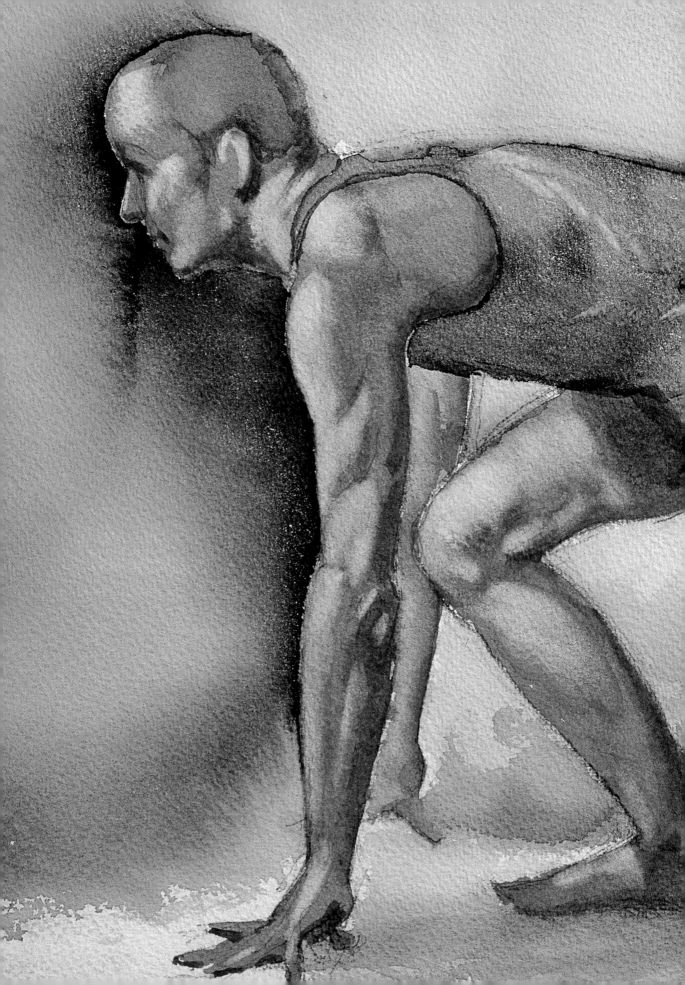

Human Anatomy

JAMES HORTON

INTRODUCTION

The human figure has been an important part of world art since the first prehistoric attempts to create images. At the zenith of their cultural and artistic achievements, the Ancient Greeks (7th–5th century BC) made great advances in the depiction of the human form. Sculpture was then the most important medium, and those carvings and bronzes that have survived demonstrate the Greeks' great skill.

Among the works of Pheidias, who lived in the 5th century BC, are the two great sculptures of Athene and Zeus in Olympia. Pheidias's work demonstrates the Greeks' understanding of how the human body worked – and how it should be represented.

We can recognize similar contemporary criteria for the perfect muscular male form also esteemed in Ancient Greece. However, the criteria for the female form has differed throughout history, and is certainly different now compared to when the Greeks created

Venus de Milo
Greek, 1st century BC

This famous statue, which resides in the Louvre Museum in Paris, is an example of the advanced anatomical knowledge of the Ancient Greeks.

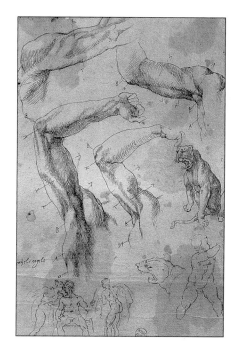

Arms Studies
Michelangelo Buonarroti (1475–1564)

Michelangelo's many anatomical studies gave him an excellent eye for the human form.

their works of art. The *Venus de Milo* for example – a 1st-century BC Greek statue discovered on the island of Melos in 1820 – shows that the ideal woman of that time was of a fuller build than is idealized in our modern society.

In the Rome of antiquity (750 BC–AD 500), athletes, warriors, soldiers and gladiators were all at the heart of Roman culture and there are many sculptures from Roman times that bear witness to the importance of physical perfection.

The long period between the end of the Roman empire and the start of the Italian Renaissance in the 14th century produced very little in artistic terms; but by the time the Renaissance was in its stride, the human form was once again at the centre of high art. As always, religion was providing an outlet for the depiction of the human form and although the worship of a Christian God was based more on the spiritual than the physical, Christ was in the main portrayed as a well-built man. Indeed, most characters portrayed in Renaissance paintings are shown with well-nourished bodies.

It was at this time that there began a more scientific inquiry into the workings of the human body, which extended into the dissection of corpses. Michelangelo (1475–1564), for example, risked a death sentence when he secretly dissected a human body by candlelight, in order to extend his anatomical knowledge. Interfering with dead people was illegal at that time – even if the purpose was a search for knowledge.

Leonardo da Vinci (1452–1519), the quintessential Renaissance man, made a whole series of anatomical drawings from a flayed figure to further medical knowledge as much as that of art.

During the Italian Renaissance, the study of anatomy assumed great importance. Paintings were full of characters wearing little or no clothing. In the early stages of composition the artist would envisage a variety of poses from his imagination, establish the scene with the relationship of one figure to another and then require the models to enact the scene for the final work.

As studio practice, this continued until the 19th century, but with the start of the Romantic period in the late 18th century, the

Valpincon Bather
Jean Auguste Dominique Ingres (1780–1867)

Ingres used his knowledge of anatomy to achieve near-perfection in his paintings of nudes.

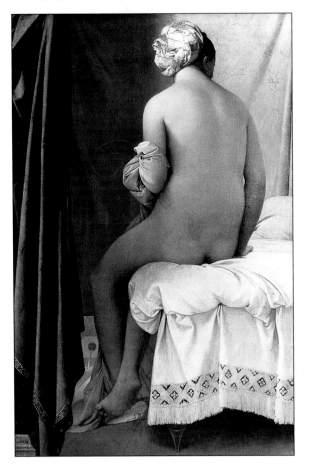

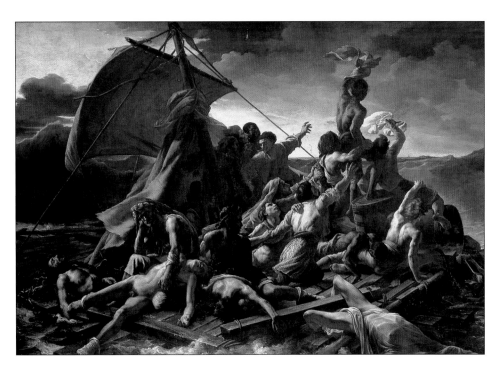

subject matter for paintings gradually shifted towards nature. The last historical subjects on a grand scale were made during the Neo-classical period (19th century) by painters such as Jacques Louis David (1748–1825) and Jean Auguste Dominique Ingres (1780–1867). These were artists who wanted to keep the spirit of the Renaissance alive and believed that the highest form of art was based upon the figurative image. Perhaps the last great classical painting that used heroic images of anatomically accurate construction was Théodore Géricault's (1791–1824) giant masterpiece *The Raft of the Medusa* [4.9 x 7.2m (16 x 23½ft)], painted in 1819. Géricault took the quest for realism in anatomy one step further than ever before by making studies of recently executed victims of the guillotine. By the middle of the 19th century the study of anatomy survived as part of a typical art

The Raft of the Medusa
Théodore Géricault (1791–1824)

Considered one of the greatest depictions of the human form, this work shows the power of expression possible in representational art.

school education. The days when knowledge of anatomy was an intrinsic part of an artist's vocabulary were drawing to a close.

The growth of Modernism in the 20th century saw a revolution in working practices. No longer was it essential to understand the construction of the body. In fact, the appearance of people in a painting might not even be human. However, in the 21st century there are some major artists, such as Lucian Freud (born 1922) and David Hockney (born 1937), who are concerned with the human figure as a central theme.

HOW THE BODY WORKS

A knowledge of how the body is structured and moves is essential for an artist who wishes to capture accurate depictions of human beings. This chapter provides a basic grounding in essential anatomy.

Although the study of anatomy can assist an artist in painting and drawing from life, it should never become a formula, and the portrayal of an individual should always take precedence. However well an artist might understand human anatomical construction, the way muscles appear on the surface is not always obvious – even in quite muscular people. This is due, in part, to a thin layer of fat called the panniculus adiposus, which is present in even the slenderest person or muscular super-fit athlete. Only in cases of extreme malnutrition and emaciation is this layer not present. Secondly, muscle development differs greatly between individuals, depending upon how they use their body. For instance, the muscle formation of boxers, runners, weightlifters and foot-ballers will all appear quite different on the surface.

Body builders of the type who go in for the 'Mr Universe' competitions are completely different once again. Here, a special programme is followed that deliberately targets specific muscles and consequently can enhance them beyond anything that natural activity or normal exercise can achieve.

We also have to consider the differences between the sexes. Broadly speaking, women have up to 30 per cent more fat than men, which can greatly affect how the muscles appear on the surface. Also, generally speaking,

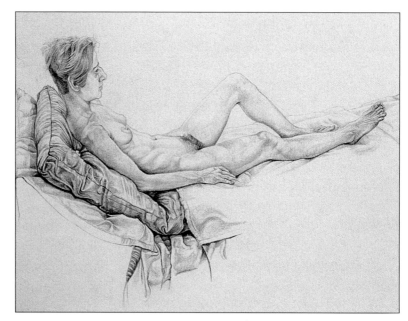

Although we all have the same basic building blocks, individuals differ superficially. To the artist, these differences define the individual.

The Skeleton

The human skeleton is a framework to which the muscles are attached. In all animals, the skeleton is directly related to the type of actions that the creature performs. This has been determined by millions of years of evolution and adaptation to the sorts of tasks that creatures needs to perform in order to survive.

The skeleton also has the important function of protecting vital organs. The skull, for instance, provides a hard, bony case to protect the brain. Likewise, the ribcage protects the lungs. For our purposes as artists, all we need to know about the skeleton is how it moves and which muscles attach to which bones.

Most bones are held together by muscles that are attached by tendons. It is the way in which these muscles link together various bones that defines our movements.

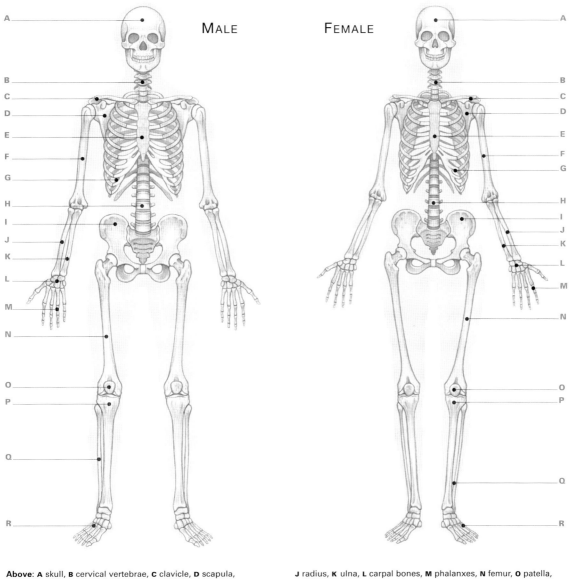

MALE FEMALE

Above: A skull, **B** cervical vertebrae, **C** clavicle, **D** scapula, **E** sternum, **F** humerus, **G** rib cage, **H** lumbar vertebrae, **I** pelvis, **J** radius, **K** ulna, **L** carpal bones, **M** phalanxes, **N** femur, **O** patella, **P** tibia, **Q** fibula, **R** metatarsal bones

women tend not to perform as many manual tasks as men and therefore have less muscular development. However, in the modern world, where stereotypical role-play between the sexes is in decline, it is best to approach all situations with a very open mind.

As a figurative artist, to be able to work with knowledge of the structure of your subject is obviously an advantage and reduces the tendency towards copying or drawing in a way that ends up being over-literal. Understanding the construction of a subject, whether it is a boat or a human being, will always enhance your work.

THE HEAD AND NECK
The muscles of the head and neck can be seen to a large degree on the surface. It varies greatly between individuals,

but muscles such as the zygomaticus major, orbicularis of the mouth, masseter and buccinator, are all instrumental in creating facial expressions. Each of us uses our facial muscles quite differently, and will therefore have a bias towards some muscles being more developed than others. For instance, trumpeters have enormously developed buccinators because of all the blowing they do. People who smile a great deal usually have a prominent zygomaticus.

The most important neck muscle for artists is the sternocleidomastoid. This connects from behind the ear to the collar bone. It is the main anchor of the head to the shoulders via the neck, and can be seen on virtually anyone regardless of the degree of fat they have on their body. Also apparent in certain situations is the platysma.

In this image the sternocleidomastoid muscle in the neck is clearly visible. This is one of the defining muscles for the artist.

This is a thin, sheet-like muscle of the neck. Wincing and expressions of terror make this muscle quite pronounced.

At the base of the neck is the trapezius muscle. This connects from the back of the skull to well down the spine. It also forms the principal muscle of the shoulder and has an overall shape similar to a diamond. Weightlifters and boxers can have extremely well-developed trapezius muscles.

The other important muscle of the shoulder is the deltoid. This is a powerful muscle and is

We all use our facial muscles in different ways. This can cause us to develop certain muscles while neglecting others.

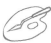

The Muscles

In simple terms, all muscles connect from one bone to another so that when those muscles are tensed they can either pull those bones together or push them further apart. For every muscle movement there is another set of muscles to assist in doing the reverse. To make sense of the technical sounding Latin names, it is useful to understand the meaning of the following terms:

Abduction This describes the movement away from the body, e.g., lifting the arm upwards.
Adduction This is the opposite of the above: movement towards the central axis.
Extensor This is a muscle that contracts to straighten or extend a joint.
Flexor This is a muscle that contracts to bring together the two parts it connects.

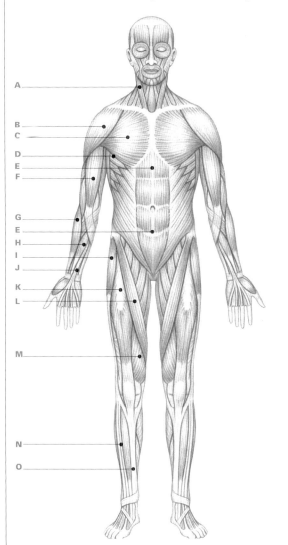

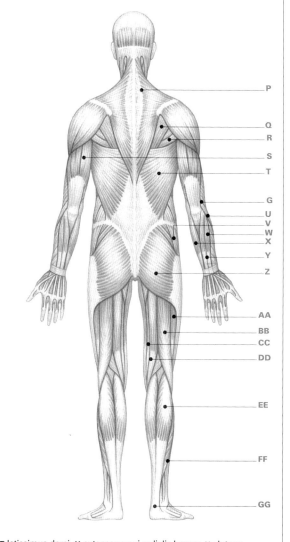

Above: **A** sternocleidomastoid, **B** deltoid, **C** pectoralis, **D** serratus anterior, **E** rectus abdominis, **F** biceps, **G** brachioradialis, **H** flexor carpi radialis, **I** tensor fascia latae, **J** palaris longus, **K** rectus femoris, **L** sartorius, **M** vastus medialis, **N** peroneus longus, **O** tibialis anterior, **P** trapezius, **Q** infraspinatus, **R** teres major, **S** triceps, **T** latissimus dorsi, **U** extensor carpi radialis longus, **V** gluteus medius, **W** extensor digitorum, **X** flexor carpi ulnaris, **Y** extensor carpi ulnaris, **Z** gluteus maximus, **AA** vastus lateralis, **BB** biceps femoris, **CC** semimembranosus, **DD** semitendinosus, **EE** gastrocnemius, **FF** soleus, **GG** tendon calcaneus

in constant use when the arm moves, as is the great abductor. In fact, most of the muscles of the arm are fairly easy to see on the surface. This is because even in the least sporty or active of individuals the arm is in fairly constant use and consequently the accumulation of surface fat is kept to a minimum.

THE UPPER ARM

As the name implies, the biceps has two heads and is the muscle that is usually associated with power and strength when flexed. The biceps are the flexor of the forearm.

The brachialis is a deep, powerful muscle that lies between the biceps and triceps and is a strong flexor of the elbow. It can usually be seen on the surface as a bump just below the deltoid on the outer side of the upper arm.

Occupying the whole of the back of the arm is the triceps, which, as its name implies, has

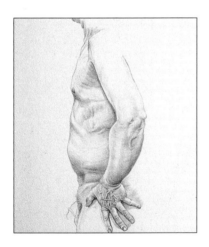

The inside of the forearm contains the finger flexors and the outside flexor for the forearm itself.

three heads. It is the principal extensor of the forearm and can easily be seen on the surface, especially when it strains, for example to lift a heavy object.

THE FOREARM

The muscles of the lower arm are numerous and complex in action. Unlike the upper arm, where the muscles are fewer but longer and perform actions of strength, the lower arm governs the movements of a much finer and more precise nature.

These muscles can be split into two groups: those that arise from the inner side of the

The armpit is formed principally by two muscles, the pectoralis major and the latissimus dorsi. When the arm is raised, these muscles are particularly visible.

humerus and those that arise from the outer side. Those that originate from the outer side are much higher than those arising from the inner, giving the forearm its characteristic curve. You will also notice that as the muscles become tendons at the wrist, the forearm is also slimmer than higher up nearer the elbow, where the fleshy ends originate. All of these tendons

connect to the phalanxes and metacarpals to perform a wide variety of dextrous movements.

THE TRUNK

The muscles of the trunk can also be divided into roughly two types: those that are long and thick, like the erector spinae group, and those that are broad and sheet-like in form, such as latissimus dorsi.

Along with the biceps, the other muscle associated with strength and fitness is a well-defined rectus abdominis. The rectus abdominis is a long, flat muscle extending the whole length of the abdomen. It begins at the pubic crest and inserts into the cartilage of the fifth, sixth and seventh ribs. This muscle is responsible for bending the trunk forwards and is used in sit-up exercises.

At the back, the erector spinae muscles extend the whole length of the spine and fill the groove either side of the spinal column. These muscles connect from the pelvis and sacrum all the way up to the cervical vertebrae. Although not truly superficial, these muscles are important to the artist because their effect can always be seen in the form of a furrow down the centre of the back.

At the top section of the thorax, the erector spinae is covered by the trapezius and below by the latissimus dorsi. The latissimus dorsi muscle is the wide muscle of the back and at its outer edges it forms a thick ridge that can be seen to great effect in many athletes.

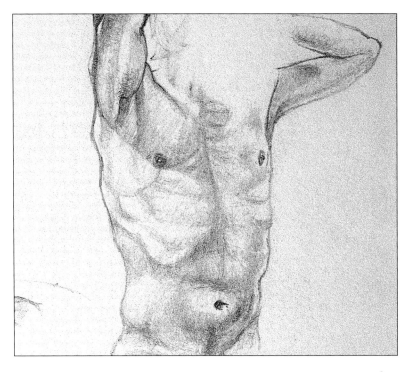

At the front, on the chest lies the pectoral muscle. With the latissimus dorsi, this forms the armpit over either side of the ribcage. On muscular males, the pectoral can achieve very good definition because of the part it plays in moving the arm. Boxers and weightlifters can often develop this muscle so much that the individual fibre strands can be seen. On the female, however, this muscle supports two-thirds of the mammary gland (in the breast) so it figures far less, although it is always evident as an important part of the armpit form.

Beneath the armpit and directly between pectorals and latissimus dorsi is the serratus anterior, otherwise known as the fencer's muscle. The bumps that appear on the surface are

The front of the body is defined by the ribcage, the pectoral muscles and the rectus abdominis, which runs from the chest to the pelvis.

often mistaken for ribs in thin people but when this muscle is developed, as it is in boxers, who are constantly performing lunging movements, there is no mistaking it for the ribcage.

Because of the way the serratus anterior attaches to the ribcage, it produces an interlacing effect with the external oblique. This is a large sheet-like muscle that attaches to the top of the iliac crest of the pelvis and is easily seen on the surface in most males. It is generally less visible in females, however, because at this point on the hips there is usually a greater fatty covering than on males.

103

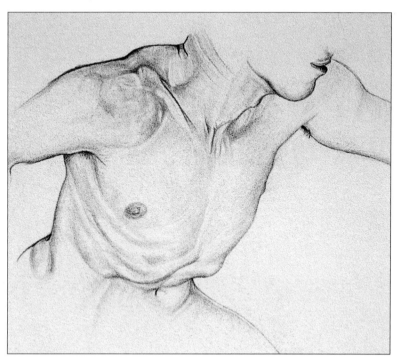

At the shoulders and upper back, the deltoid and trapezius muscles are most prominent.

To return briefly to the back, it will be noticed that there is a large area in the centre that is formed by a tendon common to several muscles. This gives great strength to this part of the body, and in muscular individuals it is possible to identify separate muscle movements.

THE UPPER LEG

The buttocks and legs contain some of the longest and most powerful muscles of the body, many of which can be seen superficially. The heaviest and strongest muscle in the body is the gluteus maximus, which is the main muscle of the buttock. It is the large extensor of the thigh and is used for rising from a sitting position and leaping, etc. It is usually a larger muscle in the male although, because of the extra accumulation of fat, the superficial appearance of the female buttock is larger than that of the male.

The gluteus medius muscle is a fan-shaped structure that is a strong abductor of the thigh and is used in such actions as standing to attention. The other important muscle in this region is the tensor fascia latae, which joins a long area of tendon known as fascia latae or the ilio tibial band. The tensor fascia latae runs the whole length of the upper leg, tapering at the end to join at the fibula.

The other muscles of the thigh are the rectus femoris, the inner vastus and outer vastus.

These muscles run the whole length of the femur bone arising from the pelvic area and join in a mass of tendon at the patella, or kneecap. Together with the other muscles, the rectus femoris serves to straighten the knee and flex the thigh.

Between the femur, pelvis and innermost part of the upper leg is a triangular shape filled by a group of muscles known as the adductors. The adductors longus, magnus and brevis together with pectineus perform the same function, which is adducting the thigh. They would be used, for example, when riding a horse to keep the thighs pressed tightly against the saddle and for bringing the leg, which has been lifted away

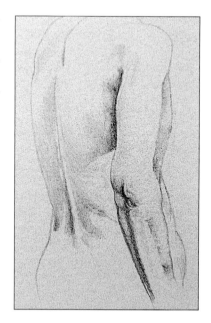

The main feature of the back is the furrow surrounding the spine. This is created by the erector spinae muscles.

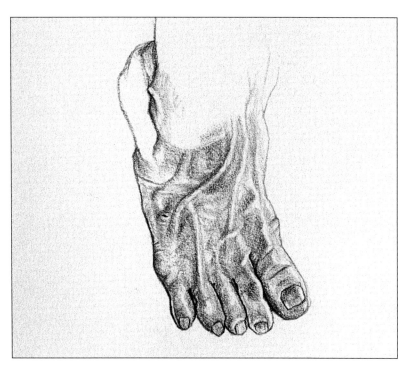

The foot muscles are thin and look like tendons on the surface.

from the body, back again. At the back of the leg, the principal muscles are the biceps femoris, semitendinosus and semimembranosus. These long muscles are the flexors of the knee. When the knee is in a bent position the tendons of these muscles stand out like taut strings. This appearance has earned them the name of hamstrings.

Joining at the same point at the inner side of the knee on the tibia bone are the two last muscles of the upper leg – the sartorius and gracilis. A knowledge of the sartorius muscle is important to artists, because it defines the whole character of the upper leg, as it effectively bisects the whole area.

THE LOWER LEG

There are not very deep muscles in this part of the leg, as the area is mostly occupied by the somewhat sturdy shin bone. At the front, the most easily seen and powerful muscle is the tibialis anterior, which raises the foot towards the leg.

There are two outer muscles in the lower leg, peroneus longus and brevis, which can be seen quite well when performing their function of pointing the sole of the foot outwards.

At the back, in the area known as the calf, there are two muscles, the soleus and gastrocnemius. The soleus is the deeper of the two and runs right underneath the two halves of the gastrocnemius. It can be seen on the inner and outer side of the leg. The two heads of the gastroc-

nemius can be seen when it is performing its main job, which is standing on tip-toe. Both these muscles unite at the lower end in the tendon to form the Achilles tendon and attach to the heel bone.

THE FOOT

The muscles of the foot are not very fleshy. They are seen on the surface as tendons that originate from the muscles of the leg as they attach to the phalanxes.

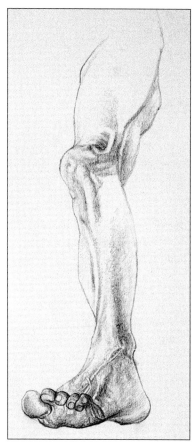

The lower leg is defined by the tibialis anterior at the front and the two heads of the gastrocnemius and their tendons to the rear.

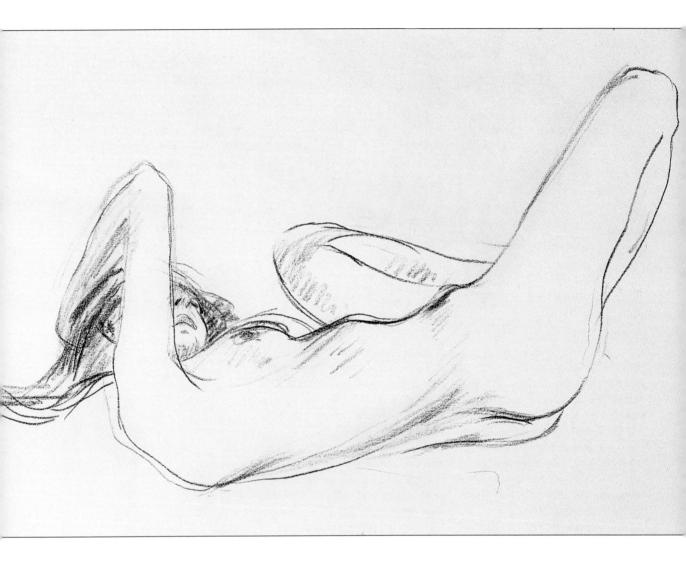

GALLERY

The works shown here demonstrate the degree to which a knowledge of anatomy affects accurate depictions of the human body. From the general proportions of the body to its surface details, anatomical considerations are crucial when drawing or painting the human figure – whatever style you use. The range of styles used here demonstrates that the same knowledge of anatomy does not mean that pictures will end up looking the same. This standard knowledge gives artists the freedom to use their individual styles while still achieving a high degree of anatomical accuracy.

Reclining Nude

Kay Gallwey
30 x 40cm (12 x 16in)

In this stunningly energetic drawing of a reclining woman, the artist has responded to the femininity of the model through the expressive use of line. The hips and raised leg in particular contain a highly sensuous use of linear definition.

Anatomical Study

James Horton
30 x 20cm (12 x 8in)

This drawing was a deliberate attempt to make an anatomical study. The model was chosen for his well-developed body. The work was a wonderful opportunity to utilize previous knowledge of the geography of the human body in a drawing.

Weights

John Holder
30 x 40cm (12 x 16in)

This drawing demonstrates the relation of biceps and triceps to the lower arm. The tension can be seen quite clearly in the form of parallel bulges running along the arm.

Geraldine
John Raynes
18 x 25cm (7 x 10in)

In this fresh-looking image the artist manages to achieve a balance between free-flowing chalk marks and accurate anatomical representation. This freedom comes with an in-depth knowledge of anatomy, which allows the artist to focus on his art.

Long Thin Man
Paul Bartlett
25 x 17.5cm (10 x 7in)

In this finely detailed, textured drawing in graphite pencil, the artist emphasizes the contours of the body with gentle shading. The bones and surface muscles are prominent in this study, especially on the back. The shoulder blades, spine, erector spinae and latissimus dorsi can all be seen very clearly, while the legs are shrouded in heavy shadow. The fine detail suggests a comprehensive knowledge of anatomy.

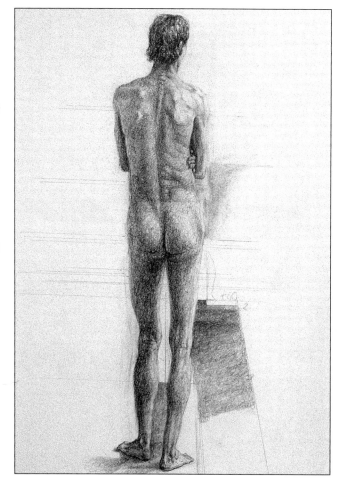

Lynton (seated)

Paul Bartlett
35 x 22cm (14 x 9in)

In this charcoal study the development of the form has been taken up to quite a high and 'polished' looking level. The superficial anatomy works well and there are many familiar anatomical landmarks – particularly in the construction of the shoulders, chest and thorax.

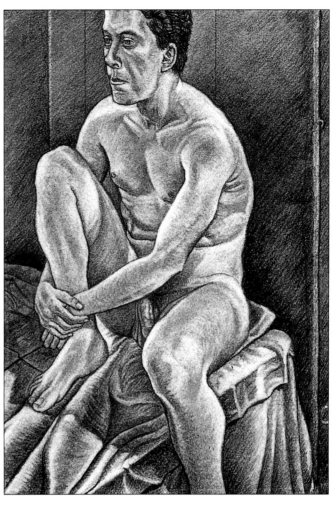

Chest and Arms (seated)

Paul Bartlett
27 x 18cm (11 x 7in)

In this drawing, the folds of the skin on the chest and stomach are accentuated through light pencil strokes and gentle shading. The shape of the pectoralis muscles, ribs and serratus anterior are suggested beneath the surface.

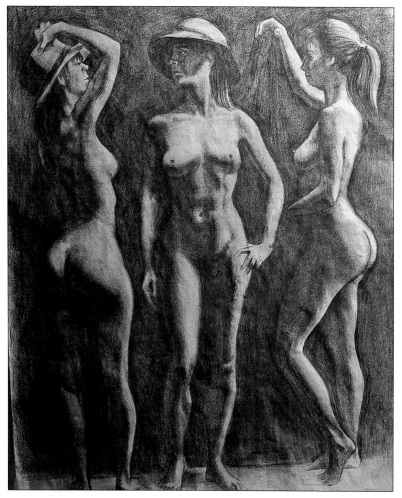

The Three Graces

James Horton
150 x 90cm (60 x 36in)

In this drawing the same model has been used three times. The central figure has excellent definition through the torso. The other figures display the deep curve in the spine typical of the female figure.

Anatomical Study

Byron Howard
28 x 18cm (11 x 7in)

In this pencil sketch the artist shows a detailed knowledge of the anatomy of the male back muscles, which are exposed on the left side. By contrast, the muscle structure provides a framework for the right side of the back, which focuses on the latissimus dorsi.

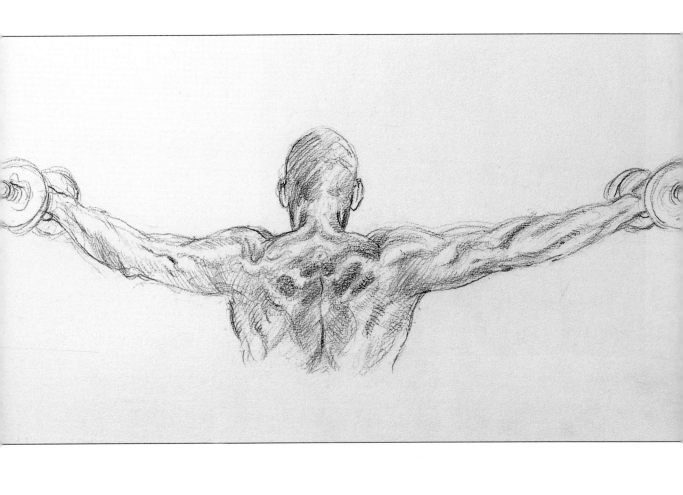

Project

1

A R M S

The arms are often central to a work of art containing human figures. They are highly expressive in their own right and can be used to convey the mood, intention or inner state of a figure. They can also be used to express abstract subjects such as strength, weakness, anger, passion and so on.

In this project the artist, John Holder, has chosen a pose in which many of the muscles of the arms are visible. Also visible are the muscles of the shoulder, neck and upper back – all of which interact with the arms. John has used pencil for this study, demonstrating how accurate figure drawing can be achieved with a basic two-tone effect.

This project emphasizes how the limbs work using a complex system of muscles and tendons. It also shows how the state of tension and the position of the limb make a huge difference to its general appearance.

John Holder
Weights Study
29 x 42cm (11½ x 17in)
Graphite Pencil

Arms Tensed

The muscle that is enabling the subject to raise his arms is the deltoid, which is the main elevator of the humerus. However, to raise the arm above the horizontal requires the added cooperation of other muscles, namely the serratus anterior under the arms and the trapezius between the arms in the back. The latter can be seen quite well defined in this subject.

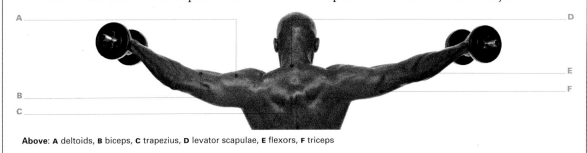

Above: A deltoids, **B** biceps, **C** trapezius, **D** levator scapulae, **E** flexors, **F** triceps

WEIGHTS STUDY

Materials and Equipment

• PHOTOGRAPH OF OUTSTRETCHED ARMS

• GRAPHITE PENCIL 4B •

SKETCH BOOK • ERASER

1. Using a graphite pencil, roughly sketch the general proportions and shapes of the figure, using light strokes from the side of the pencil. To create a freer feel to the marks, hold the pencil further up so that it sits more lightly in the hand.

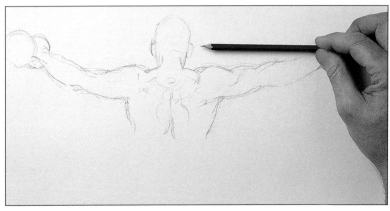

2. Use your pencil to approximately measure the horizontals – both arms should be of equal length and proportion. The head of the figure and the weights should be more loosely drawn, in order to give greater emphasis to the arms and back. The weights should only be outlined, without shading.

3. Before proceeding further, check the proportions of the figure. Use heavier strokes to strengthen the outlines and make the figure more clearly defined. Bring to life the features of the back, arms and shoulders with light shading using the side of the pencil.

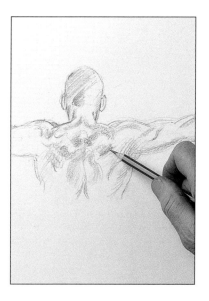

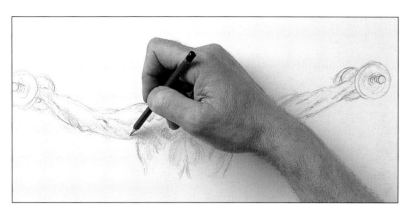

4.

The lines of the arms should not be be straight and should be loosely drawn: a series of connecting lines rather than a single line will give more fluidity. Single lines along the bottom of the left arm create the appearance of downward movement.

5.

Flowing lines along the right arm create a horizontal movement that emphasizes the outstretched pose. Build up the form using the side of the pencil. Increase the shading in areas of the arms to highlight the muscle tone. Darkening will emphasize the light areas and give greater depth and tone.

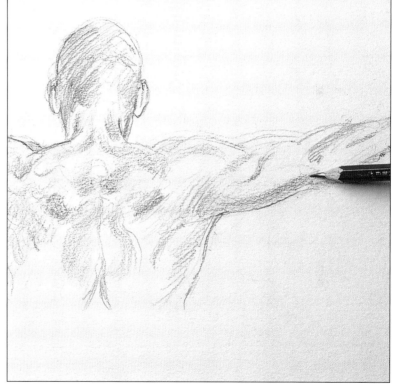

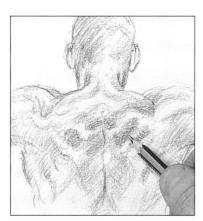

6.

Increase the shading on the back so that the white areas establish the highlights of the well-sculptured muscles. Use the pencil like a brush, stroking the side along the paper. Increase the weight to increase the colour and contrast. Soften some of the shading with your finger to give a more natural look.

7.

Use an eraser to pick out occasional highlights on the knuckles and back. Follow the curve of the muscles with your pencil to give the image a more fluid look. To finish off, darken the overall outline of the drawing to provide greater definition.

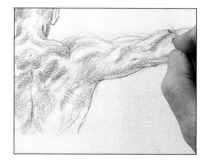

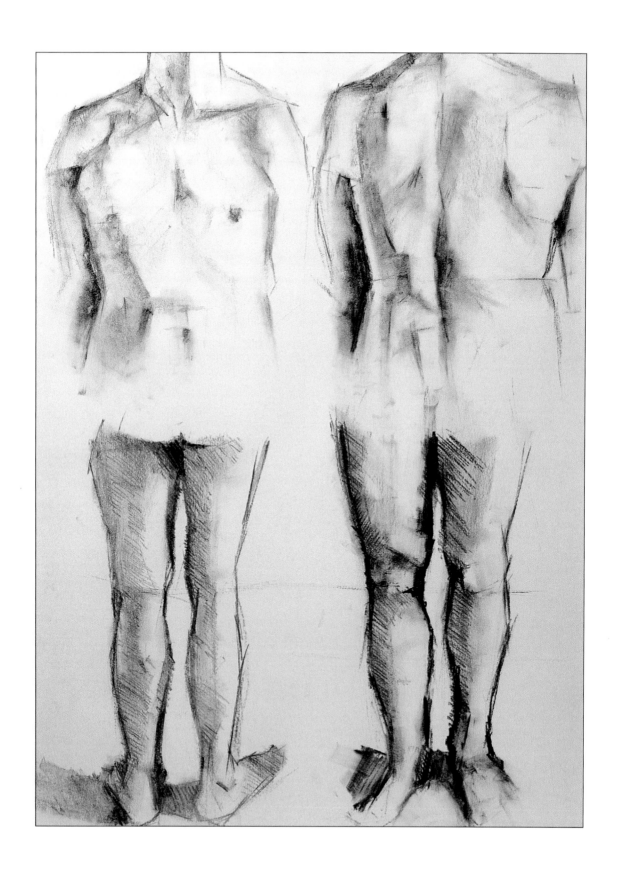

Project
2

TORSO AND LEGS

In this project, the figure is standing, but there is no specific tension or stretching taking place. Therefore the muscles are relaxed and the lines of the figure gentle. The side lighting helps to accentuate surface details of the figure.

One of the key elements to get right in this project is the proportions of the limbs and the torso. The human body is basically a symmetrical object, so make sure that each side of the torso and the two legs mirror each other.

Barry Freeman
Male Study
75 x 56cm (29½ x 22in)
Charcoal

Drawing Torso and Legs

On either side of the sternum are the pectoral muscles, which can cause quite a furrow. Attaching the ribcage to the pelvis is the long and powerful rectus abdominis, well defined in this picture and also known as the 'six pack'. The external oblique always appears as a slight bump just above the iliac crest of the pelvis.

The whole character of the centre of the back is defined by the furrow caused by the erector spinae group of muscles. These attach along the whole length of the spine from the cervical vertabrae to the pelvis. At the top the trapezius lessens the furrow effect as it swathes the erector spinae along with the other numerous muscles of the shoulder and neck region.

The upper leg contains the most powerful muscles in the body. These are all long and thick, with the exception of the vastus lateralis, which is narrower. At the front the diagonal quality of the sartorius is always noticeable.

The contour of the lower leg is defined almost entirely by the gastrocnemius muscle, which has two halves, the inner and outer. These connect with the soleus at the lower end.

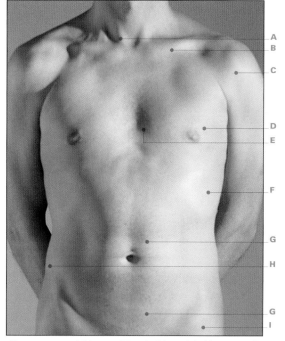

Above: A sternocleidomastoid, **B** clavicle, **C** deltoid, **D** pectoralis major, **E** sternum, **F** serratus anterior, **G** rectus abdominis, **H** external oblique, **I** tensor fascia latae

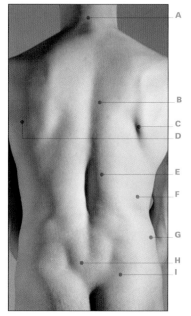

Above: A 7th cervical vertebrae, **B** trapezius, **C** scapula, **D** teres major, **E** erector spinae, **F** lattisimus dorsi, **G** external oblique, **H** aponeurosis of lattisimus dorsi, **I** gluteus medius

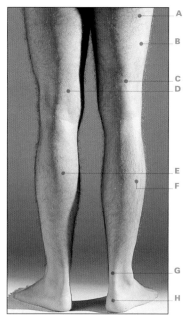

Above: A fascia latae, **B** vastus lateralis, **C** biceps femoris, **D** tendon of semimembranosus, semitendinosus and sartorius, **E** gastrocnemius, **F** soleus, **G** tendon calcaneus, **H** calcaneus

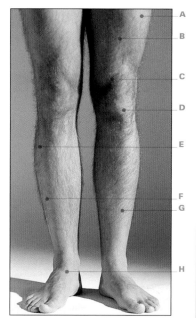

Above: A vastus lateralis, **B** rectus femoris, **C** vastus medialis, **D** patella, **E** gastrocnemius, **F** peroneus longus, **G** tibialis anterior, **H** extensor digitorum longus

MALE STUDY

Materials and Equipment

- CHARCOAL STICK • MEDIUM
 CARTRIDGE PAPER
- ERASER • FIXATIVE SPRAY

1.

Lightly sketch in the most obvious shapes and lines of the model. At this stage, concentrate on the proportions, marking the nipples, navel and the tops of the shoulders. These are your anchor marks.

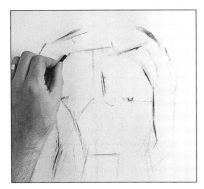

2.

Use the point of the charcoal to strengthen the outline and build up shadow on the arm. This will highlight the torso. Criss-cross the chest with charcoal and blend it in with your finger to give soft shadow.

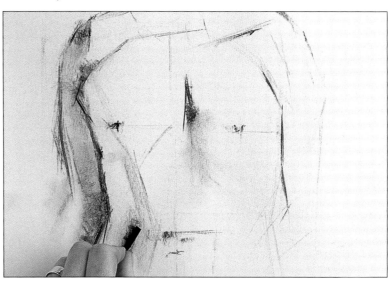

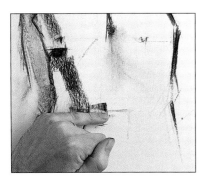

3.

Check which muscles are most evident. Use bold, confident strokes and vary between the edge and point of the charcoal. Make one thick long stroke following the shape of the muscle down to the abdomen and smudge it in with your finger.

4.

Use light strokes on the right, where there is less definition and shadow. Blend the left side, especially around the neck and the upper shoulder.

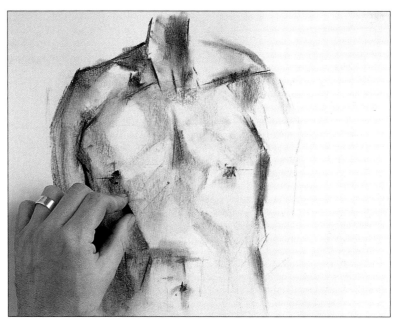

5▸

Increase shading on the arm, then blend in the charcoal. Add some very precise lines down the side of the body. Strong dark lines on one side of the body and lightness on the other shows how the light is falling on the torso. Draw light lines to show the ribs, then add shading in between. Rework the abdominal area to bring out more definition.

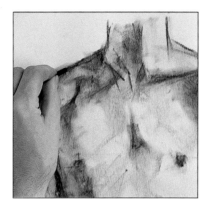

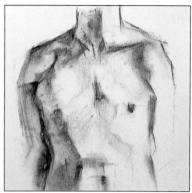

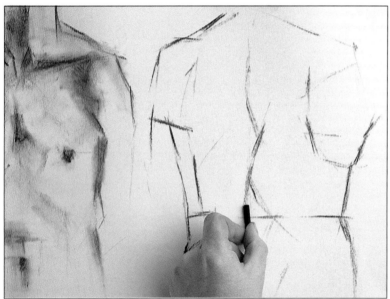

6▴

Deepen the centre line of the sternum between the pectorals. Suggest the nipples and belly button with shading rather than specific detail.

7▴

Now move on to the study of the back. Using the previous picture as a guide for proportions, use a long piece of charcoal and lightly sketch in the basic shape – shoulders, spine, arms and shoulder blades.

8▸

Use the side of the charcoal to block in the top of the shoulder and shade down the side of the body. Using bold strokes, draw in thick lines to show the main shadows on the back.

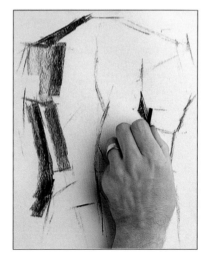

9▴

Shade in around the spine. Protect the drawing with a sheet of paper if you need to lean on it – otherwise it will smudge. Blend in the strong lines at the tops of the shoulders to shape the curve.

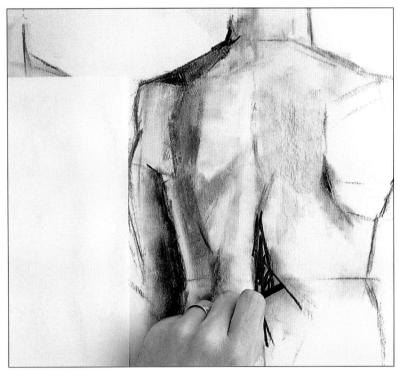

10.

Build in light shades, alternating between short and longer charcoal as appropriate, and leaving the lightest areas as clean paper to show highlights. Notice the soft texture on the back where there are fewer muscles and there is less definition. Shade in the dark shadows of the arms with very dark lines. Draw even darker lines to show the central spine.

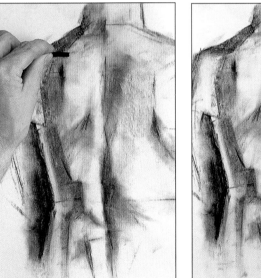

11.

Build up shapes and shadows. Notice the definition between the shoulder blades and the softening of the flesh around it.

12.

Check the whole image for areas that could be defined more clearly. Be sure to leave lots of white space for the highlight areas.

13.

Now draw the backs of the legs. Measure the proportions carefully. Draw a light guideline across to help with the proportions, plus a line down the centre of the calf. After you've sketched one leg, extend the guideline across and sketch in the second leg, using the scale of the first leg to help you. Using the side edge of the charcoal, strengthen lines once the shape is basically correct. Notice the squarish shape of the feet and prominent ankle bone.

14.

Block in the shaded area with the thick side of the charcoal. Use very dark shading on the inner legs, lighter on the outer legs. There is also dark shading on the inner ankles and on the floor between the feet to give the picture a base. Now sketch in lines around the foot and give the toes some darker shading.

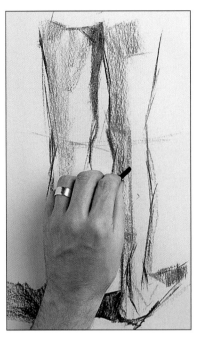

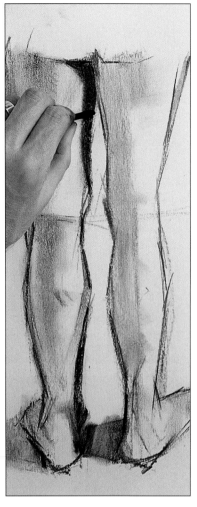

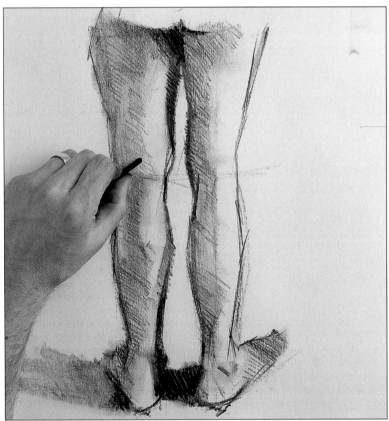

15.

Gently blend in the shading to bring the picture to life. Leave areas of paper white for the highlights. Sketch in the inner edge of the left leg. Notice how the shadow creates the edge. Notice also the angular shape of the ankle bone.

16.

Add final details and build up layers of shadow, using the side of the charcoal to create the dark shading.

17.

Now draw the front of the legs. Draw a light line across the knees, strengthening it once you feel sure of the proportions.

18.

Now start to sketch in the shadows, using strong lines to show the dark areas between the legs. Draw strong lines around the knee to show the muscle. Use smooth, long strokes to sketch in the lighter areas of shadow. Block in the shadows on the feet to anchor the picture.

19.

Gently blend in the shading. Vary the direction of the blending so that it doesn't look uniform. Leave clear areas of white for highlights.

20.

Add the linear shading, following the shape of the shadows. Apply dark shading between the legs. Draw in the shadow around the feet to create a suggestion of weight. Add a few sharper lines across the knee, then blend them in. Finally, spray the picture with fixative.

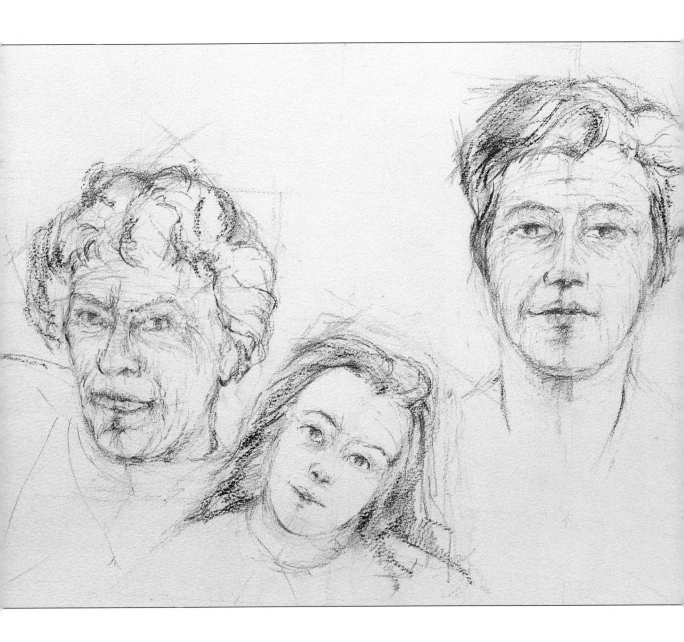

Project
3

HEADS

This project takes three generations of the same family as its subject. The use of a single colour heightens the comparative effect of the work. The fact that the subjects are all part of the same family allows the artist to focus on the changes caused by the ageing process. These include deep anatomical changes as well as the more obvious surface ones. A knowledge of the anatomical changes that take place over the years of a person's life enables an artist to know what to expect and therefore to capture the features that convey age. A comparative study serves to highlight these features.

Charmian Edgerton
Three Generations
30 x 40cm (12 x 16in)
Red Chalk

Anatomy and Age

The ageing process dramatically affects the outer appearance of the human body. It starts to be noticeable in middle age, causing a number of physiological changes. However, of most relevance to the artist are the weakening of the muscles and loss of elasticity in the skin. This causes features such as the skin to wrinkle and the skin under the eyes to sag.

There are also other changes that occur to the human body with age. In comparing the three heads in this project we notice not only the changes in the outer appearance of the face, but also changes in the shape of the skull itself. When we are born, our skulls are much larger in proportion to the rest of our bodies than when we reach adulthood. This is due to the fact that our brains grow faster than our bodies at this early stage. Human beings are unique in the animal world for the amount of development of the brain and the skull that occurs after birth. A newborn baby has large areas of soft cartilage in place of bone in the calvaria (the domelike part of the skull). As we grow, bone develops over these areas. We start life with bulges on either side of the forehead (the frontal eminences) and on both sides of the calvaria (the parietal eminences). However, the facial areas are much smaller in proportion to the skull as whole. This ratio is what gives babies and children their distinctive features.

THREE GENERATIONS

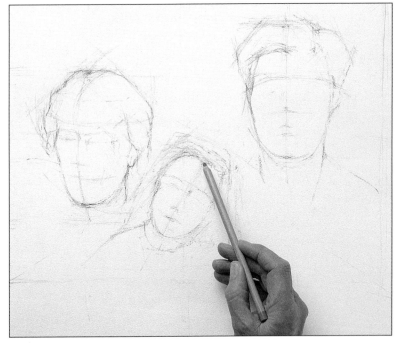

Materials and Equipment

• RED CHALK PENCIL

• HEAVY CARTRIDGE PAPER

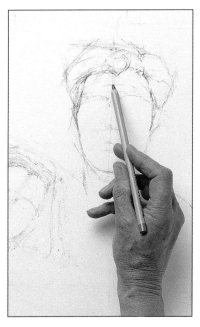

1.

First, mark out your paper. Draw a light rectangle, divided down the middle and then cross it off into 16 squares. Make some marker points for the top and bottom of the heads and then draw in some basic egg shapes. Outline the hair and mark in the positions of the facial features.

2 ▶

Look at how the light defines the nose, the brow, the chin, etc. Draw in the basic forms, thinking about the underlying bone structure. Don't draw in the eyes at this stage.

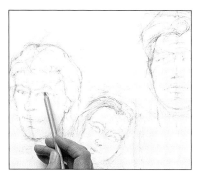

3.

Mark in the dominant eyebrows of the grandmother. Also emphasize the top of the cheekbones.

4.

Mark in the grandmother's eyes. Now move on to the child. Her features are softer and less defined, so use gentler touches.

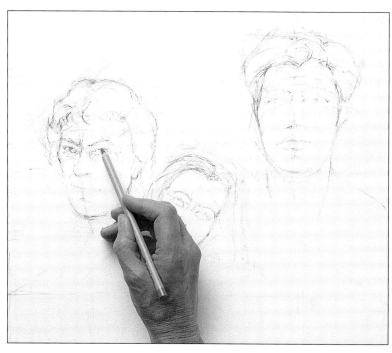

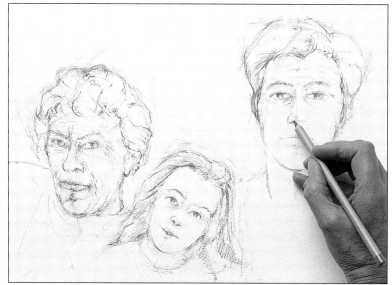

5.

The mother's features have become defined by age, but the flesh has not receded as the grandmother's has. There are more lines to draw than on the child's face, so sketch these in gently first before defining them.

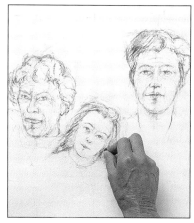

6.

Now that all the basic forms are in place, go over each face defining the detail. The child's face should be fairly free of marks, the mother's slightly more detailed and the grandmother's the most interesting. Pay particular attention to the eyes of the mother and grandmother. Age makes the eyes particularly expressive, as the muscles weaken and the surface flesh droops.

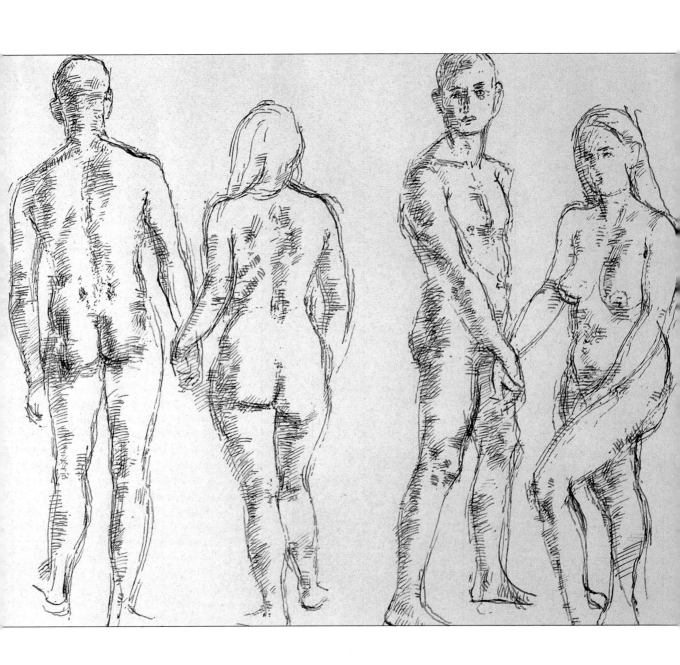

Project

4

MALE AND FEMALE

This pen and ink project focuses on the visible anatomical differences between the male and female form from both the front and rear views. Although the figures are heavily cast in shadow, light and tone should not be emphasized in this composition, as they are likely to distract attention from the differences in form and anatomy. Both views subtly stress this difference: the man stands straight and static in both photographs, while the woman takes a more active pose, as well as reaching out towards the man to hold his hand.

James Horton
Comparative Study
32 x 48cm (13 x 19in)
Brown Ink

Comparing Male and Female

In this picture we see the most typical differences in superficial anatomy between the sexes. In addition to the height difference between the two figures the most noticeable differences in the overall body shape are the shoulder to hip ratio and length of back to legs ratio.

Notice the steeper angle of the trapezius in the male, as this is generally a more powerful and well-developed muscle. Also the muscles of the hips and pelvis are much more tightly defined compared to the larger equivalent on the female. In these two subjects the gluteus muscles would be much larger in the male, but superficially the female's buttocks are much larger due to the accumulation of fat. It is interesting to note that the contours of the legs are very similar, due to the minimal amount of fat. In this standing pose the muscles are relaxed and there are no specific regions of stress. The spine and pelvis are the principal supporting structures in this position, and the line formed by the erector spinae dominates the back.

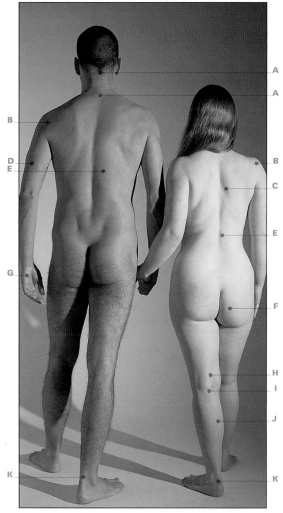

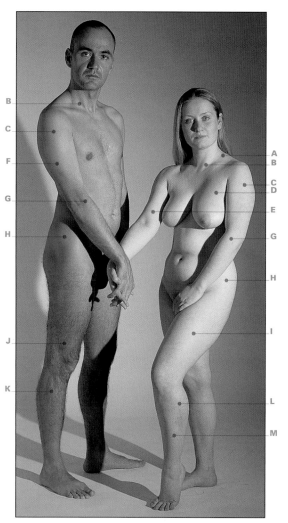

Above: A trapezius, **B** deltoid, **C** scapula, **D** triceps brachii, **E** erector spinae, **F** gluteus maximus, **G** ulna, **H** biceps femoris, **I** common tendon of sartorius, gracilis, semimembranosus and semitendinosus, **J** gastrocnemius, **K** tendon calcaneus

Above: A trapezius, **B** sternocleidomastoid, **C** deltoid, **D** pectoralis major, **E** biceps brachii, **F** brachialis, **G** extensor carpi radialis longus, **H** gluteus medius, **I** vastus lateralis, **J** biceps femoris, **K** peroneus longus, **L** gastrocnemius (outer head), **M** tibialis anterior

COMPARATIVE STUDY

Materials and Equipment

- BROWN INK • OLD-FASHIONED DRAWING NIB • CALLIGRAPHER'S DIP PEN • HEAVY CARTRIDGE PAPER • PENCIL

1.

Using an old-fashioned drawing nib and brown ink, sketch out the tallest figure first. You need to outline the tallest figure before looking at the relationship between them. The linking place should be sketched first. This provides a central reference point for the whole composition. Sketch in the outline and muscle tone at the same time, beginning with light strokes.

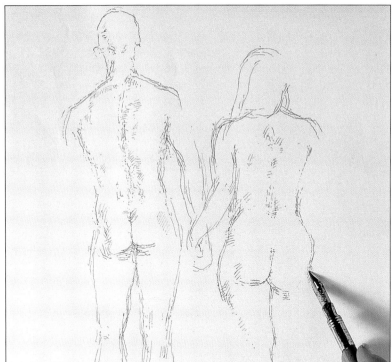

2.

Once you have lightly outlined the proportions of the man, work out the proportions of the female. Note the angles of the bodies and plot key landmarks: the curvature of the spine and buttocks, the position of the legs. The woman should have less muscle construction and more fat: do not be tempted to add too much definition to her shape, or you will lose this softness.

3.

Strengthen the shape of the composition by re-evaluating the relationships between the different parts of each body and between the two figures. Tracing down the backs and legs will emphasize the natural curve of each body.

4.

Use the first illustration as a reference point when beginning the front view. Avoid starting too low down, as the two sets of figures need to be in proportion to each other. Start with the tallest figure, sketching out the form lightly, and then building up a series of layers. The facial features are important for the front view: begin by outlining their basic proportions rather than the details, since a simple outline creates a stronger impact.

5.

To sketch the female figure, again begin where the hands link. Look across to get the proportions correct: for example, the man's navel lines up roughly with the woman's left nipple.

6.

Use the straight edge of a pencil to establish the position of the woman's knee: it lines up vertically with the edge of her right hand, and horizontally with the man's knee.

7.

Great care should be taken when drawing the legs and knees because of the 'negative', undefined space between the two figures. If this space is disproportionately large or small, the figures will not look natural. To avoid problems, do not develop one body area too far ahead of another, but build up the features gradually together.

8.

Once the outlines are complete, pick out the detail and increase the definitions. Make sure the two sets of figures match in tone and style: observe the thickness of the lines and work out which features have been emphasized.

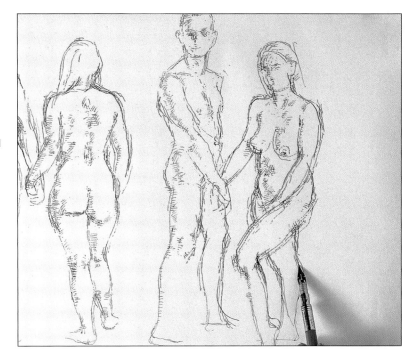

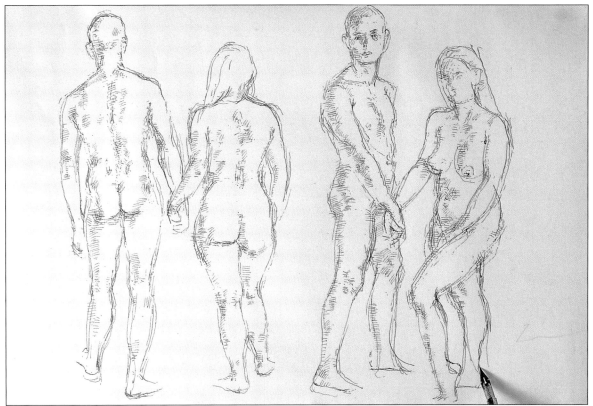

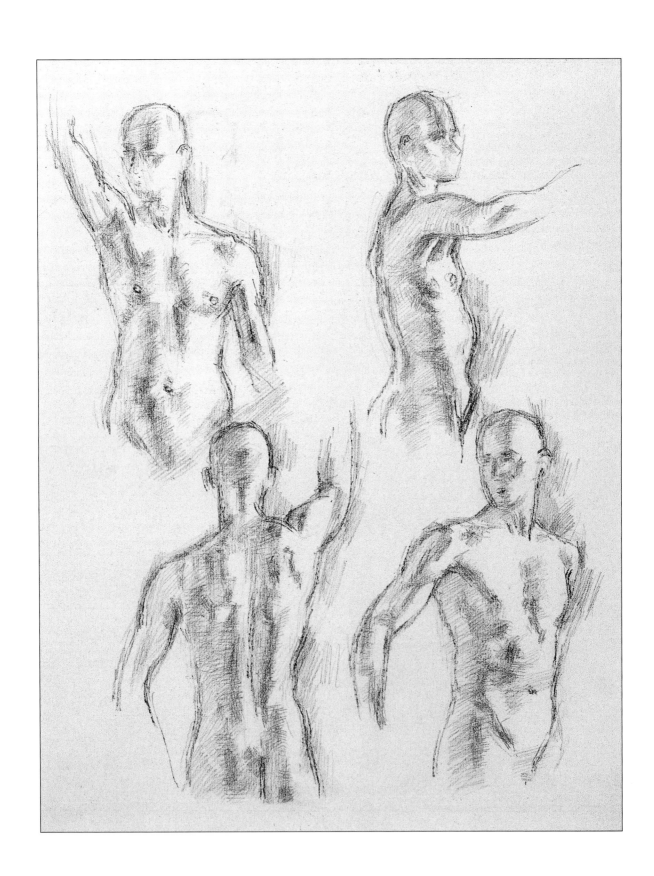

Project
5

MALE TORSO

In this carefully observed study the artist provides a simple but comprehensive image of the male torso with a series of pencil sketches from front, rear, side and twisted positions. The four views allow the artist to explore the various surface muscles on the chest, shoulders, neck and back simultaneously through using lines and shading built up with a combination of lighter and darker strokes. Generally, the style of shading is loose to suggest the outline of the form and convey a sense of movement. The four illustrations should be viewed as a single composition, and as such, they should be of a proportionate scale and highlight the same parts of the male anatomy.

James Horton
Four Studies
30 x 20cm (12 x 8in)
Pencil

135

Upper Body Muscles

In order to keep the arm raised, the latissimus dorsi must be extended. With the head turned to one side, the sternocleidomastoid muscle in the neck becomes very prominent – this is especially noticeable on the first and last photographs. A deep furrow is formed on the front of the body, caused by the sternum (breast bone) and the rectus abdominis muscles (stomach). On the rear view, an even deeper furrow down the spine is created by the powerful erector spinae muscles. The pectoralis muscles, by contrast, appear as flatter expanses of flesh.

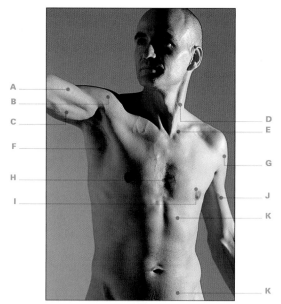

Above: **A** biceps, **B** deltoid, **C** triceps, **D** sternocleidomastoid, **E** clavicle, **F** latissimus dorsi, **G** deltoid, **H** sternum, **I** pectoralis, **J** biceps, **K** rectus abdominis

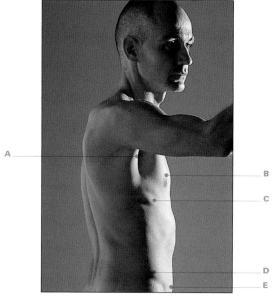

Above: **A** latissimus dorsi, **B** pectoralis, **C** serratus anterior, **D** external oblique, **E** rectus abdominis

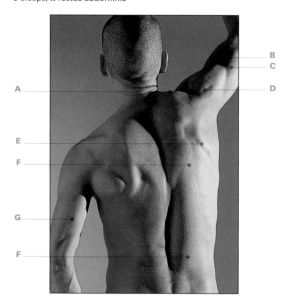

Above: **A** trapezius, **B** biceps, **C** brachialis, **D** deltoid, **E** scapula – showing rotation over ribcage, **F** erector spinae, **G** triceps

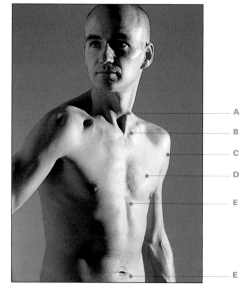

Above: **A** sternocleidomastoid, **B** clavicle, **C** deltoid, **D** pectoralis, **E** rectus abdominis

FOUR STUDIES

1.

First, roughly position each pose on the page. Lightly sketch in the top left pose first – start from the head and work down the body. Once you have sketched in the first figure, check the scale to see if all four figures will fit. Take your time, as even experienced artists have difficulty calculating the correct scale. You can also overlap the images as a way of linking them together.

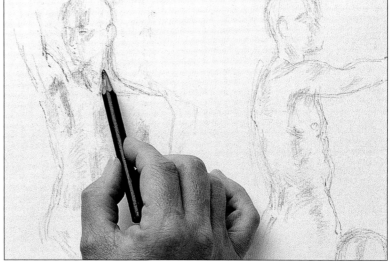

2.

Sketch in the figures with a series of light, short strokes that overlap – this will create a soft, natural outline. Let your intuition and the shape of the muscles guide you with the shading, which can be vertical, horizontal and cross-hatched. Work in the detail of the sternocleidomastoid, the main muscle connecting the collar bone and the back of the head.

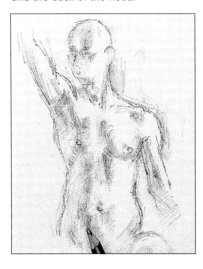

3.

Deepen the shading to show the join between the pectoralis major (the largest chest muscle) and the anterior deltoid (shoulder) muscle. Outline the rectus abdominis, which links the ribcage to the pelvis.

4.

Now move on to the third figure. Begin by shading the back of the head to show the roundness. There are several layers of muscle on the back, some of which appear as surface features. You can begin to shade in the trapezius.

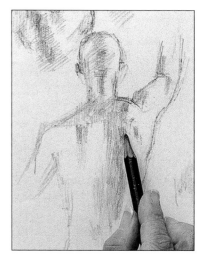

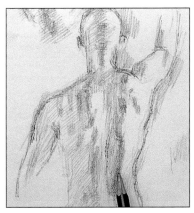

5.

Using vertical shading, emphasize the ridges of the erector spinae down each side of the spine, all the way from the pelvis to the neck. Many of the other back muscles are sheet-like and should be highlighted with shading. Light, diagonal strokes along the outside of the body will suggest the shape of the latissimus dorsi, while a heavier line under the arms will emphasize the teres major.

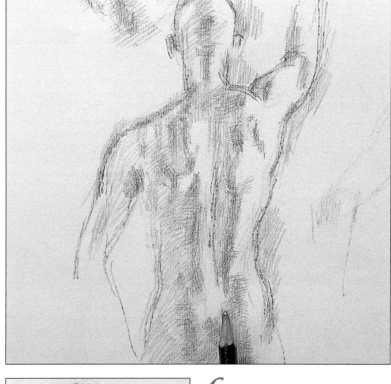

6.

Add the final detail, deepening the shading. Sketch a very light line down the centre of the back to bring out the posterior median furrow. Leave areas of the paper untouched to emphasize the areas of light. You can also sketch in the beginnings of the gluteus medius (buttocks).

7.

Now move on to the third picture. First define the head (note that it is turned slightly to the right). This side-on pose shows the construction of the armpit, which is formed by the angle of the latissimus dorsi and the pectoralis major.

8.

Down the side of the body there is quite a dramatic contrast. Using some heavy strokes, define the serratus anterior muscles, which are the most heavily shaded part of the abdominal muscles. Lightly shade the shoulder and latissimus dorsi to provide definition. Also, a little background shading will help emphasize the body line.

9.

Using light strokes, increase the shading down the back to show the definition between the front and back. Sketch in the buttocks, to link in with the second picture and bring the composition as a whole together.

10.

Sketch in the head, using a clear line to mark the sternocleidomastoid and to demonstrate that the head is turned. Shade along the top of the arm to give good definition to the biceps. Lightly shade in the edge of the pectoralis major, cross-hatch the serratus anterior, and very lightly shade the outer edge of the body to show the latissimus dorsi.

11.

Darken around the rectus abdominis – vary the angle of the shading to emphasize the different muscles in this group. Shade in the head, suggesting the features rather than drawing in detail. Shade in the line showing the external obliques along the front of the pelvis. Remember that loose shading adds a sense of movement to the composition.

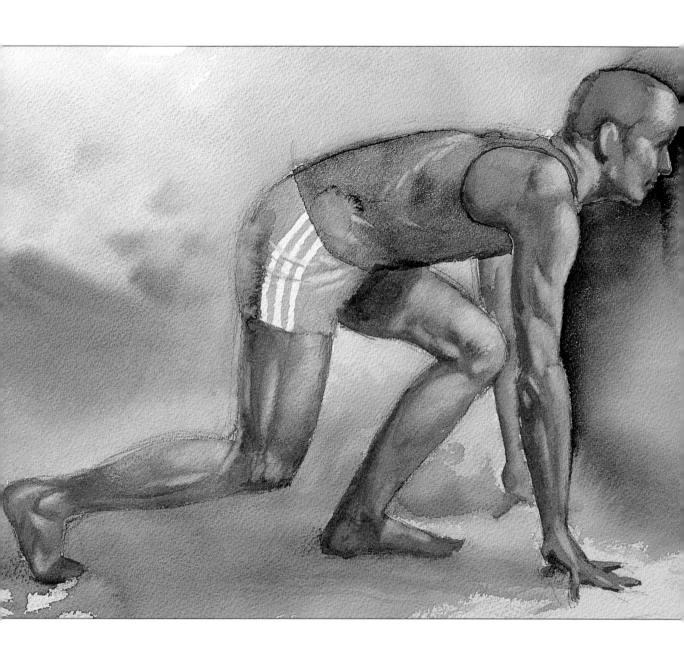

ATHLETE

The figure used in this project is focused and ready for action. Muscles and tendons are in a state of tension, and the whole body seems to point in the direction the runner is about to go. Here the anatomy tells an important part of the story of the picture, as the muscles and tendons display the fact that the figure is ready for movement. The arm in the foreground is especially effective in this role, and the artist highlights this area by making the muscles and tendons evident, to enforce the idea of imminent forward motion.

John Barber
Tensed Muscle Study
38 x 56cm (15 x 22in)
Watercolour

Observing Muscle Tension

In this project the aim is to show tension, the sort of tension that is used just prior to forward propulsion. What is also essential to this position is balance. Here the artist needs to observe and place each limb very carefully or the figure will not balance correctly. The use of horizontal and vertical measurements would be useful in this pose to check on the angle of the limbs. It is also a perfect position for using the negative shapes that exist between the legs and arms to gain extra accuracy.

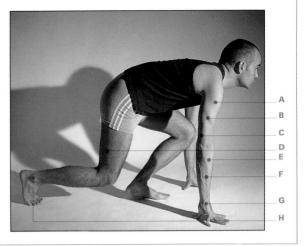

Right: A deltoid, B triceps brachii, C tendon of triceps, D vastus lateralis, E extensor carpi radialis longus, F extensor carpi ulnaris, G ulna, H lateral malleolus (fibula)

TENSED MUSCLE STUDY

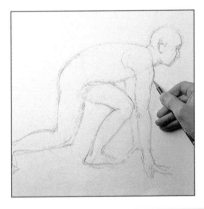

1.

Sketch in the outline of the figure with a graphite pencil. Place the figure in the centre of the paper, with about 2.5cm (1in) outside the drawing to the edge of the paper. This allows for lengthening of the limbs if you make an error in your initial proportions. Note that where the tendons are close to the surface, the outline is quite straight, whereas muscle creates curving shapes.

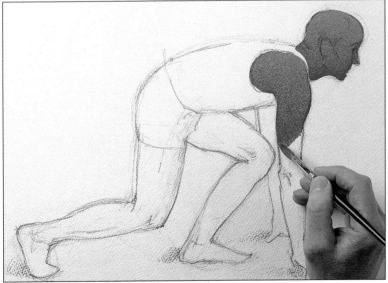

2.

Mix yellow ochre and burnt sienna (slightly more sienna than ochre). Apply this in a flat wash over the flesh areas of the body. Use a number 10 brush with a good point.

142

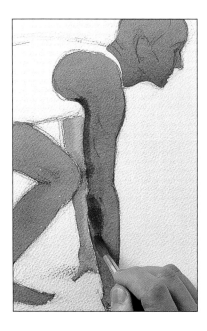

3.

Add a little raw sienna to the mixture and use this to touch in the shadows. Do this while the first wash is still damp.

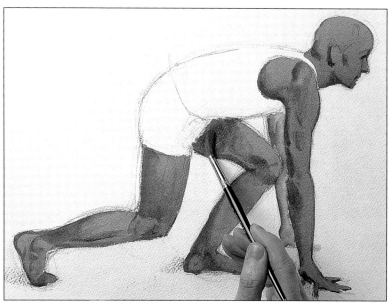

4.

Add some raw sienna to make a deeper tone for the darkest areas of shadow. Apply this to the groin area.

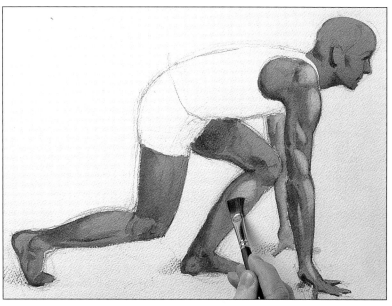

5.

Use a clean ¼ inch flat nylon brush with a flat head dipped in clean water to lift out areas of paint for the highlights. Gently stroke the surface with the wet brush and then blot the area with tissue.

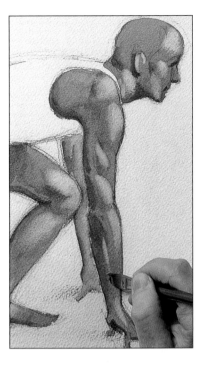

6.

Continue adding highlights until the variations of light and shade give a good impression of the general anatomy of the figure.

7.

Mix a weak wash of Prussian blue and violet for the shorts. Apply this to the whole area and then lift out paint for the stripes and the creases. Use pure Prussian blue for the running vest, blocking in the colour over the whole area.

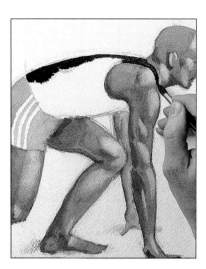

8.

While the paint for the vest is still damp, dab more colour into the area and tilt the paper so that darker paint runs where you want it, creating shadows on the material. Use raw sienna with a little Prussian blue for the cropped hair.

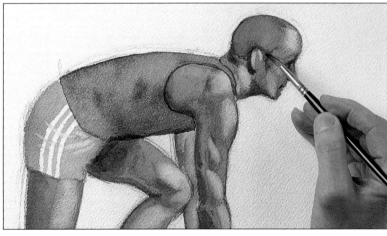

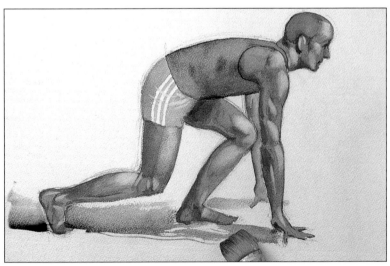

9.

Use Prussian blue with a little violet and light red and lots of water for the shadow under the figure. Let the paint run up to the edge of the area to create a sense of perspective, but try to keep the lines sharp.

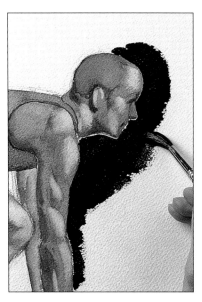

10.

Now mix some Prussian blue into the mixture; wait until it is a little dryer, then use it to outline the runner's face and the upper part of his arms.

11.

Now use a 1½ inch nylon brush with lots of water to create the background. Use the wet brush to move the paint already on the page around. Be careful not to allow paint to run back over the figure.

12.

Let the wash go over the legs to focus attention on the arms and face. Finally, add some light red to the area behind the runner.

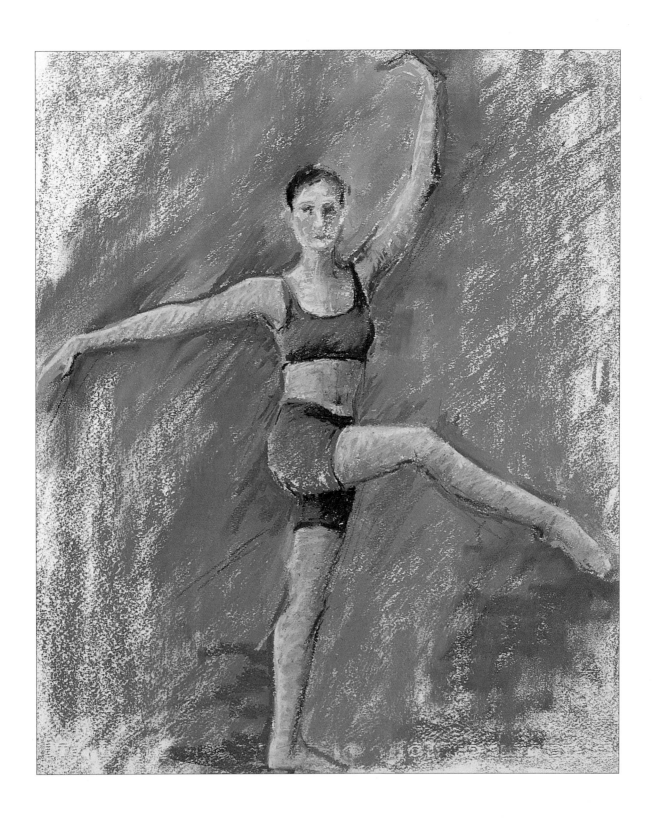

DANCER

The entire weight of the dancer in this project is supported on one leg. Yet she maintains perfect balance while creating graceful shapes with her arms and other leg. This is a study not of the body under tension but of the body used to express grace and poise. An understanding of anatomy is vital here in order to get the proportions of the figure right and to make sure that the pose is recorded correctly. The torso, neck and head are held upright, while the arms and upper leg form curves away from the body. Although the pose looks effortless, muscles and tendons are at work beneath the surface. The artist is careful to pick these out without losing the overall grace of the image.

Charmian Edgerton
Grace
55 x 38cm (22 x 15in)
Charcoal and Pastel

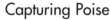

Capturing Poise

To elevate the arms up to the horizontal position, the deltoid in the upper arm is used. In order to raise the arms above horizontal, the trapezius and serratus anterior come into play. The serratus in particular enables the scapula to rotate across the ribcage, which in this case is almost vertical along the humerus.

To raise the leg into this position the muscle group known as the quadriceps femoris is used. As the upper leg is moving towards the centre of the body there will also be some assistance from the adductor group, including the gracilis muscle. In this subject the muscles provide strength and control. The extended arms and leg help balance the supporting foot.

Left: **A** deltoid, **B** extensor carpi radialis longus, **C** radius, **D** humerus, **E** biceps brachii, **F** lattissimus dorsi, **G** flexor carpi radialis, **H** tendon of biceps brachii, **I** pectoralis major, **J** rectus abdominis, **K** patella, **L** tibialis anterior, **M** medius malleolus, **N** lateral malleolus, **O** Achilles tendon

GRACE

1.

Start by dropping a very faint line in charcoal down the centre of the paper. Sketch in the head and the arms in light charcoal. Make sure you get the proportions right.

2.

Use the head to get the size of the body right: the body is about 6½ times larger than the head. Mark a centre line down the body. Continue to sketch the body and correct mistakes as you go. Smudge some of the lines with your finger to give the impression of movement.

Materials and Equipment

- SMOOTH, WHITE PASTEL PAPER
- CHARCOAL • PASTEL COLOURS:
 LIGHT YELLOW, CHROME YELLOW, BURNT ORANGE, DARK BURNT ORANGE, BLUE-GREEN, GREEN-BLUE, ULTRAMARINE BLUE, PRUSSIAN BLUE, LIGHT PINK, LIGHT RED, PERMANENT ROSE, VERMILLION, PINK-VIOLET, MID-VIOLET, DARK VIOLET, INDIGO, PURPLE (4, 6, 8), BURNT SIENNA, VANDYKE BROWN
- TISSUE • PUTTY ERASER

3 ▸

When the figure is outlined, go back and fill in some of the detail. When you have all the elements on the paper, brush off the surplus charcoal with clean tissue. Excess charcoal will interfere with the pastel colour.

4 ▾

Fill in the background with ultramarine blue and blue-green pastel. These two colours will complement the skin tones to be used to colour the figure.

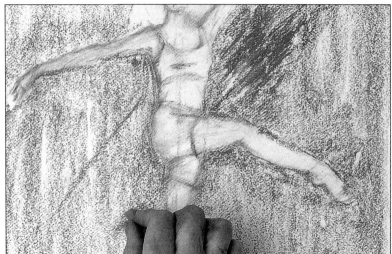

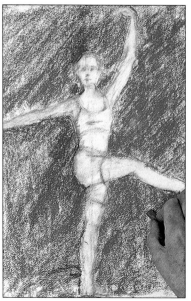

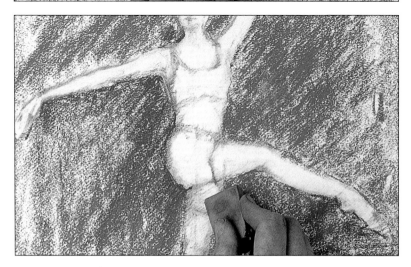

5 ◢

Use the side of the pastels to block in the background colour. Smudge in the two colours lightly.

6 ◂

Use ultramarine blue to block in around the figure. Now use a clean putty eraser to rub out the charcoal lines. Use the eraser as a drawing tool in its own right, following the flow of the body. Don't go over the pastel, as it will just smudge.

7.

Use a very dark purple to colour in the darkest areas of the figure: the top of the head, under the breast, the waist band and the upper thigh of the back leg. Now use indigo to add depth to this tone and put some Prussian blue lightly over the top so that the other colours show through. Now use a lighter purple to colour in the unshadowed parts of the clothing.

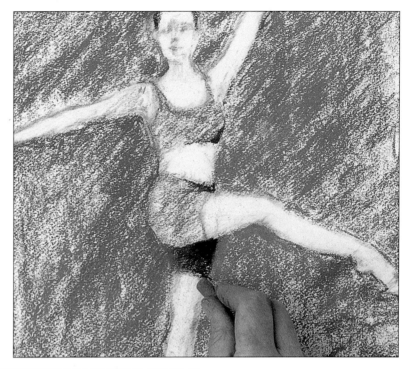

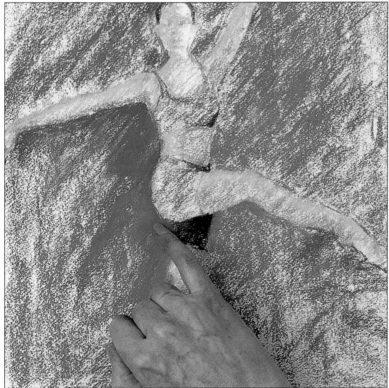

8.

Use a light violet to add the base tone to the skin. Then use a pink-violet pastel to block in the lighter areas and a mid-violet for the mid-tones. Now smooth the background colours around the figure with your finger. This will make the transition between the figure and the colours of the background softer – hard edges will leave the picture lifeless.

9.

Use burnt sienna for the hair and then pick out highlights with Vandyke brown, light red and permanent rose. Use the last colour to highlight areas of the clothing.

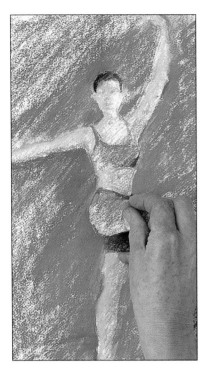

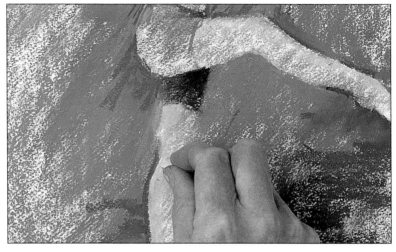

10.

Outline the edge of the figure to emphasize the form. Use a mid green-blue and a mid blue-green. Add some mid green-blue to the background. Use a light pink to enhance some of the highlights on the skin.

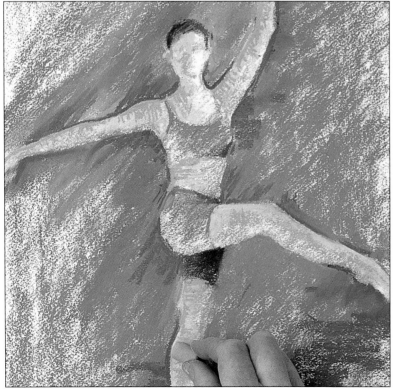

11.

Use burnt orange to start to emphasize the muscles. Work your strokes across the form to show the roundness of the shapes.

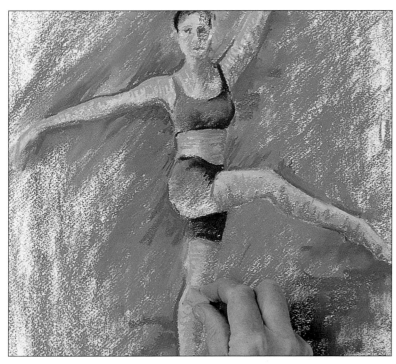

12.

Mark in the eyes with a dark purple. Apply a mid-violet in downward strokes to get a slight cross-hatching effect. Use a dark burnt orange on the underside of the arm, the neck, the underside of the legs and the front of the supporting leg. Add a dark purple to the clothing to show the top of the leg and the shape of the breast. Smudge in the orange tones.

13.

Use a light yellow to accentuate the muscles of the calf, using strong strokes to apply the colour. Continue to accentuate the dark tones with dark burnt orange, particularly the underside of the upper arm and the abdomen. Use some dark violet for the top of the upper leg.

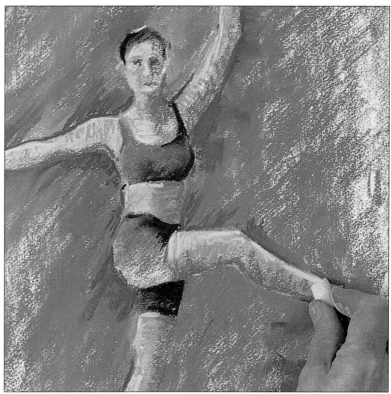

14.

When you approach the completion of the picture do not rub in the colour too much, as this will give the image a flat look. Add the final touches to the background by putting in a few lines of burnt sienna. This will chime with the colours used in the figure.

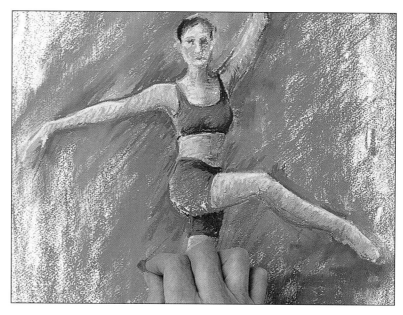

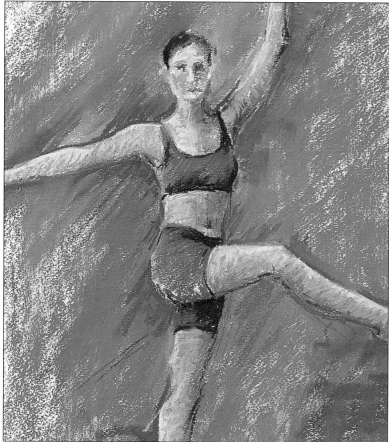

15.

Now mark in the final detail. Use vermillion red and chrome yellow to exaggerate some of the muscles in the stomach area. Use indigo for the navel and for the vertical muscle lines. Vermillion brings warmth to the shadow on the legs as well as to the buttock area.

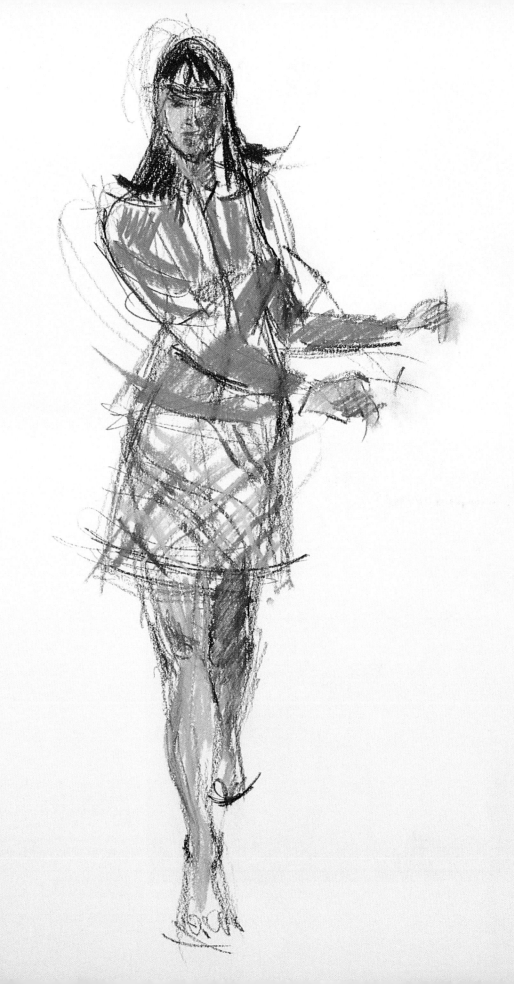

Figure Drawing

PATRICIA MONAHAN
with
Albany Wiseman

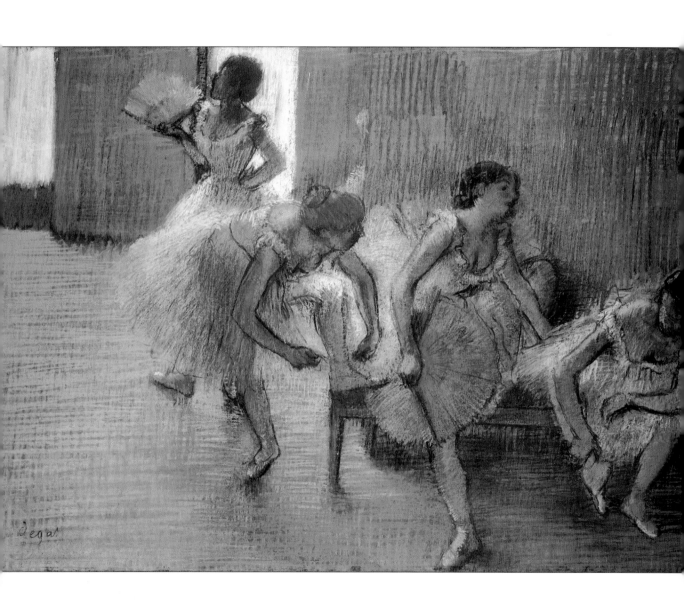

INTRODUCTION

For the artist, the human figure is infinitely absorbing and inspiring – it is a subject to which Western artists have returned time and time again. Attitudes to the human body and the way it is depicted in art have varied throughout the centuries and seem to reflect a society's social structures and religious beliefs, as well as its views on the importance of the individual. In fact, concern with the portrayal of the human form is not universal; the art of Islam prohibits the depiction of any living creature on religious grounds.

The art of ancient Egypt was a funerary art, designed to glorify a dead pharaoh or other powerful person and to magically ensure that the dead were supplied with all their needs in the afterlife. The figures in surviving tomb paintings have a flat, stylized quality, with clear, crisp outlines infilled with flat colour. Each part of the figure was depicted from its most recognizable angle. Feet were shown from the side, one in front of the other, while the head was in profile with the eye shown from the front. The shoulders were straight on, hips and legs were in three-quarter view and the torso was slightly turned. Identity was established by inscriptions rather than physical likeness. Artists were craftsmen who worked to a rigid set of rules and Egyptian art changed little over 3,000 years.

The Ancient Greeks were concerned with the ideal beauty of gods, heroes and humans. From ancient writers we know that they attributed great importance to drawing, but the best record of Greek figurative art is their pottery which was elaborately decorated. Prior to the fifth century BC, the figuration was geometric, stylized and worked

Dancers on a Bench
Edgar Degas (1834–1917)
Pastel on tinted paper

Degas was a virtuoso draughtsman who drew from the model in a range of media. He achieved glowing flesh tones in his pastel paintings by overlaying strokes in many different colours. Despite their apparent spontaneity, his 'finished' pastels and paintings were usually made in the studio.

An Actor Standing
Rembrandt van Rijn (1606–1669)
Chalk on tinted paper

Dutch artist Rembrandt was a gifted and insightful student of the human form. In this assured drawing, he has used a variety of techniques to capture the volumes of the figure, using fine lines in the lighter areas and applying the chalk with more vigour for the darker tones and heavy creases of the actor's cloak.

black on red. Later, in the classical period, figures were picked out in red against a black ground and were elaborated with line to give the forms more detail and solidity. Artists also attempted to suggest space and recession by overlapping elements. These drawings, made 2,500 years ago, look remarkably modern and realistic.

The Life Class *Edward Ardizzone (1900–1979) Line and watercolour*

The English artist and illustrator, Edward Ardizzone, had a marvellous ability to sum up a character with a bold, gestural outline. Cartoonists and illustrators must convey the essence of a subject quickly and efficiently, and this requires excellent draughtsmanship and knowledge of the human form.

The Romans borrowed heavily from Etruscan and Hellenistic art. They were more concerned with the actual rather than the ideal view of the figure and produced some very realistic 'warts and all' portraits.

The Renaissance was crucial to the development of Western European art and culture. It can be dated from the early fifteenth century in Florence, reaching its high point in the early sixteenth century, by which time it had spread to the rest of Europe. It was a time of intellectual and artistic upheaval and revival. Portraiture and mythological themes became popular and artists sought to represent the human figure naturalistically. They studied proportion and explored ways of depicting solid form, space and depth. This interest in anatomy can be seen in the sketchbooks of Leonardo da Vinci (1452–1519),

which include studies of dissections. The Renaissance was also a time of technical innovation. Artists used a range of drawing media including chalks, charcoal, pen and ink, brush and wash and silverpoint – a technique which used metal wires to create a line on a prepared support. Drawings were used as preparations for paintings, but they were also made as artworks in their own right.

By the seventeenth century, artists were drawing with greater freedom, using a flowing, expressive line. Rembrandt van Rijn (1606–1669) was a master draughtsman with a succinct but lively line. Among his many portraits, he captured the continuing concern with scientific research into the human body in his paintings *The Anatomy Lesson of Dr Tulp* (1632) and *The Anatomical Lesson of Dr Joan Deyman* (1656) in which he depicts the dissection of a human brain.

During the Rococo period in the eighteenth century, France produced brilliant draughtsmen in François Boucher (1703–1770), Jean-Honoré Fragonard (1732–1806) and Jean Antoine Watteau (1684–1721), whose drawings were lively, colourful and charming. With the classical revival at the end of the eighteenth century, free drawing and the spirit of frivolity were abandoned in favour of a more severe style epitomised by Jacques-Louis David (1748–1825) and Jean-Auguste-Dominique Ingres (1780–1867).

Later artists valued an even more personal and expressive style. Vincent van Gogh (1853–1890) used reed pen to create vigorous, often decorative images. Edgar Degas (1834–1917) drew from the model throughout his life, and sometimes recycled a composition by tracing it several times and reworking it in different colours and tones to create a series of variations on the original theme. He was a master draughtsman in many media, including pastel, often using strong, almost expressionist colour.

In the twentieth century, figure drawing has produced many exponents, from Henri Matisse (1869–1954), with his decorative use of flat colour, to Pablo Picasso (1881–1973), who could encompass a figure in a single line.

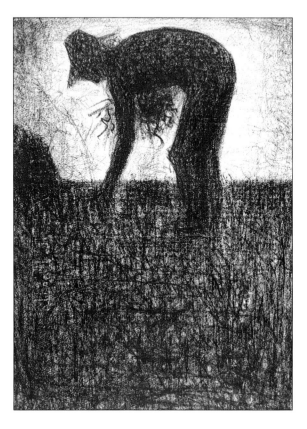

The Gleaner *Georges Seurat (1859–1891)*
Conté crayon

In this simple, evocative drawing, Seurat has built up the dark, stooping figure from layers of wispy, agitated strokes. He has set the bold image against a light sky, so that it is seen in silhouette. This emphasizes the strong shape created by the curve of the man's back and his bent limbs.

You can learn an enormous amount from the great artists of the past and the present. Their drawings of the human form offer the aspiring artist a huge, varied and inspiring resource which can be studied in galleries, museums, books and prints. By looking at the human figure through their eyes, you will see it in a new way, finding solutions to problems and discovering innovative and exciting ways of using materials.

APPROACHES TO DRAWING THE FIGURE

The figure is probably the most important subject in the artist's repertoire. As human beings, we have a natural interest in investigating and recording our own kind, but our close involvement with the subject can make drawing the figure seem more daunting than it really is. One of the aims of this book is to help you rid yourself of preconceptions and see the figure as an abstract assemblage of shapes, volumes, surfaces and textures. Only then will you be able to look rigorously, stripping away the significance and associations of the subject so that you can see objectively. When you've learnt to see, you will be able to draw.

WHY DRAW THE FIGURE?
Until the 1960s, the ability to draw the figure competently was a primary test of artistic skill. Every art school held life classes and all students were required to attend. The thinking behind the curriculum was that if you could draw the figure you could draw anything.

The processes involved in drawing the figure are actually no different from drawing a still life group or a landscape, but our 'knowledge' of the subject and our preconceptions about the way that we look can interfere with our ability to see the figure clearly. All the skills acquired in learning to draw the figure can be applied to other subjects, so if you absorb

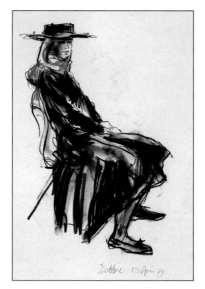

In this striking study of a young woman, Albany Wiseman has used black coloured pencil to establish the figure and then applied bold, black crayon for the dress. The touches of scarlet provide an eye-catching contrast.

the lessons in this book and work through the projects, you will find that not only can you tackle the figure competently and confidently, but your general draughtsmanship will also have improved.

LEARNING TO DRAW THE FIGURE
Drawing the figure is not about specific techniques such as hatching, shading, using a pen or handling a pastel. There are many amateur artists who have a wonderful technique in an array of media, but can't draw. Being able to get the best from your chosen medium is an advantage, and a beautifully handled line or a well-laid wash will add to the viewer's enjoyment of an image, but it won't make a poor drawing better, nor will it make a badly proportioned figure look convincing.

The ability to draw the figure accurately and confidently is gained from an understanding of the proportions of the figure, its structures and volumes and the extent and limitation of its movements. The exercises in this book are designed to give you that understanding.

WARM-UP EXERCISES

Before you start a drawing session, try some or all of the following warm-up exercises. They will help to dispel the fear of the blank white page and the hesitation that is inevitable when you begin.

You will need a good supply of cheap paper and some charcoal, chalk or a soft (6B or 4B) pencil – whichever medium you feel most comfortable with. Try to persuade a friend or a member of your family to pose for you. If you are really stuck for a model, you can always draw yourself in a mirror. Secure the paper to a drawing board with bulldog clips or masking tape, and position yourself comfortably.

Exercise 1: Use a single line to draw around the silhouette of the figure. Avoid the temptation to put in any details. You should end up with a continuous outline containing an empty space. If the figure is crouched, seated or kneeling, the shape may look a little strange. Now try the same exercise but don't look at the paper – keep your gaze fixed on the subject. See if the end of your line links up with the beginning of the line.

Exercise 2: Make a quick line drawing using your left hand, or your right hand if you are left-handed. Because you are engaging a different part of your brain, you will find that you bypass your normal assumptions about the figure and produce a surprisingly lively drawing.

Exercise 3: For this exercise, cut a rectangle in a sheet of paper or card and hold this up in front of you so that it frames the subject. Make sure that some parts of the figure – for example, the head and the feet in a standing pose – are cropped by the edge of the frame. Now draw the spaces which are trapped between the figure and the edge of the frame. You'll find that by drawing 'nothing', you have actually drawn the figure.

ABOUT THIS BOOK

Each section of the book deals with a basic principle, such as reducing the figure to simple geometric shapes, considering the way the bony skeleton and the soft tissues affect the appearance of the figure or drawing with line or tone. You are then invited to apply these concepts in a series of associated projects. Read through the project and then set up a similar pose. Draw the figure, applying the concepts outlined in the theory boxes and the project.

Remember that it is the process that is important, not the finished image. You often learn more by making mistakes, recognising them and righting them than by producing a

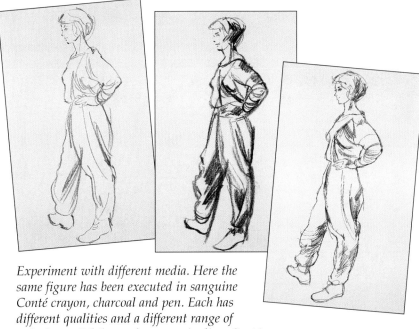

Experiment with different media. Here the same figure has been executed in sanguine Conté crayon, charcoal and pen. Each has different qualities and a different range of techniques. While pen has a precise line, Conté crayon and charcoal are bolder and more direct.

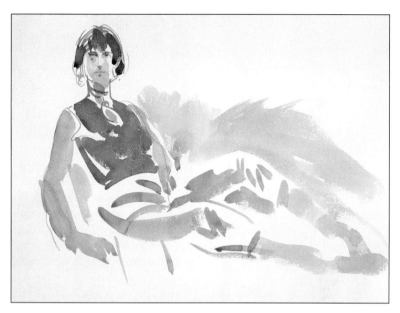

This study was made directly using brush and watercolour. It has a force and simplicity which could not be achieved in any other way.

perfect 'finished' drawing. Practice will improve your ability to see and to draw accurately, and inevitably your manual dexterity and the skill with which you handle different media will also improve.

WORKING WITH THE MODEL

The best way of finding out about the figure is by direct observation, which means using a model. You need cooperation for subjects such as the figure in arrested motion (see pages 184–191), but often you can draw friends or family as they relax watching television or reading. Alternatively, drawing yourself in a mirror is an excellent way of making studies of particular features such as the head or hands and feet. However, if you are really to get to grips with the volumes of the figure in a variety of poses, you need to work from a model. If you can get a group

of artists together, you could hire a model or take turns to pose for the group. You can also attend a life drawing class at a local college – they offer excellent opportunities to work from the nude at very little cost.

Be considerate to your models, make sure that they are comfortable and allow them a break at regular intervals. Chalk or masking tape can be used to mark the location of the body, so that the model can easily resume the pose. And, if the pose isn't exactly the same, adjust your drawing to accommodate the changes.

When you are setting up the model's pose, think about the background and the lighting. The background can become an important element in the finished image and it can also enable you to draw more accurately (see pages 180–181). Clothes can be used to add

character, create a mood or add a splash of colour and texture. Fabrics are interesting to draw and can reveal the underlying forms or completely mask them. A large hat often creates an interesting shape on the page and can also be used to reflect a personality or tell a story.

Light is a vital component of any drawing and, by adjusting it, you can affect the amount of detail that it is possible to see and also create a specific mood (see page 210). Strong side light produces dramatic contrasts of

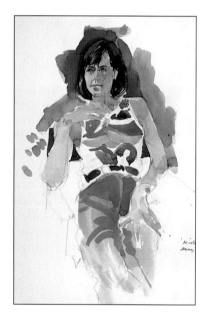

Pencil line and watercolour wash combine control with spontaneity. The figure is beautifully resolved, but the washes of colour give it a fresh and lively quality.

tone and dark shadows, while a more diffuse overall light allows you to see the entire figure in detail.

TYPES OF DRAWING

The human figure is uniquely flexible and expressive, and lends itself to many interpretations. A figure drawing may be made as an exercise, a record, an investigation, a preparation for another work, or it may be a 'finished' work in its own right. Some drawings are developed slowly over a period of time and have a cool, restrained quality while others are dashed down at great speed and retain the immediacy of the moment. The subject will affect the approach and the mood of the drawing so, for example, an informal drawing of a young child will have a different feel from a formal portrait of a distinguished adult.

As you become more accomplished and confident of your abilities, you will inevitably develop a personal drawing style. You will find that certain media suit your personality, method of working and subject matter. Nevertheless, it is a good idea to force yourself to experiment with different media and approaches from time to time – it will keep you alert and your drawings fresh. And, no matter how skilled you become, you should never abandon drawing directly from life. Even the greatest draughtsmen never stopped looking and learning about the figure.

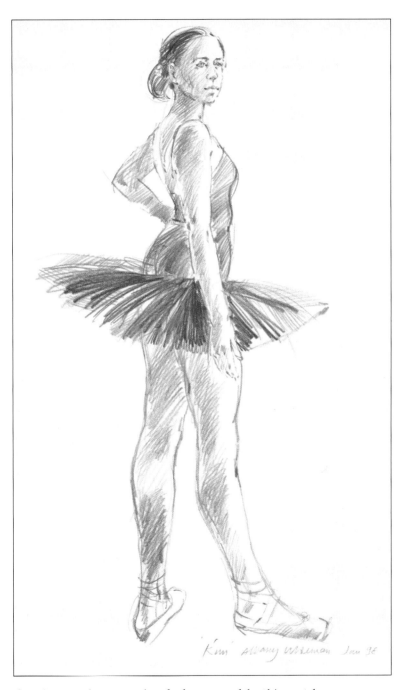

Conté crayon in a sanguine shade was used for this acutely observed and carefully rendered study of a dancer. The artist has combined a precisely drawn line with meticulous hatching, to create an image which has a classical rigour and beauty.

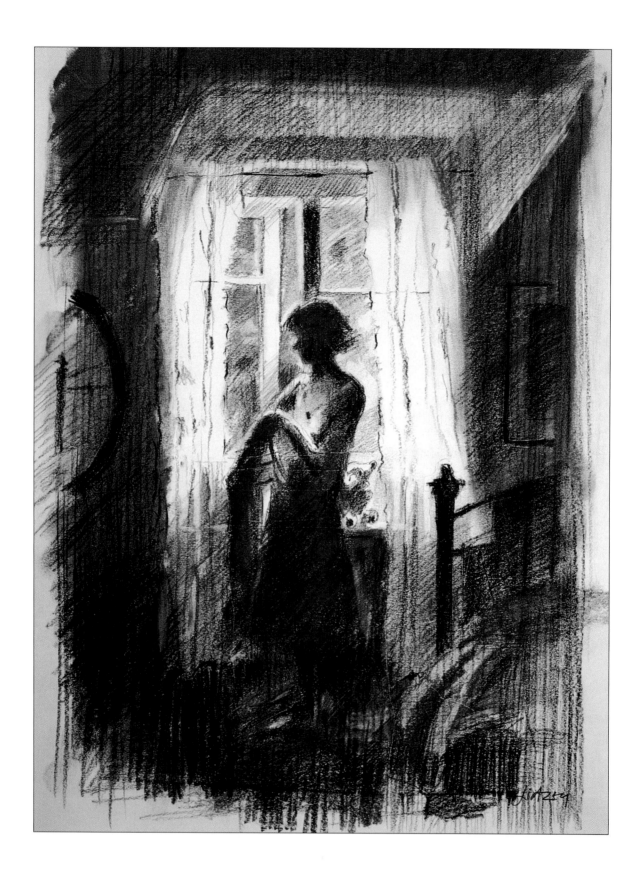

GALLERY

Each artist interprets the human figure in his or her own unique way, and studying these different interpretations can be fascinating, revealing and inspiring. The character of the image will be affected by the intention of the artist, the purpose of the drawing, the nature of the subject and the type of medium and support. Brush drawings in ink or watercolour have a soft and flowing quality, pastel and charcoal are bold and vigorous, while a carefully rendered drawing in hard pencil can seem cool and clinical. You will find it rewarding to study the work of other artists whenever you can, and remember that there isn't a single 'right' way of drawing the figure – there are lots of right ways.

Elsie Dressing at the Dell
John Lidzey
46 x 30cm (18 x 12in)

In this study of a figure seen *contre jour* (against the light), the cool, dim interior contrasts with the sunlight outside. A waxy black Conté pencil has been used to create a range of tones from light grey to a deep, velvety black. The white of the paper stands for bright sunlight falling on the pale, gauzy curtains.

GALLERY

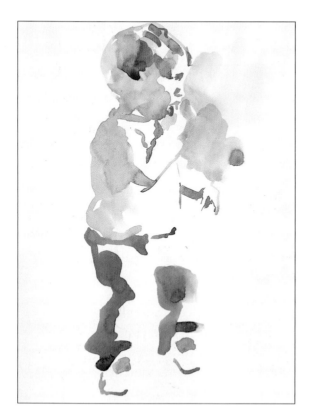

Tom, Watching TV
Susan Pontefract
20 x 15cm (8 x 6in)

The only time children are still is when they are asleep, so you have to work fast to capture them on paper. The artist's confident handling of watercolour allowed her to capture her child's hesitant stance, the transparency of his skin and the character of his clothes and shoes with a few economical brushmarks.

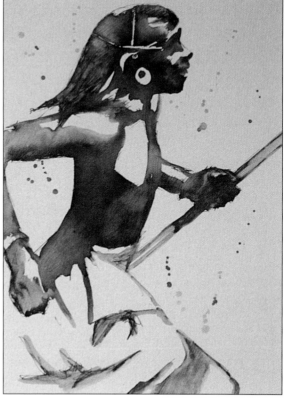

Masai Warrior
John Cleal
41 x 30cm (16 x 12in)

The directness and speed with which this artist works is evident in this vigorous pen and wash study, and echoes the energy of the lean, running figure. The cropping of the figure as it moves into the picture space, and the counterpointed diagonals of the torso, limbs and spear all contribute to the pervading sense of movement.

GALLERY

Up Over my Head
Sarah Cawkwell
122 x 162cm (48 x 64in)

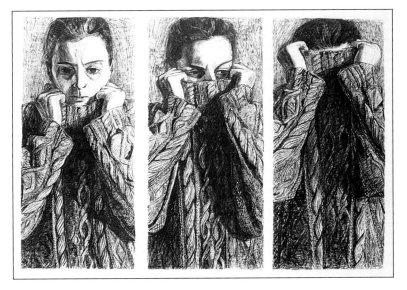

In this unusual triptych, the artist
has combined close observation,
meticulous detail and tight
cropping to transform an everyday
subject into an arresting image.
She uses the linear and tonal
qualities of charcoal to describe
the complex patterns and textures
of the woman's pullover – which
in turn suggest the form beneath
the clothing in a subtle but
completely believable way.

Young Dancer
Michael Whittlesea
41 x 30cm (16 x 12in)

Pastel is a wonderfully flexible medium.
Here, the artist combines acute observation
and understanding of the figure with sensitive
but bold handling of the medium. He uses a
confident line to define the figure, scribbled
lines for the net tutu and colour skimmed on
with the side of the stick for the leg warmers.
Energetically applied splashes of colour draw
attention to the ballerina's head.

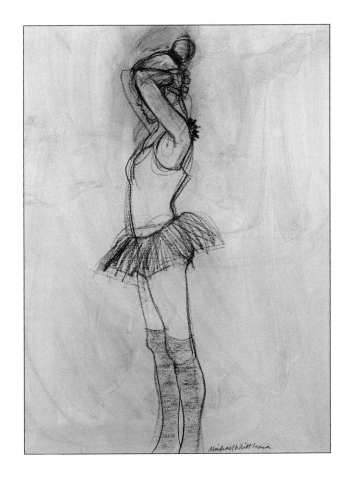

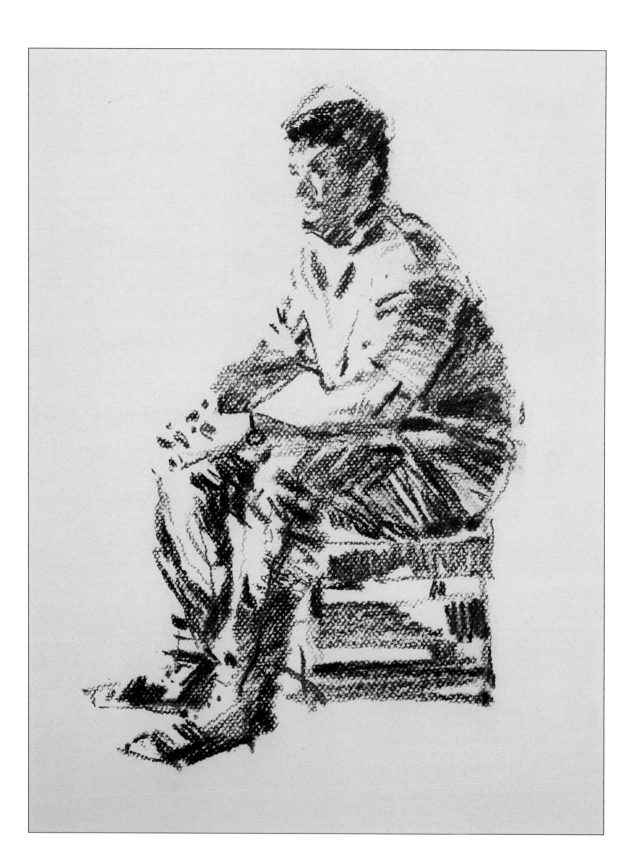

Exercise

1

DRAWING IN LINE AND TONE

There are two principal ways of drawing – in line and in tone. Both methods are useful and both will help you to understand the figure in different ways. Line drawing is the most demanding of the two, because it is so economical. You have to look at the subject intensely and edit rigorously and, for this reason, line drawing is an excellent exercise for the beginner. In a tonal drawing, on the other hand, you dispense with line and simply record the areas of light and dark on a subject. Again, this method really forces you to look, and will help you to understand the bulk and roundness of the figure. But the most satisfying aspect of this approach is the ease with which even an absolute beginner can produce a convincing drawing when working in tone. The projects in this exercise introduce you to both methods and use charcoal as a drawing tool because it encourages you to work boldly and broadly.

Male, Seated
Charcoal on tinted paper
55 x 46cm (21½ x 18in)

LINE OR TONE?

The most sophisticated and demanding drawing technique is line drawing without shading. A line is a way of representing the edge of an object or a form, or the junction between areas of colour or tone. In reality, of course, there are no lines around a figure, so you have to work very hard in order to summarise the subject using this rather artificial device.

Pure outline drawing has a flat, two-dimensional quality which is often exploited in cartoons, comic illustrations and some animations. Most line drawings also include contour lines that go around and across the body, following the rise and fall of the surface to give a sense of the volumes of the form. You can also suggest depth and form by varying the quality of the line, using thin, light marks on the edges which catch the light and darker, thicker lines where an edge is in the shade. You can add tone by using hatching and stippling techniques.

The advantages of line are the speed with which you can work and the way that it forces you to distil the essence of the subject. But it is a very unforgiving technique and you'll find that, because errors and inaccuracies really show, you are forced to be rigorous. However, the best line drawings have a spare, fluid beauty which cannot be matched by any other technique.

Drawing in tone involves an entirely different process, and you will be surprised to find how easily you can produce a figure which has a convincing solidity. When light shines on a figure, the side which is turned away from the light source, or sources, will be in shadow. The areas between light and dark are called 'half-tones'. Tone describes the lightness or darkness of a thing or a colour. It is the contrast between the lights and darks and the distribution of the 'half-tones' that allows us to understand form.

Practise drawing the figure using line only, tone only and a combination of both techniques. The finished images will have very different qualities, but perhaps more importantly, each process will help you to understand better the different aspects of the figure.

This figure, drawn in pure tone using charcoal, describes the light falling on the body and the solidity of the form.

The same figure drawn in pen and ink using outline, contour lines and loosely hatched tone has a lively and expressive quality.

A LINE DRAWING EXERCISE

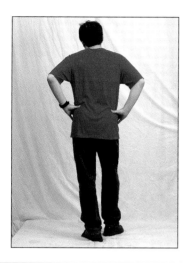

For your first line drawing, ask the model to take up a standing pose with his back turned towards you. This will avoid technical problems like foreshortening, and you won't be distracted by trying to get a facial likeness. However, you will find that back views are just as characterful as frontal views. If you can, work standing at an easel, at least 2.4m (8ft) away from the model, so that you can see the entire figure without distortion, and give yourself ten minutes for this exercise.

Materials and Equipment

• CREAM TINTED DRAWING PAPER, OR WHITE CARTRIDGE PAPER • THIN STICK OF CHARCOAL, PLUS A CHARCOAL HOLDER (OPTIONAL) • FIXATIVE

MALE, BACK VIEW

1

Position yourself so that you can look at the model and then at the drawing by simply shifting your gaze. Study the figure carefully and plot the head on the paper, checking that the entire figure will fit within the sheet. This is an outline drawing, so look for the edges of the torso and the arms. You don't need to stick to a continuous line – broken and repeated lines give the drawing a lively quality.

2

Look at the spaces between the arms and torso, and between the legs – if these 'negative' shapes are correct, your drawing is probably on the right lines. Draw the folds on the back of the tee-shirt, as these give a clue to the underlying forms. Vary the pressure on the charcoal to produce thick and thin lines.

3

Suit the line to the subject's character. Here, the artist has used a solid, vigorous line to suggest the heavy quality of the model's jeans. The folds in the fabric and the lines around the bottom of the trouser leg capture the heavy drape of the material. Try to mentally 'feel' the nature of the surfaces and fabrics you are drawing.

LOOKING AT DIFFERENT VIEWPOINTS

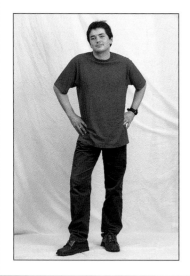

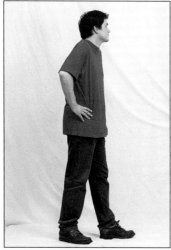

These line drawings should be made quickly, so ask the model to hold each pose for five minutes – set a timer or an alarm clock and stop drawing whether you have finished or not. After the first pose, ask the model to keep a similar stance, but to change position so that he is sideways on. Then start another drawing immediately, on the same sheet of paper. Choose simple standing poses similar to the ones shown; you will have to learn to cope with minor shifts of the head and hands, particularly if you use an inexperienced model.

MALE, FRONT AND SIDE VIEWS

1

This drawing has to be done very quickly, so take a long, hard look at the model and begin to draw the head, shoulders and torso, noting the angles they make against each other. Try to suggest that shapes continue around the image, and that the figure has another side. Don't erase lines, simply redraw them if they are incorrect.

2

Let your eyes roam around the figure, constantly checking and rechecking the relationship between one area and another – the tilt of the head, the angle of the leg, the distance between the feet. Imagine the figure beneath the clothing. Note, for example, where the knees should be, and see how this point relates to the folds in the fabric.

Materials and Equipment

• CREAM TINTED DRAWING PAPER, OR WHITE CARTRIDGE PAPER • THIN STICK OF CHARCOAL, PLUS A CHARCOAL HOLDER (OPTIONAL) • FIXATIVE

3

Ask the model to turn to the side and adopt exactly the same pose as before. Start another drawing on the same sheet of paper if there is room. Take a deep breath and plunge in. Start with the head, establishing the slope of the jaw and the eyes, and the angle of the neck. Notice the way the neck sits into the front of the shoulders and projects forwards. Establish the angles of the upper arm and forearm, the curve of the shoulder and the sleeve. The best way to give volume to your figure is to 'feel' the shapes as you draw them. Concentrate on their roundness, solidity and bulk.

4

Establish the line of the legs, then use a bolder line to capture the drape of the heavy jean fabric.

5

Drawing with line only will force you to edit and decide what is really important. The figures have been simplified so that only the most essential features are shown. Notice how the creases in the jeans help to establish the character of the fabric, while the seams convey the structure of the garment as well as the form beneath. Lightly spray the finished drawing with fixative in a well-ventilated room or outdoors.

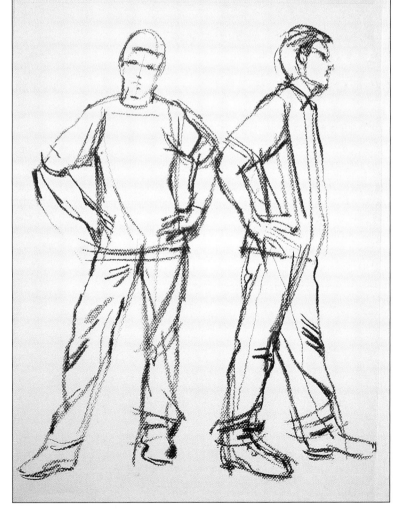

AN EXERCISE IN TONE

For this tonal exercise, you need a strongly lit figure, so place the model by a window or use a spotlight to direct light from one side. A seated pose provides interesting shapes and interlocking areas of light and dark.

Materials and Equipment

• SHEET OF CREAM TINTED DRAWING PAPER, OR WHITE CARTRIDGE PAPER • THIN STICKS OF CHARCOAL, PLUS A CHARCOAL HOLDER (OPTIONAL) • FIXATIVE

MALE, SEATED

1

At first, it can be difficult to see tone because colours, patterns and reflected light cause confusion. If you screw up your eyes, you will find it easier to see the distribution of lights and darks across the surface. Start by simplifying the tones, looking for the lightest and darkest areas. Use the tip of the charcoal to hatch in the dark tones on the back of the head and torso, noting the dark shadow that the head casts on to the shoulder.

2

Continue hatching in the dark tones, allowing them to travel around the form. Put in patches of dark tone on the face, the forearm and the torso. If you draw exactly what you see, you will find that features and forms begin to emerge as if by magic from the jigsaw of light and dark shapes. Use brisk, spiky marks where the thigh is in shadow to suggest the pull of the fabric.

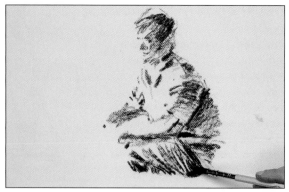

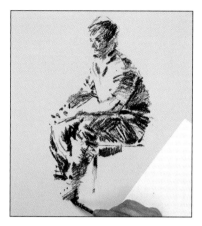

3

Add areas of darker tone around the waist, on the inside of the far leg, on the trousers and on the back of the foot. Place a sheet of paper under your hand to prevent smudging, if you wish. Continue surveying the figure through half-closed eyes, comparing the tones across it. Look for areas that are the same tone and check that the contrasts between areas of light and dark are correct. Draw exactly what you see rather than what you 'know' to be there. This exercise is about pure observation.

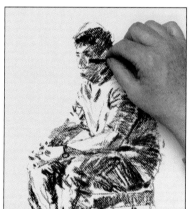

4

Block in the areas of dark and mid tone on the shoes and the crate on which the model is sitting. Stand back and assess your drawing from a distance, comparing it with the subject. Use an extra-thin stick of charcoal to add details like the seam on the trousers, the shadows and creases on the trousers, and the darkest tones on the hair and face.

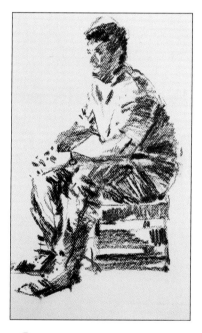

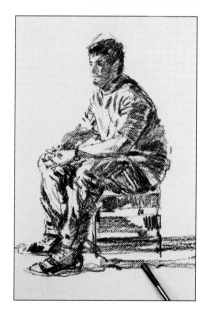

5

Your eyes should travel from model to drawing and from one part of the drawing to another, constantly assessing the tonal values. Work across the entire drawing, making adjustments here and there. Cast shadows are important, because they provide information about the surface on to which they fall, and about the direction and quality of light. Here, the shadows establish the horizontal surface of the floor, and they are dark and crisp because the light is strong and directional.

6

You will probably be surprised to find how easy it is to create an accurate, solid and convincing figure drawing by organising the areas of light, dark and mid tone accurately. Practise working in this way whenever you can – you will soon develop a feel for the volumes of the figure and this will be carried into all your drawings and paintings.

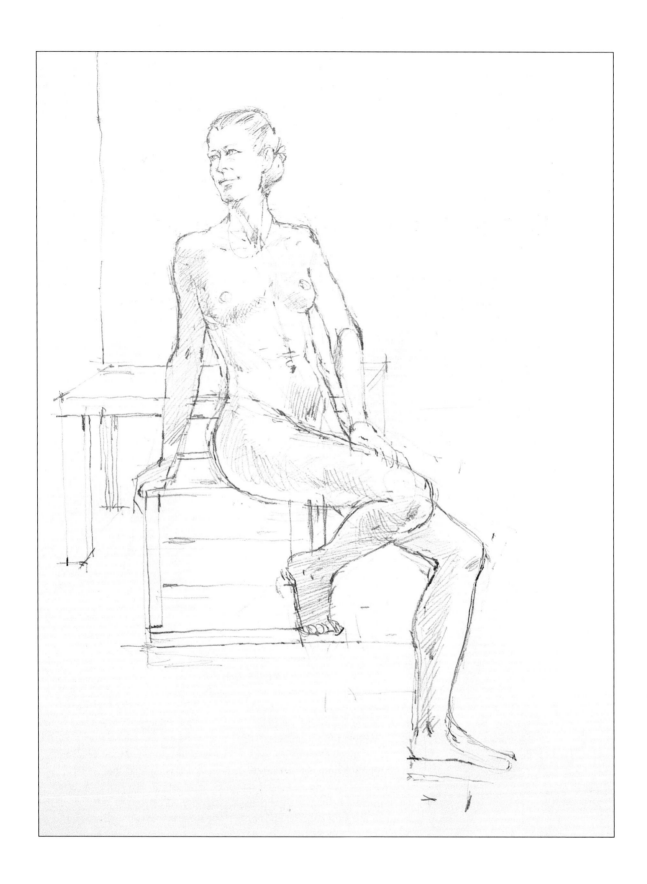

DRAWING ACCURATELY

Based on close observation, 'objective' drawing is analytical and enquiring. This approach allows the artist to discover and describe the appearance of the subject, and to create an illusion of three dimensions on a two-dimensional support. It is the foundation of all traditional Western art. Learning to draw anything, whether it is the figure or a cup and saucer, is really about learning to look and see. That sounds simple, but unfortunately we are often led astray by what we 'think' we remember about the human form. So we know that legs and arms are cylindrical, the head sits on top of the shoulders and the hand consists of four separate fingers and a thumb. But, if they are seen in perspective, legs and arms cease to be cylinders, the head actually projects from the front of the shoulders, and the hand is often seen as a single, compact shape. Drawing from life forces you to look again, to question every mark, and to unlearn what you think you know.

~

Seated Nude
Graphite on watercolour paper
56 x 38cm (22 x 15in)

~

IMPROVE YOUR ACCURACY

The impact of an objective drawing depends on the accuracy with which you reproduce the image. Your pencil can be used to take precise measurements, to check proportions and angles, and to transfer this information to the drawing (see photographs below). Keep your arm straight to maintain a constant distance between the pencil and your eye.

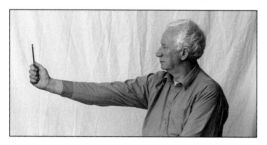

To check relative proportions of the body, hold a pencil vertically out in front of you, closing one eye. Align the top of the pencil with a key point, then slide your thumb down to align with another key point.

Another useful technique to maintain accuracy is to look for vertical and horizontal lines and alignments, and see which parts of the body a line would pass through or touch if it were extended. The centre of the face, the centre of the front torso and the spine are key lines, so indicate their location and see where they fall in relation to the shoulders, limbs and background.

You can also use edges in the background to locate the figure. If the model is standing in front of a door or a window, for example, notice where architectural points impinge upon the figure and pay special attention to lines that appear on either side of it.

Negative spaces are spaces between and around the figure or other objects. Study them carefully, noticing their precise shapes, and draw those rather than the 'positive' shapes. Because negative shapes are abstract, you will be more objective and will draw what you actually see rather than what you assume you know, so you are likely to build up a more accurate figure with a pleasingly uncontrived quality.

If you are worried about the proportions of a drawing, try turning it on its head – this gives you a new viewpoint, helping you to see flaws to which your eye has become accustomed. Reversing the image in a mirror has a similar effect. And remember to stand back from your drawing from time to time so that you can view it from a distance.

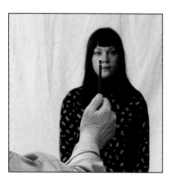

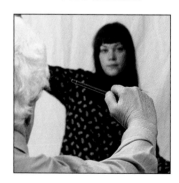

Left: Once you have established a measurement between two key points, such as the top of the head and the chin, you can check this against other body measurements.

Right: With your arm extended, lay the pencil along the slope of the shoulders to check the angle. Transfer that angle to the paper.

PROPORTIONS OF THE FIGURE

Because we take our own form for granted, drawing the figure can be full of surprises. We tend to assume the head is bigger than it is and the hands and feet are smaller, so it can be disconcerting to find that the hand covers the face from chin to hairline, and the foot is a similar length to the head.

The other revelation is the sheer diversity of the human form. There are the obvious differences between male and female, and adults and children, but you'll find that there are variations in height, body weight, shoulder width and length of leg, too. Nevertheless, it is useful to work with a set of ideal

The hand covers the face from the chin almost to the hairline.

proportions, because most people can be fitted into the standard pattern with some adjustments.

In the 'average' human, the head fits into the standing figure approximately seven to eight times. The upper torso, from waist to the neck, is about two heads high and the pelvis about one head high. The legs are approximately the same length as the head and trunk, with the thighs and the lower legs being about two heads each. If the arms are hanging by the side, the tips of the fingers will reach halfway down the thigh. The shoulders are about three heads wide and the pelvis is about one-and-a-half heads wide.

In general, the female figure differs slightly from the male. In the male the hips are narrower than the shoulders, whereas in the female they are about the same width. In the female the pelvis is longer, but the legs are shorter.

A baby's head is large in proportion to the rest of the body. Throughout childhood, the rest of the body grows much more than the head, so that by adulthood, the figure's proportions have radically changed.

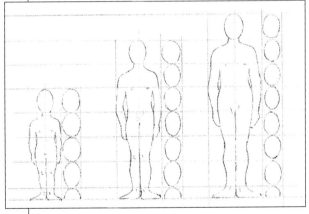

At a year old, a child's head is still quite large in proportion to the rest of the body. The legs are relatively short, so the centre point of the figure falls at the stomach.

By eight years' old, the head has enlarged slightly and the legs have lengthened so that the mid-point of the body now falls just above the hips.

In the average adult, the head fits into the body approximately seven-and-a-half times. The legs account for about half the height of the figure.

A VISUAL REFERENCE

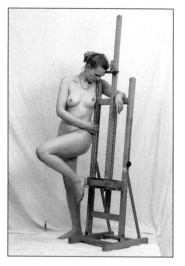

Use a piece of furniture or an architectural feature as a reference against which to plot a figure drawing. Here, an easel provides a support for the model as well as a grid of lines to assist the drawing process. A plumb line has been pinned to the backdrop to give a useful vertical.

Materials and Equipment

• SHEET OF NOT WATERCOLOUR
PAPER

• HB PENCIL

STANDING NUDE

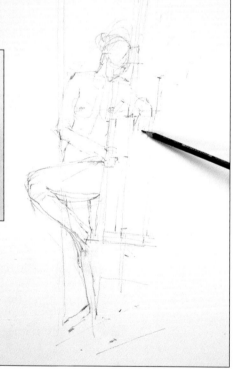

1

The angles of the model's torso and the upright of the easel are key elements of this study, so use your pencil to measure both these angles (see inset) and transfer them to the paper. Measure the slope of the shoulder, the thigh and the horizontal struts of the easel and lightly tick them in. Note the points at which the easel meets the model's body, and the angle between the figure and the plumb line. Measure the model's head and see how many times it fits into the body – just over seven times. These measurements provide a solid foundation for the drawing. Start to sketch in the figure, working lightly.

2

Check the height of the vertical strut of the easel: the distance between the top and the first horizontal is the same as that between the horizontal and the ledge. If you get these measurements right, the figure is more likely to look correct.

3

Continue developing the drawing, trying to get a broad feel for the pose. Allow your eye to travel over the figure to check horizontal and vertical relationships. Note that the angle of the model's right leg mirrors the angle of the supporting struts of the easel, and the bar she is leaning on aligns with her nipples.

4

Let the model rest from time to time – use chalk or masking tape to mark the position of the feet and hands so that she can resume the pose. If the pose is slightly different after the break, make adjustments to your drawing. The feet are important to the logic of the drawing, so draw them carefully.

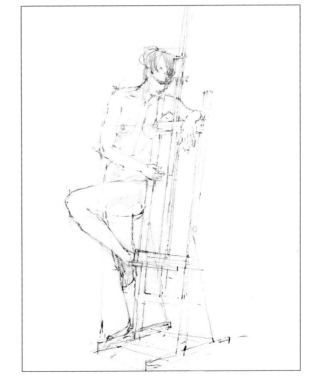

5

When you are satisfied that the figure is accurately established, start to add details such as the hands and face. Half-close your eyes and look for the light and shadow. Hatch areas of tone on the stomach, under the breasts, on the thigh and on the raised foot. Finally, apply a tone to the hair, allowing the hatching to describe the way the hair grows.

ARRANGING A SEATED POSE

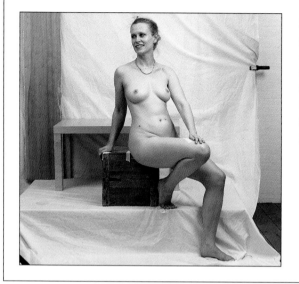

Experiment before you settle on a seated pose. This pose presents the figure as an extended diagonal, with the legs making a series of angles. The props were arranged to produce interesting negative shapes, and horizontal and vertical lines against which to measure the figure. Because the pose is somewhat complex, it is important to mark key positions with masking tape.

SEATED NUDE

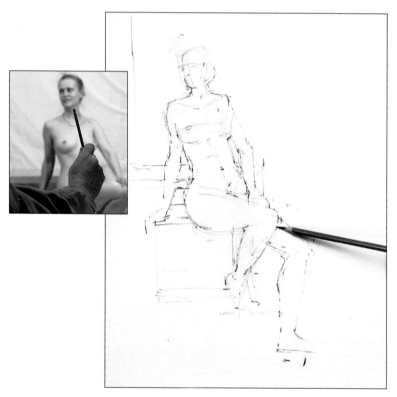

Materials and Equipment

• SHEET OF NOT WATERCOLOUR PAPER
• HB PENCIL

1

Use a pencil to find the angle of the seated figure (see inset), as this is the key to the entire pose. Mark this slope on the paper. Draw the head, indicating the centre line, and check that the angle is correct. Lightly sketch in the horizontals and verticals in the background. Begin to outline the figure, looking for the points at which it meets the background. Check the 'negative' shapes between the arms and the torso, and the angular shapes delimited by the legs.

2

Draw the model and the crate on which she is sitting as a single entity. The seated figure does not support itself, so you need to explain how the weight is distributed. Here, the model is taking a lot of the weight on her right hand. Start to add the dark tones on the right arm and under the right breast. Notice that the artist has indicated how the left leg passes behind the right leg – the drawing will be more convincing if you understand what is happening to the hidden parts of the figure.

3

Begin to refine details such as the head and hands. Lay in loosely hatched tone on the torso, following the curves of the form. Draw the far leg of the small table – the obvious perspective creates a sense of space in the drawing. Block in a dark tone on the shin of the near leg.

4

Develop the model's head by applying tone under the chin and the lower lip, on the hair and behind the jawbone. Complete the drawing by adding hatched tone on the calves, around the upper thigh and on the inside of the left arm.

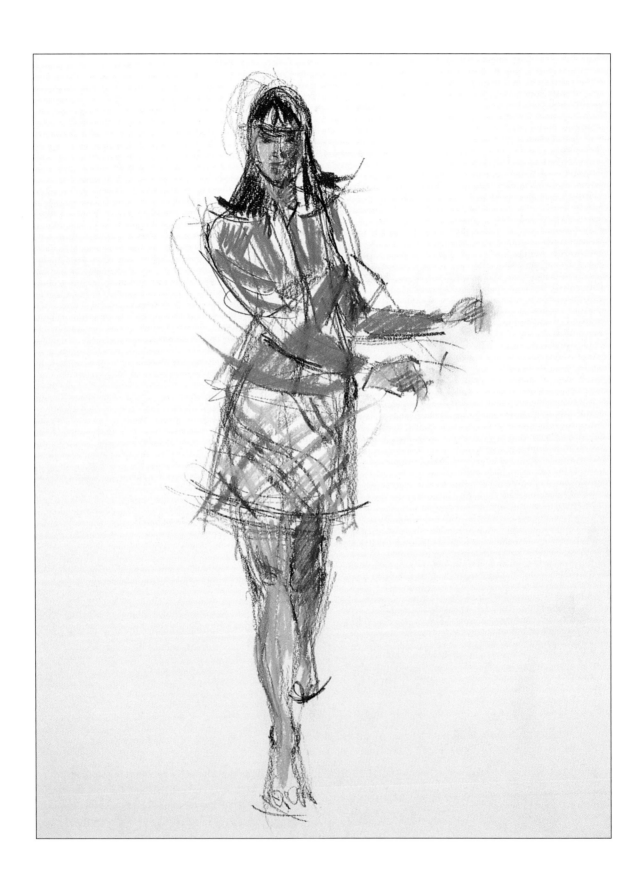

EXERCISE

3

THE MOVING FIGURE

Capturing the figure in motion is a challenge, even for the most accomplished artist. You must learn to draw quickly and capture the essence of a gesture or a movement in a few fluid lines. This is much easier if you simplify the forms in your mind, seeing the figure as a series of solid geometric shapes which articulate against each other in predictable ways. If you practise drawing rapidly from life, you will develop a shorthand which allows you to express movement with a few telling strokes. The projects in this exercise involve drawing from the model, freezing movements mid-action in a way that rarely occurs in real life. These short poses will give you a greater understanding of the figure in motion. Avoid detail, concentrate on how the weight of the body is distributed, and look for lines that imply that the movement will be continued.

~

Striding Out
Hard pastel on cartridge paper
44 x 35cm (17¼ x 13¾in)

~

185

SIMPLIFYING THE FIGURE

To draw a convincing figure, you must create the illusion of a solid form in space. A useful way of understanding the solidity of the figure is to reduce the component forms to geometric shapes. The head can be seen as a sphere, the arms and legs as tapering cylinders, the torso and pelvis as modified cylinders or cubes, and the hands and feet as basically cubic shapes. Because these shapes are simple and familiar, it is easy to visualise them tilted, overlapping or in perspective. If you use them as the basis for a drawing and then apply your knowledge of proportion and the underlying structures, you will be able to draw a solid figure in any position.

If you imagine the human figure as a doll made up of these geometric shapes joined by elastic, you will begin to understand the way in which the different parts articulate against one another and this will give you an insight into the figure in motion. These 'manikins' can be fleshed out to produce a convincing nude or clothed figure. They are also a useful way of investigating what is going on in a difficult pose before you start a drawing.

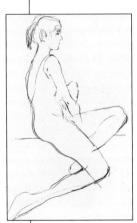

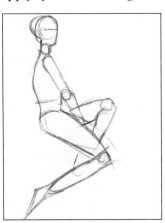

The dancer in this pose (above left) is poised and erect, her weight resting on one buttock, while her legs are very slightly braced against the bench, the floor and each other. The manikin figure (right) reveals the relationship of the main elements of the figure and shows how the legs articulate around the knee joint.

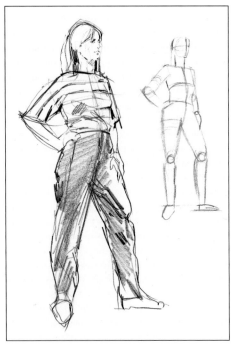

The swing of the pelvis and the slight bend in the left leg are the key to this pose, as shown in the manikin figure.

CAPTURING MOVEMENT

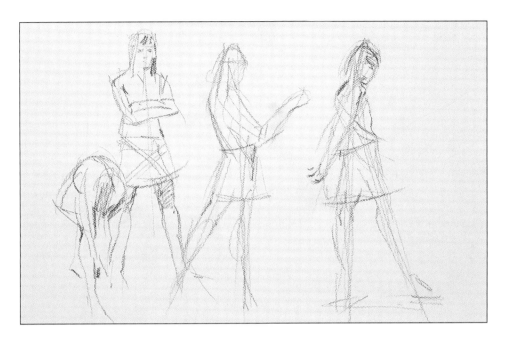

Drawing the moving figure requires many skills. You must be able to simplify the forms, find the lines that sum up the movement and commit poses to memory so that you can complete the drawing when the moment has passed. Above all, practise, work quickly and don't be afraid of making 'mistakes'.

Begin by persuading a friend to model for a series of short poses. Ask her to walk around the room and then stop suddenly, freezing a movement. Start with five-minute poses and reduce the time as you become more proficient. If you want to sketch people going about activities such as shopping or playing sports, you need to get something down in about ten seconds.

Work on a large sheet of paper and use a medium such as charcoal, chalk or pastel which allows you to work freely and boldly. Ideally, stand at an easel – this encourages you to use big

Do a series of quick warm-up exercises on a sheet of paper. Short poses force you to reject non-essential information and focus on the key directions and rhythms.

movements from the elbow and the shoulder, rather than finicky gestures from the wrist. Study the pose carefully and then start to draw, looking for the direction of the motion, the distribution of weight and the centre of gravity. If some of your lines are inaccurate, simply redraw them. The build-up of lines will suggest movement and vitality.

Apply the three-dimensional forms of the manikin figure as you draw. Use ellipses and contours to suggest the volumes of limbs and torso, and visualise what is happening on the far side of the figure. Try to understand the logic behind the pose, the action of the joints and how compression in one area is balanced by stretching in another.

POSES SHOWING MOVEMENT

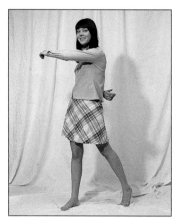
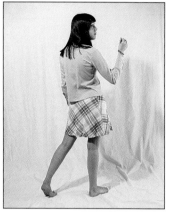

Ask the model to move around and then stop mid-movement. Allow a maximum of five minutes for each of the poses.

Materials and Equipment

• SHEET OF CREAM CANSON PAPER
• CONTÉ CRAYON: SANGUINE

GIRL, TURNING

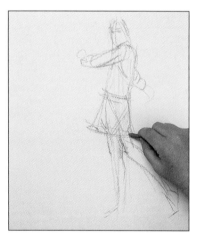

1

Look for the way the figure is balanced – here the weight is on the model's right leg while her body swings around to the right, pivoting at the waist. Work quickly, feeling the flow of the movement and the rhythms of the pose. Simplify the shapes, using an oval for the head and cylinders for the limbs and trunk. In that way, you will capture the volume of the figure.

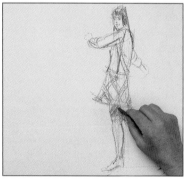

2

Once you have captured the essence of the pose, start to add superficial details such as the hair, the pattern on the skirt and the dark tone where the knee is in shadow. Indicate the folds in the sleeve – these contours suggest the roundness and foreshortening of the arms.

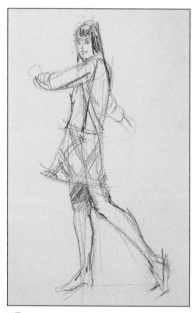

3

The finished sketch captures the energy of the pose. Short poses force you to be selective, and this is good practice for working on location when you have no control over the model.

GIRL, TURNING, BACK VIEW

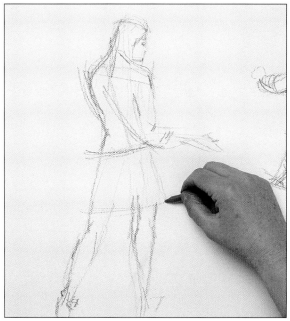

1

Ask the model to turn and 'freeze' another gesture. Look for the line that expresses the main thrust of the pose – in this case, the line down the left side of the figure. Indicate the angle of the shoulders and hips. These are critical as they change as the weight shifts from one leg to the other. Work quickly, looking for the main thrusts and tensions. These mid-movement poses are difficult to hold, so be prepared to adjust the drawing as the model shifts.

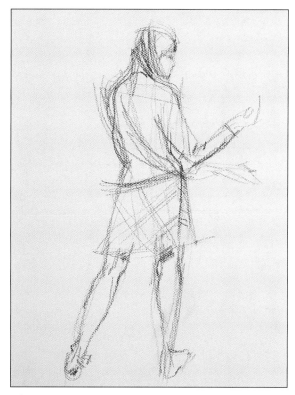

2

Begin to add more emphatic lines, firming up the outlines of the legs and arms, and refining details such as the pattern on the skirt and the hair, all the time searching for the forms and the sense of an implied movement. Allow your gaze to switch back and forth between the model and the drawing.

3

The finished drawing is simple, direct and energetic. The redundant construction lines emphasise the immediacy and energy of the drawing.

STRETCHING AND BENDING

Ask the model to take up a pose that she can hold for at least five minutes. To find interesting and realistic poses, ask her to move around and then tell her to freeze.

Materials and Equipment
- SHEET OF WHITE CARTRIDGE PAPER
- BLACK CHARCOAL PENCIL
- HARD PASTELS: PINK, FLESH TINT, BURNT SIENNA, SAGE GREEN, LEMON YELLOW, BLUE AND ORANGE

GIRL, STRETCHING

1

Use a charcoal pencil to sketch the figure. Forget about detail and concentrate on the proportions and position of the body. Try to see the figure as the linked geometric shapes described on page 186. With the pencil, check the relative positions of key elements such as the head, the waist and the knees. Work boldly, using quick gestural marks that follow the stresses and tensions of the pose.

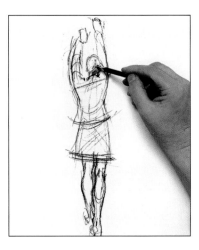

2

Using a pink pastel stick, describe the folds on the sleeves and the back of the model's blouse. Rub flesh tint on to the hands and the legs, and add burnt sienna for the shadows on the legs. Use the pink, sage green, lemon yellow and blue pastels to complete the pattern on the skirt.

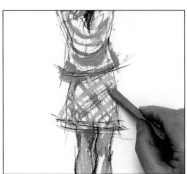

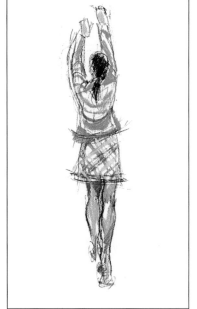

3

The vigorous finished drawing captures the essence of the stretching figure perfectly. The lively lines reflect the speed with which it was made.

GIRL, BENDING

1

Using a charcoal pencil, indicate the main rhythms of the pose. Work quickly with flowing lines that follow the direction of the movement. Look for the telling lines: here, they are the curve of the model's back and the line of the right, supporting leg. Don't use an eraser, simply redraw inaccurate lines – multiple lines and a blurred outline all add to the sense of movement.

3

Complete the skirt plaid with blue, sage green and lemon yellow pastel. Use burnt sienna for the shadows on the model's legs and for her bag. Add a touch of orange where the bag catches the light. The finished image captures the essence of the movement with great economy.

2

Suggest the colour of the blouse and the skirt plaid with a few brisk strokes of pink pastel, using the side of the stick to block in general colour and the tip to lay in the folds and stripes. These swinging lines are wonderfully energetic and enhance the sense of motion in the drawing. Apply flesh tint on the face, hands and legs, warming it with a little pink.

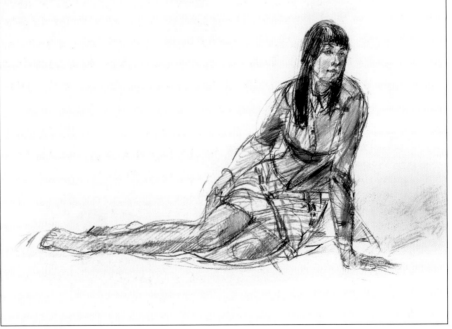

BONES, MUSCLE AND BALANCE

A basic understanding of anatomy – in particular, of the skeleton and the muscle groups and how they change with every action – will enable you to draw the nude and clothed figure with confidence and conviction. The way that fabric drapes around the figure is largely dependent on what is going on underneath – a good drawing should make you aware of the figure under the clothing. The skeleton provides a rigid framework and is overlaid by muscles and fatty tissue, the whole package contained in an envelope of skin. In some places, the bony structures are near the surface and determine the form; in others, it is the soft tissues that create the contours. These are also the factors that create the differences in shape between individuals, men and women, adults and children. If the figure is to stay erect, the muscles must work against each other, keeping the body in balance. Capturing these often fleeting moments of equilibrium is important if a drawing is to look stable and convincing.

~

Girl, Standing
33 x 50cm (13 x 19in)

Girl, Sitting
56 x 51cm (22 x 20in)

Graphite and water-soluble coloured pencils

~

THE SKELETON

The skeleton is a lightweight framework of bones, held together by muscle, cartilage and tendons. From the artist's point of view, the spinal column is the most important structure as it is the axis around which the other bones are grouped and its position is the key to many poses.

The most notable feature of the spinal column is its flexibility. It isn't straight, but curves out in the shoulder area, inwards towards the waist and out again over the pelvis before tucking in and out at the coccyx. These curves act as shock absorbers and define many aspects of posture.

Although there is only a little movement between one vertebra and the next, the cumulative effect over the entire length of the spine allows for bending backwards, forwards and side to side, plus twisting movements. These movements are made possible by the powerful muscles of the back.

The top part of the skeleton consists of the ribcage, at the top of which the hoop of collar bones and shoulder blades provides an attachment for the arms. The pelvic girdle, attached to the lower end of the spine, is a heavy and fairly rigid structure designed to carry the weight of the upper body and allow it to be supported on the lower limbs.

The limbs consist of long bones. The upper arm fits into a shallow socket in the shoulder blade and the two slim bones in the lower arm meet the upper arm at the elbow joint.

The rounded heads of the thigh bones sit in deep sockets in the pelvis. Note that the hip joints are on the outside of the pelvis, so that the thigh bones slope in towards the knees – this effect is more pronounced in women who tend to have wider pelvic bones.

The skull is balanced on top of the spine. All its plate-like bones are fused except the lower jaw bone which articulates against the rest of the structure from points just in front of the ears.

The hands and feet are complex structures consisting of many tiny bones. The hand is heavily jointed to provide maximum flexibility, while the foot bones are wedged tightly together and bound with ligaments to give the foot both flexibility and strength.

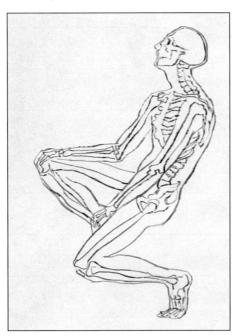

The skeleton provides the basic architecture of the body and gives it a solid underpinning.

THE SOFT TISSUES

The bony skeleton defines the broad structures and dimensions of the body, but the appearance of the figure is also determined by layers of muscle and fatty tissue. In some places the muscular tissue is bulky and dominates the surface area, while in others, bones come close to the surface.

Muscles work in pairs, providing power and leverage for the body. The musculature of the body is complex, consisting of layers of large and small muscles which perform specific tasks. Although you can draw the figure effectively without becoming an expert on anatomy, you should be aware of the way that some muscles affect the shape and surface forms of the figure.

The upper part of the torso is quite bony in character. If you run your hands over that area, you will find that the collar bone, breast bone, ribs and the bones in the shoulder are only thinly covered. The area between the rib cage and the pelvis is soft and fleshy and is capable of considerable movement. Notice the furrow that runs down the front of the torso to the base of the rib cage, and the fleshy mound of the abdomen. The pectoral muscles emanate from the breast bone and insert into the shoulder – in women they are partially masked by the breasts.

On the back, a furrow runs the entire length of the spine, with the powerful muscles of the back radiating out from this line. The fleshiest part of the back is the buttocks, which are formed by several muscles.

When the arm is flexed, the biceps and deltoid muscles bulge and become more apparent. The form of the legs is

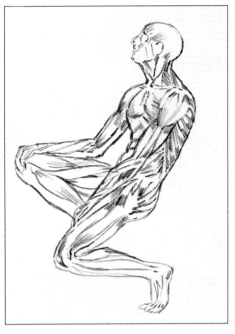

The skeleton is enveloped in layers of muscle and other soft tissue that smooth the outline and create fleshy masses in certain areas of the body.

defined to a large extent by the hard-working muscles that almost entirely mask the thigh bones and create the typical rounding on the back of the calves. At the front of the leg, the shin bone is relatively unprotected.

The most convenient way of familiarising yourself with human anatomy is by getting to know your own body. Run your hands over your arms or make some exaggerated movements and notice the way that the muscles lengthen or bulge. Stand in front of a mirror in a strong light and observe the fleshy masses on the abdomen, buttocks, arms and legs.

A POSE IN EQUILIBRIUM

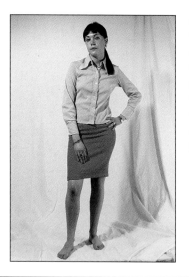

Ask the model to stand with her weight on her left leg and her hand on her hip. Automatically, the left hip will swing out and up, and the other hip will drop down. The shoulder on the left side will also drop slightly. These adjustments all help to keep the body in balance.

Materials and Equipment

• SHEET OF CARTRIDGE PAPER
• 7B PENCIL • WATER-SOLUBLE COLOURED PENCILS: PINK, ORANGE, RAW UMBER, FLESH TINT, VENETIAN RED, CRIMSON

GIRL, STANDING

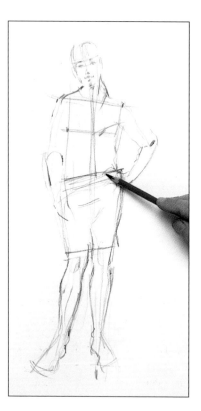

1

Using a 7B pencil, start by establishing the central axis and the opposing slant of the shoulders and hips. These angles give you the structure of the pose. Try adopting the pose yourself and notice how one part of the body acts as a counterweight to the other.

2

Develop the drawing with vigorous lines, keeping in mind the model's underlying forms. Simplify the main elements – the arms are cylinders, the legs are tapering cylinders and the knees are convex domes on the surface of the leg. Use heavier lines and scribbled shading for areas of dark tone. Develop the facial features and hatch some light shading to give the face form.

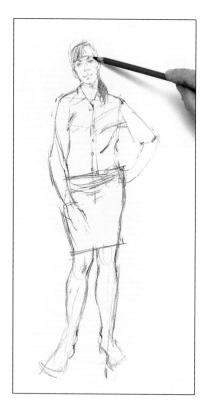

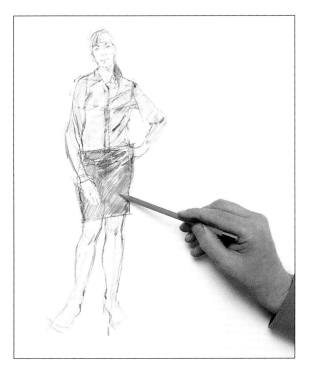

 3

Using water-soluble coloured pencils, hatch pink on the blouse and a combination of orange and raw umber on the skirt. Soften the coloured pencil marks in places by blending them with a little water applied with a brush or with the tip of your finger.

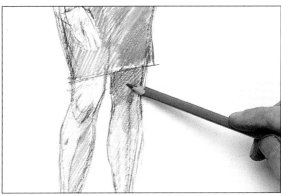

 4

Apply a light flesh tint on the face, hands and legs, and warm the inside of the calves with a little Venetian red. Add shadow at the top of the leg in raw umber. Don't overwork the coloured pencil – the white paper shining through the hatching has a lively, shimmering quality which solidly applied colour would lack.

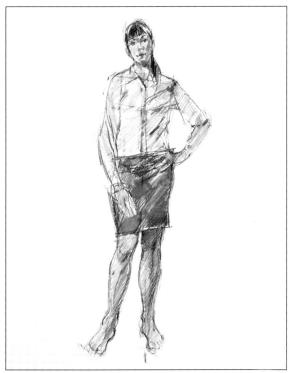

5

Refine the drawing a little further by adding more detail to the face – a touch of flesh tint on the cheek that is catching the light, some crisp detail in 7B pencil around the eyes and mouth, and a touch of crimson on the lips. While the face should capture the character of the individual, it is important that it remains in harmony with the rest of the drawing.

LOOKING AT BALANCE

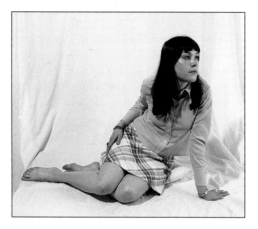

Balance is important even in the seated figure. In this pose, the spine curves to the side but the head remains over the centre of gravity. Use masking tape or chalk to record the model's position.

Materials and Equipment

• SHEET OF NOT WATERCOLOUR PAPER • 7B PENCIL
• COLOURED PENCILS: BURNT UMBER, PINK, FLESH TINT, DARK BLUE, GREEN, CRIMSON, VENETIAN RED, YELLOW

GIRL, SITTING

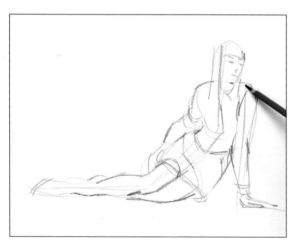

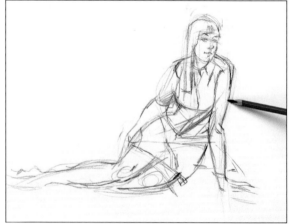

1

Using a 7B pencil, block in the outlines of the main segments of the body: head, ribcage, pelvis and limbs. Note the location of the spine as this is the key to the pose, and notice, too, how the left side of the body is extended while the right is compressed. The legs present a challenge in perspective as the thighs project forwards. If you check relative measurements with your pencil and draw what you see, you will draw the foreshortening accurately.

2

Develop the drawing, looking for the relationships between one part of the body and another – the way that the head is balanced above the torso, for example, and the point at which a line extended from the head would meet the floor. Try to visualise the skeletal underpinning – the tilt of the shoulders and pelvis, and the foreshortening in the ribcage. A hard line suggests the tension in the muscles of the left arm and shoulder, while a softer line is used for the relaxed right arm.

3

Indicate the shadows and folds on the blouse, and the way the pattern on the skirt curves around the thighs. Details such as seams, cuffs and hems provide clues to the underlying structures. Add dark tone on the hair and warm it with a touch of burnt umber. Apply pink to the skirt and blouse, changing the direction of the marks to follow the surface planes or the tension on the cloth.

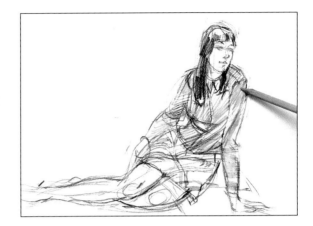

4

Lightly hatch flesh tint on to the face, hands and legs. Elaborate the pattern on the skirt with dark blue and green coloured pencils. Note how the lines rise and fall as they travel across the undulations of the thighs, revealing the underlying forms.

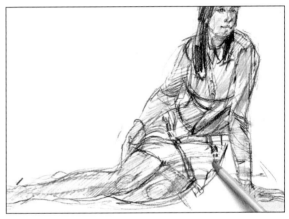

5

Develop the face with touches of burnt umber, flesh tint and crimson. Use flesh tint, raw umber and Venetian red for the skin tones on the leg, using the pencil marks to indicate how the surface planes change direction. Complete the plaid pattern on the skirt, add a touch of yellow to the cushion, and lightly hatch in the shadow cast by the model. Although the pose appears complicated, it is simple to draw if you combine an understanding of the underlying structures with careful observation.

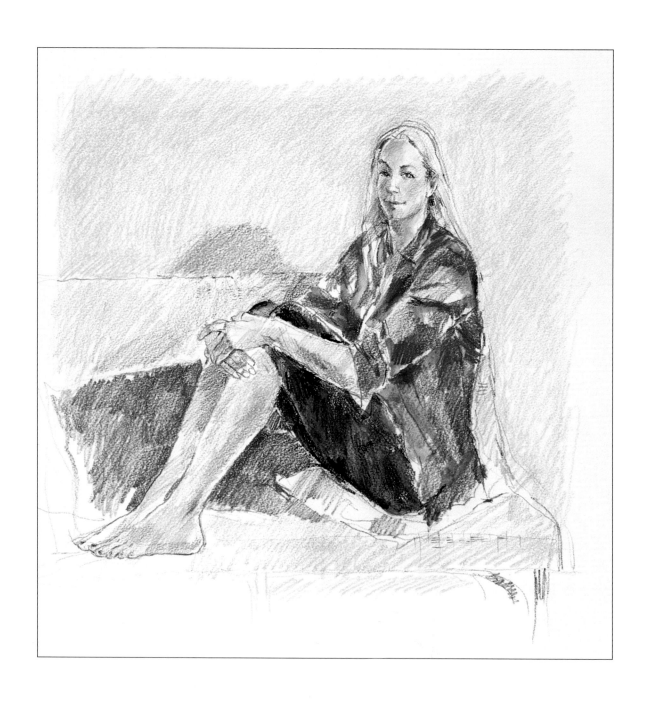

Exercise

5

HEADS, HANDS AND FEET

The head is the part of the body that most expresses the individuality of a person. For beginners, the need to find a likeness can be daunting. However, if you understand the basic structures, then look hard and measure, you will find that not only is it easy to produce a convincing image, you can also get a good likeness. The basic proportions of the head are illustrated on the following pages. Study them and then observe your own face in a mirror.

Hands can also present a problem for the less experienced artist, but if you look carefully, reduce them to basic shapes and work from life, you will soon be able to draw hands that are three-dimensional, convincing and expressive. In this study, the artist started by treating the hands as simple shapes, adding details, tone and colour as the rest of the drawing progressed.

Feet, too, are easy to draw if you understand their volumes and underlying structures. Because hands and feet are quite complicated shapes, there is a temptation to put in too much detail which upsets the balance of the drawing. In this study, the hands and feet are indicated with a few deft touches and sit comfortably within the composition.

~

Girl on a Settee
Water-soluble pencil
40 x 40cm (15 x 15in)

~

LOOKING AT HEADS

The skull is a bony structure to which the facial features are attached. The eyes are spheres embedded in the hollows of the eye sockets. They are surrounded by the eyelids, the upper lid being more apparent than the lower lid. When drawing the upper eyelid, use a heavy line to indicate the thickness of the lid, and a shadow under the lower lid to suggest the depth of the lid and its angle to the cheek.

The nose is a wedge jutting out from the face. It is narrow at the top and flares out to a wide base. The bone of the nose stops short of its tip which is soft and fleshy; some noses come to a shapely tip, others are bulbous. When drawing the face from the front, a touch of shadow under the nose will make it seem to project from the face. The appearance of the nose changes as the face dips forwards or tilts backwards, and this movement also affects how much of the nostrils is visible.

The mouth is an expressive feature which gives a face much of its character. It is also an important clue to mood. The bottom lip is lighter in tone than the upper lip because its plane faces up to the light. A touch of shadow under the bottom lip will help to give it form. In profile, the upper lip tends to jut forward beyond the lower lip.

The ears can only be seen fully from the side, so usually they are seen in perspective. They equal the nose in length, aligning with its base and top.

The chin is a convex mass on the surface of the head, creating a furrow between it and the lower lip. The chin, which varies from person to person, is another important defining characteristic.

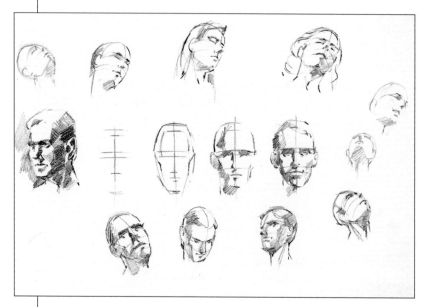

The head is basically an egg-shape with the broader end at the crown, the nose providing a central axis. The eyes are positioned half-way between the chin and the top of the head and are about an eye-width apart. The eyebrow aligns with the top of the ear and the nose is about the same depth as the forehead. The lines of the eyebrow, eyes, nose and mouth tilt as the head is lifted or lowered.

DRAWING HANDS AND FEET

Hands are flexible and complex structures. You will find it easier to tackle them if you reduce them to simple shapes. Look for the basic structures – the roughly five-sided shape of the palm, the two separate masses of the hand proper and the thumb, and the planes of the clenched fist. Move your hand and notice the range of wrist movements. Lay your hand and arm flat on a table and you'll see that the hand is broader at the fingers than at the wrist and that the wrist slants up from the hand to join the arm. When the hand is fully extended, the fingers converge to a point below the middle finger.

Make a series of drawings of your own hands in different positions. A mirror will extend the possible viewpoints. Simplify the shapes, trying to see the hand as a single unit rather than an assemblage of different elements. Place the hand you are drawing in a strong light – the shadows and highlights will reveal the surfaces and contours. Use straight, hatched lines for the planes and curved shading for the curved surfaces.

If you stretch your hand fully, you will see that the tips and joints of the fingers lie along a series of curved lines, and the thumb aligns with the

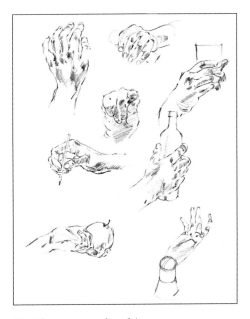

Sketch your own hand in as many different positions as possible. The model hand (bottom right) articulates at the joints and is a useful drawing aid.

second joint. Keep these relationships in mind as you are drawing.

The foot is perfectly designed for movement and support. Study the sole and note the points of contact with the ground – the heel, the ball, the toes and the outside rim. The ankle is higher on the inside of the leg than the outside, and the top of the foot forms a plane which splays out and slopes down from the inner ankle and instep.

Use a mirror to make a sheet of drawings of your own bare feet from as many different angles as possible. Notice the relationship of the foot to the leg and how the shape of the foot changes as you shift your weight.

Seen from one side, the foot is in contact with the floor along its entire edge, but the inside edge is raised over the arch.

A SEATED POSE

Ask the model to sit with her feet up on a settee or bench and her arms clasped around her knees. This pose has many advantages: the model is comfortable, the flexed arms and legs make interesting angles, and the hands and feet are clearly visible. Costume and colour are an important part of a figure study. Here, the crimson blouse and cushions provide a vibrant contrast to the blue trousers, the delicate colours of the hair and skin, and the cane of the settee.

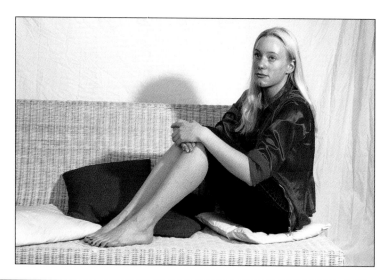

GIRL ON A SETTEE

Materials and Equipment

• SHEET OF NOT WATERCOLOUR PAPER • WATER-SOLUBLE COLOURED PENCILS: BURNT SIENNA, CRIMSON, ORANGE, DARK BLUE, GREY, LIGHT BLUE, SEPIA, CARMINE, YELLOW OCHRE, INDIAN RED, FLESH TINT • NO.3 WATERCOLOUR BRUSH

1

Decide how you are going to position the image within the support. This pose produces an almost square composition. Start to draw with a burnt sienna water-soluble pencil, working lightly but freely. Use your pencil to check proportions and angles, especially the slope of the arms, legs and back, and the tilt of the head. Tick in the line of the eyes, the mouth and the centre of the head.

2

Develop the drawing with the same burnt sienna pencil. Use light lines while you are searching for the image and more emphatic lines once you are sure that you have got it right. You can also vary the weight of the line to reflect the character of the edge you are drawing – use crisp, dark lines between areas of highly contrasted light and dark such as the hairline, the collar and the opening of the blouse and lighter lines for folds in the fabric. Add more detail to the head – the dark tone under the nose and chin and between the lips, for example. Lightly indicate the pupils.

3

Apply hatched tone on the shaded side of the face and neck. Sketch the hands with a few lightly applied lines, suggesting the location of the knuckles and the individual fingers. Shade the fingers of the left hand, treating them as a single block of tone. To render the shiny, reflective surface of the satin blouse you will need a selection of cool and warm reds, leaving the white of the paper to stand for the highlights. Use a crimson water-soluble pencil to apply loosely hatched patches of colour in the darkest areas of the fabric.

4

It is good practice to advance all areas of the drawing at the same pace, so apply some crimson to the cushion and add touches of orange to the blouse. Use the burnt sienna pencil to indicate the shadow under the left forearm, then start to block in the dark blue of the trousers.

5

Study the feet carefully and then use the burnt sienna pencil to refine the drawing. Notice the way the feet slope down from the ankle and then flatten out into the toes. Indicate the areas of tone under the ankle, between the legs, and along the edge of the foot. When you are satisfied that the drawing is correct, draw a more definite outline with the burnt sienna pencil.

6

Use a grey pencil with a sharp point to draw the eyebrows, the edge of the upper eyelid and the pupil. Use a light blue pencil for the irises. Indicate the outline of the settee with a sepia pencil, then add colour to the red cushion with the crimson pencil.

7

Add touches of carmine to the jacket. Apply a little colour to the hair with a yellow ochre pencil, then use the same colour to hatch a light tone on the forehead, the cheeks and the neck. Use the grey pencil to define the hairline and shaded area under the hair. Dip a No.3 watercolour brush in water and use it to soften and blend the colour on the face and neck – don't overdo this. While the brush is still loaded with this colour, apply a delicate wash to the left arm and hand.

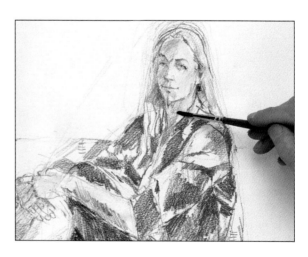

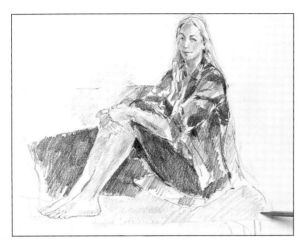

8

Work Indian red into the red of the blouse, then add touches of grey for the darkest areas. Allow the drawing to dry and then hatch flesh tint on the arm and on the face. Apply yellow and orange to those areas of the cushion that are catching the light. Hatch grey on the cushion the model is sitting on. Use yellow ochre to scribble some local colour on to the cane settee, then return to the grey pencil for the cast shadow on the wall behind the settee.

9

Dip the No.3 watercolour brush in water and start to blend the blue of the trousers and some of the hatched areas of the blouse. Don't overdo the blending – it is the combination of line and wash which gives this medium its attractive quality. Water-soluble coloured pencils are really best for small areas of wash or for softening lines. If you want to use the full range of watercolour effects, choose watercolour paint.

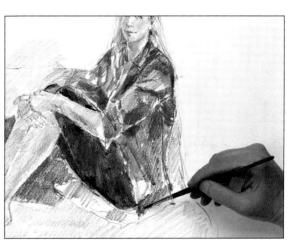

10

Use the sepia pencil to suggest the leg of the settee and the weave of the caning. You could leave the picture at this stage, or use the grey pencil to add a light overall tone to the background. In the final image, the figure of the girl is accurately drawn and beautifully rendered in a combination of hatched pencil techniques and blended washes. The various shapes, textures and blocks of colour also work as an abstract composition.

LIGHTING THE FIGURE

Light is the means by which you discern forms in the world about you, but it also allows you to introduce atmosphere into a drawing or painting. Light is an integral part of the subject in a figure study, establishing a mood, holding disparate elements together, emphasising forms here, rendering them ambiguous there. Change the lighting and you change every aspect of the image. A bright spotlight shining on to a figure creates contrasts of tone and a sense of drama, while softly dappled light and flickering shadows produce a quieter, more mysterious mood. Bright light casts crisp shadows, while the shadows cast by diffuse light have softer, less defined edges. Artists often use backlighting to combine drama and mystery in a study. By placing a figure against a window, as shown left, the silhouette is revealed, often with great clarity, while the rest of the figure is cast into a shadow. This near-silhouette effect is called *contre jour*.

Seated Woman, *Contre Jour*
Pastel pencil and hard pastel on tinted paper
55 x 38cm (21 x 15in)

LEARNING TO USE LIGHT

When you are setting up a figure study, it is important to consider how the light will affect the composition and the mood you want to achieve. For an investigative drawing, you will need a combination of light sources – an overall light so that you can see the entire figure, with a side light to reveal the surface forms with greater clarity. But if you want to create a more intriguing image, you could choose to illuminate the figure from behind or with a directional light from one side. With the more exaggerated light effects, the shadows become an increasingly important element in the composition.

Daylight is generally preferred by artists because it shows colours at their truest. If you are working by natural light, remember that it will change throughout the day, so you either have to work quickly, make a few reference sketches or photographs, or return to your drawing or painting at the same time on another day. Very bright light can be filtered through muslin or blinds. Fascinating effects can be achieved by allowing light to shine through slatted blinds so that bands of light and shadow drape themselves across the undulations of the form.

The advantage of artificial light is that it is predictable and controllable. It can be brightened or dimmed, directed on to the subject or bounced off an adjacent surface. An adjustable desk light or spotlight can be used to create a dramatic directional light.

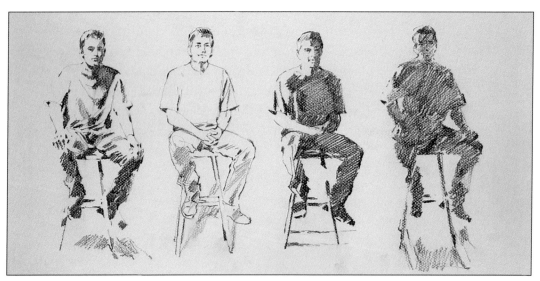

Light from above gives a fairly even distribution of highlight and shadow and the details of the figure are easy to read.

Light from the front flattens the form and provides little contrast of light and shadow, but the facial features are clearly visible.

Light coming in from the left throws the right side of the figure into shadow. Side light can be atmospheric and informative.

Light coming from behind emphasizes the silhouette. The figure drawn and painted contre jour *has an ambiguous quality.*

Setting Up a *Contre Jour* Pose

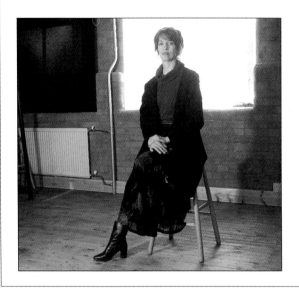

Position the model so that the main light source is behind her, but make sure there is enough overall light to illuminate the front of the figure as well. The silhouette is an important element in this composition, so find a pose that creates an interesting shape on the page, and choose dark, flowing garments that emphasize the silhouette.

Seated Woman, *Contre Jour*

Materials and Equipment

- SHEET OF TINTED PASTEL PAPER
- CHARCOAL PENCIL
- PASTEL PENCILS: BLACK, BLUE, CRIMSON, YELLOW
- HARD PASTELS: WHITE, VENETIAN RED, GREY, BLACK, CYCLAMEN, FLESH TINT, RAW SIENNA, NAPLES YELLOW, SCARLET, VANDYKE BROWN, GOLD, BRIGHT PINK, RAW UMBER

1

Using a charcoal pencil, block in the main outlines of the figure. Check proportions and angles with your pencil. Use the verticals and horizontals in the background to locate the components of the figure accurately.

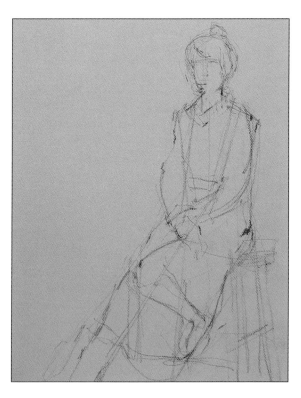

2

Organize the figure on the paper so that it makes a satisfying composition. Here, the model is placed to one side to create an asymmetric design. The predominant vertical of the perched figure is counterpointed by the diagonal of the outstretched leg. Develop the drawing, looking for the way the different parts relate to each other and to the stool. Check these relationships by extending lines from one part of the drawing to another. Consider the way the figure is balanced and visualise the body under the clothing.

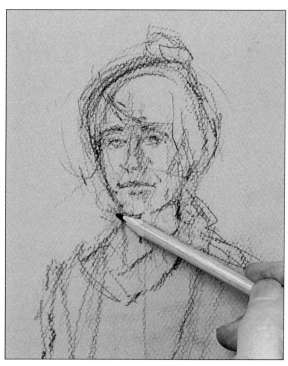

3

Once the figure is broadly set out, you can begin to develop the facial details. Add a dark tone in the eye sockets, alongside the nose, on the upper lip and under the lower lip. It is useful to have a recognisable face at this stage, but don't take it too far or it will cease to be consistent with the rest of the drawing.

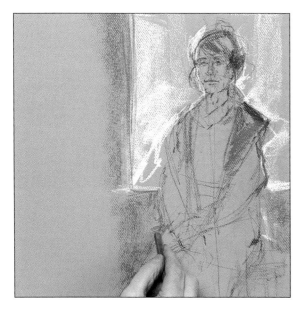

4

Using a pastel stick, scumble white over the screened window area. Use the stick to cut back into the silhouette, crisping up the outline. Block in the brick wall in Venetian red. Add touches of grey and black to the coat and to the model's hair. Because the support is a good mid-tone, the image feels more resolved than it would if you were working on white.

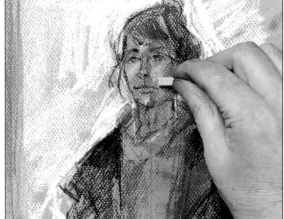

5

Scumble more white over the window area – the broken colour creates the luminosity you need for the light source. Hatch in the black of the coat, apply a glaze of Venetian red to warm the face, and add the cyclamen of the model's pullover. Start to develop the skin tones using flesh tint and raw sienna.

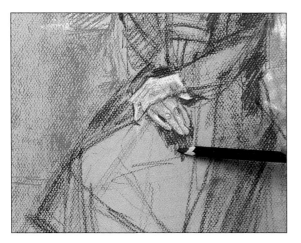

6

Apply a glaze of Naples yellow to the hands and then refine the shapes with the black pastel pencil and a little Venetian red. Apply black around the hands so that you are using the colour of the coat to define their outline – drawing the negative shapes is often more accurate than drawing the positive, and gives a more subtle result.

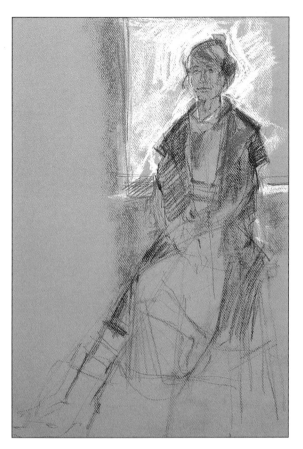

7

Stand back and study the picture from a distance, comparing the drawing with the subject. Block in the lower part of the model's flowing garments – sketching the position of the legs underneath will help you to produce a more logical drawing. Add touches of grey and scarlet to the jumper.

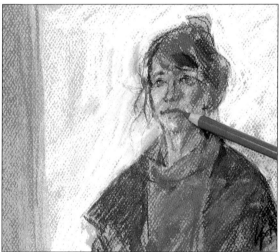

8

Don't focus on one part of the drawing, but try to keep the figure and the background progressing together to produce a more coherent, harmonious result. Add more scumbled white to the background and then develop the face with pastel pencils, using blue for the eyes and crimson for the lips. Pastel pencils are useful for detail, because they can be sharpened to a fine drawing point.

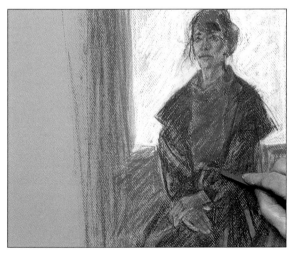

9

At this stage the colours are a little vibrant, so apply darker tones to create a more muted effect. Apply Vandyke brown over the brick wall and use the same colour on the face, hands and jumper. Sketch the stool with a yellow pastel pencil – it is important to the logic of the picture to describe how the model is supported.

10

Add white and grey for the highlights on the shiny surface of the leather boots. Then apply the darkest tones, using the black pastel pencil. These touches of light and dark give just the right amount of detail.

11

The floor is quite light in tone compared to the rest of the picture. Use a pale colour like Naples yellow to block in the floor, taking this light tone around the stool, so that it is drawn in negative. The colour of the paper stands for the local colour of the stool.

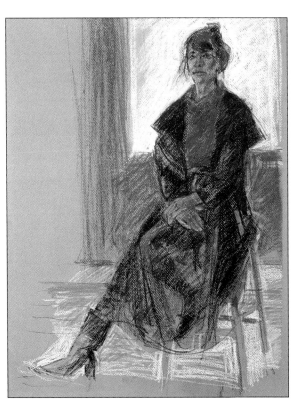

12

Add a few tiny touches of brighter colour to show where the light catches the edge of the figure – a touch of gold in the hair, a sliver of bright pink on the collar. Hatch a little raw umber on the floor at the base of the wall, which is darker because it is not fully illuminated. The completed figure is suggested rather than accurately described. It is these hints and suggestions, the concealing and revealing of forms, that make *contre jour* such an appealing lighting effect.

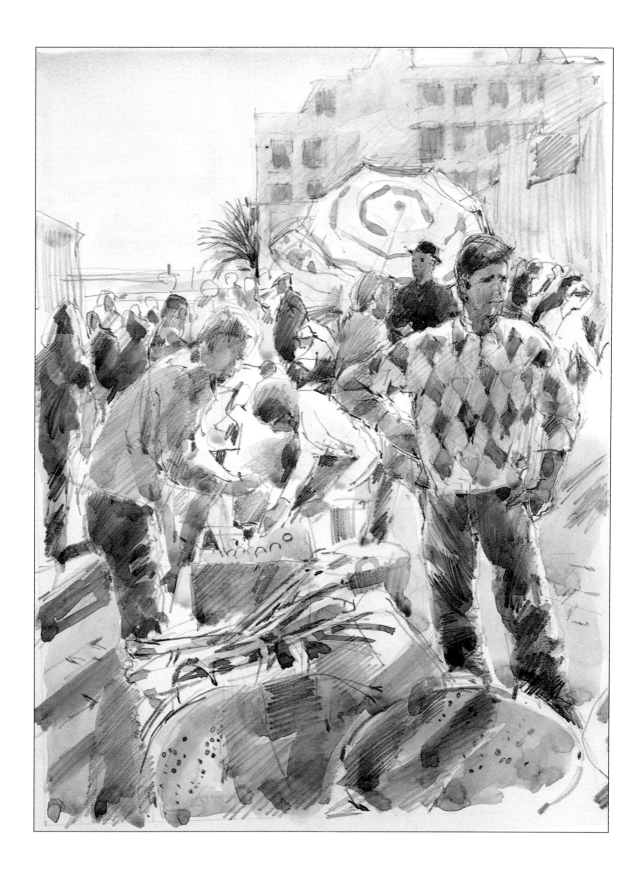

DRAWING GROUPS OF PEOPLE

Drawing from a model posing in mid-movement is one thing, drawing people moving about amidst the hustle and bustle of a public place – a market, a restaurant or a station, perhaps – is quite another. But if you are to use your figure drawing skills to produce scenes from everyday life, you need to collect 'live' reference material. Get into the habit of using a sketchbook and take every opportunity to make drawings of people going about their business. You will find that your drawing skills will improve immeasurably, and you will build up a source of fascinating material on which to base drawings and paintings. Use your camera to provide back-up information – photographs are useful reference for backgrounds, colour and detail, but it is the images that you have actually drawn that remain fixed in your memory.

~

Market Scene, Portugal
Pencil and watercolour
40 x 32cm (16 x 12in)

~

SKETCHING A CROWD SCENE

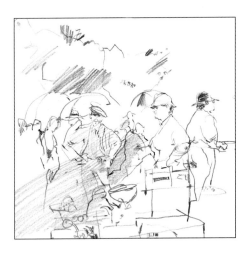

In this rapid sketch, the artist has managed to encapsulate the stance and character of the main figures in just a few lines, giving them individuality even though they are not drawn in any detail. The busy market atmosphere is suggested with just a few scene-setting objects such as fruit and vegetable boxes and scales. Areas of tone denote cast shadows.

A small sketchbook is one of the artist's most useful possessions. Keep one in your pocket and work in it when you are waiting for a train, sitting in a bar or visiting a market. In locations such as these, you will often find unusual characters and interesting poses.

In a busy place like a market, people are constantly moving about, so you must look intently and try to capture the scene as quickly and economically as possible. Ignore details and observe the principal thrusts of the figures – the angles of the torso, head and limbs. At first your sketches will be rudimentary, but with practice you will get better at selecting the significant features, and your visual memory will improve, so that you can complete the sketch when the person has moved on.

When you are more confident, you can start to place people in a setting. If a person is weighing out vegetables, show the scales, the stall and some of the background. Add a few clues to the perspective, so that you have a stage on which to put your characters. If you can sit somewhere comfortable – in a bar or café, perhaps – you can work in a large sketchbook. The format allows you to make a series of studies without constantly turning the page.

For drawing, use simple, portable materials such as a pencil, a fountain pen, a biro or a fibre-tipped pen. A few coloured pencils are useful for dashing

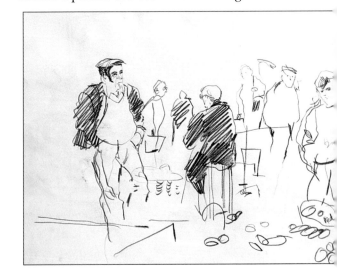

in scribbled colour – even a few clues will help you to recall the colours in the scene. You can also annotate the sketch. Practising artists' sketchbooks are full of colour notations that are meaningful only to them.

Light is an important element of any drawing or painting, so, if you have time, make a quick thumbnail study of the distribution of light and shadow across the scene. Half-close your eyes and hatch in the areas of dark tone, paying special attention to any shadows that might be important in a composition. Make a note of the position of the sun, the time of day and the weather conditions if relevant. You will find this information helpful if you develop the sketch into a more resolved drawing or painting. You could also use a camera to take a few overall reference shots of the scene.

When you want to progress to a more detailed drawing of a scene, you can transfer your sketch to another support by using a grid of squares or rectangles. Draw the grid directly on to the sketch or draw it on a sheet of acetate and lay that over the sketch. Now draw a grid on the support to which the image is to be transferred. It must be the same shape as the original and be divided into the same number of squares. If you want the new drawing to be larger, make the squares bigger than those in the original. Then copy the drawing, square by square.

This is one of many drawings that Albany Wiseman made at the market in Lagos in Portugal. He was staying nearby and returned several times to draw. Using both pages of a landscape format sketchbook gave him a broad working area.

USING REFERENCE MATERIAL

This project is based on sketches made on location in Portugal together with a colour photograph taken at the same time. Around the main sketch the artist has made additional studies of figures and background details. He has drawn a grid of nine rectangles over the sketch, so that he can transfer it accurately to the support used for the project.

MARKET SCENE, PORTUGAL

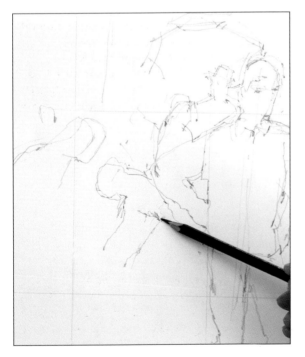

Materials and Equipment

- 300GSM (140LB) HOT PRESSED WATERCOLOUR PAPER
- PENCILS: 4B AND 6B
- WATERCOLOURS: CERULEAN BLUE, VENETIAN RED, RAW SIENNA, FRENCH ULTRAMARINE, ALIZARIN CRIMSON, CADMIUM YELLOW
- SQUIRREL WASH BRUSH

1

Draw a grid of rectangles over the sketch and then draw a similar grid on the paper. Remember that, to avoid distortion, the picture area must have the same proportions as the original sketch. Using a 4B pencil, copy the sketch rectangle by rectangle. Work in a logical way from the foreground to the background or from the centre to the edges. This will make it easier to assess how the image is working as a composition. Work carefully but freely, so that the final drawing captures the energy of the original.

2

Once you've got the main features down, transfer details by eye using the original sketch, the photograph and your memory. Remember that you don't have to follow the original sketch slavishly. You can make additions and other adjustments if these will produce a better picture. Use your imagination or take elements from another sketch or photograph. At this stage, important components of the composition have been established – the bending figure on the left and the standing figure on the right create a broad triangle with its apex in the striped parasol near the top of the image.

3

Start to suggest the figures in the background, ensuring that they diminish in size as they move away from the foreground. Crowd scenes are potentially confusing, so it is important to have a firm compositional structure and a lucid sense of space and recession. Begin to add detail to the faces and clothing in the foreground to help bring this area into sharper focus and resolve the spatial relationships.

4

Work across the drawing, developing the key figures and the context, thinking all the time about how the image works as a composition. Sketch in the buildings in the background and suggest the diamond pattern on the pullover worn by the standing figure on the right.

5

Using the sketch and the photograph as a guide, start to hatch in areas of tone. Work lightly at first, as you can darken these areas later if necessary. The man seen in silhouette against the backlit parasol is a key focus in the composition, so start by applying tone to this figure. Don't concentrate on just one part of the drawing. The image will be more coherent if you work across the entire surface, developing it as a whole rather than section by section.

6

Use hatched tone to suggest the patterns of light and dark falling across the image. Tone can also be used to suggest the solidity of objects and figures. Shadow applied to the end of the stall-holder's crate gives it three-dimensional form, while a dark tone on his arm suggests its roundness and volume.

7

Work across the drawing, applying areas of mid tone. Stand back and assess progress so far. The drawing is broadly established, but it lacks emphasis and detail. Using a 6B pencil, start to build up the dark tones on the man beneath the parasol, in the shaded areas between figures, on dark hair and in the darkest diamonds on the standing figure's pullover.

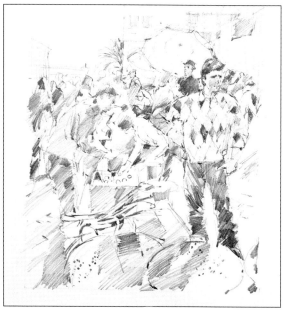

8

Develop the faces and clothing as well as the fruit, vegetables and nuts in the foreground. Think of the composition as a series of receding planes and reserve the greatest detail for the areas in the foreground. The standing figure on the right is nearest to the picture plane, so put more detail into the pattern on the pullover and the creases and folds in the jeans. The bending figure on the left is further away and should be described with lighter tones and less detail.

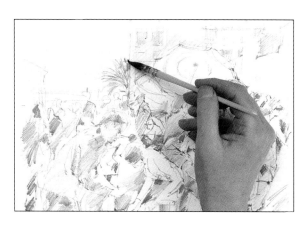

9

The drawing is now complete, so you can begin to enliven it with transparent washes of watercolour. Watercolour adds glowing colour and also fixes the drawing. Using a squirrel wash brush, mix a pale wash of cerulean blue and lay this over the sky area.

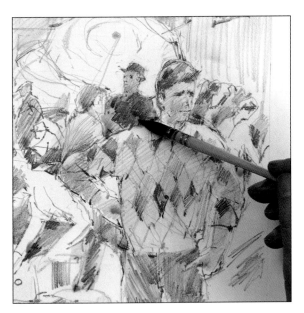

10

Using the same cerulean blue wash, but varying the intensity, lay a cool blue tone over the areas of shade and cast shadow in the drawing. Allow to dry.

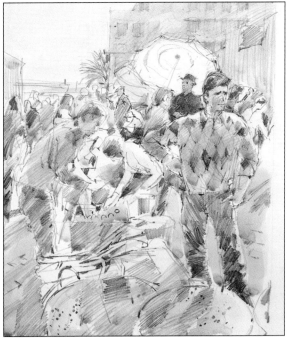

11

Mix Venetian red, cerulean blue and raw sienna to give a warm ochre tone and apply this to the sunlit areas in the drawing. Contrasting warm and cool colours is a powerful way of suggesting light and dark in an image.

12

Mix Venetian red and raw sienna to give a warm flesh tint. Apply this very loosely to the faces and hands of the foreground figures as well as to a few in the background. Use a darker tone of the same colour for the barrels of nuts in the foreground. Mix French ultramarine with alizarin crimson to paint the dark shadows on the jeans of the main figures, adding the same cool colour to the cast shadows throughout the image.

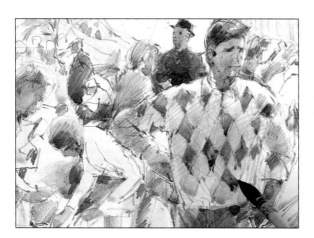

13

The clothes on the main figure on the right are painted in more detail than those on the other figures. The strong diamond pattern on the pullover, in particular, creates foreground interest. Use alizarin crimson for the crimson diamonds, applying the colour loosely.

14

Apply stripes of alizarin crimson to the parasol. This provides a visual link which leads the eye from the figure in the foreground to the parasol in the background. Complete the image by applying touches of cadmium yellow to the standing figure and the parasol, and a mix of French ultramarine and cadmium yellow to the leeks in the foreground. The image is now complete. Although it has been created in the studio from sketches and photographs made on location, it retains the energy and freshness of the original sketch.

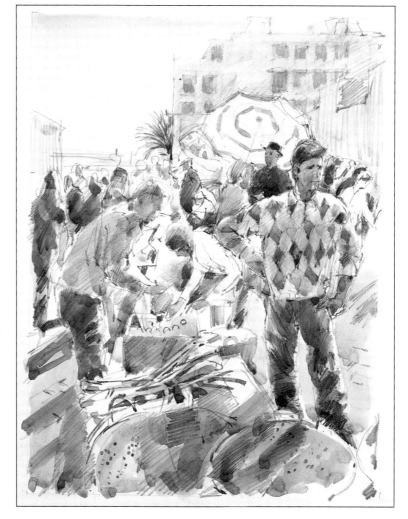

The Female Nude

IAN SIDAWAY

INTRODUCTION

The naked female form has moved man to creativity as far back as Palaeolithic times. Throughout Europe and Russia naked female figures, known as Venuses, have been found scratched into cave walls.

In the art of the ancient civilisations the human image is idealised – almost without exception men and women are depicted as youthful, following strict representational conventions. This preoccupation with the idealised human form is most evident in the art of ancient Greece and Rome. In sculpture, painting and the decorative friezes around pots and amphorae, the figure was always depicted as possessing a perfect athletic physique. However, the female figure appears relatively rarely.

The female nude was not a subject to be dealt with during the dark days of war and religious guilt of the early medieval ages. But with the Renaissance in 15th century Italy, art took a giant leap forward. Anatomical

Venus, Cupid, Time and Folly *c1540–1560*
Agnolo Bronzino 1503–1572

This allegorical painting on the subject of love places its erotic subject matter in a classical setting, and so was seen as acceptable.

La Source 1856
Jean Auguste Dominique Ingres 1780–1867

Ingres planned this painting, a blatant celebration of the female nude, for many years before it was painted. The central figure appears in an earlier work, Baigneuse de Valpincon.

investigations by Antonio Pollaiuolo (*c*1432–1498) and Leonardo da Vinci (1452–1519), and a greater understanding of perspective, made it possible for artists to treat the figure more objectively, and to create the illusion of three dimensions by positioning the figure convincingly in a two-dimensional space.

Armed with this new knowledge, artists turned once more to the legends of classical antiquity and the female nude was increasingly used as a subject to invest paintings with emotive power and intensity, appearing in many works by such great painters as Michelangelo (1475–1564), Raphael (1483–1520), Botticelli (1445–1510), Titian (c1487–1576) and Tinteretto (1518–1594).

But whilst the nude was used in works by artists as diverse as Rembrandt (1606–1669) in Amsterdam, Tiepolo (1696–1770) in

Olympia 1863
Edouard Manet 1832–1883

This painting, Manet's reinterpretation of the theme of the reclining Venus, painted so many times before, raised more controversy than all the others because it showed her as a prostitute.

Venice, Velazquez (1599–1660) and Goya (1746–1828) in Madrid, and Ingres (1780–1867) and Delacroix (1798–1863) in Paris, its acceptability relied on its being seen in a classical or mythological context. The naked portrait of a real person was rare. Examples are Helena Fourment as Aphrodite by Rubens, and François Boucher's painting of Louise O'Murphy commissioned by Casanova.

The later work of Ingres can be seen as something of a watershed, with two paintings, although popular, raising a degree of controversy. Both are overt celebrations of naked femininity. These were *La Source*, 1856, and *Le Bain Turc*, 1862.

In 1863, French artist Edouard Manet (1832–1907) caused a storm of controversy when he exhibited *Le Dejeuner sur l'Herbe* at the Paris Salon des Refuses. The picture, showing two fully dressed men seated with a

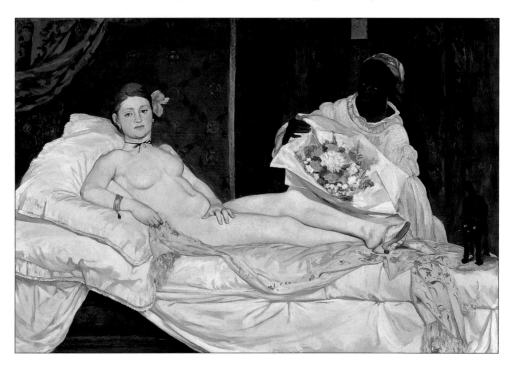

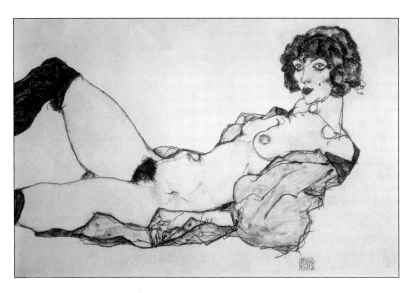

naked woman, was seen as scandalous. In 1865 Manet exhibited *Olympia* to critical and public outrage, rooted in the fact that the model, Victorine Meurent, who appeared in many of Manet's pictures, was obviously representing a prostitute.

This image of the female nude in real-life situations gained impetus with the pastel works of Edgar Degas (1843–1917) and the oils of Auguste Renoir (1841–1919), both of whom produced a large body of work showing the nude female bathing or at her toilet. Criticism was now more about technique than content. Renoir and Degas were respected artists and when their pictures of female nudes appeared, a decade after *Olympia's* unveiling, public opinion had sobered.

Degas' bathers showed the female nude going about her toilet apparently unposed and oblivious to the artist and onlooker. These were truthful representations of the female nude, used as a means to explore and experiment with the imagery and problems of composition, colour and technique.

Reclining woman with green stockings 1914
Egon Schiele 1890–1918

Drawn towards the end of his short life, this work shows the economy of line and colour with which Schiele was able to capture the pose.

This raw approach is perhaps seen best in the superb drawings and paintings made by the Austrian artist Egon Schiele (1890–1918). His works, although often erotic, disturbingly contorted or pornographic, were superbly drawn. Schiele's main strength was his use of line which searched out the figure's form with a startling fluid simplicity.

The 20th century has seen a huge diversification in artistic direction and discipline. Depictions of the female nude still abound, and looking at paintings by Picasso, Stanley Spencer, De Kooning, Wyeth, Philip Pearlstien or Lucien Freud gives an idea of their diversity. The female nude is still a primary subject to test the artist's techniques and powers of representation.

TECHNIQUES

Painting or drawing, your style will be determined to some extent by the materials and the technique you choose, whether drawing with the fine detail of pencil and pen, or applying the bolder strokes of pastels and oils.

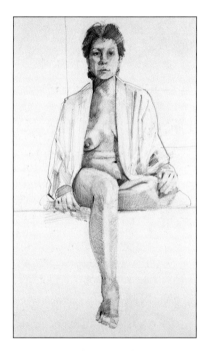

Above Graphite pencil

GRAPHITE PENCIL

The simple graphite pencil is familiar to everyone and is one of the very first mark-making implements we use as children. It is perhaps due to this familiarity that we frequently fail to recognise its wide-ranging potential. Pencil is available in a range of grades from very hard to very soft and the best grades for drawing are the softer grades from HB to 8B.

Pencil is a fast medium. It can also be used to make very considered drawings which build up tone or line slowly. The same is true of the graphite stick, which is simply a pencil with a thick "lead". Another consideration with pencil is that very little equipment is needed to make a drawing. Tone is built up using one of many methods, such as mixing different shading methods together in the same drawing. Here the drawing uses line work and tone, built using scribbled and hatched lines. The tone is then worked on with a putty eraser, knocking it back or lightening it and adding any highlights. Drawings done with soft pencil smudge easily so make sure that you fix them at regular intervals with fixative.

CHARCOAL

Like pencil, charcoal is a quick medium, and is capable of rapidly capturing a pose in line and tone. The possibilities of the material are increased if used with a coloured paper and white chalk, pastel or crayon. Here a mid-grey paper gives a mid-tone out of which the dark charcoal represents the darker tones and the white chalk is

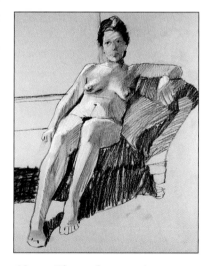

Above Charcoal

used for lighter tones and high-lights. Very seductive drawings can be made using this method, which was often used by the old masters. A variation on this method is known as *les trois crayons*, the three crayons. This involves using black, white and sanguine crayons to produce the dark, light, and mid-tones.

HARD PASTEL

In many respects, hard pastel sticks are similar to charcoal. They are capable of producing a similar quality of line but are cleaner as they "take" more firmly to the paper. This makes them more difficult to erase and tone cannot be laid or erased quite as easily as with charcoal.

By varying the pressure applied to the pastel stick, light or dark lines of varying thick-ness are easily made; this makes them ideal for drawings which require strong line work. In reality, lines around people or objects don't exist. Surfaces are seen to change, turn or join one another by altering colour, tone or direction and not by ending with a line. Good line drawings try to show this by having a variety of line density and thick-ness, which is suggestive of these characteristics.

Here the drawing was first made using a series of light, flowing lines which explored and searched out not only the figure's outline but the internal contours. Once these were seen as correct, some of the lines were redrawn and strengthened in order to suggest both shadow and highlight.

Below Hard pastel

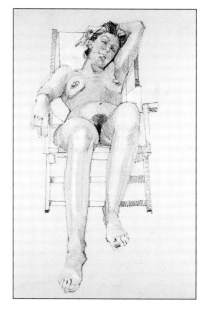

Above Coloured pastel pencil

COLOURED PASTEL PENCIL

Here pastel pencils have been used to produce a drawing which expands on the ideas seen in the charcoal drawing. A paper, the colour and tone of which was sympathetic to the subject, was used to give a light mid-tone base on which to work. Six coloured pastel pen-cils were then used to lightly draft out the figure and gradual-ly build up the tone and colour, with highlights being added last with a white pastel pencil.

This finished drawing uses a combination of tone and line to successfully describe the form of the figure. Hidden amongst the tone and colour can be seen a few contour lines which give a clue as to the shape and direc-tion of the surface. The same technique can also be used with coloured pencils or soft pastels.

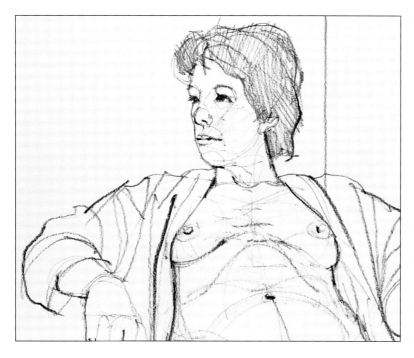

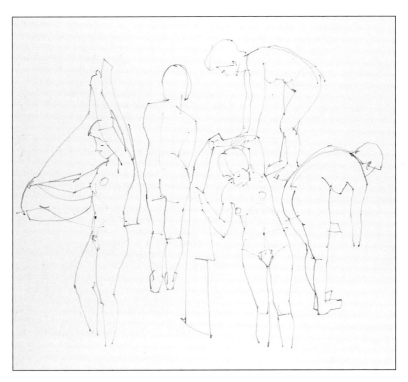

Above Pencil quick poses

PENCIL

Pencil makes the ideal medium for making rapid drawings. Any medium which makes a strong solid mark would also be suitable, including charcoal and graphite sticks. Rapid drawings and quick poses serve several purposes: they force you to draw boldly and fluently and they help develop your powers of observation as, given the rapidity with which the model alters her position, the artist is forced to look for those lines and shapes which represent the pose or position with the most economy. Quick poses are also a useful way of limbering up before attempting to draw or paint the figure proper. The model can keep changing the pose after a few minutes or she can be asked to perform a task. Here the model is seen preparing for and drying herself after taking a bath.

PEN AND INK

Good drawings made with a dip pen and ink have a real beauty but they are notoriously difficult to achieve. Pen and ink is an intimidating medium which can be difficult to correct, and if lines fail to flow freely, they can easily look tired and uninspired. If a pen and ink drawing goes wrong and the mistake is not easily disguised or incorporated, it may be better to begin again. Initially when working with the medium, try working over a light pencil drawing. Do not think of this as cheating; it will simply help keep the work moving in the right direction. Try not to follow the pencil lines but redraw using the pencil marks as a guide. Adding water to the ink will lighten it and can make your initial marks less apparent. Once the figure is fully realised, the ink can be used neat and at full strength. If you have used a pencil drawing as a guide, this can be erased once the drawing is complete. Always allow plenty of time for the ink to dry so as not to ruin the drawing by smudging it.

Below Pen and ink

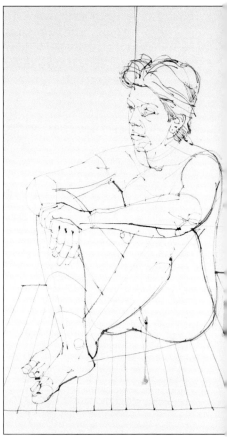

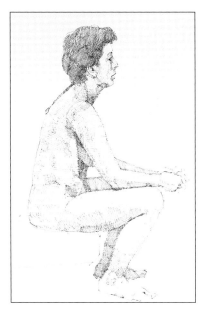

Above Technical pen

The beauty of a dip pen is its ability to make a line that varies in thickness according to the degree of pressure applied to it. Technical pens, biros and some markers make a line of one thickness only. However, these are all capable of making drawings which contain a full range of subtle tone, and lines can appear to alter in thickness by being restated several times. As with the conventional dip pen, mistakes are not easily corrected; working over a light pencil drawing can help. Tone is built up by hatching and cross-hatching a series of lines to build up areas of varying density. The technique is both absorbing and controllable and is capable of producing very subtle drawings. The technique is also valuable because it teaches how to observe the gentle transition of tone from light to dark. Highlights are left as white paper, whilst very dark or black areas are heavily cross-hatched so that little or no white paper can be seen.

SOFT PASTELS

Soft pastels are mixed and blended in one of two ways. Either they are blended on the support using a finger, torchon or blending brush, or the coloured hues are placed next to one another on the support and

Stretching Watercolour Paper

In order to stop watercolour paper buckling and cockling each time it is wet, the paper should be stretched prior to starting work. You need a sheet of watercolour paper, a wooden board larger than the sheet of paper, four lengths of gum strip, water and a sponge.

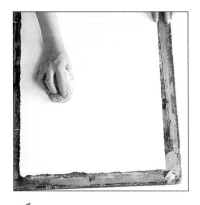

1
Lay the sheet of paper onto the board and wet it with water using the sponge. Do not rub the paper too hard because it is easily damaged when wet. Remove any excess water with the sponge.

2
Take a length of gum strip and wet it. Lay the strip down one edge of the paper and secure it to the board. Do the same along the other three sides.

3
Remove any excess water on the paper, making sure all four edges are secure, and place the board to one side. Let it dry thoroughly before starting work.

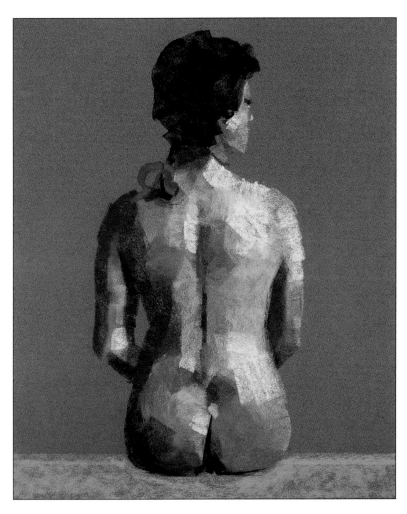

ground which was seen to be sympathetic to the overall colour and gives the work an underlying sense of harmony.

WATERCOLOUR

This is ideally suited for figure painting as the subtle medium is capable of representing the equally subtle transition of colour, tone and light at play on the contours of the naked female figure. Watercolour is usually worked on a white surface, which reflects light back through the layers or washes of paint. Washes are worked "wet in wet" – colours are applied over each other while still wet – or "wet on dry" – each layer is allowed to dry before another is added. A combination of these methods is usually used in any one painting. In this painting of a reclining figure, the lightest tones and colours were applied

Left Soft pastel

Below Watercolour

the mixing takes place optically in the viewer's eye. This was the principle used by the pointillists in the late 19th century. If a limited range of pastel colours are available, this direct approach can result in a very complex work which will enable the marks to keep their freshness and intensity without colours becoming muddy and confused. By fixing between layers of marks the work can be taken to an exceptionally high degree of finish. This simple back view has been done on a coloured

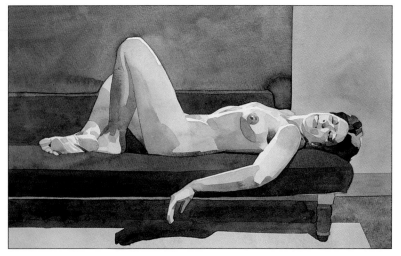

first, with each subsequent colour wash modifying the one beneath. When subtle changes of colour or tone are required, washes are allowed to run together and mix. The darkest colours are painted in last of all. Depending on the paper used, watercolour can be corrected by rewetting areas and blotting off the redissolved paint.

OIL PAINT

Oil paint, despite its reputation to the contrary, can be remarkably easy and clean to use. This small painting was done using only six colours which were mixed with liquin. This is a quick-drying medium and will allow oil paint, which can take up to several days to dry, to be dry enough for overpainting in a few hours. The painting was made quickly on a board prepared with primer and was drawn and painted in under one hour. The painting was then repainted the following day. The figure is seen in the context of a slightly unusual environment, a picture waiting to be painted! An advantage of oil painting is that corrections can be made easily; the wet paint can simply be scraped off and the new paint applied on top. Picture-making possibilities surround us, and unusual ones may crop up several times a day. Keep alert to them and if it proves impossible to produce a picture there and then, make a note of the idea for future.

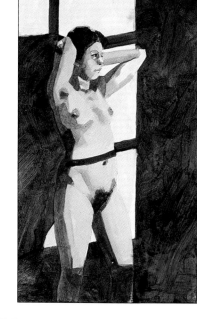

Right Oil paint

You can buy wooden paintboxes which will keep everything clean and tidy – and in one place!

Priming Canvas and Board for Oil Painting

1 If using MDF or the smooth side of hardboard, first key the surface with a sheet of sandpaper. Using an acrylic primer, work across the board or canvas until it is totally covered. Allow to dry thoroughly.

2 Once dry, repeat the process, working the brushstrokes at an angle to the brushstrokes used in the first coat. The process can be repeated several times depending on how smooth the surface is intended to be.

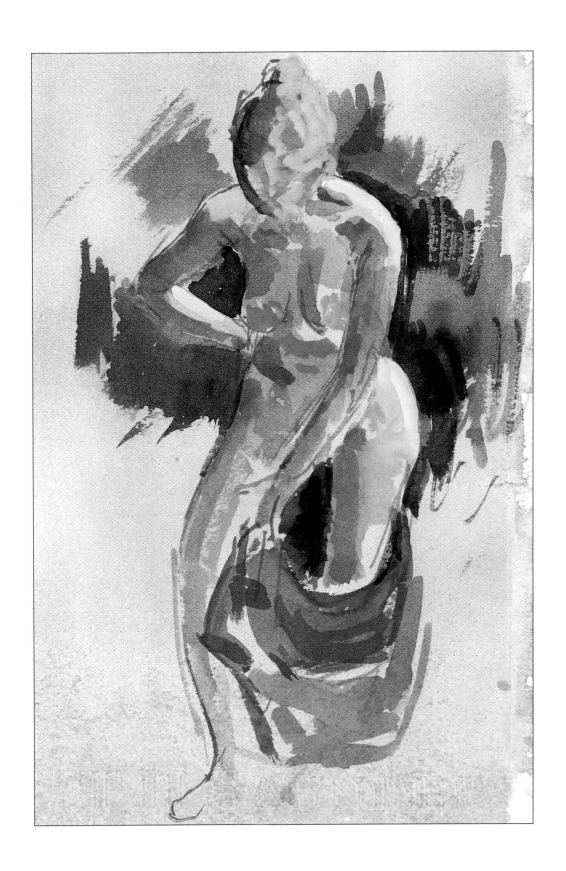

GALLERY

Each medium brings with it not only its own range of techniques but also its own problems of representation. Artists solve these in many ways and this small gallery of drawings and paintings done by different artists with a range of different materials aims to show just a few chosen solutions. The pictures have been selected to demonstrate how choice of material, technique, composition, framing, scale and colour, together with the figure's chosen pose, all contribute to creating a mood and style.

Woman Undressing
James Horton
25 x 18cm (10 x 7in)

Expressive brush work lends a sense of immediacy to this figure caught in the act of removing an article of clothing. Artists often do several pictures at one sitting with the model changing her pose every few minutes. The exercise is excellent practice for honing the artist's powers of observation.

Study of Debbie
David Curtis
25 x 30cm (10 x 12in)

A splash of bright sunlight
streaming through a
window has been seen as a
perfect picture-making
opportunity. The shadows
cast by the window frame
serve to show up the
contours of the body in an
otherwise flat patch of light.

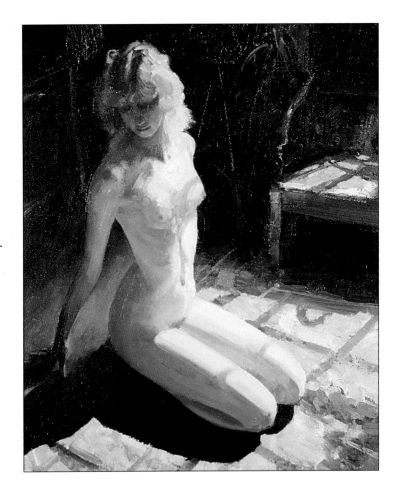

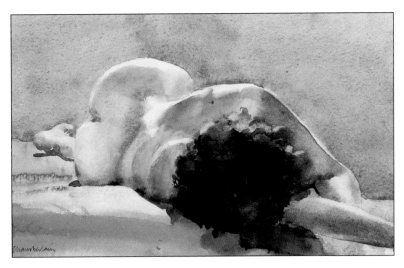

In the Spotlight
Trevor Chamberlain
18 x 25cm (7 x 10in)

Foreshortening occurs to
some degree in most poses.
Here the artist has solved the
problem with clever use of
colour and by painting what
he sees, rather than what he
thinks is correct. A splash of
red in the foreground
exaggerates the effect.

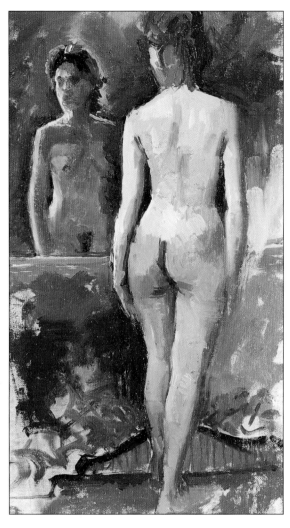

Nude By The Mirror
James Horton
25 x 15cm (10 x 6in)

This oil study is done on a canvas previously given a toned umber ground. The coloured ground acts as a mid-tone which shows through intermittently, giving the work a sense of harmony. It also speeds up the painting process and saves the artist from having to mix colours against a pure white background.

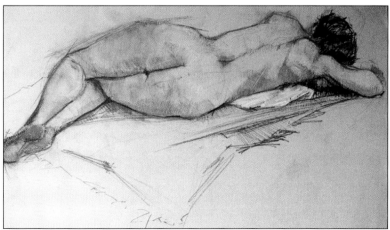

Life Study 2
Barry Freeman
76 x 56cm (30 x 22in)

There is a sculptural quality to this drawing. Done on toned buff-coloured paper which acts as a mid-tone, the figure is almost carved out of the paper using black and sanguine crayons. White chalk highlights give the finishing touches.

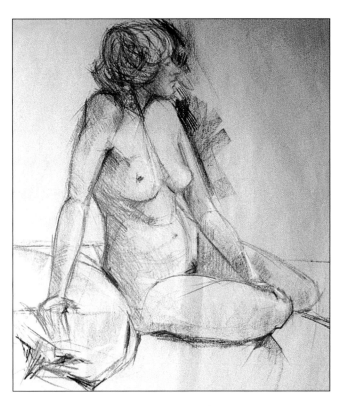

Life Study 1
Barry Freeman
76 x 56cm (30 x 22in)

Using three coloured
chalks, the artist has drawn
the model with a certain
economy. He has made
no attempt to cover
underdrawing lines or
construction marks, all
of which add to the
drawing's interest and
give the viewer an insight
into the creative process.

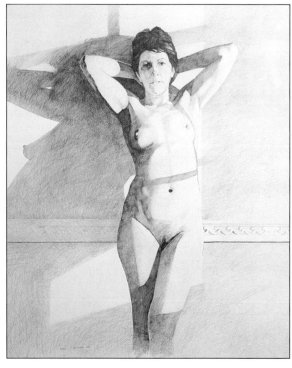

Standing Figure
Ian Sidaway
110 x 74cm (43 x 29in)

Careful hatching and cross-
hatching with a range of
graphite pencils create a full
range of tones in this
drawing. The graphite was
fixed periodically, and an
eraser was used to work
back into the tone to modify
and lighten areas.

GALLERY

South Carolina Girl
Trevor Chamberlain
25 x 36cm (10 x 14in)

This well-posed watercolour has been painted using predominantly wet-in-wet washes. Both warm and cool colour washes have been delicately introduced to give the figure a sense of contact with her surroundings.

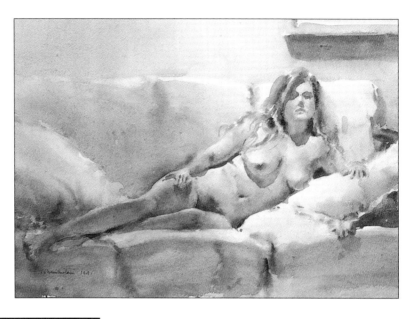

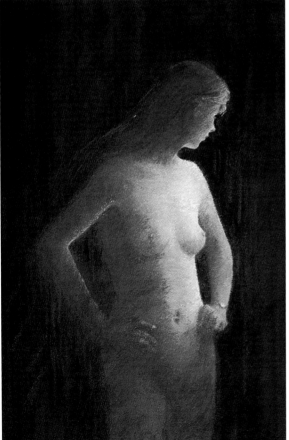

Evening Light
Charmian Edgerton
23 x 38cm (9 x 15in)

This pastel painting was made by the steady build up of pastel in broken strokes. Each layer allows a little of the previous layer to show through. Notice how the dark background is not a flat colour but built up with several different colours in much the same way as the figure.

Kim in a Green Scarf
Maureen Jordan
33 x 24cm (13 x 9½in)

A fluid line and sure sense of colour together with a clever choice of pastel paper all contribute to this delightful figure drawing. The artist has defined much of the outline, especially the right shoulder and breast, by working into the figure with the background colour.

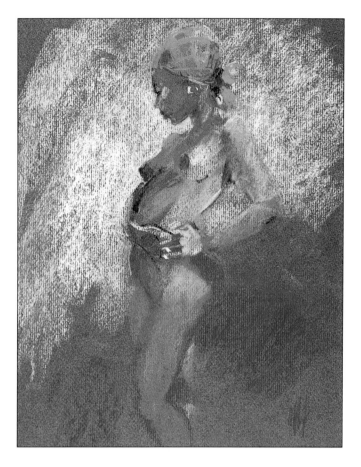

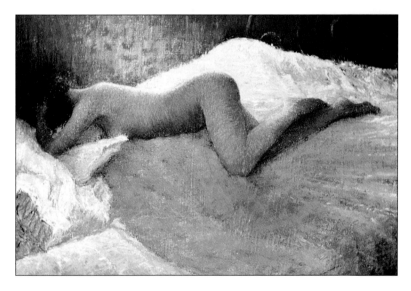

Blue Nude
Charmian Edgerton
20 x 38cm (8 x 15in)

This small pastel is delicately built up with strokes of pure cool colours placed next to each other, allowing the mixing to take place in the viewers' eye. There is little or no blending, which gives the work an intensity and brilliance that overworking could easily lose.

Pose
1

HELENA

This seated pose is a comfortable one and it should be possible for the model to hold it for a period of time quite easily. Mark those areas where the model touches the stool, so that after breaks it is easy for her to return to the same position. Dramatic lighting helps to accentuate the figure's form, adding interest and depth, and gives the student a little less, in terms of detail, to think about. The pose also allows the figure to be viewed from 360 degrees, making it possible to assess angles and shapes, and to select the best position to work from. The shapes seen around the figure, especially through the gaps made by the model's legs and the arms and legs of the stool, all help you to assess the precision of your work. This is achieved by looking at the negative space and shapes around the model and those created by her body, rather than just concentrating on the shape of the figure. A seated figure is more contained than a stretched-out figure, and makes far more interesting shapes, which should make it easier to relate one part of the body to another.

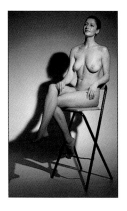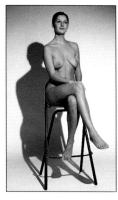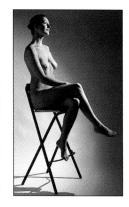

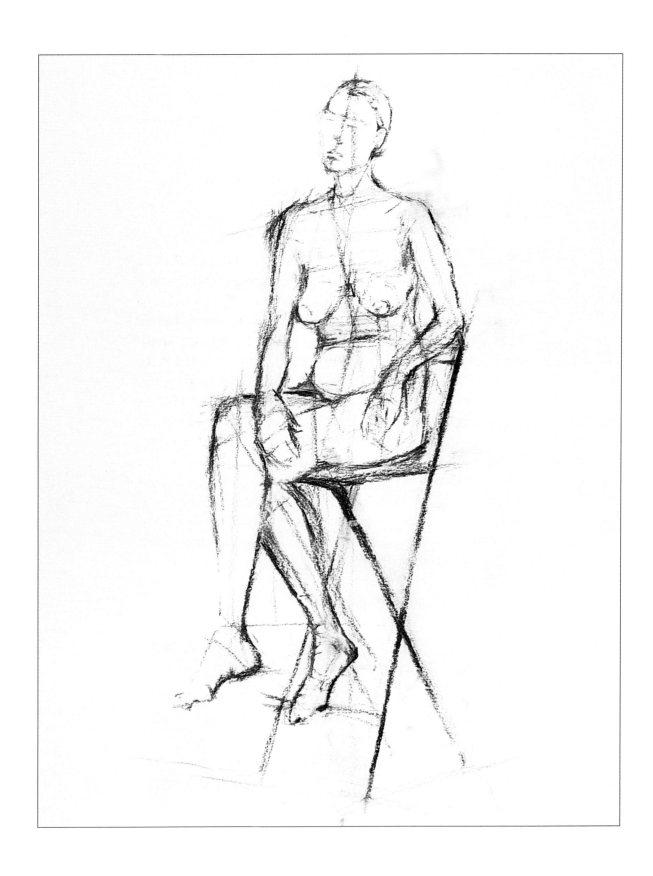

Project

1

CHARCOAL LINE DRAWING

Charcoal is a versatile and descriptive medium, which is perfect for showing the graceful flowing line that is a characteristic of the female nude. The medium allows a degree of detail but its very nature encourages a broader approach, forcing the artist to look at the figure as a whole. Charcoal has a beautiful line quality and by varying the pressure it is possible to make a wide variety of line thickness and degrees of tone. As charcoal can be messy, it would be wise to wear old clothes while you are working, and to protect the floor beneath the work area with newspaper.

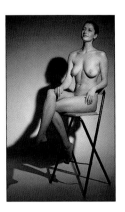

Charmian Edgerton
Helena – side view
36 x 25cm (14 x 10in)

HELENA – SIDE VIEW

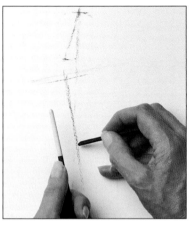

Materials and Equipment

• CARTRIDGE PAPER (ANY KIND OF PAPER CAN BE USED AS LONG AS IT DOES NOT HAVE A SMOOTH SURFACE) • VINE CHARCOAL STICKS IN A RANGE OF THICKNESSES • KNIFE FOR SHARPENING • OIL PAINTBRUSH, TO USE AS A STRAIGHT EDGE FOR MEASURING AND TO REMOVE LARGE AREAS OF CHARCOAL • PUTTY ERASER AND BALLS OF WHITE BREAD (FOR ERASING SMALL AREAS) • BOX OF TISSUES • FIXATIVE SPRAY

1.

Use a narrow charcoal stick to make two dots at the top and bottom of the paper, joined by a guideline to denote the figure's general extent and position. Look at the angle of the head using the straight edge of a paintbrush, held at arm's length, with your thumb at the figure's chin and the top of the edge at the top of her head. Bring the angle down onto the paper and mark in a light guideline. This will form the basis for the rest of the figure.

2.

Work down the figure, sketching guidelines for all of the body's key angles: shoulders, torso, hips and legs. Move the charcoal in the direction that the body moves.

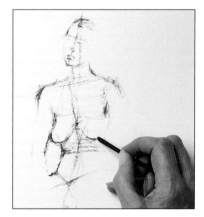

3.

Then start to flesh out the outline, working on either side of the central line. Pay attention to the spaces created by the figure, for example between the arm and the body, to assess the precision of your work.

4.

As you work down the figure, use the straight edge of a paintbrush again to assess the angles created by the body. Compare the proportions of the different parts of the figure; for example, the distance from the top of the breasts to the chin is roughly equal to that from the top of the head to the chin. Do not get too bogged down in measurement, or the drawing will start to look static.

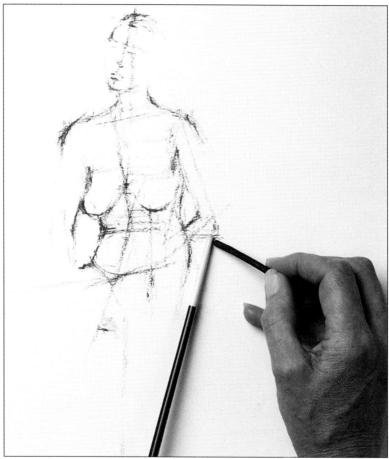

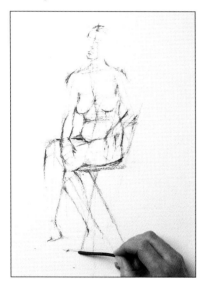

5.

Once the figure is almost complete, draw in the stool or chair, but beware of placing too much emphasis on this. Concentrate on the shapes and lines that the chair makes with the seated figure. Remember that the focus of the picture should be the nude, and the support should only really be hinted at in such a simple line drawing.

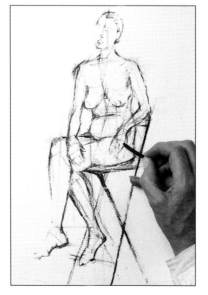

6.

In more difficult areas, for example in this drawing the hands and the angle of the arm resting on the chair, you may need to restate lines or adjust your initial framework to compensate for errors or movement by the model. Don't worry too much about detail, or erasing mistakes; remove lines only if they are making it difficult to redraw or if they are distracting to your eye.

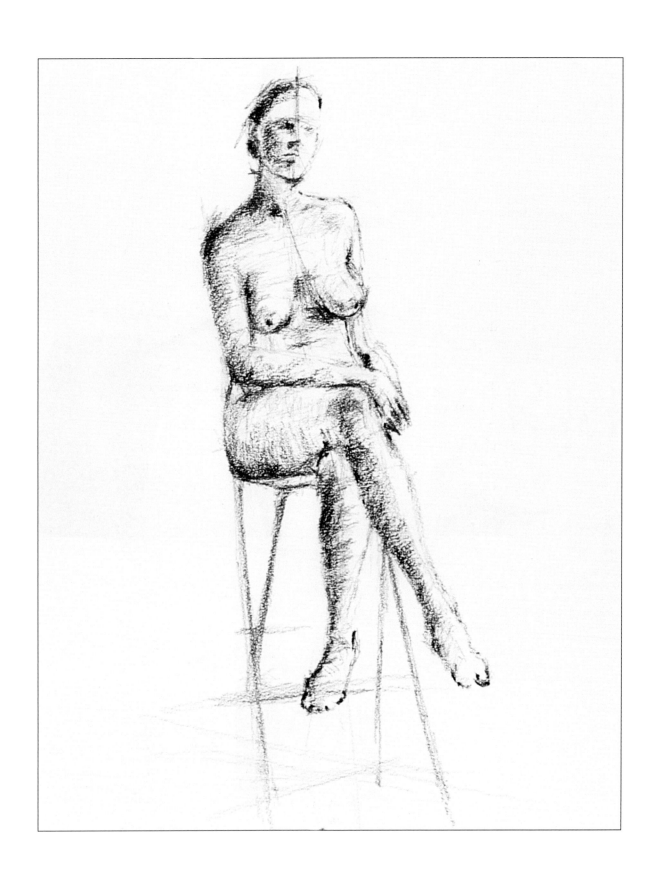

Project
2

GRAPHITE

Graphite sticks are available in different grades, ranging from HB to 8B. They are available either in pencil shapes coated with a plastic film to keep the fingers clean, or as thicker, short, hexagonal-shaped sticks. They can be sharpened like ordinary pencils. Graphite is used to produce a full tonal range and, by altering the angle at which the stick meets the paper, you can produce various thicknesses of line. With practice you can make a smooth transition from a thick to thin line in one uninterrupted stroke. Take care when using graphite, as it is relatively fragile and will shatter if dropped. When pressing hard, do not hold the graphite pencil or stick too far up the shaft. Shading, blending and erasing are carried out as with a conventional pencil.

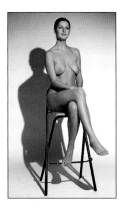

Charmian Edgerton
Helena – face on
25 x 18cm (10 x 7in)

HELENA – FACE ON

1.

Sketch out the body shape in line using the same principles to capture the basic angles and proportions as in Project 1. Work with a graphite pencil for this stage, as it is the easiest to control. As you sketch, look for the three main tones of the figure – dark, medium and light.

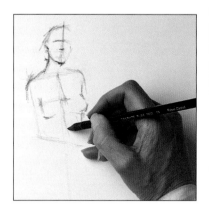

Materials and Equipment

• CARTRIDGE PAPER • SOFT (3B) GRAPHITE PENCIL • SOFT GRAPHITE STICKS • PUTTY ERASER • KNIFE FOR SHARPENING • FIXATIVE SPRAY

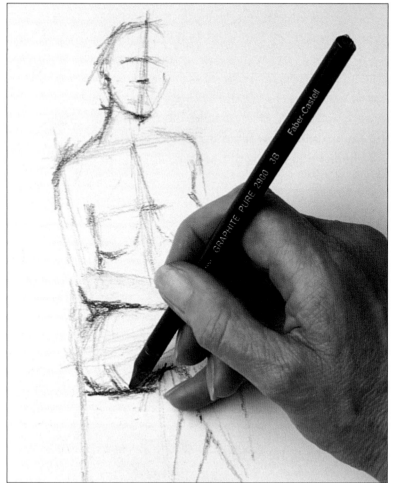

2.

Work down the figure, fleshing out the outline and adding contour lines and the areas of shadow which give the figure its weight – particularly where the body rests on the chair and the arm rests on the thigh.

3.

Choose one area of the darkest tone and shade this area, then go back over the figure adding the other areas of the same dark tone. Use the graphite stick for large areas. Draw with the graphite in the direction of the body's natural movement – across the thigh, then down the calf.

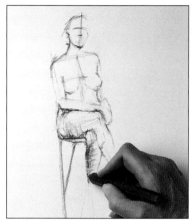

4.
Look out for the tonal shapes created on the body by the light. Observe how the differences in tone bring out the contours to give the sense of depth and volume. Applying mid-tones, working around the contours of the body, will lift the figure off the page and recreate this weight. For example, the tones and direction of the shading on the thigh help to define its shape and volume. Go back over the figure applying the areas of darkest tone, for example where the foot meets the stool. In the lightest areas, work very gently with the stick or pencil with small strokes. On the lightest edges of the figure, gently dot and dash in the outline to give the illusion of the body curving away from your eye.

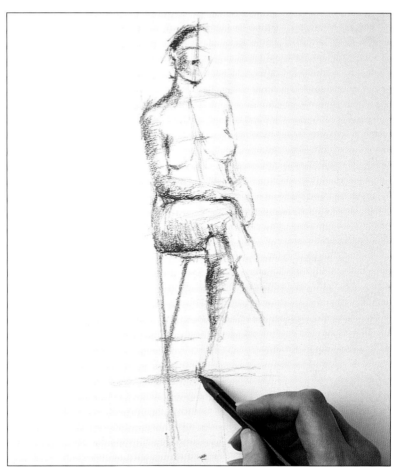

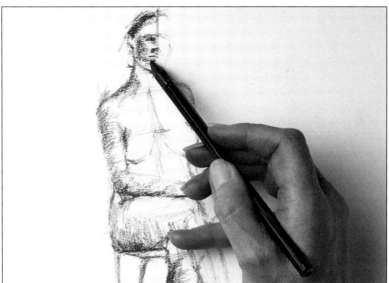

5.
Do not concentrate on the detail of the face, but search out the three tones – light, medium and dark – to give an impression of the features. Here, the right side of the face and the forehead are in strong light and are the lightest tone. The left-hand side of the face is in strong shadow and is made up mainly of the darkest and medium tones.

253

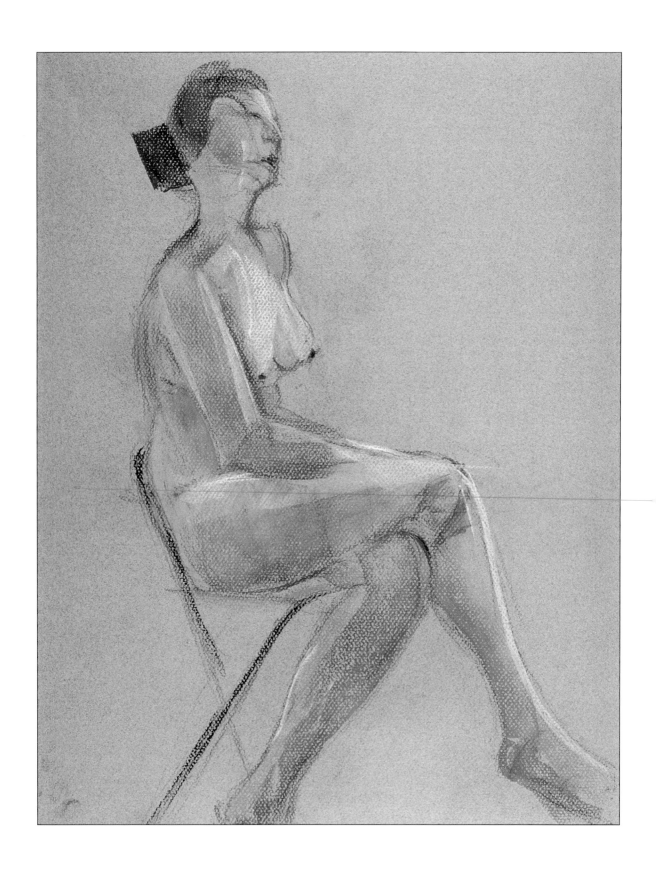

Project
3

HARD PASTELS

Pastels are dry, coloured pigment mixed with a binder and formed into sticks. One of the best known manufacturers is Conté, who make a range of hard pastels, which for the beginner can be easier to work with. These come as pastel sticks or as pencils (crayons). Coloured pastel pencils have many of the characteristics of charcoal but are easier and cleaner to use. Both sticks and pencils can be sharpened with a knife, allowing for fine line work and the building up of subtle hatched and cross-hatched transitions of colour and tone. However, these pastels smudge as easily as charcoal and they can be more difficult to erase. Pastels benefit from using a broader approach: begin lightly and gradually strengthen the drawing once you are sure it is correct.

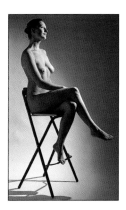

Frances Treanor
Helena – side view
56 x 41cm (22 x 16in)

HELENA – SIDE VIEW

1.

Using a spectrum blue pastel pencil, lightly sketch in guidelines to give the proportions of the figure as in Project 1. Work from the neck down, leaving the head until last. This is a working drawing, so don't be afraid to make mistakes.

Materials and Equipment

• GREY INGRES PAPER WITH GRAINED SURFACE, A3 MINIMUM SIZE – USE ACID-FREE PAPER IF POSSIBLE • SPECTRUM BLUE PASTEL PENCIL FOR DRAWING OUTLINE • HARD PASTELS: SALMON PINK, YELLOW, OCHRE, BROWN, BURNT SIENNA, PURPLE AND WHITE • KNIFE FOR SHARPENING • TORCHON FOR BLENDING • FIXATIVE SPRAY

2.

Once you have completed the outline, look at the model to decide what the range of colours should be. In this case, the hair is the darkest, probably rating 8 on a scale of 1 to 10. Don't choose too many tones – keep it simple. Start with a salmon pink pastel stick, working from the top of the body down. Pinch the pastel between finger and thumb and use the side of the pastel to get a soft effect and cover broad areas.

3.

Continue to add the pink in other areas with the same basic tone as the neck and shoulder – down the back and along the thighs. Sweep the pastel along the curves of the body. Try to think of the method as "drawing with pastel" rather than simply "colouring in" the outline.

4.

It's best to start with light tones and then add darker ones. Once you have applied the first, broad strokes, you can start to build up some tonal contrast – here burnt sienna is being applied over yellow. You're not trying to match the colours to life, but to render the tonal contrasts. Feel free to overlap colours or apply one on top of another and to blend them together.

5.

Continue to add colour – yellows and ochres are used here – but don't overwork the figure, keep it simple and work with the colour of the background paper to emphasise the highlights and shadows. Think about the direction of your strokes, following the direction that the body is taking in order to give a sense of the figure's shape and movement. Here, different strokes have been used to suggest the horizontal line of the thigh and the downward curve of the buttocks.

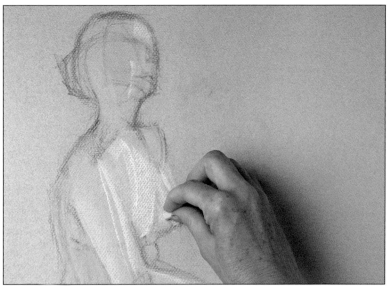

6.

Use the pale yellow pastel in the light-toned chest area. Sweep the flat side of the pastel around the curves of each breast to create a soft effect and to capture their form.

7.

As you work, you may find that you need to redraw. Don't be too concerned about erasing mistakes, unless they are distracting. If you do want to correct a mistake, use the torchon to blend the colour.

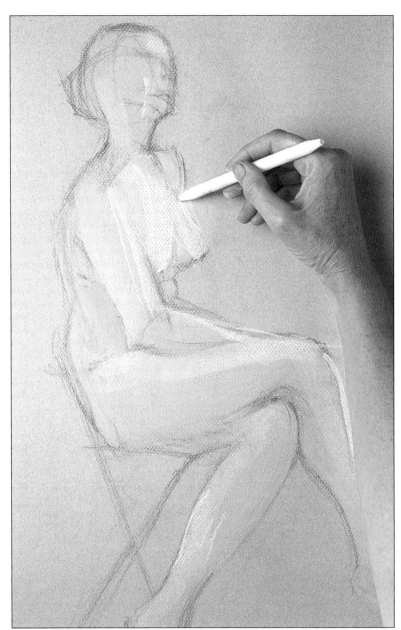

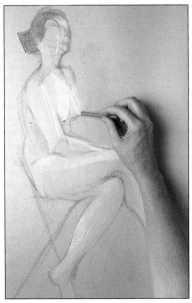

8.

Once you have added the main blocks of colour and got the tonal range right, including the highlights, you can add a minimum of detail using strong colours. Here a bold swathe of brown is used to delineate the hair, and burnt sienna for the nipples.

9.

Use your lightest tones sparingly, mainly for highlights. In this case, the figure is quite dramatically lit, giving very bright highlights, so some use of white is appropriate, but keep it to a minimum.

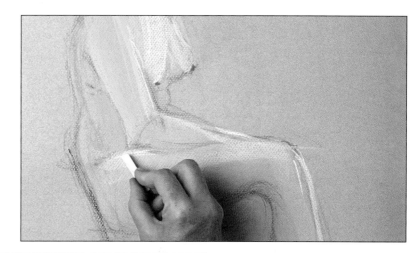

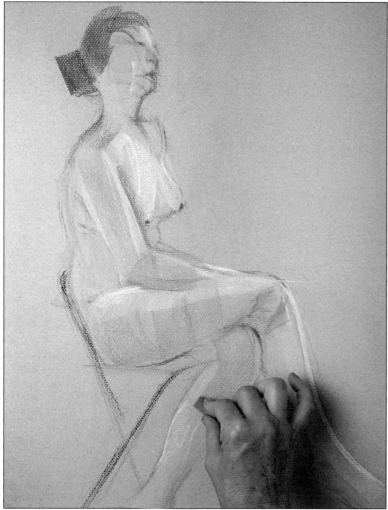

10.

Once you are satisfied with the overall figure, you can add a little detail to the face. You may also want to add some shading to give depth to the figure, but don't overwork it. Here, purple is used to strengthen the shading on the calves; a little has also been added to the hair.

Pose

2

SARAH

The straightforward standing figure may at first seem to be the simplest to draw or paint, but this is not necessarily the case. Here, the model is lit from the side to accentuate the tonal contrast from light to dark, which means that much of the tone which defines the form could be inferred rather than accurately represented. The main problem with drawing or painting the standing nude figure is achieving the correct balance and distribution of weight. Working from a vertical line, either imagined or actually drawn, will help you to position the figure correctly. This line should be positioned to run vertically from the centre of the neck to the floor as this represents the body's centre of gravity. Correct measuring of proportion is critical in order to prevent the figure appearing too short or long, and correct use of this vertical line will prevent the figure seeming to fall over. Make frequent reference to the shapes around the figure to check and reassess the accuracy of your work, and readjust as you go.

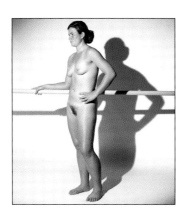
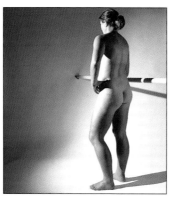
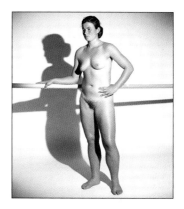

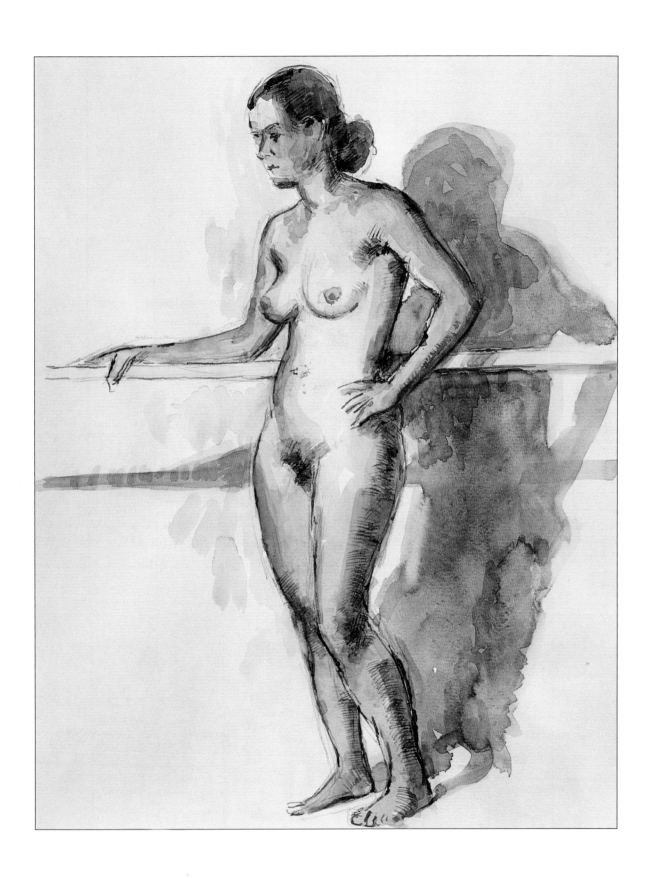

Project

4

PEN AND WASH

Using pen and wash can be deeply satisfying. The pen can produce beautiful line work of varying thickness and solidity, or hatched, cross-hatched, broken, dotted, ticked and smudged lines. Diluting the ink with water extends the possibilities even further. Water-soluble ink washes extend the medium's potential, enabling you to add solid blocks of line and tone. Corrections are difficult to make in pen and wash and are best incorporated into the work. Any mark should be considered carefully and, to this end, a light pencil drawing can be of assistance as a guide. This will enable you to concentrate on the pen work, which can be suprisingly varied. The pen and wash should work together, rather than the wash being used simply as a means of "filling in".

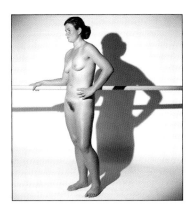

James Horton
Sarah – three-quarter view
36 x 25cm (14 x 10in)

SARAH – THREE-QUARTER VIEW

Materials and Equipment

- CREAM WATERCOLOUR PAPER
- HB PENCIL • WATERCOLOUR
PALETTE: CADMIUM RED, YELLOW
OCHRE, COBALT BLUE, PAYNE'S
GREY • RANGE OF SMALL, SABLE
ARTISTS' BRUSHES • WATER
- BROWN INK • TWO OR THREE
GOOSE QUILLS CUT INTO A
POINT • FINE METAL-NIBBED
DIP PEN

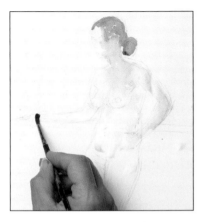

1.
Sketch the basic lines of the figure using an HB pencil. Do not include any shading or form, as the pen and wash will be used for this. Using cadmium red and yellow ochre, with a touch of cobalt blue for the darker tones, mix one or two basic skin colours and start a watercolour wash across the figure with a small brush. Aim to indicate only the broad areas of the main variations in tone and colour across the flesh. Use very transparent layers of paint.

2.
Build up thin layers of colour, to indicate changes in the depth of tone. Pick out the shapes of the shadows on the body by using the darker skin colour. Then using a grey-blue wash and a larger brush, add the background shadow.

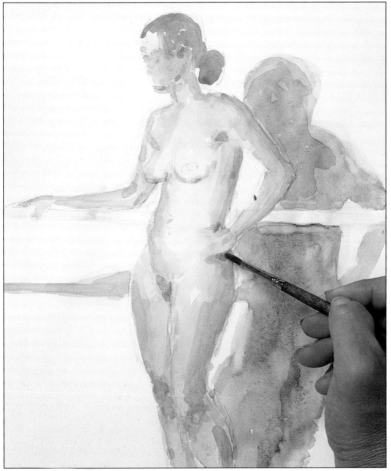

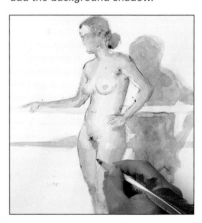

3.
Wait for the paint to dry, then use a quill and brown ink to restate the main lines and add some detail to the face and hands. The quill is not a totally controllable tool and the blotches and variations in line add to the spontaneity of the picture.

4.

Use fairly light hatching in the areas of darkest tone to accentuate the form of the figure and changes of plane, for example around the knee cap where the leg angle changes. Keep the hatching fairly loose so that the ink does not dominate the picture and give the impression of a "coloured-in" line drawing.

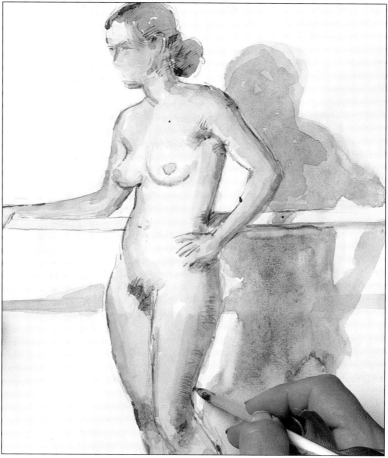

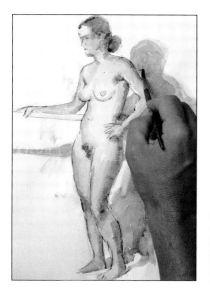

5.

Using a small brush, mix Payne's grey with a little cobalt blue and build up the changes in depth of the background shadow. The shadow should be slightly darker around the figure to "lift" the nude off the page and to indicate the space between the figure and the background.

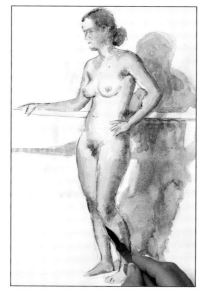

6.

Finally, use a fine metal-nibbed dip pen to restate any fine lines and the finer detail around the face and head. The position of the ear is particularly important as it indicates the angle of the head, but do not try to achieve too much detail.

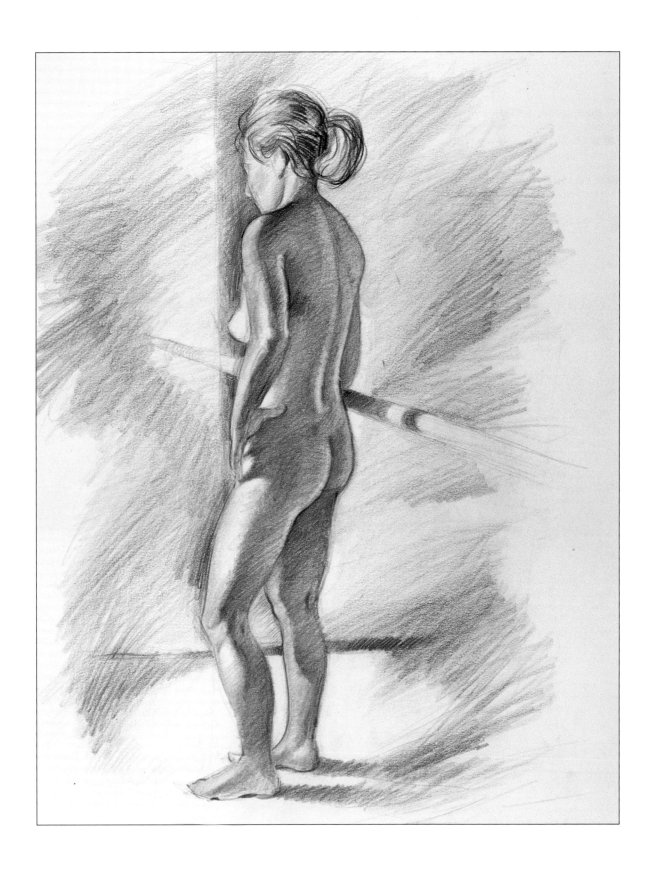

Project

5

COLOURED PENCILS

Coloured pencils give the tight control found with ordinary lead pencils. The techniques that can be achieved using coloured pencils far outstrip the traditional image of them as children's playthings. Although they are capable of producing loosely scribbled expressive work, they can also produce very subtle images of almost photographic quality. The range of marks that can be made is similar to graphite pencils, but because they are made from pigmented wax they can be more difficult to erase. Coloured pencils are mixed either by layering one colour over another, or by laying colours close to one another so that when viewed from a distance they are mixed in the eye of the viewer.

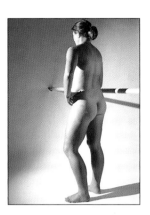

John Barber
Sarah – rear view
25 x 18cm (10 x 7in)

SARAH – BACK VIEW

1.

Make a preliminary sketch, using a reddish brown pencil, to get the proportions and position of the figure correct. Make sure that the feet are firmly established in relation to each other. The shin of the leg that is taking the weight should be vertical. Block in the head and mark the position of the left ear. Then refine the sketched outline.

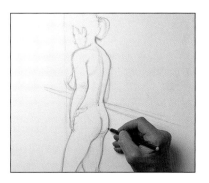

Materials and Equipment

• LANA WATERCOLOUR PAPER (A3) • SELECTION OF COLOURED DRAWING PENCILS: RED-BROWN, PALE ORANGE, PALE BLUE, PURPLE, LILAC, GREY, BROWN, DARK GREY • KNIFE FOR SHARPENING • RUBBER ERASER • ADHESIVE PUTTY

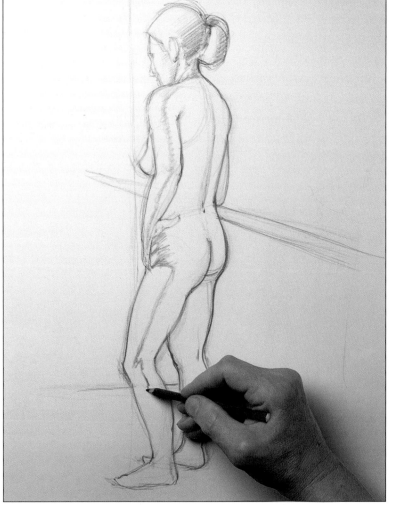

2.

Notice which parts of the body turn away from the light and draw a line from the top of the head to the feet, splitting the figure into a basic dark side and light side. The shape of the cast shadow tells a lot about the form. For example, the shape of the shadow where the hand meets the hip shows that there is a space between the arm and the body.

3.

Using a loose hatching technique, block in the area of darkest tone all across the body. Do not try to show the changes in form of the body. Concentrate only on the patterns of light, shade and tone in order to keep the emphasis on the fluid lines of the nude.

COLOURED PENCILS

4.

As you work, continually readjust and restate the lines of the figure. Each stage of work is likely to draw your attention to areas of inaccuracy in the drawing. Use an ordinary pencil eraser to remove any inaccurate lines.

5.

Change to a pale orange and hatch in the mid-tone areas, but continue into the shaded areas, to keep the continuity of colour across the skin.

269

6.

Once the basic three tones have been established, look at the figure again and using the pale orange start to elaborate on the changes of tone across the body, darkening and deepening the colour where appropriate. For example, the edges of the areas of shadow often give the impression of having a deeper, richer tone and colour. This will start to bring out the form of the body.

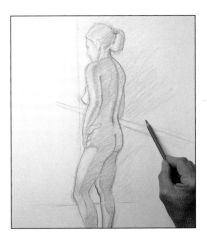

7.

Use pale blue and purple pencils to hatch in the background. To achieve a continuous tone, use the side of the pencil. The background will give the picture more depth and will bring out the leading edge of the figure because the cool colours contrast with warm flesh tones. In some areas around the edge of the figure the contrast will be more marked than others. For example, along the model's back the tone of the wall and the figure are much closer than down her front.

8.

Use a purple pencil to add the cast shadow. Because the model is well lit, this will be quite an intense colour with definite edges. The angle of the shadow tells you where the light source is (as does pattern of light and tone over the figure). The shadow can be drawn to denote the texture and angle of the background. It can also be used to judge whether the model has taken up the correct pose after breaks.

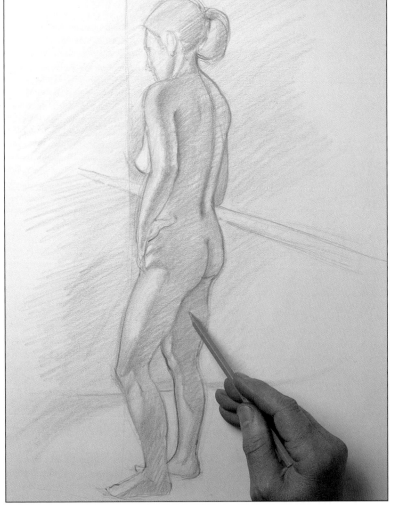

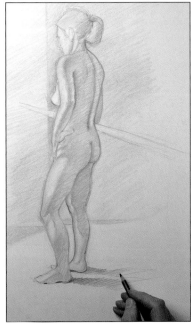

9. Start to add the final touches. Bring out strength of colour in relation to the background by adding the reddish tones of legs, emphasising the strong shadow edges. If areas begin to look too "hot", tone them down with a cool lilac hatched over the top. Add the shadows on the barre using grey and brown. These shadows indicate the gap between the furthest arm and the body, even though this cannot actually be seen in this view. Then using a piece of adhesive putty, moulded into a point, gently dab off some of the colour on the highlighted areas of the body, for example, on the breast, where the hand meets the hip, and down each side of the spine.

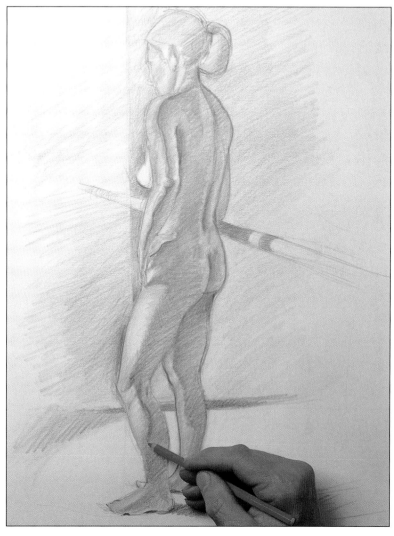

10. Finally, use the brown pencil to pull together the figure with more line work, and using the same colour, add the final detail to the hair. Look carefully at how much of the face is actually showing: about sixty per cent of the head is covered by hair. Use a darker grey to bring out the face, and the front of the shoulders. Do not overdo the hair and face or the head will dominate the picture, and this is not intended to be a portrait, but a celebration of the female form in its entirety.

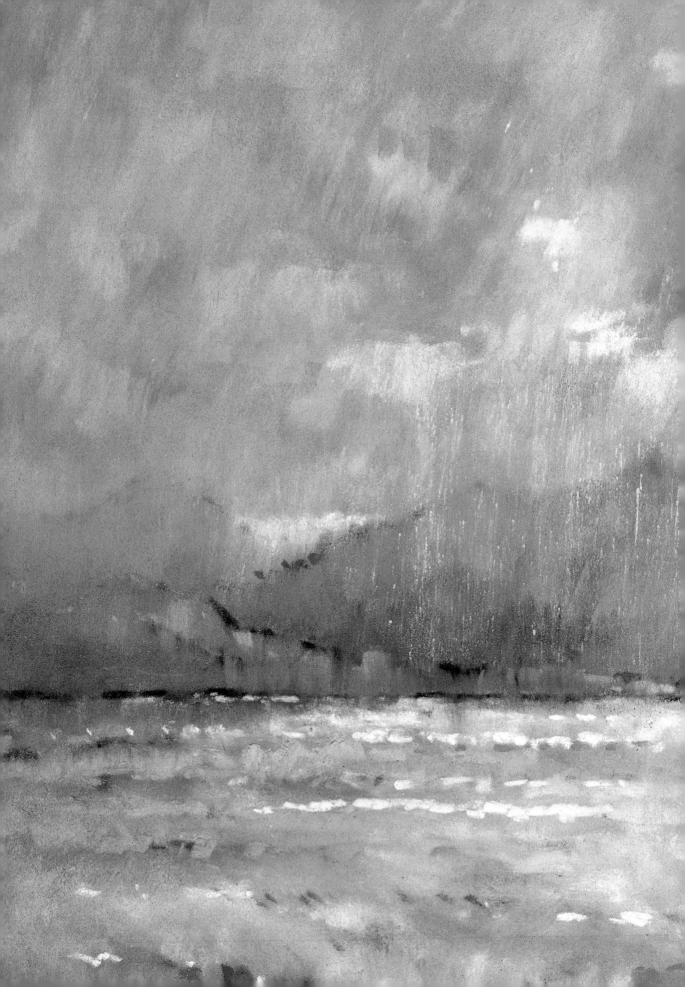

Pastels

ANGELA GAIR

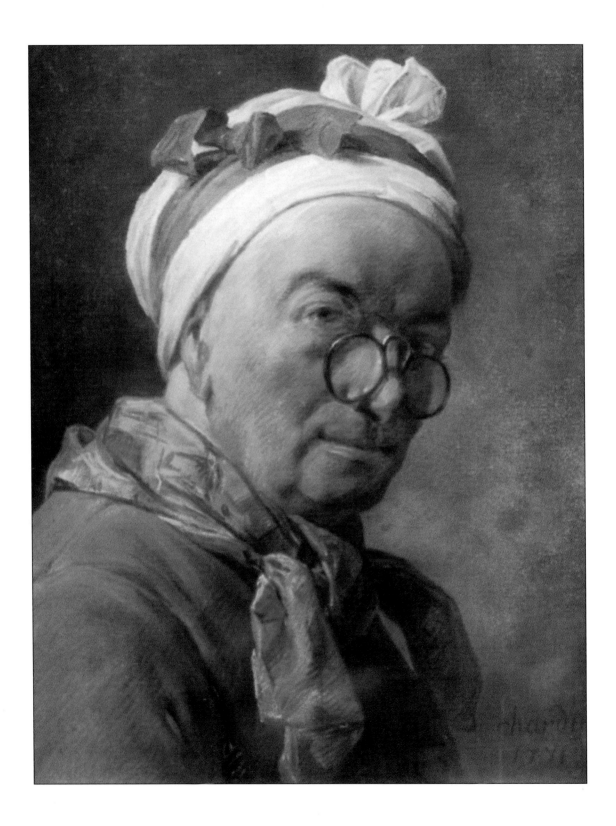

INTRODUCTION

Compared to other drawing and painting media, the history of pastel painting is comparatively short, and it was in eighteenth-century France that some of its earliest and finest exponents worked. The real pioneer of the medium was a Venetian woman, Rosalba Carriera (1674–1757), one of few female artists to have achieved fame in the visual arts before the nineteenth century. Her method, like that of all early pastelists, was to conceal the strokes of the chalk by smoothing and blending, thus giving an effect similar to an oil painting. She specialized in producing silk-smooth portraits of lords and ladies of the royal court and enjoyed a tremendous vogue when working in France during the regency of Louis XV.

It was Carriera who introduced Quentin de la Tour (1704–1788) to the pastel medium. Under her influence he became one of the most sought-after pastel portraitists of his day. The accomplished ease and rapidity with which he handled what he called his "coloured dust" helped him to capture a spontaneous expression of his sitters' personalities. "Unknown to them", he said, "I descend into the depths of my sitters and bring back the whole man."

Self-portrait with Glasses *Jean-Baptiste Simeon Chardin*

Chardin's works contrast with those of his contemporaries in that they are more solid and reflect the painter's search for realism. In this portrait fused and blended strokes are reserved mainly for the background; on the face, unblended open strokes of pastel describe the modulations from one plane to another and give life and animation to the drawing.

Portrait of a Young Girl *Rosalba Carriera*

Carriera, the pioneer of the pastel medium, used a very delicate and fused touch to produce extremely subtle grades of tone with barely a trace of individual strokes.

In France pastel painting became a craze and by 1780 there were hundreds of pastelists working in Paris, producing charming but somewhat vacuous portraits of aristocrats in all their finery, or sentimental studies of smiling, mischievous children, which have perhaps been responsible for giving the medium its undeserved reputation for superficiality.

The latter half of the eighteenth century, however, brought with it a renewed emphasis on realism, naturalness and honesty in painting, as evidenced in the pastel work of the great French master, Jean-Baptiste Simeon Chardin

(1699– 1779). Chardin only took up pastel when failing eyesight prevented him from continuing to paint in oils. Nevertheless, his contribution to the medium was important, for he broke with the tradition of his day and developed techniques that deliberately emphasized the marks of the pastel. He used superimposed layers of colour to build up a thick impasted texture, and he introduced methods of building form by juxtaposing strokes of pure colour without blending that were to be admired by Degas a century later.

Café-Concert at the Ambassadeurs *Edgar Degas*

Café life was very much a part of nineteenth-century culture, and formed the theme of many of Degas' works. He was particularly attracted to the effect of artificial illumination, such as the spotlights in this scene which produce a dramatic glare from beneath the figures on stage.

With the outbreak of the French Revolution in 1789, pastel fell out of favour for a time because it was associated too much with the frivolity and excesses of the *ancien régime*. It was the great Romanticist, Eugène Delacroix (1798–1863) who was responsible for its revival in the early nineteenth century. Both he and his compatriot Eugène Boudin (1824–1898) took their pastels into the countryside to make rapid sketches of sea, sky and land. For these *plein air* painters, pastel offered a medium well suited to recording the sudden excitement of visual sensations, the fresh colours of nature and the fleeting effects of light.

Given the speed, facility and brilliancy that pastels offer, it is surprising that the French Impressionists did not make more use of them in their efforts to capture the immediate and transient effects of light on the landscape. Even Edgar Degas (1834–1917) did not turn to pastels until his later years when, like Chardin before him, his fail-

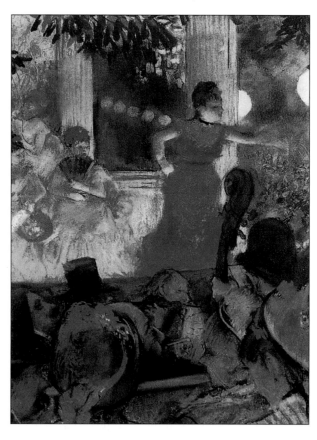

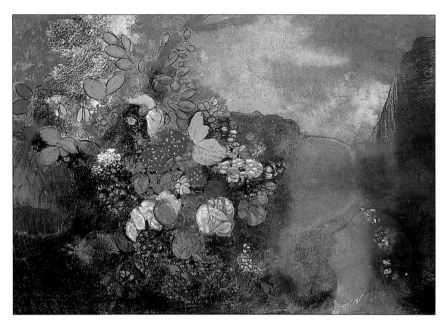

ing eyesight prevented him from working in oils. Unlike his contemporary Impressionists, Degas actively disliked outdoor painting, remarking that "The gendarmes should shoot down all those easels cluttering up the countryside." His reputation as the greatest pastelist of all time rests on his breathtakingly original compositions of indoor life, featuring dancers, café scenes and women washing or bathing.

Degas developed the pastel medium far beyond the traditional formulae of the eighteenth-century masters. He experimented with an incredible variety of strokes and combinations of strokes to render form, light and texture. At one time or another, he employed every pastel technique known and invented many new ones. For example, he frequently sprayed steam over his pastels or mixed them with fixative to form a paint-like paste that he could then work into with a stiff brush or his fingers.

Another innovation made by Degas, which opened up a whole new field for the twentieth-century artists, was his use of pastel and mixed media. He often built up densely textured layers of colours combining pastel, gouache, tempera and oil paints diluted with turpentine. He also frequently used pastels in combination with

Ophelia Among the Flowers *Odilon Redon*

Having worked in black and white media most of his life (mainly lithographs and charcoal drawings) Odilon Redon turned to pastels in the 1890s. Associated with the Symbolists, his central themes were flowers and mythological scenes, and he found the ethereal quality of pastel ideal for creating a dream-like atmosphere of mood and reverie. This picture, for example, is a meditation on the theme of youth and the ephemeral beauty of flowers.

monotypes; the print was used rather like an underdrawing, and the pastel colour was applied on top. He found this technique ideal for reproducing such visual effects as the gauzy, semi-transparent tutu of a ballerina.

Thanks to Degas, pastel in the twentieth century has been appreciated for its versatility and its powers of expression. The French artist Odilon Redon (1840–1916), for example, exploited the jewel-like colours of pastel in his symbolist paintings of flowers and mythological scenes. Modern pastel artists enjoy the "sculptural" qualities of pastel and its ability to be both a painting and a drawing medium, emphasizing its linearity and texture as well as its powdery insubstantiality.

Basic Techniques

TINTING THE SURFACE
There is an extensive range of coloured papers and boards for pastel painting, but you can also work on a textured white surface, such as watercolour paper, and tint it with a thin wash of watercolour, gouache or acrylic paint. (Lightweight papers will need to be stretched first, to prevent buckling when the wet colour is applied.) In this way you can achieve the precise colour value you require, and even produce tonal or colour variations rather than a flat, uniform area of colour. You can also rub damp tea leaves or a tea bag over the paper to obtain a pleasing warm tint.

Canvas and muslin-covered board can also be tinted with a thin wash of water-based paint such as gouache or acrylic.

Alternatively, you can tint the surface subtly with a "dry wash" of pastel powder. Reduce the pastel stick to a fine powder by scraping the edge with a sharp blade (or save the broken ends of pastel sticks and crush them to a powder with a palette knife). Use a large soft brush or a cotton ball to pick up the powder and spread it over the paper. Work it well into the grain, laying down a thin tint of colour.

MAKING MARKS
Pastel is a wonderfully expressive medium to draw with, so responsive it is almost like an extension of the artist's hand. Discover the expressive potential of the medium by making random marks on sheets of paper. Try using both hard and soft pastels, on rough and smooth-textured papers. A soft pastel on smooth paper glides effortlessly, leaving behind a satiny trail of vibrant colour; the same pastel used on rough paper gives a splattered, irregular line as the tooth of the paper breaks up the colour.

Dry Wash

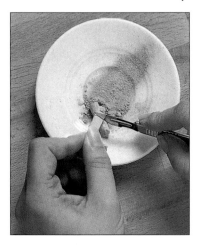

1
Use a craft-knife blade to scrape the edge of the pastel stick and create a fine powder. Hold the pastel over a dish to catch the powder as it falls.

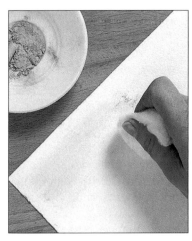

2
Dab a cotton ball into the powder and rub it across the surface. Further tones or colours can be added and blended on the paper surface.

LINEAR STROKES

SIDE STROKES

Loose hatching

Blended side strokes

Crosshatching

Scumbled side strokes

Stabbing marks

Stabbing marks

LINEAR STROKES

Use the point of the pastel, or snap the stick in two and use the sharp corners, to create linear marks. By varying the pressure on the stick and twisting and turning it you can produce lines that swell and taper.

You can also use line work to create subtle blends of tones and colours with techniques such as feathering, hatching and crosshatching.

SIDE STROKES

Snap off a short length of pastel and use it on its side to make broad bands of grainy colour. The depth of tone or colour depends on the pressure you apply and the texture of the paper. Heavy pressure forces more pastel into the tooth of the paper to create a dense, velvety quality; light pressure produces a delicate veil of colour through which the texture and colour of the paper, or a previous layer of pastel, is visible – a technique called scumbling.

Use ground rice to clean your pastels. The small plastic tray shown here also comes in handy as a lightweight, easy-to-hold "palette" in which to keep the particular colours you need for a painting.

CLEANING PASTELS

Pastels get dirty through handling – after a while they all look the same dusty grey colour. To clean your pastels, pop them in a container filled with ground rice and shake gently. The gritty texture of the rice rubs away the surface dirt and in no time at all your pastels emerge sparkling once more. Sieve to remove the dirtied rice.

ERASING PASTEL

While the pastel is still thinly applied and fairly loose on the surface, the best way to erase mistakes is to use a stiff-bristled paintbrush to flick away the powdery colour.

Conventional rubber erasers tend to flatten the texture of the paper and smear the pastel into the grain instead of lifting it off.

A kneaded or putty eraser can be useful for lightening a small area to obtain a highlight. Press the eraser on the spot and gently lift the loose colour off with a dabbing motion. A small piece of bread gently rolled between the fingers can also be used.

In general it is best to avoid erasing in the later stages of a painting, as any method you use interferes with the natural texture of the pastel strokes and can spoil the paper surface. The best course, at a late stage, is to spray the area with fixative and rework it.

FIXING PASTELS

Pastel paintings can be protected from smudging by spraying with fixative. When you spray be careful not to saturate the

Use a bristle paintbrush to remove excess pastel pigment.

drawing as this darkens the colours and merges the pigment particles. The idea is to produce a fine mist that floats down lightly over the pastel. It is worth practising on pieces of scrap paper until you discover how to produce a fine mist without getting any drips on the paper.

First, tap the board to dislodge all the loose particles of pigment. Standing at least 30cm (12in) from the easel, begin spraying just beyond the top left side of the picture. Work swiftly down the picture, spraying with a steady back-and-forth motion, always going beyond the edges of the picture before stopping. Keep your arm moving so that the spray doesn't build up in one area and create a dark patch or drip down the paper.

Always work in a room with adequate ventilation to avoid excessive inhalation of the spray.

ALTERNATIVE METHODS

Some artists avoid fixing unless it is absolutely necessary, on the grounds that it diminishes the brilliance of the colours and spoils the velvety surface bloom of the pastel. However, there are ways to get round the problem and still give your work a degree of protection from smudging. Try spraying lightly at intervals while working to seal the surface so that colours can be overlaid without muddying. Leave the last layer free so that the work retains its freshness.

Since the spray affects the lighter colours most, another alternative is to lightly spray the finished work and then pick out the light tones again.

Unless you are using a heavy paper or board, you can spray a light mist over the back of the paper. The fixative will soak through and hold the pigment without damaging the surface.

An alternative to spraying with fixative is to lay a sheet of smooth paper over the painting, then cover it with a board and apply pressure. This pressure fixes the pastel particles more firmly into the grain of the paper without affecting its surface.

Finally, there is a theory that pastel fixes itself in the course of time due to the presence of moisture in the air. Before framing a finished pastel, try leaving it on a shelf with air circulating freely around it for three or four weeks to allow the humidity of the room to help set the colour.

Squaring Up

You may wish to base a pastel painting on a photographic image or a sketch; but it is often difficult to maintain the accuracy of the drawing when enlarging or reducing a reference source to the size of your paper or board. A simple method of transferring an image in a different scale is by squaring up (sometimes called scaling up).

Using a pencil and ruler, draw a grid of equal-sized squares over the sketch or photograph. The more complex the image, the more squares you should draw. If you wish to avoid marking the original, make a photocopy of it and draw the grid onto this. Alternatively, draw the grid onto a sheet of clear acetate placed over the original, using a felt-tip pen.

Then construct an enlarged version of the grid on your support, using light charcoal lines. This grid must have the same number of squares as the smaller one. The size of the squares will depend on the degree of enlargement required: for example, if you are doubling the size of your reference material, make the squares twice the size of the squares on the original reference drawing or photograph.

When the grid is complete, transfer the image that appears in each square of the original to its equivalent square on the support. The larger squares on the working sheet serve to enlarge the original image. You are, in effect, breaking down a large-scale problem into smaller, more manageable, areas.

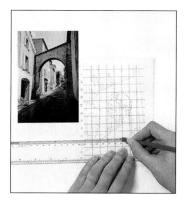

1 Make a sketch from the reference photograph and draw a grid of squares over it.

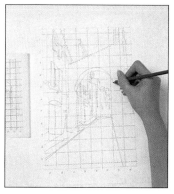

2 Draw a grid of larger squares onto the support and transfer the detail from the sketch, square by square.

GALLERY

Pastels are a unique and versatile medium, combining the speed and directness of drawing with the rich and varied range of colour associated with painting media. Working with the pastel tip enables the artist to exploit the calligraphic qualities of line and contour, while using the long side of the pastel resembles painting with a broad brush to create soft fields of luminous colour.

There are many ways of applying pastel, and the "painting" and "drawing" techniques can be used alongside each other to produce a breathtaking range of effects. The small gallery of images that follows has been selected to demonstrate the expressive potential of pastel work, and represents a wide variety of styles, subjects and techniques.

Mother
Paul Bartlett
64 x 43cm (25 x 17in)

One of the most striking features of this portrait is the pin-sharp detail, not normally associated with the powdery, insubstantial nature of pastels. Bartlett uses countless tiny strokes to build up a variety of textures, giving the picture a sense of heightened reality.

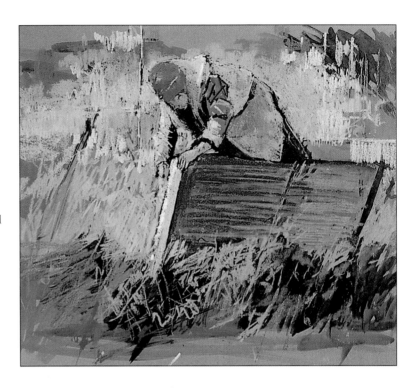

Mending the Fence
Barry Freeman
51 x 67cm (20 x 26in)

This is a study for a painting in oils. The artist washed in the broad areas with gouache paint, then used pastel to provide additional detail and textural contrast. Gouache and pastel are ideal partners, both being opaque media with brilliant colour qualities. The sketch is worked very freely, with large areas of the buff paper left uncovered to provide a unifying middle tone.

Windowsill, Summer
Derek Daniells
33 x 46cm (13 x 18in)

We tend to think of still life as a group of objects arranged against a background, but "found" groups, such as this row of potted plants on a windowsill, have a refreshingly uncontrived quality. Daniells combined blended and linear marks here to suggest the softly dappled quality of the light.

Bowl of Lemons
Maureen Jordan
37 x 29cm (14½ x 11½in)

The chiaroscuro effect of light in this still life was achieved with the aid of acrylic paints. Thin washes were washed onto the background to establish the deepest darks, which are difficult to attain with pastel colours. The image was then built up using hard pastels initially and then soft pastels in the final stages.

Farmhouse, Provence
Alan Oliver
28 x 38cm (11 x 15in)

Here the artist freely combines areas of broken colour with a variety of linear marks to build a complex, rich impression of colour and texture. The grain of the paper breaks up the pastel strokes, enhancing the lively quality of the image.

Figs, Plums and Grapes
John Ivor Stewart
36 x 51cm (14 x 20in)

By tightly cropping his subject the artist gives it maximum impact. In effect, we enjoy the picture on two levels: first as a finely observed study of natural forms and textures, and second as a rhythmic pattern of harmonious shapes and colours.

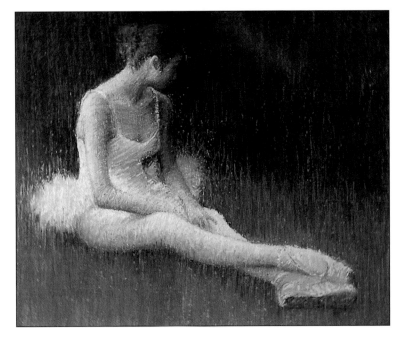

Waiting in the Wings
Charmian Edgerton
30 x 38cm (12 x 15in)

This study was worked on a textured ground, which breaks up the strokes of soft, friable pastel and creates a striated, flickering effect that accentuates the play of light on the figure. The dark background contains no black but consists of an optical mix of browns, greens and indigos; similarly, the dancer's white tutu, tights and pumps comprise strokes of yellow, pink, blue and green.

Gladioli
Frances Treanor
112 x 81cm (44 x 32in)

This flower portrait contains a riot of colour, but the diversity is tempered by a strong sense of design. The exuberant impact of the image is enhanced by the tension between the vivid pinks of the flowers and the equally vivid blue of the background, which sets up a push-pull vibration. The decorative border is a feature of Treanor's paintings, echoing and containing the colours in the main image.

After the Storm, Walberswick
Barry Freeman
38 x 49cm (15 x 19in)

This painting captures a moment in a shifting pattern of light which so characterizes the climate of northern Europe. A heavy rainstorm has just passed and sunlight breaks through the banks of cloud. Freeman has caught the glittering quality of the light using a high-key palette of pinks, blues and mauves. Lively, scumbled strokes throughout denote a sense of vibrancy while unifying the elements of sky and landscape.

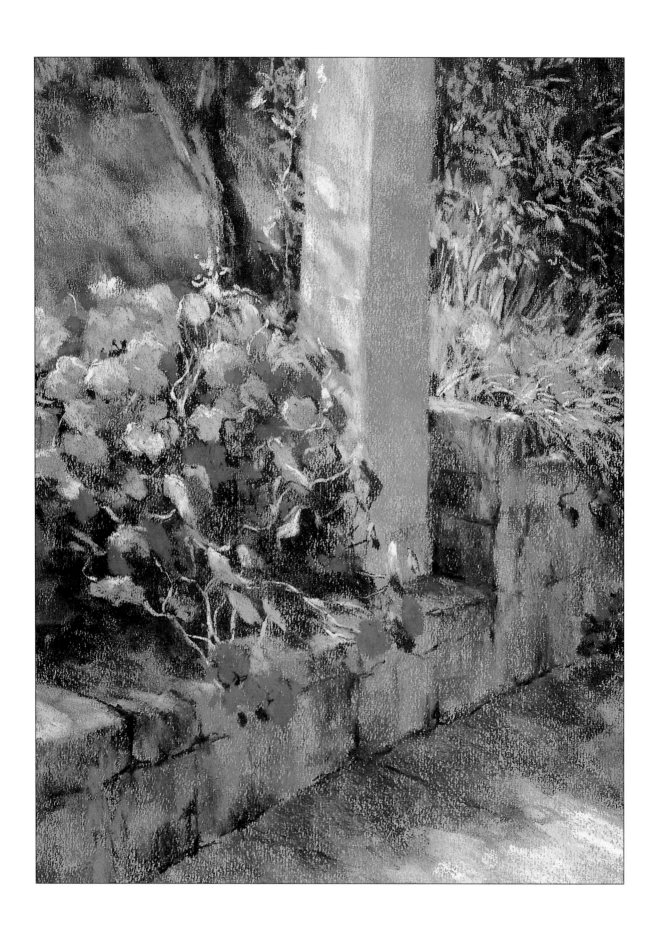

OVERLAYING COLOUR

This painting reflects the artist's delight in recreating the effects of light on the landscape. Bright sunlight filters down through the trees, casting dappled patterns on the cool, shadowy patio and brightly illuminating a flower here, a leaf there. A rich and exciting surface is achieved through the combined techniques of blocking in broad colour areas with the side of the pastel and drawing into shapes with the pastel tip.

Although the composition itself is quite simple, there is a lot of texture and detail in the flowers and foliage – subjects that can all too easily become overworked and muddy. In order to make sense of the complex mass of flowers, grasses and foliage, the artist began by blocking in the composition with thin layers of colour applied with the side of the pastel. From this initial "underpainting" she was able gradually to work up detail and intensify colour, creating the impression of massed foliage without clogging the paper surface.

Jackie Simmonds
Sunlit Patio
51 x 41cm (20 x 16in)

BUILDING UP THE PAINTING

Whereas an aqueous medium such as watercolour sinks into the body of the paper, dry, powdery pastel pigment more or less sits on the surface. If you apply too many heavy layers of colour, especially in the early stages, the tooth of the paper quickly becomes clogged and the pigment eventually builds up to a solid, slippery surface that resists further applications of colour.

To avoid this, you need to pace yourself in the early stages – it is a mistake to try to get to the finished picture too soon. A successful method of building up a pastel painting is to start by rapidly laying in the broad shapes and colour masses of the composition with thin

colour before starting to develop the detail. Snap off a short length of pastel and block in the main colour areas, using side strokes to apply broad patches of grainy colour. These initial layers should be lightweight and open-textured; work lightly and loosely, stroking the colour on in thin veils and leaving plenty of paper showing between the strokes.

Overlaying thin, loose strokes of pigment in this way allows you to build up tones and colours gradually, without overworking the surface, so that when you come to accentuate the detail with linear marks and thicker colour towards the end of the picture, the colours will remain fresh and the strokes distinct.

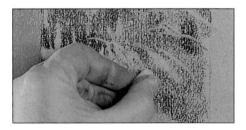

It is important to keep the surface of the picture light and open in the early stages, to avoid clogging the paper with pigment and making the surface unworkable.

SUNLIT PATIO

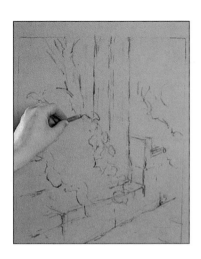

1

Sketch in the main outlines of the composition using charcoal. Draw with a light touch, keeping the lines loose and sketchy so that you can easily brush them off if you need to make alterations.

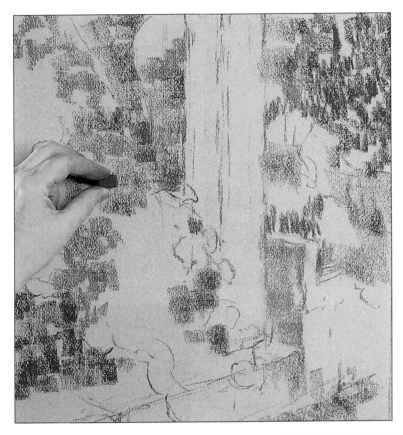

2

Rough in the main areas of light and dark tone, using a range of dark blues, greens and earth colours to establish the dark colour values of the background tree and foliage and the shadows in the foreground. Snap off short lengths of pastel and lightly stroke the colour on with the side of the stick, using short, broken marks that allow the colour of the paper to show through.

3

Using the same technique, block in the stone column and wall in the foreground using a light tint of warm ochre. Indicate the shadows on the column with a light tint of blue-grey, gently breaking it over the underlying colour with light, feathery strokes, allowing the warm ochre to show through and suggest the "glowing" effect of reflected light bouncing back into the shadows.

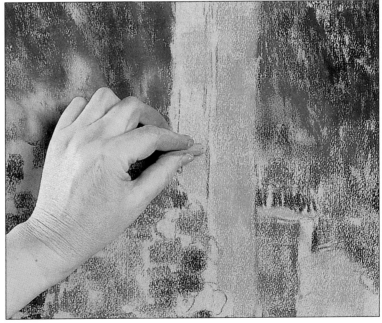

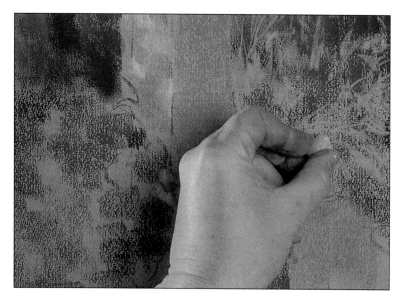

4

Apply broken strokes of very light ochre to indicate patches of dappled sunshine on the column. Now that the lights, darks and mid-tones are established, you can begin to build up the image with more colour and detail. Suggest the sunlit leaves and grasses in the background using a light, warm green. This time use the chisel edge of the stick to make linear strokes of varying lengths, and in various directions, to suggest leaves, tendrils and stalks.

5

Use the same green to paint the nasturtium leaves tumbling over the wall, using a short length of pastel on its side to make broad blocks of colour suggesting the fat, rounded forms of the leaves.

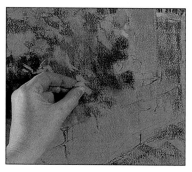

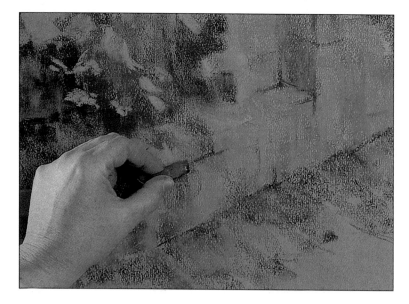

6

Before developing the nasturtiums any further, build up colour and texture on the wall using a mid-toned yellow ochre and a darker tone of burnt umber. Lay the colours over each other with broad side strokes in a vertical direction to indicate blocks of stone. Lay some of this colour over the cast shadow below the wall, too. Indicate a few fissures in the rock using the chisel edge of a dark blue pastel. Don't overdo it – just one or two broken, linear marks is all you need to suggest the crumbling texture of the wall.

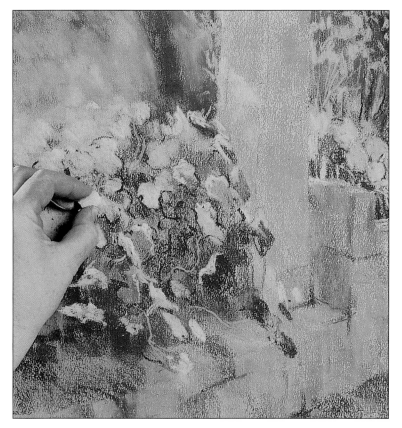

7

Using the same dark blue, pick out and define the edges of some of the nasturtium leaves, then block in the lightest tones on the sunlit leaves using a light tint of turquoise-green. Lightly spray-fix the picture so that you can add further layers of colour.

8

For the nasturtium flowers you will need two reds: a bright, warm one for the nearer blooms, and a slightly cooler, bluer one for those further back. Draw the flowers with scribbled strokes, suggesting their shapes rather than defining them too clearly and losing the spontaneity of the image. Vary the shape and size of the flowers, making them larger in the foreground and gradually getting smaller farther back.

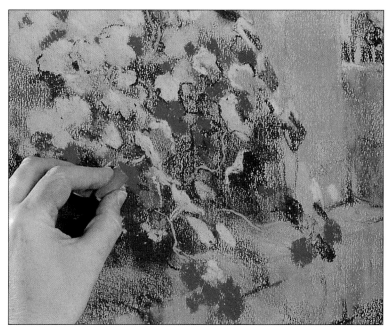

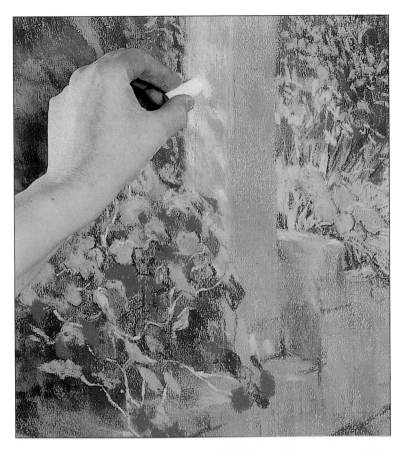

9

Use a warm, yellowish green to draw the sunlit tendrils and stalks of the nasturtiums with light, broken lines. Then add more dappled highlights on the column and the top of the wall using a very light tint of ochre. Apply a little more pressure with the pastel stick now, to give the highlights more definition. Stroke some of the same colour onto the road in the immediate foreground.

10

Deepen the shadows on the wall and road with side strokes of bluish grey applied with a light touch so that the underlying colours glow through. Then add the brightest highlights on the flowers, using a brilliant poppy red. Don't be tempted to overdo these highlights, though – brilliant spots of colour are more effective when used sparingly.

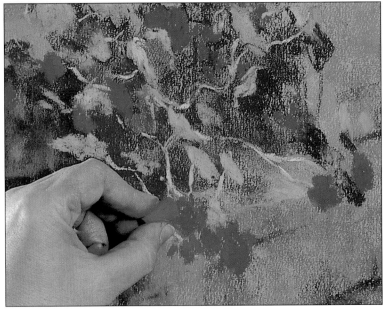

11

Develop the background, applying strokes of warm ochre on the sunlit side of the tree and suggesting the shifting patterns of light and shadow on the grass using a warm yellow green and a cool turquoise green. Gently blend the colours with the tip of your finger; these broad masses, in contrast with the sharper detail in the foreground, help to increase the illusion of space and depth in the picture.

Use a light greenish yellow to draw the creeper twining up the column and to accent the light-struck leaves and tendrils, mainly along the top edge of the flowers but also where the sun catches here and there near the bottom of the wall.

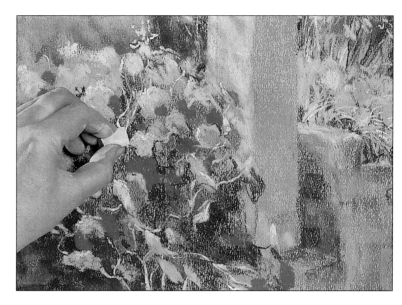

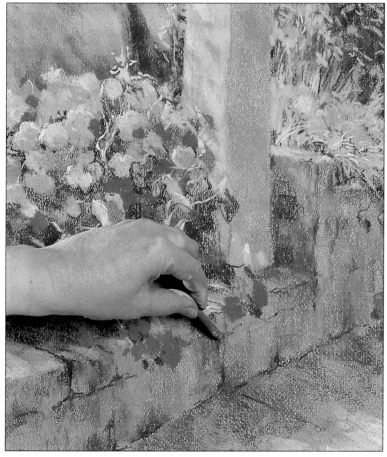

12

Finally, suggest the crumbling texture of the wall using a thin charcoal stick to lightly draw in a few cracks and fissures.

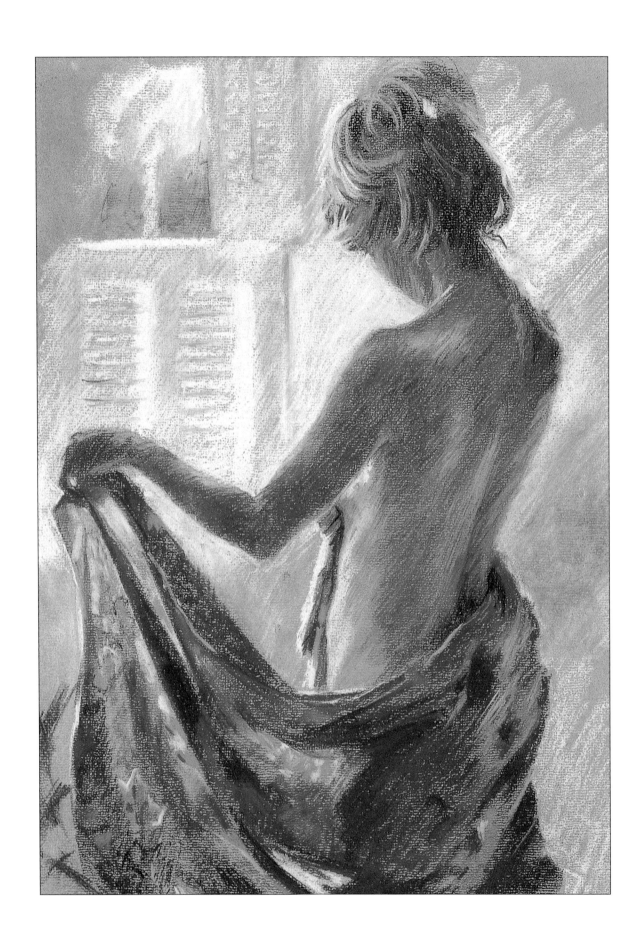

Technique

2

FEATHERING

In painting something as delicate as the skin of a young woman, it is tempting for the inexperienced pastelist to blend and rub the colours in trying to create the soft gradations of the skin tones. Yet the result is often more likely to be somewhat "sugary", superficial and lifeless.

In this painting the artist has done the exact opposite, relying on the linear marks made by the pastels to build up the structure of the figure. She has mixed her colours by laying light, feathery strokes of opposing colours, one on top of the other, to create new and brilliant hues. This juxtaposition, which calls upon the viewer's eye to mix and blend colours, produces a shimmering and vibrant interpretation of the skin tones and imbues the work with energy and life. The soft, friable pastel pigment catches on the raised tooth of the paper, creating a striated, flickering effect between the layers of warm and cool colour that accentuates the play of light on the figure.

Hazel Soan
Woman with Sarong
56 x 41cm (22 x 16in)

FEATHERING TECHNIQUE

The term "feathering" describes a linear technique used for creating exciting colour mixes in pastel. Colours are laid next to and over each other using the tip of the pastel to make quick, light, linear strokes, keeping the direction of the strokes consistent.

Similar to other broken-colour techniques, such as scumbling and pointillism, feathering is a way to integrate a range of hues and to blend them optically, in the eye of the viewer, rather than physically on the support. Particularly vibrant areas of colour can be achieved by feathering complementary colours, such as red and green, or yellow and violet, over one another. In addition, the feathered strokes create an active surface effect that adds a further dimension to the finished picture. The many touches of colour add a luminous quality to the surface, making it shimmer and dance with light.

Feathering is also a useful way to revive a particular area of colour that has become lifeless through excessive blending or rubbing in. Simply make light, feathery strokes of a contrasting colour over the blended area. Be careful to let the underlying colour show through and become enlivened, but not covered, by the overlaid strokes. Feathered strokes can also be used to tie together and unify shapes and colours and to soften hard edges.

Similarly, feathering provides a means of subtly altering or enriching colours without having to resort to erasing or scraping. For example, a red that looks too "hot" can be easily cooled down by feathering over it with strokes of its complementary colour, green, and vice versa. The secret is not to press too hard; use a light, feathery touch that causes the colour to float on top of the existing one.

WOMAN WITH SARONG

Materials and Equipment
• SHEET OF GREY CANSON PASTEL PAPER • SOFT PASTELS: WARM RED, WARM RED BROWN, PURPLE-RED, PALE ORANGE, PALE YELLOW, DARK BROWN, DARK COLD GREEN, PALE TURQUOISE GREEN, LIGHT PURPLE, DARK PURPLE, PALE BLUE AND WHITE
• CHARCOAL OR GRAPHITE STICK

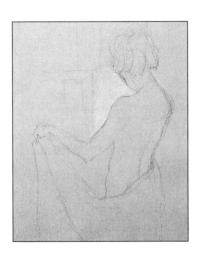

1

Using fine willow charcoal or a graphite stick, lightly sketch the figure and suggest the background. Avoid making solid, continuous outlines but let your pencil move lightly over the paper, feeling out the forms.

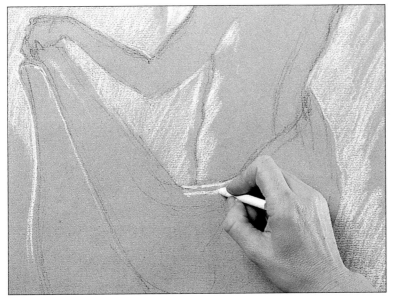

2

Block in the light tones behind the figure with loosely hatched diagonal strokes, using the tip of a white charcoal stick. Suggest the reflected light on the front of the figure and position the main folds in the cotton sarong she is holding.

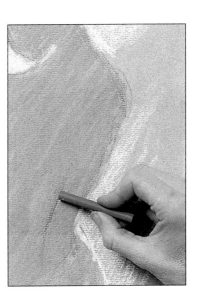

3

Use a warm, reddish brown to block in the figure with loosely spaced hatching, allowing the colour of the paper to show through. Apply light pressure so as not to clog the grain of the paper. Use the same colour to define the darkest shadows on the fabric, where it wraps around the model's body. Lightly draw the indent of the spine with a darker brown.

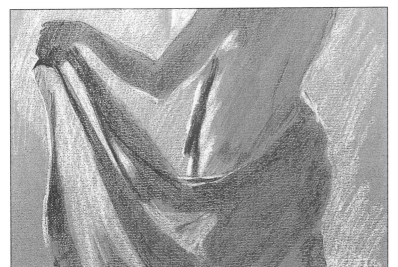

4

Use strokes of white and a cool, purplish red to build up the highlights, folds and creases in the wrap, lightly feathering the colour over the brown underlayer to deepen the tone of the darker shadows. Add touches of this cool red on the back of the model's head, across her shoulders and on her arm, which are in shadow. Use a warmer red on the hand, and at the front edge of the wrap, which reflect warm light from the window.

5

Add touches of the same warm red on the model's face, neck and shoulder. Continue developing the flesh tones, deepening the shadow areas with overlaid strokes of dark brown and dark, cold green. Stress the deeper tones by using the side of the pastel stick to make broad marks. Use the same colours on the hair, putting in the shadows that describe the contours of the model's up-swept hairstyle.

6

Add in smooth strokes of pale turquoise green around the figure to give depth and atmosphere to the room. Continue defining the lights and shadows on the model's sarong using both light and dark tones of purple. Then suggest the pattern on the cloth with dark purple, warm red and pale orange.

7

Now introduce a little more detail in the background by defining the shuttered window with white, pale blue and pale turquoise green. Draw in the highlights on the model's hair with curving strokes of a pale, soft yellow.

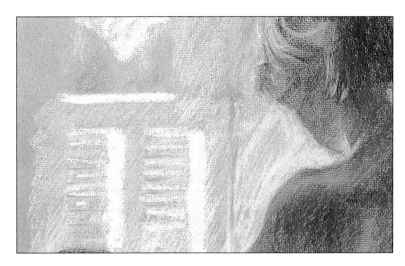

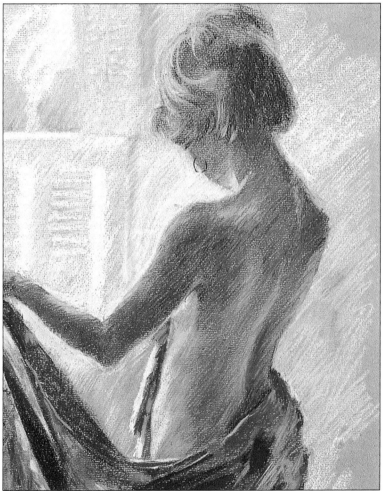

8

Use the same yellow to softly feather over the skin tones to introduce highlights on the model's back and shoulder, with the edge of the pastel stick.

9

With the contours of the figure established, you can now build up the subtle colours in the skin tones with gentle, feathered strokes. Introduce warm yellows and reds on the model's back and arm to create the luminous quality of reflected light and enhance the overall atmosphere of the image. To complete the drawing, add the final details to the pattern on the model's gaily coloured sarong.

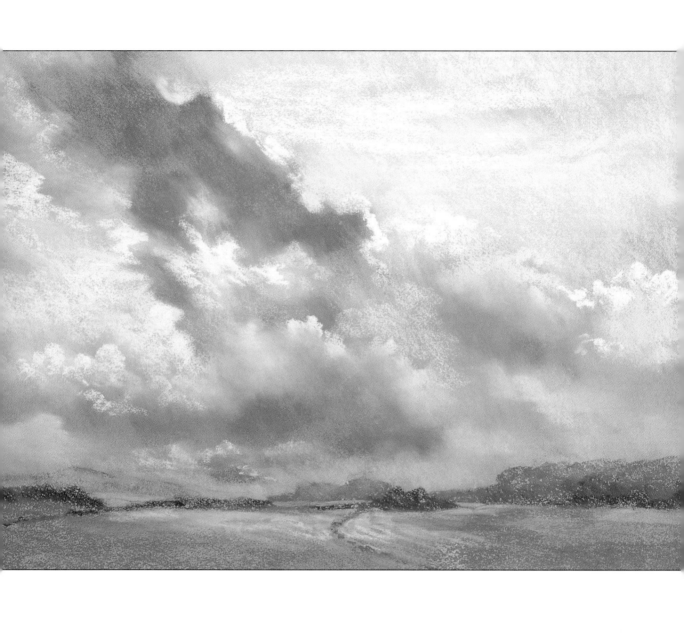

BLENDING

Soft pastels, being powdery, can be smudged and blended very easily to create a range of subtle textures and effects; for example, when suggesting the soft, amorphous nature of skies, water and soft foliage, and in recreating the effects of space, distance and atmosphere.

Blending can give pastel work a sensuous subtlety, but when overdone it creates a slick, "sugary" surface that robs the painting of all character. As a rule of thumb, it is best to retain the textural qualities of the pastel and the surface as much as possible and to use blending selectively and in combination with other, more linear, strokes for contrast.

In this skyscape, the artist did a certain amount of blending with her fingers and with tissues, but most of the soft gradation in the clouds is accomplished by using the pastels on their sides and drifting one colour over another. The surface tooth of the paper breaks up the strokes and forces one to merge with the next, but the colours retain their freshness because they are not degraded by too much rubbing.

Jackie Simmonds
Skyscape
33 x 51cm (13 x 20in)

BLENDING TECHNIQUE

The simplest means of blending consists of laying a patch of solid pastel colour, using the tip or the side of the stick, and fading it gently outward with your finger to create soft tonal gradations. Similarly, two adjoining colours can be blended together where they meet to achieve a gradual colour transition, and two overlaid colours can be blended to create a solid third colour.

The finger is perhaps the most sensitive blending "tool", but depending on the effect you want to achieve, you can use a rag, paper tissue, brush or torchon (a pencil-shaped tube of tightly rolled paper). Use your finger to blend and intensify an area of colour; rags, tissues and brushes to blend large areas and to soften and lift off colour; and a torchon for precise details.

Blending is a very seductive technique, but when overdone it can rob the colours of their freshness and bloom (this bloom is caused by light reflecting off the tiny granules of pigment clinging to the surface of the paper). You don't always have to rub or blend the colours; if you use the pastels on their sides you will find that the gradual overlaying of strokes causes them to merge where required without muddying. A light, unblended application of one colour over another is more vibrant and exciting than a flat area of colour.

It is important to provide visual contrast by integrating blended areas with other, more vigorous pastel strokes. Here, for example, grainy, scumbled strokes give definition to the edges of the clouds.

SKYSCAPE

1

With a subject such as a sky, it is best to avoid drawing any outlines, as this could inhibit the freedom of your drawing. Simply plot the main elements of the sky and land using light, scribbled strokes of red-brown, blue-grey, blue-purple and cobalt blue, applied with the sides of the pastels.

Materials and Equipment

• SHEET OF WARM GREY CANSON PAPER • SOFT PASTELS: RED-BROWN, PALE CREAMY YELLOW, PALE ORANGE, BLUE-PURPLE, COBALT BLUE, BLUE-GREY AND LIGHT BLUE-GREY • SOFT TISSUES

2

Use a piece of crumpled soft tissue to soften and blend the pastel marks and remove any excess pastel particles. In effect, you are making a loose underpainting that will enhance the colours you apply on top.

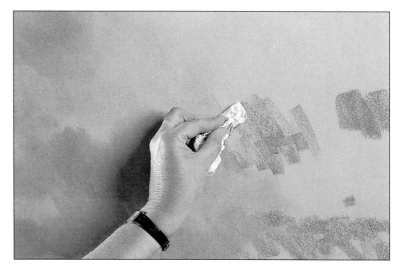

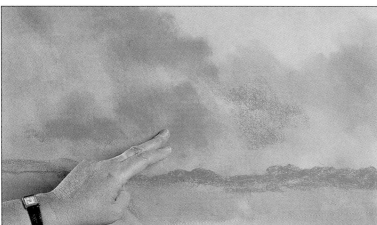

3

With the blue-purple pastel, put in the hills on the distant horizon using side strokes applied with a little more pressure. Start to develop the dark undersides of the cumulus clouds with the same colour, adjusting the pressure on the pastel stick to create denser marks in places. Use your fingers to soften and blur the clouds, dragging the colour downwards to create a sense of movement.

4

Use blue-purple to put in the smaller, flatter clouds near the horizon. This will help to create the illusion of space and recession. Now use a light blue-grey pastel to block in the mid-tones in the clouds, using the same technique used earlier to create the soft, vapourous effect of rain clouds. Adjust the tones by varying the pressure on your fingers as you blend the strokes.

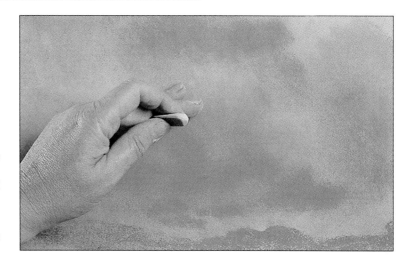

5

Now illuminate the lighter parts of the clouds, and the yellowish tinge of the sky at upper right using a very light tint of creamy yellow. Apply gentle pressure with the side of the pastel stick to float the colour over the grey underlayers.

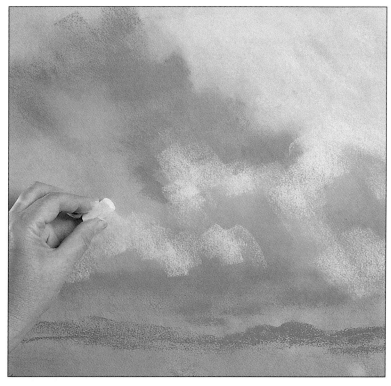

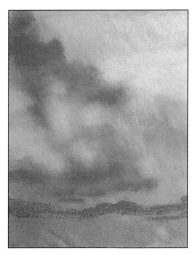

6

Softly blend the creamy yellow tones with your fingers, again using downward strokes. Build up subtle colours in the sky on the right, layering on strokes of pale blue-grey at the top and pale orange along the horizon. Blend a little with your fingers, but leave some of the strokes untouched so that the warm tone of the paper shows through the overlaid colours and enhances the glow of the evening sky.

7

Define the sharp, sunlit top edge of the cloud using fairly firm pressure with the tip of the creamy yellow pastel. Then use the same colour to build up the forms of the sunlit tops of the cumulus clouds with small scumbled strokes made by pressing the side of the pastel to the paper and then feathering it away to create soft-edged marks.

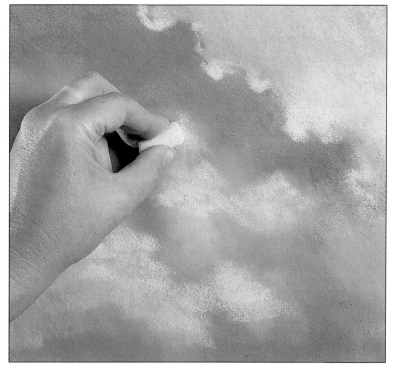

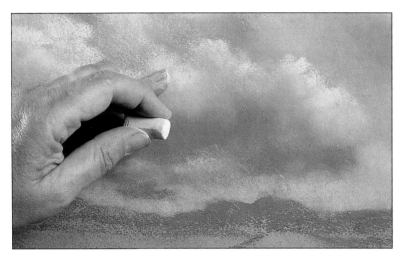

8

Build up three-dimensional form in the sunlit clouds by scumbling their top edges and then gently blending the colour downwards with your fingertip as shown, leaving the top edge unblended. The blended strokes create the translucent, airy effect of rain clouds, while the scumbled edges give form and definition, preventing the clouds becoming too "woolly".

9

As your picture develops, step back from it at intervals to assess the overall effect. Continue to develop the forms within the towering bank of storm cloud, using the tip and side of the creamy yellow pastel to create blended tones and feathered strokes that give the three-dimensional effect of some clouds floating in front of others.

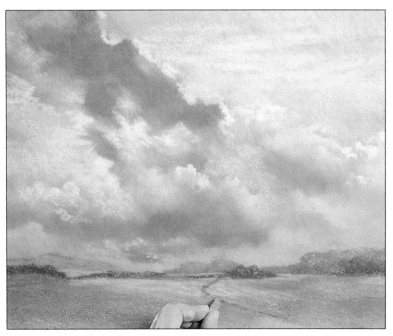

10

Finish the picture by suggesting the forms of the landscape. Go over the distant hills with light blue-grey to push them back in space, then draw in the trees and hedges with the darker blue-grey. For the foreground field, use red-brown modified with overlaid strokes of blue-grey and creamy yellow to suggest patches of light and shadows cast by the clouds. Repeating similar colours in the sky and the land also helps to unify the composition. Use the blue-grey pastel to suggest a curving track through the field that leads the eye into the picture.

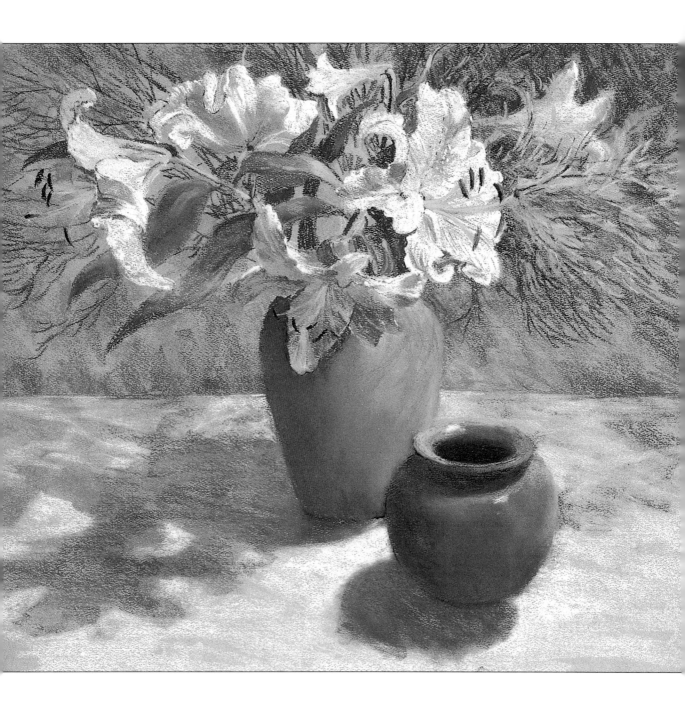

Technique

4

USING COLOURED GROUNDS

Few pastelists work on white paper. There are two reasons for this, the first being that the bright, intense hues of pastel are not shown to their best advantage on white paper, appearing rather dark, whereas they seem to sparkle on a toned paper. Secondly, because the grainy texture of pastel usually allows the colour of the paper to show through and between the applied pastel strokes, patches of white paper glaringly "jump out", ruining the effect of the picture and devaluing the applied colours, whereas a coloured ground becomes an integral part of the image and exerts a subtle influence on the colours laid over it.

The cool tonality of this elegant still life is enhanced by the choice of a neutral grey paper, which serves as the basis for the shadow tones. The artist has left small glints of untouched paper visible that allow the applied colours to "breathe", maintaining the unique airiness and sparkle that makes a pastel painting so attractive.

Jackie Simmonds
White Lilies
47 x 57cm (18½ x 22½in)

WORKING ON COLOURED GROUNDS

With pastels, perhaps more than with any other drawing medium, the colour of the support plays a crucial role. This is because pastel pigments sit on the surface of the paper rather than staining it as paints do. Light strokes applied to a rough surface will give a broken texture, and when two different pastel colours are laid lightly one over the other so that the paper shows through, the paper acts as a third colour.

It makes sense, therefore, to choose paper of a colour that will make a positive contribution to the overall colour scheme of the painting. You may, for example, wish to select a paper that is similar in tone or colour to the subject and provides an overall middle tone, so all that is needed to complete the painting are the highlights and shadows. Alternatively, you could choose a light-toned paper, which would serve as the highlight areas, or a dark-toned one, which would provide the shadow areas.

Think about the mood and tonality of the subject, then decide whether you want the background colour to complement or contrast with it. For example, when painting a summer landscape you might choose a soft green paper that acts as one of the key foliage colours and enhances the luminosity of the subject. On the other hand, you might choose a warm earth colour that complements the greens and makes them appear more vibrant.

By allowing the colour of the support to play an integral part in the painting, you achieve two things. First, when small patches of the paper's colour are glimpsed between the overlaid pastel strokes, it becomes a unifying element, tying together the colours laid over it.

Second, you can actually get away with putting fewer marks on the paper, and this gives an attractive freshness and immediacy to the finished painting. When painting trees, for example, a few brief strokes of colour applied over a contrasting paper will "read" as dense foliage, without risk of overworking the image.

When glimpses of the bare paper are allowed to show through the areas of pastel they emphasize the "bite" – the directions and edges of the strokes – and give a lively working feel.

WHITE LILIES

Materials and Equipment

- SHEET OF GREY CANSON PAPER
- SOFT PASTELS: RED-BROWN, ORANGE, PALE CREAM, LEMON YELLOW, YELLOW-GREEN, MEDIUM LEAF GREEN, LIGHT VIRIDIAN, PALE TURQUOISE, MEDIUM TURQUOISE, MEDIUM COBALT BLUE, MEDIUM PRUSSIAN BLUE, GREEN-GREY, BLUE-GREY, GREY-PURPLE AND WHITE • STICK OF FINE CHARCOAL • STICK OF WHITE CHALK

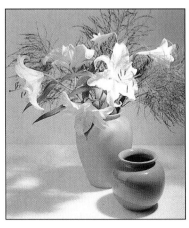

Left Spectacular white lilies form the focal point of this still-life group, with its harmonious colour scheme of cool white, blues and greens.

1

Working on the smooth side of the paper, lightly sketch the main outlines of the group with charcoal, dividing the picture area into interesting shapes. Drawing vertical lines down the centres of the vase and pot will help you to draw their shapes accurately. Use white chalk to indicate the light tones. Gently flick the charcoal lines with a rag to knock them back.

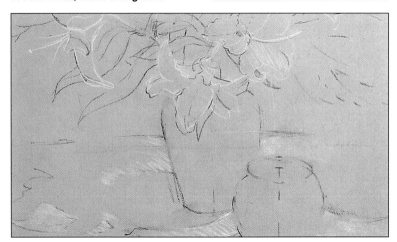

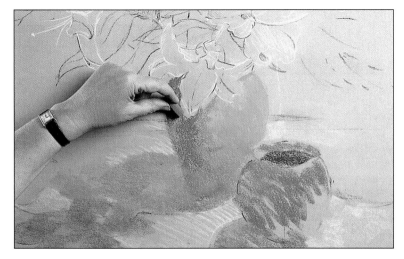

2

Start by placing a few strokes of local colour around to emphasize the shapes and indicate the tonal values of the picture. Work lightly, using broken pieces of pastel on their sides. Use a medium-toned cobalt blue for the jug, with Prussian blue inside the rim. For the vase, plot the light, medium and dark tones with a light viridian green, green-grey and medium turquoise, respectively. Bring the colour of each object down into its shadow so that the two shapes are linked. Float strokes of blue-grey and grey-purple over these shadows, to suggest the shadows cast by the lilies.

3

Block in the background behind the group with very light side strokes of grey-purple, then use the same colour to put in the shadows on the lilies. (Squint at the flowers through half-closed eyes so that you can see the dominant lights and darks more clearly.)

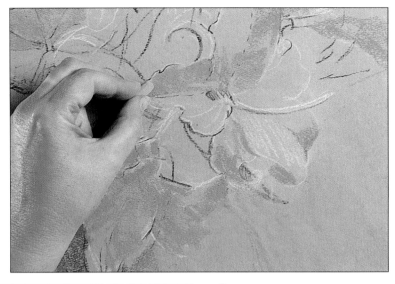

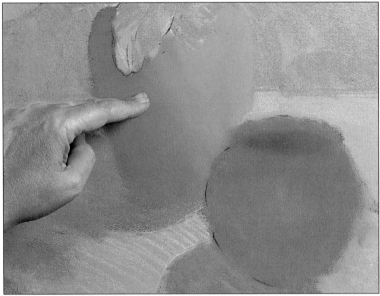

4

Use your fingertips to work over the colours applied to the vase and pot until they are blended into continuous gradations that describe their rounded forms. These soft tones also suggest the matt surface of the porcelain. Apply a light spray of fixative to the painting so that the light colours you add later will sit on top of those underneath rather than mixing with them.

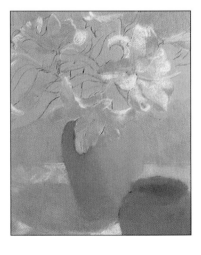

5

Use a very pale cream pastel to put in the highlights on the lilies and on the table, and add hints of lemon yellow on the trumpets of the lilies. Move lightly over the paper so that its colour maintains a strong presence, glinting through the overlaid strokes.

6

Now block in the leaves and stalks on the lilies, first putting in the darkest tones with a medium leafy green. Apply the colour lightly, with gentle side strokes, so as not to overload the grain of the paper with colour.

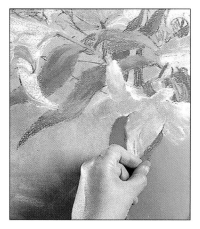

7

Use the same green, this time using the tip of the pastel, to suggest the feathery ferns that fan out between the lilies. Then add the highlights on the lily leaves and stalks with a warm, yellowy green.

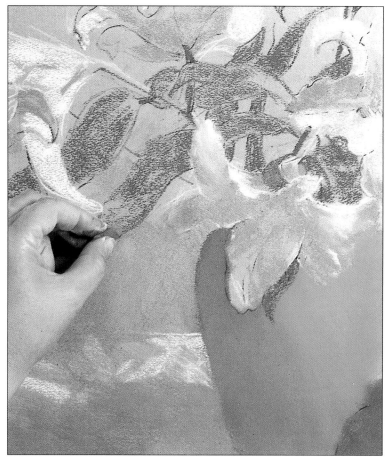

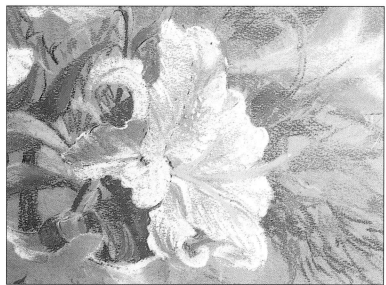

8

Now start to develop the lights on the lily flowers with white and very pale cream. Use the tip or edge of the pastels now, and apply a little more pressure. The lily at the front forms the focal point of the group, so concentrate detail here by suggesting the slightly raised texture of the petals with lines and dots. Allow glints of grey paper to show through, representing the cool, delicate shadows on the flowers. Draw the long stamens lightly with yellow-green.

9

Gently brush delicate hints of pale turquoise and grey-purple onto the shadowy undersides of the flowers, again letting the grey paper show through. Highlight the frilly edges on some of the petals with white pastel.

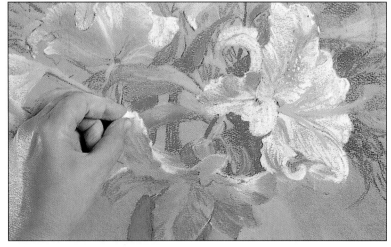

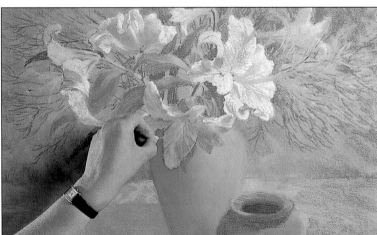

10

Don't work on one area for too long but move around the painting, adjusting the tones in relation to their neighbours. Add further strokes of grey-purple in the background, then develop the form of the blue pot by adding the shadow on the left with Prussian blue and the highlight on the rim with pale cream. Develop the foliage further with yellow-green, and put in the stamens on the lilies.

11

Now work on the table top, using delicate side strokes of pale cream to describe the patterns of dappled light that fall between the cast shadows of the flowers. Float the colour on gently, using the broad side of the pastel, so that the cool grey of the paper glints through.

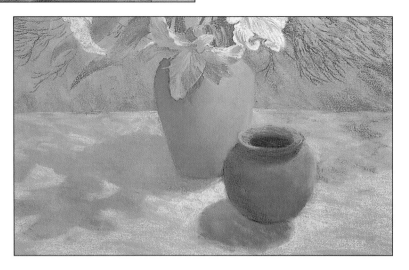

12

Apply soft strokes of pale turquoise and leaf green to the vase to suggest the dappled shadows and highlights cast onto it by the foliage. Use your fingertip to blend and graduate the tones on the blue pot to show how light describes its three-dimensional form. Then add the orange stripe on the rim of the pot and build up thick strokes of pure white for the bright highlights.

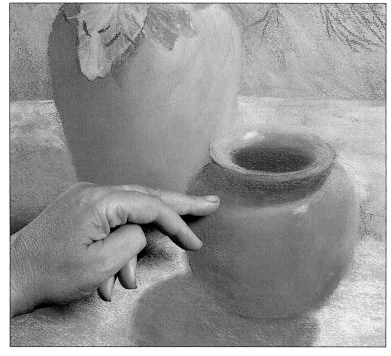

13

Now add just a whisper of cobalt blue to the shadows on the table to make them more luminous. To anchor the vase and pot to the table, slightly darken the area of shadow directly beneath them. Then use your fingertip to very gently soften the edges of the shadows.

14

Finally, add the pollen-covered anthers at the ends of the flower stamens using red-brown, overlaid with touches of orange.

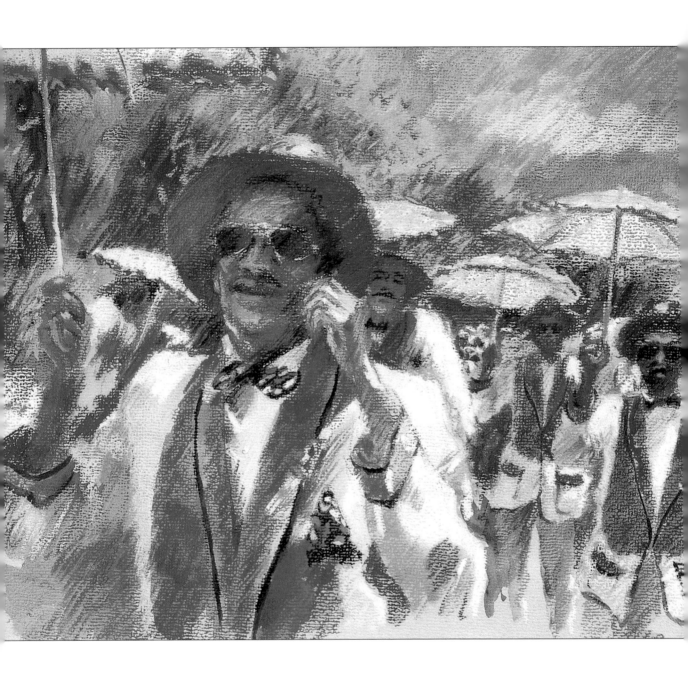

MIXED MEDIA

Because pastel is such a flexible medium it can be combined successfully with other drawing and painting media to create optical and textural effects that will broaden the range and expressiveness of your paintings. By combining pastel with an aqueous medium such as watercolour, gouache or acrylic, for example, you can exploit the unique qualities of each medium and use them to enhance each other.

In this lively painting the fluid, translucent quality of watercolour makes a perfect foil for the opaque, splattered, scintillating qualities of the overlaid pastel strokes. The artist began by blocking in the composition with watercolour washes to establish the main colour areas and the patterns of light and shade. When the watercolour was dry, she reworked the image in loose, grainy pastel strokes to develop detail and emphasize colour accents and tonal contrasts. Where the painted areas break through in places a striking optical effect is created with the pastel overpainting.

Hazel Soan
Mardi Gras
33 x 38cm (13 x 15in)

USING MIXED MEDIA

Aside from the aesthetic considerations, there are also some practical advantages to combining pastel with paint media. First, aqueous media can cover large areas quickly while still leaving enough surface tooth for the subsequent layers of pastel to adhere to. This enables you to establish correctly patterns of lights and darks, to lay a kind of blueprint of complementary colours and tones to be later deepened or lightened with pastel, to work out compositional problems, and to avoid the dense and overworked appearance that might result from building up too many layers of pastel.

Second, the one complaint artists have about pastels is that it is difficult to create really rich, dark tones with them – there are far fewer dark pastels than light ones, and even the deepest shades tend to come up relatively light on application. This problem can be overcome by first blocking in the dark areas of the composition with paint to give them more strength.

When using water-based media with pastel the paper must be strong enough to take the wetting. This means you must either mount your paper on a stiff cardboard backing, or use heavy watercolour paper (at least 285gsm/140lb).

This detail reveals how the surface grain of watercolour paper breaks up the pastel colours, giving a speckled effect that provides a lively contrast with the watercolour washes beneath.

MARDI GRAS

1
Sketch out the figures with an HB pencil. Pay particular attention to the proportions of the figures and the way they diminish in scale in the distance.

Materials and Equipment

• SHEET OF BEIGE CANSON PAPER • WATERCOLOURS: PERMANENT ROSE, CERULEAN, FRENCH ULTRAMARINE, BURNT SIENNA AND SCARLET LAKE • SOFT PASTELS: PALE PINK, MAGENTA, BRIGHT YELLOW, YELLOW-GREEN, YELLOW OCHRE, CERULEAN, DARK BLUE-GREEN, MEDIUM GREEN, TURQUOISE, COBALT BLUE, BURNT SIENNA, BLACK AND WHITE • MEDIUM-SIZE ROUND WATERCOLOUR BRUSH • HB PENCIL

2

Mix up a wash of permanent rose and apply this over all the areas of the picture that are to be warm in colour, such as the darker flesh tones and the musicians' pink jackets. Use a medium-size round brush and apply the paint freely and intuitively across the paper.

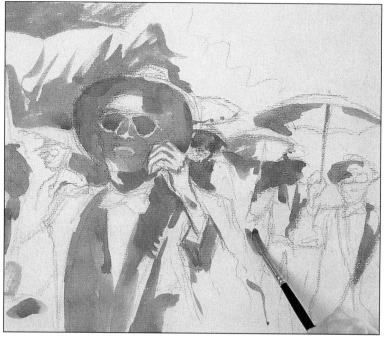

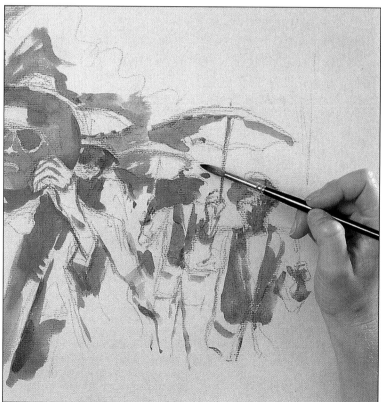

3

Now mix a wash of cerulean and use this to sketch in the cool, shadowy undertones. Again, work freely and rapidly rather than attempting to "fill in" specific areas.

4

Brush in the sky area on the right with a loose wash of burnt sienna. This will provide a warm undertone for the cool pastel colours applied over it later. Apply touches of burnt sienna elsewhere around the composition to provide colour echoes that will help to unify the whole picture.

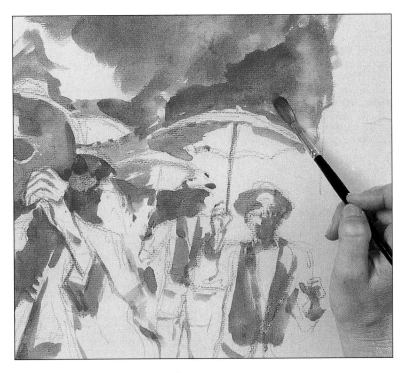

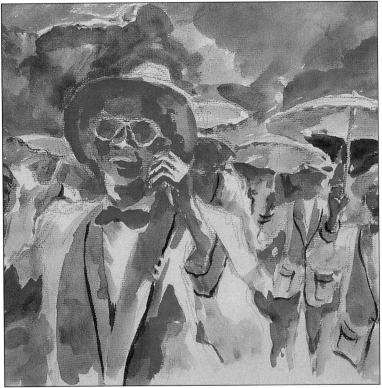

5

Finally, mix a wash of scarlet lake and use this to define the deepest tones, such as the cast shadows on the face of the foreground figure. Leave touches of bare paper showing to serve as the brightest highlights. Mix French ultramarine and permanent rose and sketch in the detailing on the musicians' jackets using the tip of the brush. Now leave the painting to dry.

MIXED MEDIA

6

Snap off a short length of cerulean pastel and work over the sky area with the side of the stick. Apply gentle pressure so that the colour deposits only on the peaks of the paper grain, allowing the burnt sienna wash underneath to show through the pastel strokes.

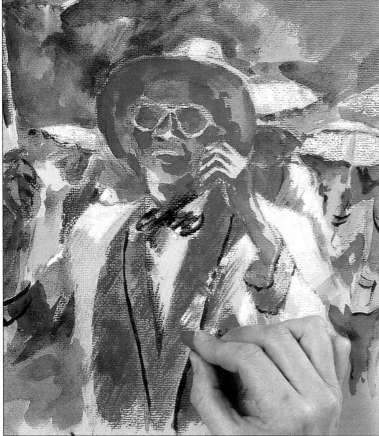

7

Now work on the foreground figure, filling in the pattern on the bow tie with dots of black, white and yellow pastel. Work over the pink parts of the jacket with parallel hatched strokes of pale pink and bright magenta.

8

Apply strokes of white pastel over the light areas of the foreground musician's jacket. Then lightly hatch over the shadow under the brim of his hat with cobalt blue. The interaction of the warm pink underwashes and the cool blue pastel strokes sets up a vibrant effect that captures the sensation of bright sunlight.

9

Add strokes of burnt sienna and yellow ochre on the musician's face and arms, then accentuate the shadows on his face with cobalt blue. Go over the sunglasses with black, then define the mouth and moustache. Fill in the parasol at top left with blended strokes of pink and white. Now move on to the trees in the background, indicating clumps of foliage with dark blue-green, medium green and light yellow-green. Note how the undertone of burnt sienna adds depth and richness to these greens.

10

Continue working around the composition, building up tone and detail and gradually bringing the picture into focus. Fill in the parasols with white, edged with cobalt blue, then deepen the tones on the left of the picture.

11

Now start to work on the figures in the background. Jot in the musicians' facial features and sunglasses with black, then shade the underbrims of the hats with cobalt blue. Fill in the jackets with hatched strokes of white and magenta.

12

Complete the jackets and trousers on the background figures with strokes of turquoise, letting the watercolour tints break through the overlaid pastel strokes. Fill in the hats with cobalt blue and white. Finally, give more definition to the facial features of the righthand figure using bright yellow, black and pale pink. Leave the other figures relatively undefined as they are farther back in space.

Technique

6

EXPRESSIVE STROKES

Pastels are unique in the way they combine the properties of drawing and painting media, providing rich qualities of colour and texture as well as a sensitive line quality. They also offer the satisfaction of immediate contact with the paper; variations between line and mass are instinctively wrought through the natural movements of the hand and the pastel stick.

The marks you can make with pastel are infinitely variable, as is amply demonstrated in this colourful landscape painting. The artist has worked on glasspaper, an abrasive, heavily toothed surface that enables him to apply layer upon layer of rich, dense colour. Using small, broken pieces of pastel, he gradually built up the colour density with broad drifts and grainy, open-textured side strokes, occasionally dashing in brilliant colour accents. He was careful to keep the whole surface active at every stage, letting the painting grow naturally and "talk back" as it progressed.

~

Geoff Marsters
Near St. Jacques, Brittany
37 x 49cm (14½ x 19in)

~

MAKING EXPRESSIVE MARKS

Each of us has a handwriting style that is unique and personal to us alone. Whether our writing is neat and precise, or full of flamboyant curves and loops, it unconsciously expresses something of our personality. The same thing applies to art; every line and stroke an artist puts into a drawing or painting expresses something about that artist as well as his or her subject. A classic example of this is to be found in the violent, swirling lines in the work of Vincent van Gogh (1853–1890), which express the intensity of his emotions and the tortured state of his mind.

Pastel sticks can be broken to produce a range of different marks and edge qualities. With practice, the different ways of manipulating the pastel – switching from tip to side and varying the pressure – will become second nature and your own personal "handwriting" will begin to emerge. Working with the long side of the pastel creates broad, painterly strokes that can be swept in as grainy "washes". Working with the tip of the crayon, or a broken edge, you can make thin lines and crisp strokes or rough dabs and dashes that create an altogether different feel. Add to this the different effects achieved by combining soft and hard pastels, rough and smooth papers, and different coloured papers, and you will begin to see why pastel is such an expressive and fascinating medium to work with.

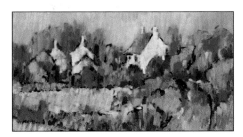

Pastel sticks can be broken to produce a range of different marks and edge qualities that act descriptively and lend vitality to an image.

NEAR ST. JACQUES, BRITTANY

1

Mark out the composition using a deep shade of ultramarine (if you doubt your drawing abilities, make light charcoal outlines first and then go over them with pastel). Let the pastel stick dance over the paper, creating lively, broken lines rather than solid, continuous ones.

Materials and Equipment

• SHEET OF FINE GRADE GLASSPAPER • SOFT PASTELS: PALE PINK, RUST RED, BRIGHT ORANGE, ORANGE-BROWN, SOFT YELLOW, GOLDEN YELLOW, LIGHT GREEN, DARK GREEN, VIBRANT GREEN, ULTRAMARINE DEEP, TURQUOISE BLUE, COBALT BLUE, MAUVE, VIBRANT BLUE, PURPLE-GREY, PALE OCHRE, WHITE AND BLACK • SOFT TISSUES

2

Assess the main shadow areas in the subject and then block them in, using a short piece of purple-grey pastel on its side to stroke the colour on lightly.

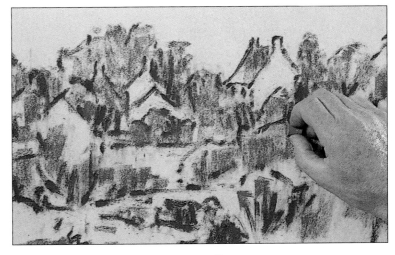

3

Start to define the light/dark accents in the landscape, putting in the lighter tones with strokes of cobalt blue and mauve. Move lightly over the paper so as not to fill up the grain too quickly.

4

Continue applying soft strokes of mauves, pinks, yellows and orangey browns in the sky. Introduce the same colours into the landscape to link the two together and unify the picture. At this stage you are not too concerned with depicting objects but concentrating on getting a flow of colour moving through the composition.

5

Introduce some strokes of light, cool green into the landscape. Get rid of any excess pastel dust on the surface of the picture by holding the board at a vertical angle and tapping it lightly onto a piece of newspaper. When you are satisfied with the distribution of colours and tones in the composition, work across the picture with a piece of crumpled tissue, very gently smudging the colours and softening the strokes. Work in a vertical direction.

6

Build up more colour in the sky with vertical strokes of pale pink, mauve and yellow, plus touches of white and light green. Use gentle pressure to create soft veils of colour, and bring the strokes down into the tops of the trees so that sky and land are linked. These broken strokes of high-key colour recreate the scintillating, sparkling effect of light in the sky.

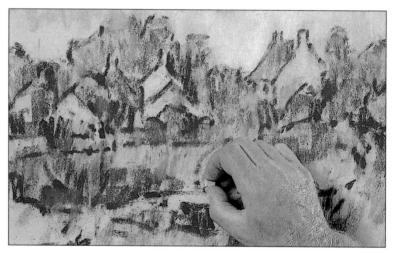

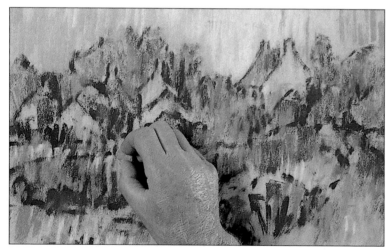

7

Now bring some warm colour into the landscape, to echo the warm yellowy hues in the sky. Use the tip of a golden yellow pastel to make short, vertical marks, applying more pressure now. Use these bright hues as visual "stepping stones", arranging them in subtle lines and curves that encourage the eye to explore the composition. Start to fill in the white walls of the houses, which are the focal point of the composition.

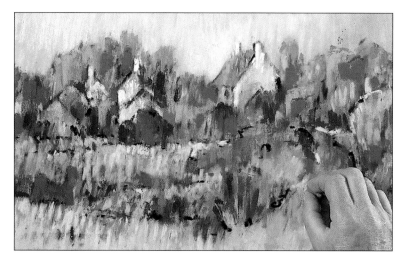

8

Build up stronger hues in the landscape, bringing in rich touches of vibrant blue, bright orange and rusty red. Use the tip and the side of the pastel sticks to create a varied range of marks, some linear and some broad and blocky.

9

Strengthen the whites on the buildings to make them stand out. Now bring in small strokes and flecks of rich turquoise blue and vibrant green, once again using these points of strong colour to reinforce the rhythms and movement in the composition.

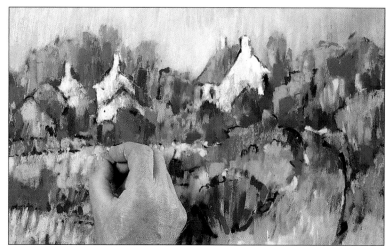

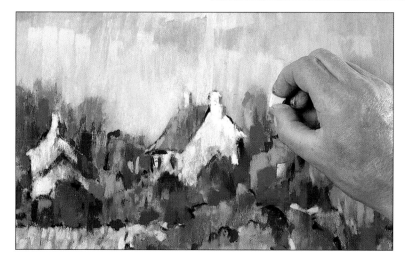

10

Complete the painting by feathering soft strokes of pale ochre in the sky near the horizon. Add small touches in the landscape as well, to unify and harmonize the picture. Do not spray-fix the completed painting because this would darken and alter the colour values. Store the picture carefully and frame it behind glass as soon as possible.

POINTILLISM

The French painters Georges Seurat (1859–1891) and Paul Signac (1863–1935) developed the pointillist technique towards the end of the nineteenth century, using oil paints. Evolving from the Impressionists' use of broken colour, pointillism involves creating an image from hundreds of tiny dots of pure colour. Seen from the appropriate viewing distance, these dots "read" as a coherent surface and the colours take on a luminous quality.

Pointillism in its pure form is a very exacting technique, but it doesn't have to be applied methodically – used in a free and spontaneous manner it produces sparkling colours and a lively and entertaining surface.

Pastels are particularly suited to the pointillist technique because of their pure, vibrant hues and ease of manipulation. In this impressionistic painting the many touches of colour add a shimmering quality to the surface, making it dance and vibrate. The poppies are picked out with quick, dashing strokes and stippled dots that make no attempt to shape the flowers, but are simply notes of colour. Small patches of the buff-coloured paper remain exposed throughout the picture, the warm colour giving an underlying unity to the mass of pastel strokes and enhancing the effect of sunlight.

~

Derek Daniells
Poppy Field
33 x 41cm (13 x 16in)

~

POINTILLIST TECHNIQUE

The technique of pointillism involves building up an image with small dots and flecks of pure colour that are not joined but leave some of the toned support showing through. When seen from the normal viewing distance, these dots appear to merge into one mass of colour, but the effect is more vibrant than that created by a solid area of blended colour. Because each dot is separate, the colours appear to shimmer and sparkle, and this is due to the way in which tiny dots of colour vibrate on the retina of the eye.

If complementary (opposite) colours are juxtaposed, the effect is even more pronounced. For example, when dots of red and green, or yellow and violet, are intermixed, the colours are mutually enhanced by contrast and the effect is strikingly vibrant. However, it is important to note that this vibrancy is only achieved when the colours are similar in tone.

The aim of this technique is to achieve a sense of immediacy; the colours should be applied rapidly and confidently and then left with no attempt made to blend them together. Try to vary the size, shape and density of the marks you make, otherwise the effect will be monotonous. By altering the pressure applied, you can make a range of stippled dots and broken flecks and dabs that give life and energy to the image.

Successful optical mixing depends on spacing the colours well in the early stages, leaving enough room to build up the succeeding colours.

POPPY FIELD

1

This image is based on a loose build-up of strokes, so avoid drawing outlines as they restrict your mark-making. Plot the structure of the work with small, widely spaced marks, using pale tints of ultramarine and mauve for the sky, sap green and cadmium yellow for the fields, and green-grey for the grasses.

Materials and Equipment

• SHEET OF BUFF-COLOURED PASTEL PAPER • SOFT PASTELS: CADMIUM YELLOW, SAP GREEN, OLIVE GREEN, GREEN-GREY, VERMILION, WHITE, AND VERY PALE TINTS OF ULTRAMARINE BLUE, MAUVE, VIRIDIAN, OCHRE AND CERULEAN

POINTILLISM

2

Define the horizontal lines of the distant fields and the shadow sides of the trees with ultramarine. Then work on the wild-flower field with small flicks and strokes, using very light tints of mauve, viridian, cadmium yellow and ochre. Touch in the colours very gently, keeping the pastel marks loosely spaced.

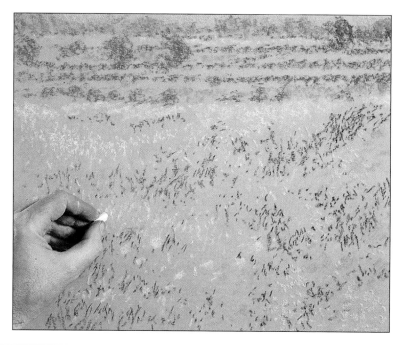

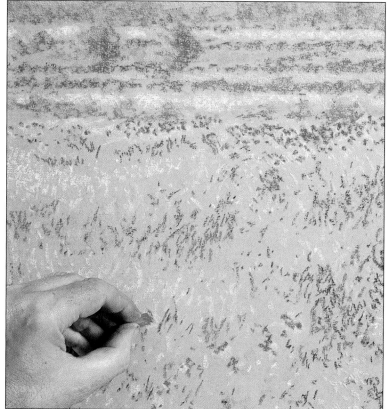

3

Suggest sunlight streaking across the distant fields with a couple of light, broken, horizontal lines of viridian. Keep adding touches of colour over the whole image, letting your pastels "dance" over the paper and keeping the whole surface active. Spot in some vermilion for the poppies, applying it over the yellow marks already made.

4

Indicate the light tones in the sky with very pale cerulean and white. Touch in warm sap green on the left side of the trees, to give them three-dimensional form and to indicate the direction of the light. Add lines of very pale ochre to suggest cornfields in the distance.

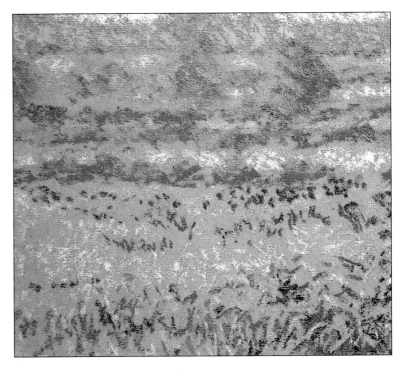

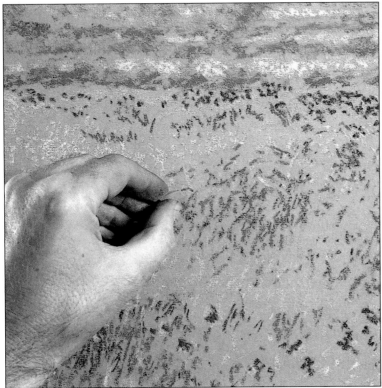

5

Flick in the tops of the grasses with sap green, varying the direction of the strokes to describe how they bend in the breeze. If all the strokes run in the same direction, the effect looks more like rain than grass!

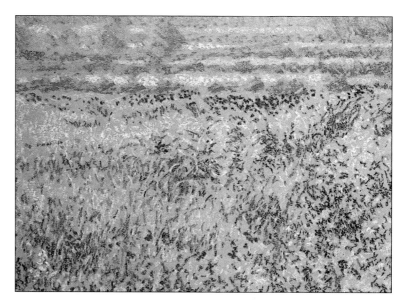

6

Continue patiently building up the textures and forms of the foreground grasses and flowers. Move lightly over the paper so that its warm colour maintains a strong presence, glinting through the overlaid strokes. Use the same colours as before, with the addition of olive green to give warmth to the shadowy grasses and touches of white to give sparkle to the blue flowers.

7

Step back to assess your progress, then make necessary adjustments. Here, the artist feels that the tone of the trees is too strong so he lightly strokes mauve over them. This "knocks back" the colour, pushing the trees back in space. The thin veil of mauve also gives the impression of hazy summer afternoon light.

8

Gradually build up the density of marks in the foreground with small strokes and flecks worked in different directions. Concentrate more detail on the flowers in the foreground to bring them forward in the picture plane, thus accentuating the feeling of space in the background landscape.

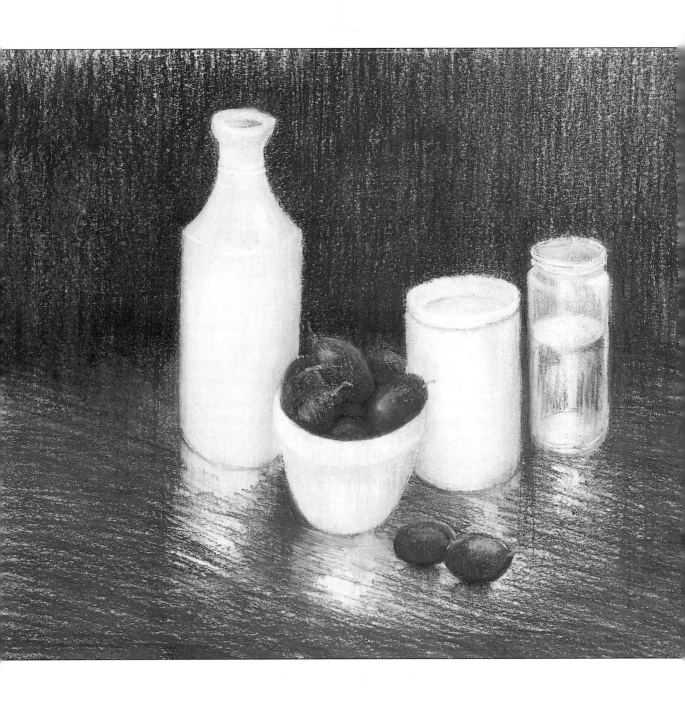

Technique

8

HATCHING AND CROSSHATCHING

There are many different ways of "mixing" pastel colours on the paper surface. By using the hatching technique of laying a series of roughly parallel lines in different colours or tones it is possible to achieve an optical mixing effect with the lines merging to give the impression of continuous colour.

This still-life study is a good example of the complexity of colour and tone that can be achieved with hatching and cross-hatching. The artist has woven subtle and complex hues from a series of densely packed parallel lines worked mostly in a vertical direction. Seen from the appropriate viewing distance, these linear marks "read" as a coherent surface, while at a closer view the colour interactions and lively textural qualities of the mingled strokes can be appreciated. The surface of the picture appears to sparkle due to the vibrant optical effects produced by the interwoven colours.

Brian Gallagher
Still Life with Plums
34 x 42cm (13½ x 16½in)

HATCHING AND CROSSHATCHING

In hatching, an area of tone or colour is rendered by making a series of close, parallel strokes that appear to the eye as a solid area. The broken nature of hatching, when seen at a normal viewing distance, produces a more vibrant quality than flat areas of tone because the individual colours retain their identity.

Considerable variations of tone and texture can be achieved by varying the pressure on the pastel stick and the spaces between the strokes; the heavier and closer the strokes the more solid the tone will appear.

You can also lay one set of hatched lines over another, in opposite directions, to create complex colour effects. This technique is known as crosshatching. If you want to build up a really dense, textural effect, you can add still more strokes in yet another direction. Hatched lines can be thick or thin, curved, tapered or broken, crisp or ragged. You can use consistent strokes that follow the forms they are describing, or vary the angles and directions of the strokes to create a vigorous, energetic surface.

Finely hatched lines can be produced by breaking off a small piece of pastel and drawing with a broken edge. Alternatively, sharpen the end of the stick with a blade.

Pastel pencils are ideal for linear techniques such as hatching and crosshatching as they can be sharpened to a fine point or a chisel edge suitable for working on detailed areas.

STILL LIFE WITH PLUMS

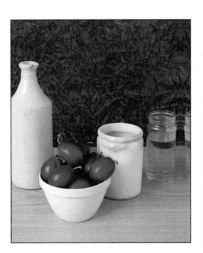

Left: The artist chose this small group of light-coloured containers for three reasons. First, they compose a natural harmony of repeated shapes and forms. Second, they create a dramatic effect when set against a dark background. And third, there are wonderful subtleties of tone and hue to be explored in the individual items and recreated using overlaid strokes of colour.

Materials and Equipment

• SHEET OF PALE GREY PASTEL PAPER • SOFT PASTELS: MID-TONE PERMANENT ROSE, LIGHT AND MID-TONES OF SAP GREEN, LIME GREEN, COBALT BLUE IN DARK, LIGHT AND VERY LIGHT TINTS, DARK ULTRAMARINE BLUE, DARK BLUE-VIOLET, LIGHT AND DARK TINTS OF VIOLET, PALE MAUVE, MID-TONE BLUE-GREY, TURQUOISE, LIGHT AND MID-TONES OF RAW SIENNA, MID-TONE BURNT SIENNA, LIGHT AND MID-TONES OF BURNT UMBER • HARD ERASER

1

Lightly draw the containers with a dark cobalt blue pastel. Sketching horizontal and vertical construction lines through the centres of the shapes will also help you draw the shapes accurately. Vary the weight of the lines, starting lightly at the top and and making stronger, more energetic lines where the forms meet the table. This "lost and found" quality suggests weight, solidity and light. Carry the lines down to suggest the reflections on the table, and blend the pigment into the paper to begin to suggest form.

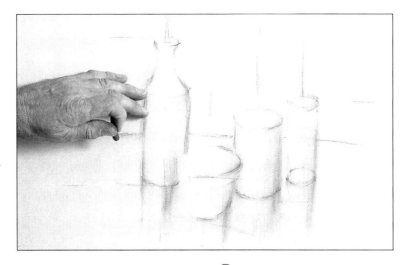

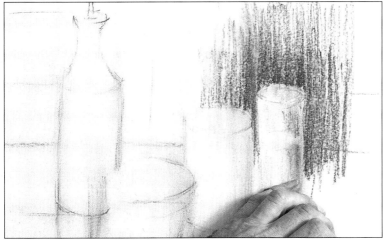

2

Block in the stone jar and the jam jar with vertical hatched strokes of light sap green overlaid with a mid-tone raw sienna, again dragging the colour down to suggest the reflections on the table. Soften some of the marks, but avoid over-blending. Start to fill in the background with vertical hatched strokes of dark cobalt blue overlaid with mid-tone permanent rose. Indicate the reflection of this colour in the jam jar, blending with your fingertip to lighten the tone.

3

Establish the horizontal plane of the table using mid-tone burnt sienna and burnt umber applied with loose, rapid hatching worked diagonally and vertically. Again, this colour is reflected in the jam jar. Apply more overlaid strokes of sap green and raw sienna to the stone jar, adding strokes of pale mauve for the cast shadow on the left. Develop the background tone with strokes of dark ultramarine blue.

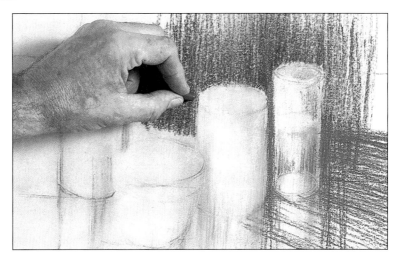

4

Draw the plums with dark ultramarine blue, then hatch with dark violet and permanent rose for the deep tones. Darken the background behind the bowl of plums with strokes of burnt umber and dark violet; this throws the plums forward and creates visual space. Develop the warm mid-tones on the plums with touches of burnt sienna, following the rounded contours with your pastel marks. Use a sharp corner of a hard eraser to clean up the drawing and to pull out some light tones, for example, those on the bowl.

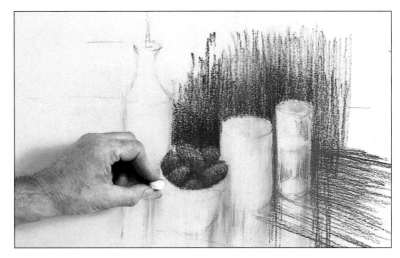

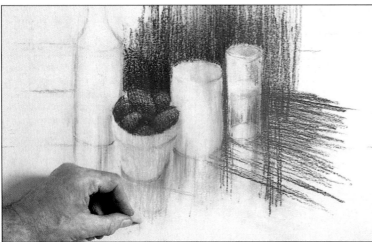

5

Work on the bowl using vertical hatching with turquoise and light cobalt blue. Define the shadow under the rim and base with light violet. Add some strokes of mid-tone sap green for the deeper tones and very light cobalt blue for the highlight on the left. Follow the pastel marks through into the reflection on the table so that the bowl becomes anchored to the table and does not appear "pasted on".

6

For the stone bottle and its reflection use light sap green overlaid with light raw sienna. Add lime green for the light areas and light burnt umber for the warm shadow tones. Continue blocking in the wooden table with diagonal hatching using mid-tone burnt sienna and burnt umber. Work over the rim of the bowl with very light cobalt blue to lighten the tone.

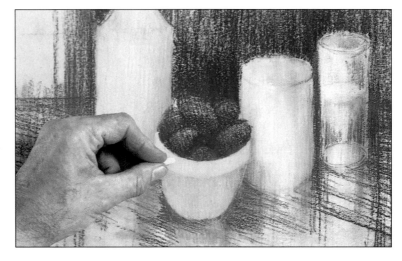

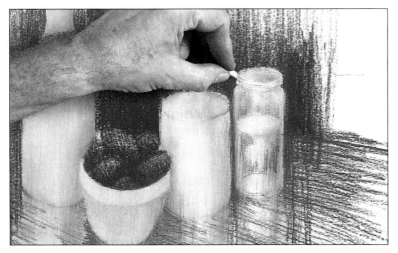

7

Define the highlights and reflections on the jar of water. Use mid-tone sap green in the water and on the shoulders of the jar. Show the reflection of the background at the back of the jar with blended tones of ultramarine blue and permanent rose. Define the ellipse of the water's surface with mid-tone blue-grey and the highlights on the rim of the jar with very light cobalt blue.

8

Define the rim of the stone jar and the highlights on the stone bottle with very light cobalt blue. Draw the two stray plums in the foreground with the same colours that were used for the plums in the bowl. Use some sap green and raw umber for the stalks. Complete the hatching on the table with burnt sienna and burnt umber warmed with hints of permanent rose.

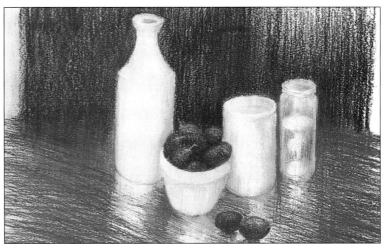

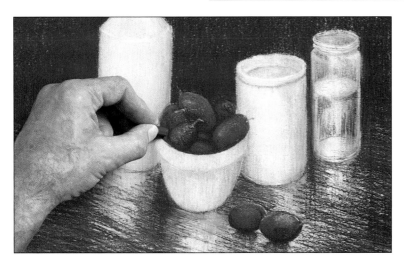

9

Continue working all over the image, refining the subtle nuances of colour. Build up the density of colour in the background with strokes of dark blue-violet and permanent rose. Put in the shadow beneath the rim of the stone jar with mid-tone blue-grey. Finally, build up the forms of the plums with further strokes of dark violet and permanent rose and use very pale raw sienna to put in the soft highlights.

Technique
9

USING GLASSPAPER

S oft pastels can be used on any surface that is rough enough to provide a "key" that will retain the grains of colour. The support used for this painting is a type of fine glasspaper manufactured for smoothing wood, which also happens to be ideal for pastel painting.

The artist is interested in capturing the feel and atmosphere of space in his landscapes, and finds that working on glasspaper enables him to achieve subtle colour nuances descriptive of the transient effects of light and weather. The heavily toothed surface of this paper grips the particles of pastel pigment well and enables crisp mark-making, but also gives a slightly softened edge to the pastel strokes. As the colours are overlaid they soften and merge, giving a lush, painterly effect. At the same time, the grainy, crumbly texture of the pastel marks is retained, creating rich, dense qualities of colour and texture that add to the surface interest of the picture.

Geoff Marsters
Scottish Loch, Evening
38 x 49cm (15 x 19in)

PAINTING ON GLASSPAPER

Fine glasspaper – the kind used by carpenters for finishing and smoothing wood surfaces – makes an excellent support for painting with pastels. Its gritty, abrasive surface grips the particles of colour firmly, allowing you to overlay many colours and build up a rich, expressive surface. It also has a mellow buff tint which, when allowed to show through the overlaid strokes, enhances the bright pastel colours and provides a unifying middle tone.

Because glasspaper holds the pigment so firmly the finished picture requires little or no fixing. Its only disadvantage is that it does shave off the pastel fairly rapidly – and it is hard on the knuckles if you hold them too close to the paper!

Glasspaper (also known as flour paper) is available in various surface grains. Most artists choose the finest grade for pastel work – rough grades shave off too much pastel. It is available from art suppliers in large sheets, which you can then cut down to the size you want. Hardware stores stock small sheets (roughly A4 size) which are handy for sketching and small-scale work.

Sansfix paper, available from larger art suppliers, is similar to very fine glasspaper. Its surface is made from a thin layer of fine cork particles and grips the pastel particles so well that fixing is not necessary.

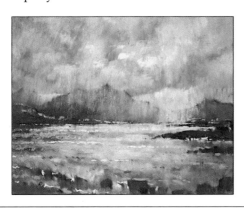

The gritty surface of glasspaper allows for both subtle blendings and crisp strokes with plenty of "bite".

SCOTTISH LOCH, EVENING

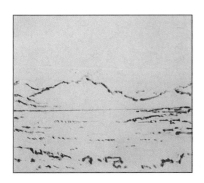

1

Plot the main structure of the composition with a dark purple pastel, placing the horizon line just below centre. Draw the outline of the mountains and indicate the rocks and water in the foreground with sketchy, broken lines.

Materials and Equipment

• SHEET OF FINE GRADE GLASSPAPER • SOFT PASTELS: PALE PINK, PALE CREAM, PALE YELLOW, GOLDEN YELLOW, PALE BLUE, COBALT BLUE, TURQUOISE BLUE, GREY-PURPLE, DARK PURPLE, MAUVE, PALE, DARK AND MID-TONE VIOLETS, PALE OCHRE AND OFF-WHITE • SOFT TISSUES

2

Start to place a few strokes of local colour around the image to emphasize shapes and indicate tonal values. Here, the artist is applying cobalt blue and grey-purple over the mountains and the loch, using short lengths of pastel on their sides to stroke the colour on gently with short, vertical strokes.

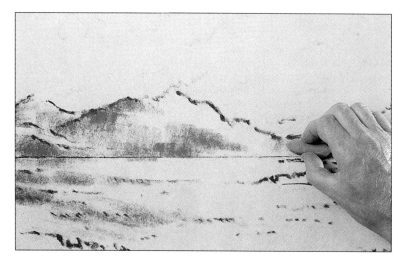

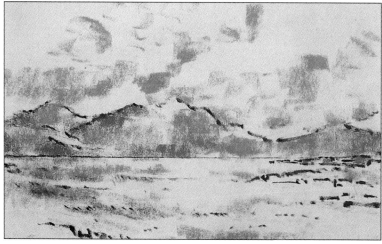

3

Continue building up the picture loosely, adding some touches of mauve and pale violet to the mountains and water. Start to draw in the main cloud formations with loose strokes and curls of pale violet, again using the long edge of the pastel stick and varying the pressure applied in order to describe the different "weights" of cloud.

4

Suggest the craggy forms of the rocks on the right of the picture and in the foreground with small strokes of dark violet and mid-tone violet. Use tiny broken pieces of pastel on their sides to build up blocks of colour and tone rather than drawing an outline and filling it in.

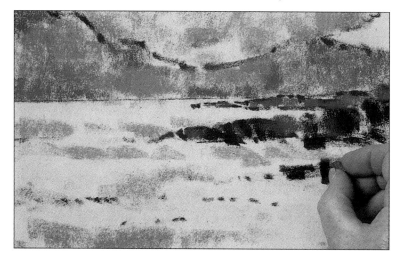

5

Don't work on any one area of the painting in isolation but continue adding touches of colour over the whole image. Loosely fill in the mountains with small side strokes, using a variety of warm and cool greys, blues, pinks and violets. Suggest the light ripples in the water with very pale pinks and blues, and echo the same colours in the sky.

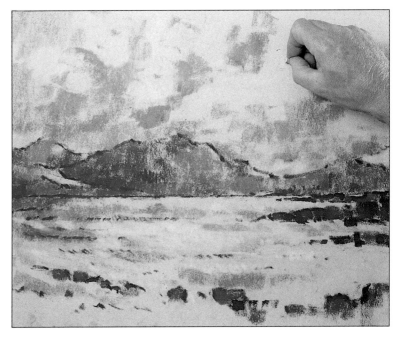

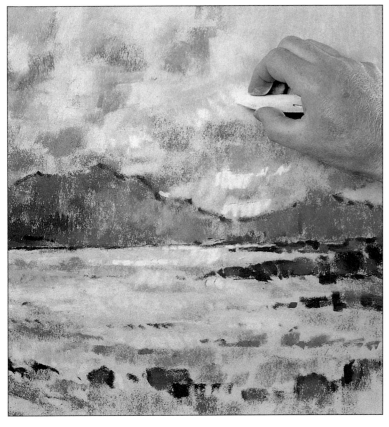

6

Scumble some warm cobalt blue into the foreground, to bring it forward in the picture plane. Now start to introduce some pale creams, ochres and yellows into the sky and the water with small marks and scribbles. Stroke the colours on lightly and let them meld with the colours already laid down.

Above: This close-up detail of the sky reveals how the rough texture of the glasspaper breaks up the pastel marks, particularly where light pressure is applied, creating the effect of soft, vapourous clouds.

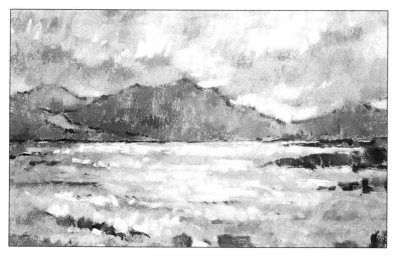

7

Develop subtle colour nuances in the sky with a combination of open-textured side strokes and lively scribbled marks. Vary the pressure on the pastels to produce different weights of colour that suggest three-dimensional form. Bring some of the sky colours down over outline of mountains to give the effect of evening mist. Once again, echo the sky colours in the water, using short dashes and upward flicks to convey sparkle and movement.

8

Now work across the sky using a tightly crumpled piece of tissue to partially blend the pastel marks. Apply very light pressure – just enough to soften the colours and describe the vapourous clouds, but without overblending. Use the same technique on the mountains, applying slightly more pressure to push more of the pastel pigment into the grain of the paper and deepen and intensify the colours.

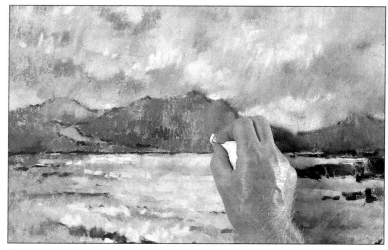

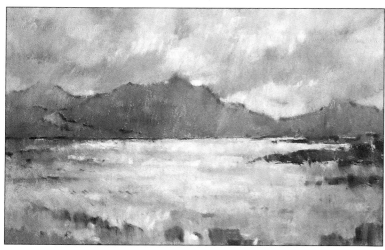

9

Continue softening the colours across the whole image, using clean pieces of tissue so as not to dirty the colours as you stroke over them. This process pushes more of the pastel pigment into the grain of the glasspaper, allowing you to apply further colours on top.

10

Put in a few touches of golden yellow and ochre in the sky near the horizon to indicate the setting sun peeping through the clouds. Use a warm off-white for the fluffy clouds that appear higher up. To create the effect of shafts of light striking through the clouds, snap off a short length of very pale soft yellow pastel and lightly skim it down through the sky and into the mountains with vertical strokes.

11

Continue stroking soft yellow over the mountains with a feather-light touch so that they appear veiled in mist. Work on the water with broken, horizontal lines of pale yellow and off-white to suggest light from the sky reflecting off the surface. These more linear, edgy marks provide a textural contrast to the veils of pastel colour and help to emphasize the impression of space.

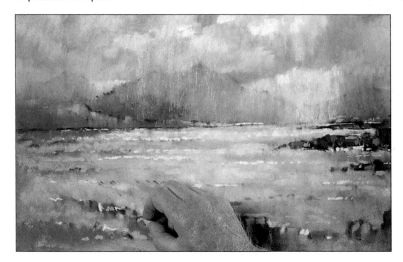

12

Finish off by adding some small, sharp hints of intense colour in the foreground using golden yellow on the rocks and turquoise blue on the water. Avoid fixing the finished picture as this will darken the colours; store it carefully until it can be framed behind glass.

Suppliers

UK

The Arthouse
59 Broadway West
Leigh-on-Sea
Essex
SS9 2BX
Tel: 01702 071 2788
Wide range of art supplies

Cass Arts
13 Charing Cross Road
London WC2H 0EP
Tel: 020 7930 9940
&
220 Kensington High Street
London
W8 7RG
Tel: 020 7937 6506
www.cass-arts.co.uk
Art suppliers and materials

L Cornelissen & Son Ltd
105 Great Russell Street
London WC1B 3RY
Tel: 020 7636 1045

Cowling and Wilcox Ltd
26-28 Broadwick Street
London
W1V 1FG
Tel: 020 7734 9556
www.cowlingandwilcox.com
General art supplies

Daler-Rowney Art Store
12 Percy St
London
W1T 1DN
Tel: 020 7636 8241
Painting and drawing materials

Daler-Rowney Ltd
PO Box 10
Southern Industrial Estate
Bracknell
Berkshire
RG12 8ST
Tel: 01344 424621
www.daler-rowney.co.uk
Painting and drawing materials
Phone for nearest retailer

T N Lawrence & Son Ltd
208 Portland Road
Hove
BN3 5QT
Shop tel: 01273 260260
Order line: 0845 644 3232
www.lawrence.co.uk
Wide range of art materials
Mail order brochure available

John Mathieson & Co
48 Frederick Street
Edinburgh
EH2 1HG
Tel: 0131 225 6798
General art supplies and gallery

Russell & Chapple Ltd
68 Drury Lane
London
WC2B 5SP
Tel: 020 7836 7521
www.russellandchapple.co.uk
Art supplies

The Two Rivers Paper Company
Pitt Mill
Roadwater
Watchet
Somerset
TA23 0QS
Tel: 01984 641028
Hand-crafted papers and boards

Winson & Newton Ltd
Whitefriars Avenue
Wealdstone
Harrow
HA3 5RH
Tel: 020 8424 3200
www.winsornewton.com
Painting and drawing materials
Phone for nearest retailer

SOUTH AFRICA

Cape Town

Artes
3 Aylesbury Street
Bellville 7530
Tel: (021) 957 4525
Fax: (021) 957 4507

George
Art, Crafts and Hobbies
72 Hibernia Street
George 6529
Tel/fax: (044) 874 1337

Port Elizabeth

Bowker Arts and Crafts
52 4th Avenue
Newton Park
Port Elizabeth 6001
Tel: (041) 365 2487
Fax: (041) 365 5306

Johannesburg

Art Shop
140a Victoria Avenue
Benoni West 1503
Tel/fax: (011) 421 1030

East Rand Mall Stationery and Art
Shop 140
East Rand Mall 1459
Tel: (011) 823 1688
Fax: (011) 823 3283

Pietermaritzburg
Art, Stock and Barrel
Shop 44, Parklane Centre
12 Commercial Road
Pietermaritzburg 3201
Tel: (033) 342 1026
Fax: (033) 265 1025

Durban

Pen and Art
Shop 148, The Pavillion
Westville 3630
Tel: (031) 265 0250
Fax: (031) 265 0251

Bloemfontein
L&P Stationary and Art
141 Zastron Street
Westdene
Bloemfontein 9301
Tel: (051) 430 1085
Fax: (051) 430 4102

Pretoria

Centurion Kuns
Shop 45, Eldoraigne Shopping Mall
Saxby Road
Eldoraigne 0157
Tel/fax: (012) 654 0449

NEW ZEALAND

Auckland

The French Art Shop
33 Ponsonby Road
Ponsonby
Tel: (09) 376 0610
Fax: (09) 376 0602

Studio Art Supplies
81 Parnell Rise
Parnell
Auckland
Tel: (09) 377 0302
Fax: (09) 377 7657

Gordon Harris Art Supplies
4 Gillies Ave
Newmarket
Auckland
Tel: (09) 520 4466
Fax: (09) 520 0880
&
31 Symonds St
Auckland Central
Tel: (09) 377 9992

Takapuna Art Supplies
18 Northcroft St
Takapuna
Tel/fax: (09) 489 7213

Wellington

G Webster & Co Ltd
44 Manners Street
Wellington
Tel: (04) 384 2134
Fax: (04) 384 2968

Affordable Art
25 MacLean Street
Paraparaumu Beach
Tel/Fax: (04) 902 9900

Littlejohns Art & Graphic Supplies
170 Victoria Street
Wellington
Tel: (04) 385 2099
Fax: (04) 385 2090

Christchurch

Fine Art Papers
200 Madras Street
Christchurch
Tel: (03) 379 4410
Fax: (03) 379 4443

Brush-N-Palette Artists Supplies Ltd
50 Lichfield Street
Christchurch
Tel/Fax: (03) 366 3088

Dunedin

Art Zone
57 Hanover St
Tel/Fax: (03) 477 0211
www.art-zone.co.nz

AUSTRALIA

NSW

Eckersley's Art, Crafts and Imagination
93 York St
SYDNEY NSW 2000
Tel: (02) 9299 4151
Fax: (02) 9290 1169

Eckersley's Art, Crafts and Imagination
88 Walker St
NORTH SYDNEY NSW 2060
Tel: (02) 9957 5678
Fax: (02) 9957 5685

Eckersley's Art, Crafts and Imagination
21 Atchinson St
ST LEONARDS NSW 2065
Tel: (02) 9439 4944
Fax: (02) 9906 1632

Eckersley's Art, Crafts and Imagination
2-8 Phillip St
PARRAMATTA NSW 2150
Tel: (02) 9893 9191
Fax: (02) 9893 9550

Eckersley's Art, Crafts and Imagination
51 Parry St
NEWCASTLE NSW 2300
Tel: (02) 4929 3423
Fax: (02) 4929 6901

VIC

Eckersley's Art, Crafts and Imagination
97 Franklin St
MELBOURNE VIC 3000
Tel: (03) 9663 6799
Fax: (03) 9663 6721

Eckersley's Art, Crafts and Imagination
116-126 Commercial Rd
PRAHRAN VIC 3181
Tel: (03) 9510 1418
Fax: (03) 9510 5127

SA

Eckersley's Art, Crafts and Imagination
21-27 Frome St
ADELAIDE SA 5000
Tel: (08) 8223 4155
Fax: (08) 8232 1879

QLD

Eckersley's Art, Crafts and Imagination
91-93 Edward St
BRISBANE QLD 4000
Tel: (07) 3221 4866
Fax: (07) 3221 8907

NT

Jackson's Drawing Supplies Pty Ltd
7 Parap Place
PARAP NT 0820
Tel: (08) 8981 2779
Fax: (08) 8981 2017

WA

Jackson's Drawing Supplies Pty Ltd
24 Queen St
BUSSELTON WA 6280
Tel/fax: (08) 9754 2188

Jackson's Drawing Supplies Pty Ltd
Westgate Mall, Point St
FREEMANTLE WA 6160
Tel: (08) 9335 5062
Fax: (08) 9433 3512

Jackson's Drawing Supplies Pty Ltd
108 Beaufort St
NORTHBRIDGE WA 6003
Tel: (08) 9328 8880
Fax: (08) 9328 6238

Jackson's Drawing Supplies Pty Ltd
Shop 14, Shafto Lane
876-878 Hay St
PERTH WA 6000
Tel: (08) 9321 8707

Jackson's Drawing Supplies Pty Ltd
103 Rokeby Rd
SUBIACO WA 6008
Tel: (08) 9381 2700

Index